PHOTOGRAPHY
AT THE DOCK

Media & Society

Richard Bolton, series editor

1. Simon Watney, *Policing Desire: Pornography, AIDS, and the Media*

2. Constance Penley, *The Future of an Illusion: Film, Feminism, and Psychoanalysis*

3. William Preston, Jr., Edward S. Herman, and Herbert I. Schiller, *Hope and Folly: The United States and UNESCO, 1945–1985*

PHOTOGRAPHY
AT THE DOCK

*Essays on Photographic History,
Institutions, and Practices*

ABIGAIL SOLOMON-GODEAU
Foreword by Linda Nochlin

Media & Society 4

University of Minnesota Press · Minneapolis

"Calotypomania: The Gourmet Guide to Nineteenth-Century Photography" was originally published in *Afterimage* 11, nos. 1/2 (Summer 1983); "Canon Fodder: Authoring Eugène Atget" was originally published in *The Print Collector's Newsletter* (January/February 1986), © *The Print Collector's Newsletter,* reprinted with permission; "The Armed Vision Disarmed: Radical Formalism from Weapon to Style" was originally published in *Afterimage* 10, no. 6 (January 1983); "Playing in the Fields of the Image" was originally published in *Afterimage* 10, nos. 1/2 (Summer 1982); "Photography after Art Photography" was originally published in *Art after Modernism: Rethinking Representation,* edited by Brian Wallis. Copyright © 1984 by The New Museum of Contemporary Art, reprinted by permission of David R. Godine, Publisher; "Living with Contradictions: Critical Practices in the Age of Supply-Side Aesthetics" was originally published in *Screen* 28, no. 3 (Summer 1987); "A Photographer in Jerusalem, 1855: Auguste Salzmann and His Times" was originally published in *October* 18 (Fall 1981) by MIT Press; "Who is Speaking Thus? Problems of Documentary Practice" was originally published in *The Event Horizon: Essays on Hope, Sexuality, Social Space, and Media(tion),* edited by Lorne Falk and Barbara Fischer (Toronto: Coach House Press, 1987); "Reconstructing Documentary: Connie Hatch's Representational Resistance" was originally published in *Camera Obscura* 13-14 (Fall 1985), reprinted by permission of The Johns Hopkins University Press; "Just Like A Woman" was originally published in the exhibition catalog *Francesca Woodman: Photographic Work,* Wellesley College Museum and Hunter College Art Gallery, 1986, and is reprinted courtesy of the Wellesley College Museum; "Sexual Difference: Both Sides of the Camera" was originally published in the *C.E.P.A. Quarterly* (Spring 1987), reprinted with permission from C.E.P.A. Gallery, Buffalo, New York.

Published by the University of Minnesota Press
2037 University Avenue Southeast
Minneapolis, MN 55414

Printed in the United States of America on acid-free paper

Library of Congress Cataloging-in-Publication Data

Solomon-Godeau, Abigail.
 Photography at the dock / Abigail Solomon-Godeau.
 p. cm. — (Media & society)
 Includes index.
 ISBN 0-8166-1913-1 ISBN 0-8166-1971-9 (pbk.)
 1. Photography, Artistic. I. Title. II. Series.
TR642.S65 1991
770—dc20 90-38571
 CIP

The University of Minnesota is an
equal-opportunity educator and employer.

Contents

CONTENTS

Illustrations

ix

Foreword

Linda Nochlin

Nothing, perhaps, is harder to write about intelligently than photography. This is true for several reasons, some of which have to do with the equivocal status of the photographic object itself and some of which are related to the unstated assumptions controlling the discursive fields of photographic history and criticism.

In the first place, there is the temptation to accept photography as a transparent representation of things as they are, uncontaminated by any sort of mediation. On the most naïve level, photographs have been used and continue to be used to prove the existence of certain facts or situations: photographs of broken pavement or unsafe railings provide evidence in damage suits in courts of law; photographs have demonstrated the insalubriousness of the living conditions of the poor or marginal—most memorably in the work of Jacob Riis, but also in that of many others before and since; photographs of atrocities or the damage of war, of disease or of torture have always assumed the status of scientific evidence in support of the contentions of those who use them. Such photographs are known as "documentary" and have had a privileged epistemological status. This is true despite the fact that such "documentary" photographs are known to have often been doctored or falsified—the pastiche photographs of supposed Communard atrocities are an early example—precisely to provide the support of apparently eyewitness veracity for assertions otherwise substantiated by far less convincing verbal testimony. ("Seeing is believing" or "a picture is worth a thousand words" are the saws associated with the higher level of veracity accorded to the visual than to the verbal document.) Many of the apparently factual photographs of miners or sharecroppers taken by F.S.A. photographers during the Depression were in fact posed; certainly a great deal depended on the photographer's point of view, the length of the exposure, the lighting, the cropping of the shot, etc. This does not mean, of course, that all photographs are falsifications or that the events or situations that they purport to record never took place; it merely suggests that some are and that it is hard to tell the difference. In other words, it seems reasonable to assume that photographs have a more problematic relationship to the reality they purport to "capture" than the other visual media, and that the critical strategies of, say, painting or printmaking simply won't do for photography.

The second temptation for the photographic critic or historian is roughly the opposite of the first. That is, to assign photography a more or less aesthetic position on the map of

criticism and to consider the work or works in question from the standpoint of purely formal criteria (composition, value, relationship to other similar photographic works, authorship, influences—and above all, originality) almost entirely apart from any issues of documentary fidelity. Here, one might say, attention moves almost imperceptibly from consideration of the photograph as a unique work of art to the hypostasization of the photographer as a unique creative genius, a move accompanied, with an equal appearance of inevitability, from the photographic archive to the photographic *oeuvre*. For as Abigail Solomon-Godeau consistently demonstrates in her essays, once the photograph is accepted as a unique work of art and the photographer as a creative artist with an interesting biography, a whole army of discursive practices and institutions springs into being: academic courses in art history departments; photography galleries and departments in museums; a supportive critical network; collectors and collections; catalog raisonnés; expertise; specialized journals, etc. Photographs are often ripped out of their original historical contexts—often quite humble and utilitarian ones at that—and inserted into new, more elevated and certainly more apolitical, aesthetic ones. The works of Atget, of August Sander, and the anonymous photographers recording the events of the Commune are a case in point. Once considered elements of an archival record or a sociohistorical survey or document, prints by these photographers, taken out of their original contexts and displayed as individual "creations" on the walls of the gallery, assume that aura of aesthetic power and uniqueness and, of course, that luster lent by "value"—aesthetic and economic at once—associated in our society with High Art.[1]

In the case of photographs self-consciously produced from the beginning as works of art rather than mere "records" or documentation, it is the uniqueness, the originality, and above all the high quality of the works in question that are the subjects of critical interest and, at times, controversy. What is rarely raised is the crucial question of how photography functions as an object of aesthetic discourse—and in the service of what interests. And, of course, one may ask just how "aesthetic" the objects of the photographer's art actually are, just as we may question how transparent, objective, and veracious "documentary" photographs are. In the instance of the female nude, for example, a favored object of photographic aesthetic delectation, the female viewer may feel something other than a purely aesthetic reaction when confronted with a woman's buttocks positioned as still life—formal simile for a pepper or a peach—no matter how "original" the shot, how astute the pose, how sensitive the lighting of the print in question.

Solomon-Godeau, as an extremely sophisticated and self-aware historian and critic of photography, avoids the temptation to deal with the photograph as either document or work of art. Indeed, she focuses for the most part not on photographs themselves but on the discourse of photography as it has been constructed during the recent past. In other words, the main thrust of her work designates itself as a sort of metacriticism, a critique of criticism as it is practiced today, and an investigation of the ideological underpinnings of photographic discourse since its inception. At the same time, her work may also be con-

sidered from the vantage point of cultural history insofar as it constitutes a critical investigation of the institutions and practices that came into being to validate and categorize the photographic object for an ever-growing public of consumers from the mid-nineteenth century to the present. Each essay addresses itself to some specific issue or problem raised within the critical discourse: the essay on the calotype to the aesthetization of a particular technique; that devoted to Atget, to the issue of authorship and the creation of canons.

However, it is the fourth section of these essays, "Photography and Sexual Difference," which seems to me to constitute Solomon-Godeau's most important contribution to the cultural critique of photography. The decisive shift constituted by the feminist analysis of visual representation, indeed of representation in general, is central to her project throughout these essays. The author's investigation of the problematic nature of gendered representation is, of course, tightly bound to her earlier critique of cultural practices generally and of photography criticism in particular. But, to borrow her own words: "Feminist theory and analysis . . . is not a supplementary activity appended to an existing critical apparatus, but, on the contrary, an epistemological shift that involves nothing less than a restructuration, a reconstitution of knowledge. . . . Through the lens of feminist analysis, as it were, the disciplinary object 'photography' is altogether remapped, refigured, and revised" (p. xxx). In the critical space opened up by feminism and its "epistemological shift," both the aesthetic and the documentary modes and the discourse supporting them are, of course, called into question, their basis in ideology revealed. At the same time, the vantage point of feminist theory makes it apparent why Solomon-Godeau finds it imperative to problematize the role of gender within a discussion of photography and photographers generally, and not merely in a special section dedicated to the topic of sexuality: to include, for instance, a discussion of the important role of Berenice Abbott in the construction of the authorial authority of Atget; indeed, the passages on Abbott in the Atget piece are the best, most penetrating analyses of her work and position as a photographic practitioner ever written—the only ones I know that take Abbott's sexuality into account as a factor in her activity, both photographic and curatorial.

It is in the three final essays in the collection, "Reconsidering Erotic Photography: Notes for a Project of Historical Salvage," "Just Like a Woman," and "Sexual Difference: Both Sides of the Camera," as well as in "Reconstructing Documentary: Connie Hatch's Representational Resistance" (an essay dealing with the work of a single woman photographer at the same time as it grapples with the very vexing issue of documentary photography itself, and acting as a bridge between the first part of the collection and the final section devoted explicitly to the issue of sexual difference) that Solomon-Godeau makes her most telling contribution to the critique of photography and photographic discourse. In the piece on erotic photography, for instance, she engages head-on with the problematic position of the woman *viewer* of the erotic—almost inevitably female—photographic object. Indeed, her ability to critique standard arguments for and against the erotic photograph, or erotic representation more generally, is premised on the marginality and ex-

ternality of that position. For Solomon-Godeau, the erotic or pornographic photo must at once be reinserted in its historical frame of reference and at the same time positioned within the more general problematic of the discursive construction of "woman" as a set of meanings with a quasi-autonomous life of its own ("Reconsidering," p. 222). "Just Like a Woman" illuminates the remarkable production of a short-lived and previously almost unknown woman photographer, Francesca Woodman. Rather than merely praising the work in question, Solomon-Godeau contextualizes and analyzes it under three main rubrics which constitute a mapping of the role of sexual difference in Woodman's photographic project: the photographer's staging of herself as her own model, as active producer and passive model, the constant insistence in Woodman's work on the woman's body as both sight (spectacle) and site (of meaning), and the photographer's unerring grasp of the operations of fetishism, which she performs, with ambiguous implications, on her own body ("Just Like a Woman," pp. 240–57).

In the final essay in the "Sexual Difference" section, "Sexual Difference: Both Sides of the Camera" (in its original form the catalog essay for an important traveling exhibition ending its tour at the Wallace Gallery at Columbia University in March 1988), Solomon-Godeau justifies, in no uncertain terms, her choice to reject a formal or stylistic rationale in the selection of the photographic images in question, as well as her attempt to avoid privileging a single form of critical approach—and, at the same time, to skirt the pitfalls of an unreflective pluralism. "Ideally," she writes, "I would have liked it [the exhibition] to be thought of as a series of questions posed to the spectator that would then be echoed in subsequent encounters with photographic imagery" ("Sexual Difference," p. 258).

This intention, of course, characterizes Solomon-Godeau's entire project in *Photography at the Dock*. Rather than offering ironclad answers to simple-minded questions, she adds to our sense of the difficulty and ambiguity of many of the questions directed at the photographic enterprise itself. At the same time, she consistently refuses the mystifying and, on the whole, patriarchal and sexist interpretations or answers to these questions offered by most mainstream photographic history and criticism, insisting on the historical, class-located, institutionalized, and, above all, gendered positions from which such discourse originates and which it functions to sustain. There is an end in view in such a project: an end both ethical and political. Abigail Solomon-Godeau speaks best for herself about this when she asserts: "To the extent that photography has been a particularly effective master's tool [she is referring to a passage by Audre Lorde in this instance], it is incumbent upon feminist art practice to try to use it in different—critical—ways. As a feminist and a critic . . . I would less wish to assert a dubious authority than to affirm a collective solidarity with the project of claiming the camera for more humanly satisfying ends" ("Sexual Difference," p. 283).

Acknowledgments

· ·

The various forms of indebtedness that anyone incurs in producing a book are frequently anterior to its conception. Had Rosalind Krauss not acquainted me with the extraordinary photographic holdings of the Bibliothèque Nationale in 1978, and generously shared her knowledge of them, it is unlikely I would ever have worked on nineteenth-century French photography at all. I am no less indebted to Linda Nochlin, who has in every way exemplified feminist scholarship in the visual arts; her unstinting moral and intellectual support has been equally crucial. Without the constant encouragement and good counsel of Tania Modleski and Constance Penley I would certainly not have had the temerity to group these essays together as a book. In this respect, I must also thank Rick Bolton, editor of the Media and Society series, for setting the project in motion. I am also deeply grateful to Judith Aminoff, Honor Lassalle, and Kathleen MacQueen, all of whom provided crucial help at crucial junctures. The friendship of Rosalyn Deutsche, Jan Zita Grover, Eva Hoffmann, Marilyn Miller, LeAnne Schreiber, and Deborah Tiernan sustained me during the years these essays were written. Last, but hardly least, the countless ways in which Fred and Sharon Stein have provided assistance enabled me to bring this book to completion.

A Note on the Essays

The title of this book, *Photography at the Dock*, was originally the title of an essay written for the catalog that accompanied the exhibition "The Art of Memory/The Loss of History" (The New Museum of Contemporary Art, November 1985) curated by the late William Olander. That essay is not reprinted in this volume, but a few paragraphs from it were carried over into the Introduction. Although the temptation was great to alter a number of the essays to better reflect my current perspectives and knowledge, or to profit from subsequent scholarship by other writers, it became clear that such a revision could not stop at half measures. Consequently, the essays have received only very minor adjustments and have been left pretty much as they originally appeared. The exceptions are "Photography after Art Photography," which received a partial graft from an essay entitled "Winning the Game When the Rules Have Been Changed," and "Playing in the Fields of the Image." In the former instance, the addition was made to include a highly abbreviated account of the formation of late nineteenth- and early twentieth-century art photography discourse—a historically significant tributary to art photography that would not otherwise have been mentioned. Similarly, a short discussion of the work of Richard Prince, also from the "Winning the Game" essay, was appended to "Playing in the Fields of the Image." Since Prince's work is referred to in a number of the essays, but addressed in none of them, it seemed useful to include a more extended reference. In some cases where relevant and important books or articles have appeared since these essays were published, I have added them to the notes but placed them within brackets. Similarly, where books containing cited articles have subsequently appeared, they too have been added to the original footnotes enclosed in brackets. In deciding to let the other essays stand as they were, my hope is that whatever their shortcomings or lacunae, they can, at the very least, function as a chronicle of photographic discourse of the 1980s.

Introduction

. .

"The events surrounding the historian and in which he takes part," wrote Walter Benjamin, "will underlie his presentation like a text written in invisible ink." The seven years (1981–1988) during which these essays were written were those in which the political and cultural ascent of the Right provided a grim counterpoint to the phenomenon once designated—with greater or lesser ironic inflection—the "photography boom." Although the term was initially coined to characterize the burgeoning market for photography (both old and new), its implications were considerably broader. These included such developments as the incorporation of photographic history and criticism into the academic discipline of art history, the heightened prestige of photography within the art museum, and the unmistakable centrality of photography within postmodernist art production. Somewhat more marginally, but undoubtedly a side-effect of photography's new prominence, critics and theorists on both sides of the Atlantic turned their attention to a medium whose very ubiquity may well have fostered its invisibility as an object of study.[1] These developments, and my attempts to situate them within their wider cultural and political context, provide the substance of many of these essays.

But by beginning the introduction with the quotation from Walter Benjamin, I wanted to frame them with his reminder that the language, terms, mode of investigation or interpretation in which any cultural object can be considered, are inescapably tied to the larger web of historical circumstance in which object and commentator alike have been formed and are equally moored. The necessity, therefore, of affirming at the outset the indivisibility of cultural discourse from its historical and political wellsprings is twofold. First, it serves as a reminder that there is no neutral ground, no ground outside history, no position of mastery, authority, expertise, or knowledge that detaches the historian or critic from a *parti pris*, acknowledged or not. Second, it helps to account for an element of urgency, even a tone of embattlement, that can be glimpsed in some of these essays, written on the cusp of supply-side aesthetics and mounting political reaction. But it is the former point that requires some emphasis because cultural fields—especially those pertaining to the visual arts—are institutionally and conceptually organized around the conviction that there is a discrete entity called the aesthetic and a discrete entity called the political, and that they occupy categorically distinct, and indeed antithetical realms. Thus, within the

conceptual framework subscribed to by, say, the average museum curator or newspaper art critic, Hans Haacke is recognizable as a "political" artist, but David Salle is not.

That all of cultural history (including that of art) reveals precisely the contrary—that is to say, the dense interweave of the social, the political, and the economic with the cultural in the production and reception of aesthetic artifacts—attests only to the continuing power of this mythology. It is important, therefore, to recognize that the insistence on the autonomy of the aesthetic realm performs a certain function within bourgeois ideology; among other things, it enables cultural institutions and cultural arbiters to present their histories as seamless, disinterested, and authoritative, and their hierarchies of value as universally valid, ecumenical, and effectively consensual.[2] The insistence that they are none of these things is the common denominator of all oppositional cultural criticism, whether derived from Marxism, poststructuralism, or, perhaps most profoundly, from feminism.[3]

Looked at in one way, it is possible to say that photography enters this discursive system as a late arrival; but it is also possible to argue that photography lay like a ripening seed, a secret sharer, within aesthetic discourse for the past century and a half. In either case, the historical moment in which photography came to be more or less fully integrated into the precincts of high art culture occurred under the sign of an ascendant right-wing politics and an exploding, volatile, and insatiable art market. This, in turn, had certain effects on which kinds of photography would be privileged and, more important, in what terms. However, for this to have happened at all, photography had to be defined in ways that permitted it to be assimilated within the museological/art-historical model of aesthetic autonomy, the model that, for shorthand, could be termed formalist modernism. There is reason to marvel at this ontological sleight-of-hand, flying as it does in the face of both reason and reality. For if any type of image-making logically appears to resist such treatment, it would seem to be photography which, as Philippe Burty observed in 1859, "covers the whole world with its products." Furthermore, a formalist modernist position is one in which subject matter, supposing it to exist at all, is usually deemed nominal, whereas photography is root and branch bound to subject matter. Be that as it may, the *sine qua non* of photography's repositioning lay in its division, from the very outset, along one axis—supposed to consist of subjectivity, art, and beauty (the axis of the icon)—and another axis—composed of science, truth, objectivity, and technology (the axis of the index).[4] Even a cursory examination of a library card catalog file under the rubric "photography" is sufficient to communicate the information that photography, consistent with the mentality of the Cartesian civilization that invented it, has been effectively bisected into technological body and aesthetic soul. Thus, on the one hand, the how-to manuals, the histories of the technology; on the other, the monographic studies of artist/photographers, coffee-table books, portfolio editions, museum catalogs. The billion-dollar multinational business devoted to amateur photography is in this regard particularly fascinating, insofar as its invention, investment in, and promotion of new technologies are typically merchandised in a language of either sentimental affect (family

memories) or individual creativity (hobbyist as art photographer). *Histories* of photography may fall in one or the other camp or uncomfortably straddle the two; generally speaking, the mid-nineteenth-century histories were primarily technological in emphasis, the mid-to-late twentieth-century ones more concerned to construct an art history of the medium; that is to say, an art history *with* names.

In so doing, such histories functioned to bolster a process that ultimately consolidated photographic history and criticism together under the sign of the aesthetic. In other words, the way in which photography has come to be constituted as a discrete object of study (e.g., something that one can get a degree in, something that one can specialize in within an art museum, something that one can address exclusively as a critic) has itself determined the parameters of inquiry. And, as I have argued throughout these essays, these parameters are ideological boundaries that serve to define, limit, and contain the kinds of questions that can be asked about this field called "photography." This epistemological straitjacket is paralleled in the act of sophisticated connoisseurship, where the analysis of a photograph will always stop short at the framing edge.

Thus, when John Szarkowski ingenuously confides to an art magazine that he's "been looking at some time-motion studies made . . . by a guy named Gilbreth," and when he enthuses, "They're fantastic, and as revolutionary as anything that was happening then in photography," he is repressing the manifestly unaesthetic fact that Frank and *Lillian* Gilbreth's "revolutionary" pictures were commissioned and used by management against labor.[5] (Significantly, Lillian Gilbreth who fully collaborated with her husband, Frank, has been banished from Szarkowski's account.) Eventually, workers who failed to produce according to the ideal rhythms established by the Gilbreths' scientific, rationalized, and objective photographic model were at risk, if not sacked. It is unlikely that anyone who has ever worked on an assembly line would find the Gilbreths' photographs either fantastic or revolutionary, but then people who work on assembly lines are not necessarily wedded to a formalist model of photographic aesthetics.

But while the omissions of official photographic criticism and history comprise one aspect of the problem, we need also to reckon with its productive dimension, since, as Michel Foucault ceaselessly demonstrated, discourses of knowledge and power are never merely repressive; rather, and more crucially, they are actively productive. Consequently, the disciplinary object "photography," fabricated under the aegis of the aesthetic, predictably functions to generate a succession of artists, styles, *oeuvres*, traditions, even masterpieces.[6] It produces, at one and the same time, an object of study, an object of delectation, and an object of consumption.

Nevertheless, there are other ways to think about photography, other ways to study it, and other ways to construct its history. There is, to be sure, an impressive, if not copious body of writing on photography beginning in the 1930s with Walter Benjamin and Giselle Freund, and continuing in the postwar period with Roland Barthes, Pierre Bourdieu, and, somewhat indirectly, Guy Debord. Within contemporary criticism, the fre-

quency of my citations of Victor Burgin, Douglas Crimp, Rosalind Krauss, Allan Sekula, Martha Rosler, and Christopher Phillips speaks for itself, and this is but a partial list. Needless to say, this constitutes a very different constellation from one composed of, say, Alfred Stieglitz, Edward Weston, Beaumont Newhall, and John Szarkowski.

To a considerable extent, my own attitudes toward photographic practice and history were shaped by my ten-year experience as a free-lance picture editor. Within this other professional domain—the domain of educational textbooks, filmstrips, magazines, and so forth—the idea of photographic autonomy, had anyone ventured to propose it, would have seemed scarcely credible. In this particular branch of the consciousness industry, the function of all photographs, whether taken by Henri Cartier-Bresson or John Doe, is to illustrate, amplify, or anchor an existing text. Picture editors do not have to read Roland Barthes to learn of the mutability of photographic meaning since they can (and do) make the same photographs serve in entirely different contexts merely by appending the appropriate caption to them. But far more significant than the lessons I learned about the malleability of photographic meaning was the demonstration that photographs are routinely used to confirm the truth of dominant ideologies. These are, of course, themselves subject to modification and retooling. But the point to be stressed is that whether a social-science textbook reproduces photographs of women as mothers and homemakers, or as crane operators and nuclear scientists, whether blacks are wholly absent or marginally present, depicted as underclass or as bourgeoisie, the photograph is, before all and after all, a building block in a larger structure. Obviously, no more efficient laboratory for the revelation of these mechanisms can be found than the textbook industry, a propaganda machine of impressive size, dazzling cynicism, and incalculable effect. But the "obviousness" of the textbook's means and ends should not deceive us into thinking that those of the *New York Times* are any different. Considerations of graphic design and marketing notwithstanding, both textbooks and newspapers use photographs to guarantee the truth of their texts (and vice versa). Like all mass media, photography is routinely made—or employed—to affirm, confirm, and promote the interests, the beliefs, the social and sexual relations of the class that possesses it. And as a corollary (for how, indeed, could it be otherwise?), I would submit that the history of photography is not the history of remarkable men, much less a succession of remarkable pictures, but the history of photographic uses.

With such attitudes about the medium, I entered the field of photographic criticism at what now appears to have been the crest of the photography boom. Part I of this book—"The Politics of Aestheticism"—represents some of the results of this dissenting encounter. As the section title indicates, the overarching theme concerns the ways in which the institutional formation of a photographic aesthetic (and the histories it engenders) masks a politics no less active and instrumental for being entirely disavowed. In one sense, the politics of photographic aestheticism is manifest in the activity of selection: what practices and practitioners are made visible, which ones are banished or ignored. In another, more profound sense, the politics of aestheticism is the expression of an ideology of cultural

production which is premised on an idealism that is at best naïve and at worst mendacious. This is an ideology that proclaims the autonomy of the aesthetic, the primacy of the individual artist, and the noncontingency of cultural production. This photographic aesthetic, jointly promoted by the museum, the academy, and the marketplace, is principally derived from that version of Anglo-American formalism exemplified by Clement Greenberg's schematic model for the development of modernist painting and sculpture. In its photographic incarnation, however, the contraction of inquiry to the limited terrain of formalist aesthetics and a senescent and academic modernism obscures vast mystifications. In some instances these mystifications are specific to photography (for example, the perennial disavowal of photography as a mechanical image-making system by art photography lobbyists; the efforts to transform—conceptually as well as literally—a technology of multiples into one of "originals"). But considered overall, the processes by which photography's protean, plural, and overwhelmingly instrumental uses are occulted, and the ways in which the myriad contexts of production and reception are alike ignored, mimic comparable developments that have occurred over much longer timespans in both literary and art history. Generally speaking, I am concerned with the various ways this newly minted disciplinary object "photography" is transformed from discourse value into commodity value and the related phenomena that contribute to the formation of a quasi-official, fully institutionalized, and wholly academicized aesthetics. This complex network of determinations, interests, and desires is perhaps most comprehensively addressed in the essay "Canon Fodder: Authoring Eugène Atget," but these are issues that appear and reappear throughout the book, forming its very armature. While "Canon Fodder" is intended as a single detailed case history in photographic canon formation, "The Armed Vision Disarmed: Radical Formalism from Weapon to Style" and "Calotypomania: The Gourmet Guide to Nineteenth-Century Photography" range over wider areas and have somewhat different emphases. "The Armed Vision," for example, contrasts the model of formalist modernism promoted in American art photography with the very different brand of photographic formalism represented by Alexander Rodchenko.[7] It traces the processes whereby cultural practices conceived quite deliberately as anti-idealist, materialist, and socially engaged can be reprocessed, so to speak, to yield eventually their virtual antitheses. But the essay is equally concerned with the manufacture of specious traditions within photography history and the concomitant denial of its ruptures and discontinuities. And while "Calotypomania" is also concerned with the dynamics of photographic history, it places greater stress on the complicity—or accommodation—of an aesthetically oriented scholarship with forces of commodification.

The reader will doubtless notice that reference to and criticism of the activities of the Museum of Modern Art's Photography Department and its enormously powerful director, John Szarkowski, constitute a refrain—a veritable leitmotif—in the essays. To the degree that the museum and its photography director represent the single most influential source of photographic legitimation in America, and that this legitimation is rooted in

profoundly conservative values, a continuing and critical interrogation of their activities must inevitably be a component of an oppositional photography criticism. But the prominence accorded this particular institution and its director, despite the vast influence of both, should not be construed as a conspiracy theory of how one set of photographers, or one model of photographic aesthetics is hegemonically imposed on the rest of us. On the contrary, it is the manifest bankruptcy of the version of formalist modernism espoused and promoted by MoMA that has enabled the kinds of analyses these essays represent, as well as creatively fueling other art practices and other conceptual frameworks. In this respect, one could propose that the moribund corpus of modernism has acted as a compost for other practices, other claims, other artistic aspirations.

A particularly telling example of the failure of modernist law is provided by the career of Cindy Sherman. Here is the case of an artist who, despite the fact that she has employed photography exclusively in her work for more than a decade, is not considered to be a "photographer" by keepers of the art photography flame. This has obviously in no way diminished her significance, her prestige, or her career. As one might expect, Sherman is an artist who emerged not from the precincts of art photography (among other things, an overwhelmingly male preserve), but from the relatively more ecumenical ambit of the art world. In this contextual sense, Sherman's relative exteriority to mainstream photographic discourse is entirely overdetermined. A daunting range of artists who have used photography—from Marcel Duchamp through Andy Warhol, John Baldessari, Hilla and Bernd Becher, Dan Graham, Barbara Kruger, Richard Prince, and Louise Lawler—to cite a mere handful, are equally invisible from the aesthetic heights of art photography. In this regard, Sherman's designation as a postmodernist artist rather than as a photographer says a great deal about how these two cultural fiefdoms have come to define themselves. Accordingly, the essays assembled in the second part of this book—"Photography and Postmodernism"—are concerned to map out the implications of the conceptual antagonism between art photography and (certain) postmodernist practices.

At the outset, and as is evident from the essay "Playing in the Fields of the Image" (1982), my advocacy of the work made by a number of postmodernist artists had partly to do with what their work appeared to signify vis-à-vis the ethos and institutions, the values and ideology of art photography. At the time, the emergence of such practices seemed to signal the collective staking of an adversary position in relation to modernist values across the board. To take just a single and initially notorious example, Sherrie Levine's deadpan appropriations of canonized masters and masterpieces functioned to deftly subvert the entire apparatus of art photographic legitimation (an apparatus concerned to secure the conceptual and/or material status of vintage prints, aura, originals, originality, author/fathers, authorization and property, and so forth). By re-presenting such icons of photographic modernism as Edward Weston's nude studies of his son Neil as her own, Levine could be seen as a kind of Duchampian feminist, conferring, as Duchamp said of "Fountain," "a new thought for the object." In this instance, the new thought—provoked by Levine's

modus operandi—encompassed issues of fetishism, reification, sexism, and commodification, issues whose implications were in no way limited to photographic production per se. Given that such postmodernist photographic work was appearing in the wake of auctions that had established record prices for vintage photography, accompanied by an aesthetic discourse that had reached truly delirious proportions (e.g., *Connoisseur* magazine's full-page color photographs of atomic-bomb explosions entitled "A Garden of Earthly Delights"), there was ample reason to interpret work such as Levine's as an alternative, disruptive, and critical cultural practice. In other words, from the perspective of the early 1980s, the formulation of an oppositional postmodernism (the term is Hal Foster's) by artists *and* critics seemed part and parcel of a two-pronged assault on the orthodoxies of late modernism: one concerned to dismantle it, the other deployed to produce other knowledges, counter-practices, "anti-aesthetics," critical practices.[8]

But in the same way that the debates around the contested meanings of postmodernism became themselves academicized (theoretical production being no less immune to forces of commodification—hence neutralization—than any other), so too did critical practices earlier perceived as transgressive and disruptive become relatively quickly digested within the high cultural maw, either because the practices themselves underwent adjustment and accommodation, or merely because yesterday's transgression frequently becomes tomorrow's tradition. The rise of what might be termed Baudrillardism, a complacently dystopic cultural analysis little different in effect from fatalistic acceptance of the status quo, can arguably be viewed as the terminus of a critical postmodernism. These deeply disturbing aspects of postmodernism's trajectory, examined in relation to its photographic manifestations and attendant criticism (including my own), constitute the substance of the last essay in the section, "Living with Contradictions: Critical Practices in the Age of Supply-Side Aesthetics."

Nevertheless, the critical articulation of postmodernism in the visual arts, and the renewed (and integrally related) analysis of what Guy Debord called the "society of the spectacle," continues to surge against the verities (and pieties) of the photographic redoubt. A particularly interesting instance of this conflictual process occurs around the issue of documentary.

To begin with, it goes without saying that the category "documentary"—unstable, untheorized, and dubious a category as it may be—occupies a prominent place within photographic discourse. In its conventional usages, it is taken to refer to a genre of picture-taking that is factual, but is, nonetheless, often presumed to be animated by some kind of exhortative, ameliorative, or, at the very least, humanistic impulse. Generally speaking it is assigned to the indexical, i.e., objective, end of the spectrum rather than the iconic, expressive end. These are, it must be said, relative positions, not absolute ones; police scene-of-the-crime photos are usually not referred to as documentary photographs, but Eugene Smith's stylized and highly rhetorical ones are. In the 1930s, the historical moment in which documentary genres were most privileged, documentary was even allowed

to be factual *and* overtly propagandistic. However, as I argue in Part III—"Rethinking Documentary"—the ability even to formulate the notion of a documentary mode is predicated on the perceived presence of its Other(s). Which is to say that without the coexistence of alternative models of photography (either expressive and subjective, as in art photography, or manifestly fabricated, as in advertising) the very notion of documentary becomes tautological. This immediately foregrounds the question of documentary's discursive construction: how is documentary *thought* and what ideological work is it performing?

It is, therefore, not surprising that the central term in the collision of postmodernist theory and photographic discourse pivots on photography's equivocal status *in* and *as* representation. From a postmodernist perspective, despite photography's liens to the real which secure its evidentiary and juridical status, the photograph ultimately functions as an image, as a representation. As such, it is as highly mediated and as densely coded as any other kind of picture. Superficially, such an argument might seem similar to those claims for the camera's transformatory, subjective, and essentially pictorial capacities tirelessly advanced from the heart of art photography. There are, nonetheless, significant differences. First and foremost, a photographic formalist modernism needs to have it both ways; the privileging of so-called straight photography (no manipulation of the negative or print, no cutting and pasting, no invented tableaux, no supplemental texts) mandates a photographic aesthetic that celebrates the camera's transcriptive capacities—Szarkowski's "the thing itself." This is the photographic equivalent of modernism's truth to materials and has been a staple of photographic modernism from Alfred Stieglitz, Paul Strand, Edward Weston, continuing with Lewis Mumford, Siegfried Kracauer, and so on and on. But on the other hand, for photography to be art at all, it needs to be redolent of the artist's unique and exceptional subjectivity, his individual (I use the pronoun advisedly) and idiosyncratic *vision*. Hence, the meaning of a title such as Szarkowski's homage to Garry Winogrand—*Figments from the Real World*, which attempts to render unto Caesar what is presumed to be his (the Real World), and unto God, the more elevated substance (Figments [of the imagination]).

From the perspective of what I am here loosely referring to as postmodernist, or, for that matter, poststructuralist theory, the notion of "the thing itself" is already somewhat suspect. For what gets effaced, if not outright denied, in these kinds of formulations is the acknowledgment of mediations: material, historical, social, psychological, *and* ideological. "The thing itself" is never just out there in the world waiting to be framed by the photographer's Leica; rather, it is something dynamically produced in the act of representation and reception and already subject to the grids of meaning imposed upon it by culture, history, language, and so forth. Victor Burgin's reading of several of Winogrand's misogynist *and* racist pictures gives the lie to the ingenuous celebration of the "purely visual" while simultaneously demonstrating the photographer's and viewer's complicity in producing those meanings.[9] Now, of course, Winogrand is not considered to be a docu-

modus operandi—encompassed issues of fetishism, reification, sexism, and commodification, issues whose implications were in no way limited to photographic production per se. Given that such postmodernist photographic work was appearing in the wake of auctions that had established record prices for vintage photography, accompanied by an aesthetic discourse that had reached truly delirious proportions (e.g., *Connoisseur* magazine's full-page color photographs of atomic-bomb explosions entitled "A Garden of Earthly Delights"), there was ample reason to interpret work such as Levine's as an alternative, disruptive, and critical cultural practice. In other words, from the perspective of the early 1980s, the formulation of an oppositional postmodernism (the term is Hal Foster's) by artists *and* critics seemed part and parcel of a two-pronged assault on the orthodoxies of late modernism: one concerned to dismantle it, the other deployed to produce other knowledges, counter-practices, "anti-aesthetics," critical practices.[8]

But in the same way that the debates around the contested meanings of postmodernism became themselves academicized (theoretical production being no less immune to forces of commodification—hence neutralization—than any other), so too did critical practices earlier perceived as transgressive and disruptive become relatively quickly digested within the high cultural maw, either because the practices themselves underwent adjustment and accommodation, or merely because yesterday's transgression frequently becomes tomorrow's tradition. The rise of what might be termed Baudrillardism, a complacently dystopic cultural analysis little different in effect from fatalistic acceptance of the status quo, can arguably be viewed as the terminus of a critical postmodernism. These deeply disturbing aspects of postmodernism's trajectory, examined in relation to its photographic manifestations and attendant criticism (including my own), constitute the substance of the last essay in the section, "Living with Contradictions: Critical Practices in the Age of Supply-Side Aesthetics."

Nevertheless, the critical articulation of postmodernism in the visual arts, and the renewed (and integrally related) analysis of what Guy Debord called the "society of the spectacle," continues to surge against the verities (and pieties) of the photographic redoubt. A particularly interesting instance of this conflictual process occurs around the issue of documentary.

To begin with, it goes without saying that the category "documentary"—unstable, untheorized, and dubious a category as it may be—occupies a prominent place within photographic discourse. In its conventional usages, it is taken to refer to a genre of picture-taking that is factual, but is, nonetheless, often presumed to be animated by some kind of exhortative, ameliorative, or, at the very least, humanistic impulse. Generally speaking it is assigned to the indexical, i.e., objective, end of the spectrum rather than the iconic, expressive end. These are, it must be said, relative positions, not absolute ones; police scene-of-the-crime photos are usually not referred to as documentary photographs, but Eugene Smith's stylized and highly rhetorical ones are. In the 1930s, the historical moment in which documentary genres were most privileged, documentary was even allowed

to be factual *and* overtly propagandistic. However, as I argue in Part III—"Rethinking Documentary"—the ability even to formulate the notion of a documentary mode is predicated on the perceived presence of its Other(s). Which is to say that without the coexistence of alternative models of photography (either expressive and subjective, as in art photography, or manifestly fabricated, as in advertising) the very notion of documentary becomes tautological. This immediately foregrounds the question of documentary's discursive construction: how is documentary *thought* and what ideological work is it performing?

It is, therefore, not surprising that the central term in the collision of postmodernist theory and photographic discourse pivots on photography's equivocal status *in* and *as* representation. From a postmodernist perspective, despite photography's liens to the real which secure its evidentiary and juridical status, the photograph ultimately functions as an image, as a representation. As such, it is as highly mediated and as densely coded as any other kind of picture. Superficially, such an argument might seem similar to those claims for the camera's transformatory, subjective, and essentially pictorial capacities tirelessly advanced from the heart of art photography. There are, nonetheless, significant differences. First and foremost, a photographic formalist modernism needs to have it both ways; the privileging of so-called straight photography (no manipulation of the negative or print, no cutting and pasting, no invented tableaux, no supplemental texts) mandates a photographic aesthetic that celebrates the camera's transcriptive capacities—Szarkowski's "the thing itself." This is the photographic equivalent of modernism's truth to materials and has been a staple of photographic modernism from Alfred Stieglitz, Paul Strand, Edward Weston, continuing with Lewis Mumford, Siegfried Kracauer, and so on and on. But on the other hand, for photography to be art at all, it needs to be redolent of the artist's unique and exceptional subjectivity, his individual (I use the pronoun advisedly) and idiosyncratic *vision*. Hence, the meaning of a title such as Szarkowski's homage to Garry Winogrand—*Figments from the Real World*, which attempts to render unto Caesar what is presumed to be his (the Real World), and unto God, the more elevated substance (Figments [of the imagination]).

From the perspective of what I am here loosely referring to as postmodernist, or, for that matter, poststructuralist theory, the notion of "the thing itself" is already somewhat suspect. For what gets effaced, if not outright denied, in these kinds of formulations is the acknowledgment of mediations: material, historical, social, psychological, *and* ideological. "The thing itself" is never just out there in the world waiting to be framed by the photographer's Leica; rather, it is something dynamically produced in the act of representation and reception and already subject to the grids of meaning imposed upon it by culture, history, language, and so forth. Victor Burgin's reading of several of Winogrand's misogynist *and* racist pictures gives the lie to the ingenuous celebration of the "purely visual" while simultaneously demonstrating the photographer's and viewer's complicity in producing those meanings.[9] Now, of course, Winogrand is not considered to be a docu-

mentary photographer, but if documentary (as opposed to the politically inflected label *social* documentary, a euphemism for liberal, or even socialist motivation) is articulated around the notion of fact, or the real, or truth, why is he not? Clearly, the concept of documentary is a kind of fault line within conventional photographic thought and, for that reason, all the more useful to explore.

However, in the most political sense, the postmodernist and poststructuralist challenge to traditional notions of documentary lies in their joint insistence on the determinations (and overdeterminations) of photographic instrumentalities and contexts, which woven together constitute the problematics and the politics of representation. In this respect, the issue of photography's "truth status" is bracketed altogether. For the postmodernist artist or critic, photographic pictures can never be isolated, free-floating entities offering windowlike views on the reality outside. On the contrary, photographic pictures are understood to participate in the construction of social reality, and unless specifically manufactured to do otherwise (as in critical art practices) photographs can only function affirmatively. Furthermore, because photographic pictures are always encountered in specific viewing situations — reproduced in magazines or newspapers, even hung on gallery and museum walls as celebrations of the art of documentary — viewing relations are inseparable from contextual determinations, and viewing relations are themselves traversed by the lived experience of class, race, gender, and nationality.

The three essays assembled in the section "Rethinking Documentary" reflect on different aspects of these themes. "A Photographer in Jerusalem" is principally concerned with some of the instrumentalities of what would now be referred to as documentary photography — in this instance, the use of the camera, almost from its inception, as a tool of imperial expansion, domination, and appropriation. At the same time it seeks to raise, if not answer, the question of documentary definition. The question, however, is posed here within the terms of the aestheticizing process that wants to turn Auguste Salzmann (but not his collaborator, Durheim) and his single body of work into a modernist artist with a modernist *oeuvre* and concomitantly efface the history that produced both Salzmann and his work.

"Who Is Speaking Thus?," on the other hand, is intended as a general overview of the critiques that have been developed of traditional documentary practices and the assumptions that underpin them. These range from the structural analysis of the apparatus and the subject/object relations it entails — a body of theory generated from within film studies — to the trenchant examination of traditional documentary modes pioneered by critics such as Martha Rosler, Allan Sekula, and Sally Stein. Implicit in the former, and explicitly discussed in the latter, is the assertion of a hierarchical set of relations between photographer, spectator, and subject. In historical terms, and within the framework of traditional documentary, the photographer (irrespective of individual politics) possesses the means of representation because he or she (usually he) is a member, an agent, or even the representative of a more powerful, wealthy, and industrialized culture for whom the subject is inevitably

the Other, and, needless to say, the lesser. For the spectator, the viewing experience constructed both phenomenologically and culturally creates a position of mastery, of scopic command, sustaining the authority of the viewer's look which is further buttressed by more or less unconscious sensations of mastery and possession. Contemporary documentarians endlessly reproduce these representational politics, buoyed by the pious conviction that color photographs of Bombay prostitutes, platinum prints of the sick and elderly dying in a hospice, and now—perhaps most egregiously—gruesomely artful portraits of people with AIDS (invariably referred to as "AIDS victims") are somehow to be understood as an enlightened, heuristic, and progressive practice.[10]

However, it is in the last of the section's essays—"Reconstructing Documentary: Connie Hatch's Representational Resistance"—that the implications of sexual difference are brought to bear on both the problematics of documentary practice and the larger purview of photographic representation itself. For once it is acknowledged that the photographer *and* the viewer of his or her images are gendered, the conventional opposition between photographic pictures that are transcriptive, objective, or impartial and those that are mediated, fabricated, or obviously instrumentalized, collapse altogether. Such a recognition further serves to put in question the concept of "documentary" as a discrete category, implicitly negating as it does any claims to a universalized, objective reading of an image. Moreover, because Hatch's work has encompassed documentary projects that operated more or less within the traditional parameters of the genre (*Form Follows Finance*) and moved in directions that entirely eclipsed them, consideration of her work illuminates with striking clarity the intersections between the structural analysis of the apparatus derived from film theory, the Left critique of documentary (inaugurated by Bertolt Brecht and Walter Benjamin in the 1930s) and the epistemological radicalism of feminist theory which informed—gave form to—Hatch's work. The discussion of Hatch's work, therefore, serves as a bridge, both formally and conceptually, to the fourth and final section of the book, "Photography and Sexual Difference."

In thus designating the final section of the book, I intended not only to reflect the chronological shift of emphasis in my writing, but equally to signal my conviction that feminist criticism and cultural production provide an overarching frame of reference which itself encompasses many of the arguments developed in the earlier essays. Further, the imperatives of a feminist analysis compel consideration of photographic practices in *all* their manifestations, effecting a necessary breakdown of the modernist boundary lines that have for so long hamstrung photographic debate. These boundaries are not only those erected and maintained to hierarchically segregate high and mass culture (a boundary long since breached by pop art and postmodernism), but consist as well in various discursive and professional distinctions drawn within photographic practice—advertising, editorial, journalistic, art, and so forth. Through the lens of feminist analysis, as it were, the disciplinary object "photography" is altogether remapped, refigured, and revised.

This is because feminist theory and analysis, of whatever stripe, is not a supplementary

activity appended to an existing critical apparatus, but, on the contrary, an epistemological shift that involves nothing less than a restructuration, a reconstitution of knowledge. Such a shift entails, as Teresa de Lauretis has described it, "a new way of thinking about culture, language, art, experience, and knowledge itself that, in redefining the nature and boundaries of the political, at once addresses women as social subject and en-genders the subject as political."[11] Consequently, it has been one of the principal insights of feminism to reveal that that which presents itself (whether in the guise of knowledge or value) as the disembodied voice of reason, of truth, of the universal, is in fact always partial, in both senses of the term. For example, the Benjamin quotation, in spite of its resonance in framing these essays, operates simultaneously to deny the possibility that the writer invoking it is a woman and that it is her text that historical events may be seen to underlie.

We do well, therefore, to consider the ramifications of a statement such as Hilton Kramer's "no ideology has proved to be more destructive to aesthetic standards in photography than that of the radical feminist movement."[12] However formulaic or bombastic such fulminations may be, however great the temptation to roll one's eyes and wish it were so, the authoritarianism manifest in presuming "aesthetic standards" to be a juridically fixed and uncontested monolith betokens other forms of authoritarianism as well. The feminism that Kramer excoriates as the source of photographic decline is, of course, very far from being the monolithic, much less hegemonic, ideology that Kramer imagines it to be. Feminism *and* its theories are very obviously international, plural, multivocal, and divided. Kramer's version is the recognizable bogeywoman of male fantasy—woman on top, the world upside down.[13] As such, it displaces its own desire to suppress difference and maintain dominance onto a feminism of its own fearful imagining. In the final analysis, Kramer's aesthetic saber rattling is no different in its politics and assumptions from former Education Secretary William Bennett's assault on bilingual education or his belief in the self-evident supremacy of white, Western, male culture. Whose culture and whose aesthetics are threatened by the tiger at the gates?

The three essays assembled in the closing section collectively reflect on the possibility of other aesthetics, other histories, other kinds of questions to be asked. They are predicated on the belief that photography has been—and remains—an especially potent purveyor (and producer) of sexual ideology and, as such, is directly implicated in psychic and social mechanisms of domination, objectification, and fetishization. In the light of such a recognition it is a crucial aspect of a feminist project to recuperate for analysis those photographic practices dismissively categorized as "marginal" and consequently banished from photographic histories. It is the thesis of "Reconsidering Erotic Photography" that the *cordon sanitaire* discursively maintained between licit and illicit imagery, between the aesthetic and the salacious, is both provisional and permeable. More pointedly, it disputes the assumption that there is a clear and self-evident distinction to be drawn between acceptable and unacceptable images of women, or of their bodies. The conviction that there exists such a clear distinction, endorsed by groups on a spectrum from far Right to far

Left, as well as by feminist anti-pornography activists, precludes the possibility that *all* images of women, from the most idealizing to the most degrading, operate to produce and reproduce the category "woman," a category that is itself a function of patriarchy and, therefore, hardly a mirror of nature.[14]

While "Reconsidering Erotic Photography" is concerned with imagery which can be assumed to have been made by men for the use of men, the essay on Francesca Woodman's work takes as its central theme the difficulty—conceptual and psychical—of self-representation for women. Such an enterprise prompts considerations that are as much strategic as analytic: namely, how can women, historically constituted as objects of the camera's gaze (among other gazes of control and domination) accede to the status of subject? How is the woman, object of desire, enabled to conscript the same apparatuses deployed to construct her as spectacle and fetish in order to speak—or to image—her own desire? Woodman's work thus confronts feminist photography criticism with the visual equivalent of the dilemma confronted by women writers and poets, a dilemma based on the recognition that language is itself indelibly marked by the patriarchal order which en-genders it as a function of the symbolic order.

Modern feminist theory exhaustively explores the ramifications of this paradox; women artists, poets, and writers have made of it the very subject of their work. Masquerade and mimicry, deconstruction and pastiche, irony and mockery, *écriture féminine* and essentialist assertion—all are strategies or positions adopted in an attempt to challenge, disrupt, or subvert a patriarchically (hence, differentially) defined femininity, or, alternatively, to try and excavate its hitherto repressed and authentic lineaments.

In Woodman's work, these conundrums of self-representation are both articulated and enacted through a troubled combat with aesthetic conventions (e.g., the nude, the self-portrait). It is work that wrestles with photographic conventions as well, of which the camera's production of reifying subject/object relations and the structural congruence of the spectator's and the photographer's point of view are perhaps the most important. Occupying simultaneously the typically separate (and typically gendered) positions of subject and object, of artist and model, Woodman's photographs tend to denaturalize the conventions they appropriate through formal tactics of excess, shock, defilement. But in contrast to surrealist photographic practices which share an obsession with the female body as volatile site of both desire and dread, Woodman's pictures carry an accusative charge. In effect, her pictures function to moot the aesthetic alibi with which the artistic image of the female body is normally supplied. Such an alibi, constituted by those formal devices which encode flesh as form, operates to assuage the anxiety that the look at the woman's body may unconsciously provoke. Defying such conventions, Woodman withholds the alibi, heightens and attenuates the anxiety, and insists that the viewer acknowledge the representational status of the female body as fetish. While making no claims for Woodman's body of work as a feminist project, I would, nonetheless, affirm its significance for an understanding of the supreme difficulty, and the daunting pitfalls, in feminine self-

representation, most especially when it is enacted in the register of the visual.[15] My interpretation of this discomfiting work thus hinges on its ability to make conceptually and materially visible the agency of photography in the production of a fetishized femininity, and the exorbitant price of that femininity for those who are trapped within it.

These central thematics in Woodman's work are no less prominent in the work of the artists and photographers discussed in "Sexual Difference: Both Sides of the Camera." This, the final essay in the book, began as a lecture and became an exhibition, which, in turn, prompted the writing of the catalog essay. Both the exhibition and the essay reflected a two-part organization consisting of one group of images that were intended to set out certain of the problems relevant to the interplay of sexuality, subjectivity, vision, and the camera image, and a much larger grouping of works that were intended to indicate the range of analyses and formal devices employed by contemporary photographers as they have negotiated such issues. In attempting to map out at least some of the nodal points in the confluence of photography and the cultural and psychic construction of sexual difference, it was necessary to use film theory as the exhibition's conceptual armature and to try to adapt it to the specificity of the photographic image, a project pioneered by Victor Burgin.

In bringing together a group of artists as ostensibly disparate as Louise Lawler and Jo Spence, Sarah Charlesworth and Diane Neumaier, Cindy Sherman and Martha Rosler, Richard Prince and Connie Hatch (there were seventeen artists in all) my intention was not to produce a specious unity — stylistic or political — in the name of a mythically unified set of feminist art practices, but, on the contrary, to illustrate the plurality, complexity, and diversity of photographic work that confronts the camera critically as an apparatus productive of, among other things, desire, consumption, and ideologies of gender. That some of these artists are identified with a now fashionable postmodernism, and others with the distinctly less upscale camp of "political" photography, seemed entirely consistent with the tenets of feminist critical theories, as well, incidentally, of postmodernist theories.

Common to virtually all the work exhibited and discussed beneath the rubric of *Critical Interventions*, and no less present as a thematic in the work of Woodman, is the centrality of the issue of photographic *agency*. Photography is in this sense understood as a conduit between social and psychic spaces whose messages are absorbed subliminally as well as perceived consciously. To be sure, this is how all representation — and, by extension, all culture — operates, interpellating subjects sometimes directly (YOUR COUNTRY WANTS YOU), sometimes in the mere act of naming; that is to say, epistemologically ("it's a girl"), and sometimes in ways that escape perception altogether. This suggests the importance of a critical investigation of photographic agency in the domain of subject formation, an investigation whose stakes are particularly high for feminism.

Recognition of the manifest forms in which the agency of representation constructs, rather than reflects, reality constitutes one of the basic precepts of contemporary critical

thinking. And what informs all modern approaches to the politics of photographic representation is not a Platonic protest at the dissimulative nature of photography (the camera lies), but the far more disturbing apprehension of the power of mechanically or electronically generated images to render ideology innocent, to naturalize domination, to displace history and memory. It is within the broadest and most encompassing terms of this quintessentially postmodern analysis that photography can be said to be brought to the dock, *in media res*, and subjected to a rigorous and far-reaching interrogation.

Such an investigation can in no way limit itself to the production, circulation, and reception of photomechanical imagery as though these were not themselves part of larger formations. In this respect, Guy Debord's chilling analysis of spectacular society, whatever its shortcomings, is especially significant for its insistence on the integrated nature of the spectacle, meshing as it does the mechanisms and dynamics of capitalism with the lures and blandishments of what Benjamin called the *Bildraum*—the image space of modern life. Hence for Debord, photography in the world of late capitalism cannot be other than a medium constitutive of reification, mystification, and abstraction: harnessed to social control and consumerism, photography both feeds the spectacle and is the spectacle; history and memory, congealed as image, are not animated but annihilated. Within the totalizing regime of the commodity, the real relations of human beings to each other, the real relations of production (the division of labor and the fact of class domination) are each subsumed into a universal and unilateral system of spectacular representations whose spurious but seductive allure obscures brutal social and political realities. "The spectacle is *capital* to such a degree of accumulation that it becomes an image."[16] It is this condensation or collapse of social realities into image that parallels the fragmentation of consciousness and experience (both consequences of the fragmentation and alienation of modern life), and finds apt visual expression in the photographic image world. In the final analysis, photography, though we place it in the dock, is ever a hireling, ever the hired gun.

It is not, of course, only photography which is at the dock, it is also "photography"—the mandarin game preserve within the larger universe of camera-made imagery—which stands accused. And the aesthetic discourse of photography, its institutions, its canons, its histories, its values, its investments, and its exclusions are as much a part of the body politic, as much rooted in existing social and sexual relations, as photography without the quotes. But political struggles take vastly different forms, one of them being the struggle over meaning: who will control meaning, who will say (and name) what has been or what may yet be?[17] For this reason, the conflicts over the "naming" of "photography" (quotes after quotes, as befitting a technology of multiple and mechanical reproduction), the writing of its history, the drawing of its disciplinary boundaries are neither trivial nor academic. The naming of photography that thus far dominates is the product of museums, markets, and academies, and consequently bears their stamp. As the official history it is, unsurprisingly, officially (his) story. It must therefore be the task of the feminist photography critic to revise it.

PHOTOGRAPHY
AT
THE DOCK

MARCEL DUCHAMP, *FOUNTAIN*, 1917. COURTESY OF THE SIDNEY JANIS

GALLERY, NEW YORK.

I

THE POLITICS OF AESTHETICISM

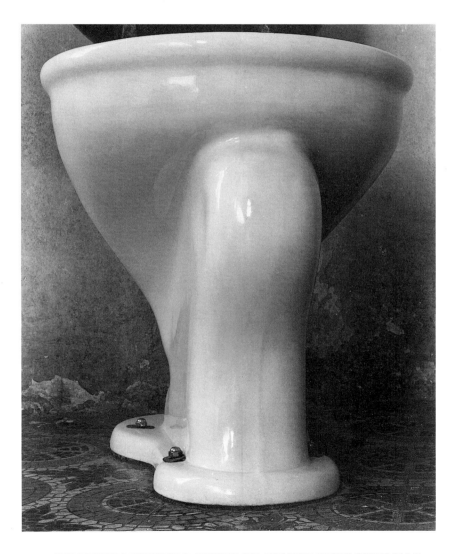

EDWARD WESTON, *EXCUSADO*, MEXICO 1925, GELATIN-SILVER PRINT, 24.1 ×
19.2 CM. © 1981 ARIZONA BOARD OF REGENTS. CENTER FOR CREATIVE
PHOTOGRAPHY.

1

Calotypomania: The Gourmet Guide to Nineteenth-Century Photography

ACCORDING TO TRADITIONAL PRACTICE, THE SPOILS ARE CARRIED ALONG IN

THE PROCESSION. THEY ARE CALLED CULTURAL TREASURES, AND A HISTORICAL

MATERIALIST VIEWS THEM WITH CAUTIOUS DETACHMENT. FOR WITHOUT EXCEPTION,

THE CULTURAL TREASURES HE SURVEYS HAVE AN ORIGIN WHICH HE CANNOT

CONTEMPLATE WITHOUT HORROR.

— WALTER BENJAMIN, "THESES ON THE PHILOSOPHY OF HISTORY"

The discipline of art history and its newest offshoot, the history of photography, differs from all other self-contained histories of cultural production (e.g., musicology, architectural history, literary studies, etc.) in that the object of study exists also as a commodity within a market system. Thus, the enterprise of scholarship—no matter how disinterested—is inevitably linked to a parallel world of dealers and collectors, investment and speculation. When, for example, art historians "rediscover" the neglected glories of American luminist painting, Bourbon restoration art, or Victorian anecdotal painting, a certain train of events is set off. Articles, monographs, and books appear; works in basement storage are brought upstairs; museum exhibitions are mounted; the art press duly reports upon the action; and the interests and activities of collector, dealer, and auctioneer are thereby provoked.

Art historians are generally thought to maintain a certain distance between themselves and the art market, but in actual practice, such a separation is by no means easy or even possible to maintain. It is considered perfectly acceptable, within certain ethical guidelines, for an art historian to make attributions for dealers, to write catalog essays for galleries or auction houses, to collect art works in his or her chosen field (even to deal privately), and to function as a consultant for collectors and corporations. But despite the murky line between the empyrean of disinterested scholarship and the vulgar precincts of commerce, the point is that a distinction does, in fact, exist. Indeed, the emergence of such practical distinctions historically signaled the passage of art history into the ranks of accredited, professionalized occupations, a movement echoed by its physical shift from the

space of the private library and collection to the space of the university and the museum. Insofar as the study of art (or photography) cannot, within the existing order of things, be wholly separate from the operations of the market, ethical and responsible practice requires at the very least an acknowledgment of these contradictions and some awareness of the contradictions they imply.[1] That photography historians seem to display an almost prelapsarian innocence in regard to such issues is integrally related to their failure to understand that the historical enterprise is enacted on and within ideological terrain. The implied belief that the photography history now being created is value-free (notwithstanding its affirmation of an ontologically construed photographic aesthetics) is somewhat remarkable, coming at a time when all but the most die-hard conservatives within academic art history are prepared to critically consider the values and agendas inscribed and promoted within their discipline.

The eighteenth-century roots of art history lie at the confluence of aesthetics, antiquarianism, and connoisseurship. Between the *cabinet* of the *antiquaire* and the modern university department of art history, we might locate a transitional stage in a figure such as Bernard Berenson. Impresario of the Italian Renaissance (most notably, the so-called primitives of the Florentine quattrocento), dealer, collector, and connoisseur, Berenson is linked, on the one hand, to the developing notion of *Kunstwissenschaft* derived from scholars such as Giovanni Morelli and, on the other, to the international art wheeling and dealing of Lord Joseph Duveen. To the extent that Berenson's art-historical and acquisitive enterprises overlapped, scholarship was occasionally—perhaps inevitably—compromised. When certain of Berenson's attributions were subsequently revised, they were almost always demotions. The extraordinary prestige and celebrity that Berenson enjoyed throughout his career (royalty, presidents, and movie stars all paid homage to him at his villa, *I Tatti*) bear witness to his charisma as much as to his professional renown. But by the time of Berenson's death in 1959, art history in America had been thoroughly altered. Bearing in mind that Berenson's art training at Harvard had consisted exclusively of Charles Eliot Norton's lectures on aesthetics, it is important to note that postwar art history represented an almost entirely different field.[2] Infusions of modernist critical theory, the influx of *emigré* art historians from Eastern and Western Europe, the new importance of social history and iconographic analysis—all these combined to shift art history away from a dominant emphasis on attribution, dating, and stylistic analysis. While these would remain staples of thesis mill grist, a new generation—exemplified by towering figures as dissimilar in temperament and method as Meyer Shapiro and Erwin Panofsky—approached the history of art in a way that stressed the cultural and religious meanings—specific to time and place—that made the work of art a site of signification, a field of constructed (and shifting) meaning. Moreover, in Europe an influential and powerful model of art history, exemplified by figures such as Max Dvořák, Friedrich Antal, and, more recently, Arnold Hauser, constituted an approach that took heed of the economic, political, and social determinations of art production. Of importance, too, is the fact that

by the 1930s, the art historian who did *not* function within a university framework was as singular an exception as one who had done so seventy-five years earlier. No longer a pursuit of cultivated and scholarly amateurs, but a thoroughly professionalized (and salaried) career, the enterprise of the art historian has increasingly come to differ from that of the connoisseur by both ends and means.

Although the etymological root of the word "connoisseur" is the same as that of the word "knowledge," we might say that the kinds of knowledge pursued by the connoisseur exist within the parameters of the aesthetic, while those of the modern art historian are increasingly concerned with the plural meanings of artworks within the larger purview of culture and history. I here intend no encomiums for the practice of academic art history as such; as a profoundly conservative discipline concerned, for the most part, with the artifacts of high culture, it is itself determined by larger discourses—both institutional and cultural. Moreover, its revisionist impulses come more frequently from the Right than from the Left. The brilliance of the work of a Panofsky, for example, more often than not ends up as a kind of routinized source-mongering; new methodologies and theoretical approaches (feminism and poststructuralism, for example) tend to enter art history rather later, if at all, than they do other disciplines and to meet greater resistance.

These somewhat general remarks on the history and practice of art history and my attempt to distinguish it broadly from connoisseurship are prompted by consideration of some of the more glaring contradictions and questionable practices that increasingly appear to characterize the writing, teaching, and presentation of photography history. Although several critics, myself included, have taken strong issue with the ongoing art historicization of photography,[3] a closer scrutiny of current approaches to the history of photography suggests that the particular kind of art-historical model most widely employed is, even within art history, fast becoming either discredited or simply obsolete.[4] In part, the tendency of photography history to ape an especially retrograde form of academic discourse may be attributable to the particular circumstances that propelled photography history into the museum and the university as a discrete discipline. Having sprung from antiquarian origins to university art departments within a relatively short period (fifteen years seems a reasonable estimate), the history of photography demonstrates at one and the same time the superficial trappings of modern art-historical scholarship and the fundamental character of nineteenth-century connoisseurship.

The recent surge of scholarly activities oriented to calotype production in France and Great Britain provides an ideal opportunity to examine closely the assumptions, methods, and consequences inherent in this approach. Between September 1982 and March 1983, there were no fewer than three major exhibitions: "The Era of the French Calotype" at the George Eastman House, curated by Janet E. Buerger; "Paper and Light: The Calotype in France and Great Britain, 1839–1870," curated by Richard Brettell, which opened at the Museum of Fine Arts, Houston, and then proceeded to inaugurate the new photography wing of the Art Institute of Chicago; and "Masterpieces of the French Calotype," at

GUSTAVE LE GRAY (1820-82), *ST. MICHEL D'AIGUILNE, LE PUY*, CA. 1860, ALBUMEN PRINT

FROM GLASS NEGATIVE. CABINET DES ESTAMPES, BIBLIOTHÈQUE

NATIONALE.

Princeton University Art Museum, jointly exhibited with the recently acquired Robert O. Dougan Collection of Historical Photographs and Photographic Literature. Additionally, an illustrated catalog of "The Era of the French Calotype" was published, and the "Paper and Light" exhibition engendered a text of the same title, containing three essays (by Nancy Keeler, Roy Flukinger, and one by Keeler, Brettell, and Sydney Kilgore) and an introduction by Brettell. In February of 1983, Princeton University Press brought out the sumptuously produced and pricey *The Art of French Calotype*, by André Jammes and Eugenia Parry Janis. Finally, both the Princeton and Houston exhibitions occasioned scholarly colloquiums and symposiums. This sepia wave (so to speak) represents the tangible results of a broad range of activities whose roots are in the 1970s—the point at which photography history came to be defined as an adjunct of art history to the exclusion of just about all other considerations.[5] But before attempting to examine the most recent fruits of this art history of photography, I would like to briefly consider the position of André Jammes within the unfolding spectacle of what I have termed in this essay "calotypomania"—a nominally historical approach to mid-nineteenth-century photography characterized by delirious boosterism and an almost *fin de siècle* aestheticism.

Although Berenson's name has been coupled with that of Helmut Gernsheim,[6] a far more apposite analogy exists between Berenson and André Jammes. Indeed, the emergence of the calotype as a more or less self-contained object of study is virtually inconceivable without the powerful influence (and above all, the collection) of Jammes himself. This is in itself not at all remarkable as a phenomenon in the historiography of photography: the Gernsheims' massive *History of Photography* derived from *their* collection and Beaumont Newhall's *History of Photography* derived from the Museum of Modern Art's.[7] The obvious problem with such practice, leaving aside for the present the issue of methodology, is that *any* history written on the basis of a personal collection will inescapably reflect its owner's partialities, prejudices, and omissions; histories drawn from a single institutional collection will reflect comparable inadequacies and bias. Just as Raymond Lécuyer's classic *Histoire de la photographie* is good for little other than French mid-nineteenth-century work, the Gernsheims—and to a lesser extent, Newhall—are cursory in their treatment of French production (the Gernsheims' collection was overwhelmingly British). Nineteenth-century German, Italian, or Spanish photography, for all intents and purposes, barely exists at all, if one is to judge by the standard histories.

What makes André Jammes such a singular figure, however, and what links him so strongly to Berenson, is that Jammes—unlike Eder, Poitonniée, Lécuyer, Newhall, Gernsheim, *et alia*—has specialized in a particular period, both in his collecting and writing, and has sought to understand and publicize it primarily in terms of connoisseurship. The privileged position that the "primitives" occupy in the thinking of both men, signifying a kind of golden age of production, is also notable.[8]

The collection of André Jammes is thirty-odd years old, having been begun after the end of the Second World War. Like his brother Paul, a dealer in old and rare books,

Jammes still operates out of the Librairie Paul Jammes in Paris's sixth arrondissement. Since the late 1950s, André Jammes has published monographs, articles, and books, as well as having had the distinction of writing the catalog introduction (his wife, Marie-Thérèse, wrote the catalog entries) for the first auction at which nineteenth-century photographs were offered as works of art rather than as objects of antiquarian interest.[9] Jammes has also translated Beaumont Newhall's *History of Photography* into French. Unlike the current major American collectors of nineteenth-century photographs, Jammes has never been content simply to amass material by the cartload and receive the assiduous attentions of curators and dealers.[10] He has been, instead, an energetic lobbying force for a certain *view* of Second Empire French photography, not only self-publishing monographs (e.g., *Charles Nègre, photographe, 1820–1880*, in 1963, and *Gustave Viaud, photographe de Tahiti 1858*, in 1965), but also organizing exhibitions from his collection and serving as an important lender to other exhibitions.

It is, however, in America that Jammes's influence has been most profound. The 1969 exhibition "French Primitive Photography," at the Philadelphia Museum of Art, jointly organized with Michael Hoffman (publisher of *Aperture*), and the accompanying catalog of the same title, which included essays by Minor White, Robert Sobieszek, and Jammes, were instrumental in introducing an entire generation of American art and photography historians to the work of early French photographers. In 1977 the exhibition "The First Century of Photography: Nièpce to Atget," drawn entirely from Jammes's collection, was presented at the Art Institute of Chicago, accompanied by an illustrated catalog. The Princeton Museum's recent exhibition, also selected largely from Jammes's collection, thus represents the third major American show drawn either exclusively or principally from Jammes's holdings, which, it is probably safe to say, represent the single most important collection of mid-nineteenth-century French and British photography in private hands. It is a collection, moreover, that has been constantly refined, structured, and enlarged, with an eye not only to quantity but to the task of demonstrating Jammes's thesis that early French (and to a much more limited extent, British) photography may be collectively subsumed within an aesthetic discourse formulated in terms of "master," "masterpiece," "*oeuvre*," "style," "school," and "influence." That this is the language of Berenson—of *Kunstwissenschaft*—is, of course, entirely in keeping with an art collector's enterprise. That it is photography rather than Old Master paintings, drawings, or prints being filed in these rather dusty pigeonholes is the only change.

I have, in general, no quarrel at all with André Jammes's activities, be they in his role as collector, curator, or even as propagandist for the aesthetics of "primitive" photography. He has rescued for posterity hundreds, if not thousands, of images that would otherwise have been lost; his commitment to exhibiting work from his collection amounts almost to a public service; and his monographs and other publications are invaluable sources of information. One can only hope that his immense collection eventually ends up in a French library or museum, for, needless to say, collections in private (or corporate)

hands (where most early photography not already in museums and libraries is progressively being concentrated)[11] are not readily available to researchers, much less to the general public.★

The problem arises with the extent and nature of Jammes's influence on photographic scholarship. This influence is, of course, a symptom rather than a cause of the recent ideological construction and ratification of photography-as-modernist-art. Here, for example, is a passage from David Travis's introduction to the exhibition catalog *The First Century of Photography: Nièpce to Atget* (Travis is curator of photography at the Art Institute of Chicago):

> If it takes but one genius to make any medium worth study, we might easily say that Atget's genius, Cameron's genius, Nadar's genius, or the genius of that obscure figure, Charles Szathmari, is enough. But to know one of those photographers is just a beginning. Further study will reveal that although photography's genius has favored several photographers, it made many small, but marvelous, visits along the way. Certainly, those visits are more numerous and scattered than we can know at this time.[12]

That the study of photography should be justified in terms of its recently designated "geniuses" is a notion of such profound absurdity that one is hard put to rebut it succinctly. Suffice it to say that within a mere twenty years after its invention, the French critic Philippe Burty remarked that "photography covers the whole world with its products." Visitations by photography's genius—here akin to a magical Fuller Brush man—are a fanciful notion having to do with the justification of photography's presence within the museum and the manifest need to invest this most ubiquitous of image-making systems with the attributes of rarity, individuality, and aura. Inasmuch as the museum must rationalize its acquisitions as well as its exhibitions, Travis's starry-eyed belief in the migratory muse of photography is, in a certain sense, the necessary belief system that goes with his job.

But while it is in no way surprising for museum curators to recite, mantralike, the familiar litany of genius, style, and *oeuvre*, it is quite another thing for art historians to join forces with collectors to corroborate and support an argument which derives principally from, and is taken to be proved by, the nature and contents of the collector's holdings. Thus, while *The Art of French Calotype*, by Jammes and the art historian Eugenia Parry Janis, can be said to represent the *summa* of Jammes's activities, it is less a work of scholarship than a pedantic work of public relations, an elaborate gloss on the patrician sensibility of Jammes and an upholstered exercise in photographic *gourmandise*.

★In the summer of 1984, the J. Paul Getty Museum purchased nineteen different photographic collections, including those of André Jammes, the late Sam Wagstaff, Arnold Crane, and Daniel Wolf. Wolf, himself a dealer in photography, helped to broker the sale for an undisclosed commission. An exact figure for the sale has never been released, but the purchase price is rumored to have been between ten and twenty million dollars.

Were *The Art of French Calotype* merely a bad or superficial book, it would barely merit extensive discussion; bad and superficial books are, for the most part, ephemera, and go away if left alone. *The Art of French Calotype*, however, with its university press imprimatur, influential supporters, and insidious legitimation of the relentless commodification of nineteenth-century photography, should not go unchallenged. As a collaboration between a major collector and an established art historian (and I know of no other such collaboration in modern art history), it demonstrates more clearly than anything else the forces that shape and determine the new history of photography.

The central thesis of *The Art of French Calotype* belongs, properly speaking, to Jammes. It has evolved gradually in his monographs and articles, was fully formed by the time of the exhibition and catalog "Die Kalotypie in Frankreich" (1966), and was succinctly restated in Jammes's essay "Alfred-Nicolas Normand et l'art du calotype." Briefly stated, the argument runs like this: although the calotype (a negative-positive photographic process using a paper negative and either printed out or developed out on various papers) was invented by Fox Talbot in England in the same year as Daguerre's process was made public in France (1839), its widest use and highest aesthetic achievement occurred in

LOUIS DE CLERCQ (1836-1901), *A FORTRESS ON THE WATER*, CA. 1855,

CALOTYPE, 21 × 28 CM. MUSÉE D'ORSAY. FROM *LE VOYAGE EN ORIENT,*

VILLES, MONUMENTS ET VUES PITTORESQUES: RECUEIL PHOTOGRAPHIQUE

EXECUTÉ PAR LOUIS DE CLERCQ, 1858-59. PREMIER ALBUM.

France. Because of the patent restrictions Talbot was able to impose in Britain, exploitation of the process there was relatively limited. In France, however, various technical refinements made by French photographers (e.g., Gustave Le Gray and Blanquart-Evrard) enabled the French courts to rule that the French calotypists were not employing Talbot's method. Hence, in France, the calotype enjoyed a high level of official patronage (for example, the 1851 Missions Héliographiques, various other governmental and imperial commissions) and was, in addition, regularly employed in expeditionary and touristic contexts *outre mer* (e.g., Du Camp, Salzmann, de Clercq, etc.). Most important (so the argument goes), the calotype constituted a particular and unified *aesthetic* of photography. Its principal practitioners are thus considered a breed apart from the entrepreneurs of the boulevards, be they the Nadars, the Disdèris, or the Mayers and Piersons. The softer, less detailed, putatively more "pictorial" attributes of the paper negative recommended it to artists and aesthetes. Overwhelmingly amateurs, the devotés of the calotype (whose reign Jammes places between 1850 and 1860) constituted a cross-section of Second Empire officialdom, savants, literati, experimenters, and dilettantes. Jammes unites them: "These 'happy few' who practiced photography on paper formed a homogeneous group whose structures are traced upon the artistic society of the time." ("Ces 'happy few' qui pratiquent la photographie sur papier forment un groupe homogène dont les structures se décalquent sur la société artistique du temps.")[13]

Using this skeleton framework as her point of departure, Janis has spent the past eight years inflating, buttressing, elaborating, and extending this hypothesis. *Grosso modo*, she is concerned to demonstrate that "the photographers electing to work with paper constituted a sort of early photographic school, sharing a collective visual ideology."[14] Marshaling the machinery of art-historical exegesis, Janis argues for a pictorial ancestry for French calotype production in (variously) the "*maniere noire*" of romantic lithography, the tradition of the picturesque, and the topographical, landscape, and architectural lithographs comprising Charles Nodier and Baron Taylor's twenty-volume *Voyages pittoresques et romantiques dans la France ancienne* (1820–78).[15] The putative aesthetics of the calotype are then harnessed to the creaky Wöfflinian axis of line versus form, or classic versus romantic; the "classical" represented in this configuration by wet collodion or albumen on glass, the "romantic" represented by the "painterly" medium of the calotype.[16]

Having thus established a stylistic pedigree in the graphic arts, Janis is concerned to link the calotypists to contemporary developments in the art of the Second Empire, to which end even the radical, politicized realism of Courbet is occasionally conscripted. Last, and by way of indicating her grasp of the *Zeitgeist* in which the calotypists lived and worked (particularly in that any serious consideration of the profound social upheavals, revolutions, and massive economic and industrial transformations of this period is virtually absent), Janis lards her text with references to Victor Hugo (the adjective "hugolian" appears with some frequency), even to the extent of dividing the two parts of the book's introductory essay into "The Shadows" and "The Light" in homage to Hugo's verse cycle

Were *The Art of French Calotype* merely a bad or superficial book, it would barely merit extensive discussion; bad and superficial books are, for the most part, ephemera, and go away if left alone. *The Art of French Calotype*, however, with its university press imprimatur, influential supporters, and insidious legitimation of the relentless commodification of nineteenth-century photography, should not go unchallenged. As a collaboration between a major collector and an established art historian (and I know of no other such collaboration in modern art history), it demonstrates more clearly than anything else the forces that shape and determine the new history of photography.

The central thesis of *The Art of French Calotype* belongs, properly speaking, to Jammes. It has evolved gradually in his monographs and articles, was fully formed by the time of the exhibition and catalog "Die Kalotypie in Frankreich" (1966), and was succinctly restated in Jammes's essay "Alfred-Nicolas Normand et l'art du calotype." Briefly stated, the argument runs like this: although the calotype (a negative-positive photographic process using a paper negative and either printed out or developed out on various papers) was invented by Fox Talbot in England in the same year as Daguerre's process was made public in France (1839), its widest use and highest aesthetic achievement occurred in

LOUIS DE CLERCQ (1836-1901), *A FORTRESS ON THE WATER,* CA. 1855,

CALOTYPE, 21 × 28 CM. MUSÉE D'ORSAY. FROM *LE VOYAGE EN ORIENT,*

VILLES, MONUMENTS ET VUES PITTORESQUES: RECUEIL PHOTOGRAPHIQUE

EXECUTÉ PAR LOUIS DE CLERCQ, 1858-59. PREMIER ALBUM.

France. Because of the patent restrictions Talbot was able to impose in Britain, exploitation of the process there was relatively limited. In France, however, various technical refinements made by French photographers (e.g., Gustave Le Gray and Blanquart-Evrard) enabled the French courts to rule that the French calotypists were not employing Talbot's method. Hence, in France, the calotype enjoyed a high level of official patronage (for example, the 1851 Missions Héliographiques, various other governmental and imperial commissions) and was, in addition, regularly employed in expeditionary and touristic contexts *outre mer* (e.g., Du Camp, Salzmann, de Clercq, etc.). Most important (so the argument goes), the calotype constituted a particular and unified *aesthetic* of photography. Its principal practitioners are thus considered a breed apart from the entrepreneurs of the boulevards, be they the Nadars, the Disdèris, or the Mayers and Piersons. The softer, less detailed, putatively more "pictorial" attributes of the paper negative recommended it to artists and aesthetes. Overwhelmingly amateurs, the devotés of the calotype (whose reign Jammes places between 1850 and 1860) constituted a cross-section of Second Empire officialdom, savants, literati, experimenters, and dilettantes. Jammes unites them: "These 'happy few' who practiced photography on paper formed a homogeneous group whose structures are traced upon the artistic society of the time." ("Ces 'happy few' qui pratiquent la photographie sur papier forment un groupe homogène dont les structures se décalquent sur la société artistique du temps.")[13]

Using this skeleton framework as her point of departure, Janis has spent the past eight years inflating, buttressing, elaborating, and extending this hypothesis. *Grosso modo*, she is concerned to demonstrate that "the photographers electing to work with paper constituted a sort of early photographic school, sharing a collective visual ideology."[14] Marshaling the machinery of art-historical exegesis, Janis argues for a pictorial ancestry for French calotype production in (variously) the "*maniere noire*" of romantic lithography, the tradition of the picturesque, and the topographical, landscape, and architectural lithographs comprising Charles Nodier and Baron Taylor's twenty-volume *Voyages pittoresques et romantiques dans la France ancienne* (1820–78).[15] The putative aesthetics of the calotype are then harnessed to the creaky Wöfflinian axis of line versus form, or classic versus romantic; the "classical" represented in this configuration by wet collodion or albumen on glass, the "romantic" represented by the "painterly" medium of the calotype.[16]

Having thus established a stylistic pedigree in the graphic arts, Janis is concerned to link the calotypists to contemporary developments in the art of the Second Empire, to which end even the radical, politicized realism of Courbet is occasionally conscripted. Last, and by way of indicating her grasp of the *Zeitgeist* in which the calotypists lived and worked (particularly in that any serious consideration of the profound social upheavals, revolutions, and massive economic and industrial transformations of this period is virtually absent), Janis lards her text with references to Victor Hugo (the adjective "hugolian" appears with some frequency), even to the extent of dividing the two parts of the book's introductory essay into "The Shadows" and "The Light" in homage to Hugo's verse cycle

Les rayons et les ombres.[17] Similarly, Flaubert's *L'Education sentimentale* does service for everything from establishing the relative cost of a calotype (as much as eight francs compared to a student breakfast of 43 sous, which is what Frédéric Moreau paid) to providing a description of a drive through Fontainebleau forest, which Janis quotes in discussing the stylistics of a particular calotype by Gustave Le Gray.

That Janis avails herself of literary sources is not the problem. But because she ignores or, worse, totally misunderstands the significance of the works she uses, they end up functioning as a kind of toney padding that supplements her nostalgia for the romantic "escapists and visionaries" she believes the calotypists to have been. For example, *L'Education sentimentale*, which acidly dissects the bankrupt second-generation romanticism of the Second Empire, is a novel which in every way contradicts the "Golden Age" notion that Jammes and Janis wish to impose on the era of the calotype.[18] Indeed, the hack painter Pellerin, who bounces from style to style and career to career in the course of Flaubert's novel, is probably a far more accurate depiction of a Second Empire photographer than the heroicized aesthetes that Janis claims to have found: "Pellerin, after dabbing in Fourierism, homeopathy, spiritualism, gothic art, and humanitarian painting, had become a photographer; and on all the walls of Paris there were pictures of him wearing a black coat, with a minute body and an enormous head."[19]

The unreflective use of Hugo and Flaubert is but a minor aspect of *The Art of French Calotype*. It is, however, wholly consistent with the larger failure of the book—a complete lack of any critical distance, analysis ("stylistics" and "aesthetics" notwithstanding), or historical contextualization. Having diligently read every issue of *La Lumière*, every work written on photography by contemporary critics such as Ernest Lacan or Francis Wey, having pored through the biographical dictionaries, and the *Bulletins* of the Société Française de Photographie, Janis is content to paraphrase, quote, or recapitulate these (for the most part) thoroughly formulaic adaptations of academic art theory to photography. While the collective agenda of these early lobbyists for the art of photography turns out to be an apt presentiment of current practices (just as the insistence on photographic subjectivity is the cornerstone of all art photography debate, whether of the Second Empire or the Photo-Secession), Janis flourishes these texts, reviews, treatises, etc., as proof of a highly developed aesthetic theory—not merely of photography, but of calotype photography. Thus, Gustave Le Gray's "*théorie des sacrifices*," of which Janis makes much, is proffered as evidence of an elaborately developed photographic aesthetic, when in fact its main tenet—the subordination of extraneous detail to overall pictorial effect—is a staple of academic art theory going back at least to the *Discourses* of Sir Joshua Reynolds. As such, it would have been entirely familiar to an academic painter like Le Gray (or Charles Nègre, Henri Le Secq, or Roger Fenton, all of whom emerged from the studio of Paul Delaroche).[20]

The fundamental claim of *The Art of French Calotype*—and indeed, "Paper and Light", the Chicago and Princeton exhibitions, and the substance of most of the associated

colloquium — is the assertion that there does in fact exist such a thing as a calotype aesthetic. This is by no means as self-evident a proposition as its partisans seem to think it is. Although paragraphs, pages, chapters are consecrated to fulsome panegyrics on the calotype's formal properties (color, tonal range, chiaroscuro, etc.), there are as many factors that argue against as for such a notion.

First, and most obvious, the calotype was not a rigidly codified technology, but, on the contrary, encompassed a broad range of variation and individual experimentation in the preparation of the negative, the papers used, the chemistry, the development, and the printing. This is acknowledged by everyone and is commonly used to support the contention of "aesthetic choice" (what else?). To my way of thinking, however, the very fact of this flexibility and variety of effect raises some question about a unified aesthetic framework.[21] The characteristic grainy, soft, and shadowy quality of, for example, the Hill and Adamson portraits of the mid-1840s or Le Secq's still-lifes of 1856 bears little resemblance to the crisp detailed appearance of Edouard-Denis Baldus's *The Abbey and the Town of Saint-Antoine en Dauphiné* (made in 1851 under the aegis of the Missions Héliographiques). Talbot's process involved brushing the light-sensitive emulsion onto the surface of the paper negative, whereas Blanquart-Evrard discovered that floating the negative in solution yielded a more detailed, less fibrous image. Similarly, Le Gray's process, which involved waxing the negative before exposure, could be employed to produce either the relatively sharp focus effects of Baldus's *Saint-Antoine* or Alfred-Nicolas Normand's *An Aloe: Pompeii*, (1851), or to produce the softer, more tenebrous surface of much of Le Gray's own landscape photography. With the introduction of albumenized papers for printing (which provided a smooth, nonporous surface), a print from a finely textured wax paper negative was — and is — frequently indistinguishable from a print made from a wet collodion or albumen negative.[22] By the same token, several of Le Gray's hazy, almost ghostly studies of military maneuvers at the camp of Châlons (made on Imperial Commission in 1858) look very much like calotypes but are in fact made from collodion negatives. Furthermore, an albumen negative on glass was equally capable of rendering the sorts of effects Janis *et al.* consistently describe as the calotype's particular quality, as in Louis-Alphonse de Brébisson's *Study of a Forest Path* (ca. 1855).

In addition to the fact that the pictorial attributes of the calotype were by no means limited to the calotype itself, a further question is raised by the activities of the calotypists themselves. For the most part, those who were involved with photography professionally (the Bisson *Frères*, Charles Marville, Gustave Le Gray, Roger Fenton, Charles Nègre, Edouard-Denis Baldus, *et al.*) moved freely from paper negatives to wet-plate processes. Nor did it follow that paper negatives were employed for "art" and glass for utilitarian or commissioned work — Le Gray, for example, used wet collodion for his artistically intended seascapes, and Marville photographed works of art in the Louvre on paper negatives. Blanquart-Evrard's printing establishment at Loos-les-Lille produced individual prints, albums, and photographically illustrated books consisting exclusively of calotypes

ALFRED-NICOLAS NORMAND (1815-82), *AN ALOE: POMPEII*, 1851, CALOTYPE,

21.8 × 16 CM. CAISSE NATIONALE DES MONUMENTS HISTORIQUES ET DES SITES.

EDOUARD-DENIS BALDUS (1798-1872), *THE ABBEY AND THE TOWN OF SAINT-
ANTOINE EN DAUPHINÉ*, 1851, CALOTYPE, 26.3 × 36.2 CM. CAISSE NATIONALE
DES MONUMENTS HISTORIQUES ET DES SITES.

(but these works included reproductions of art works—*L'Art chrétien*, *Les Septs Sacrements de Poussin*, etc.), as well as the better known photographic volumes such as Salzmann's *Jerusalem* and Du Camp's *Egypte, Nubie, Palestine et Syrie*. Certainly photographers were aware of the specific formal qualities of paper photography, just as they were aware of its technical advantages in certain contexts (its greater portability compared to glass, the fact that it could be sensitized weeks before exposure, etc.), and its disadvantages (e.g., longer exposure time than wet collodion) in others. The paper negative may indeed have been the preferred and exclusive medium of certain amateur art photographers for purely formal reasons, but to rope into this category *every* photographer known or reputed to have employed the calotype and to claim that this indicates a "collective visual ideology" is nonsense. The visual ideology at work here is none other than the art historian's.[23]

We might do better to ask instead why these photographers—almost to a man (no women have been unearthed)—appear to have ceased production totally by the beginning

of the 1860s, if not before. Thumbing through the critical dictionary of photographers in the second part of *The Art of French Calotype* and comparing the death dates with the last known photographs made or the last contemporary photographic citation is, in this regard, quite striking. This rather provocative aspect of Second Empire calotype photography (to the extent that it is addressed at all) has been vaguely explained, by Jammes in his articles and by Janis in her book, as (variously) owing to the eventual technical hegemony of the wet-plate processes, the disappearance of the cultivated and discerning market the calotypists required, and a general decline in taste resulting from such profitable vulgarities as the *carte-de-visite* and other products of professionalized, entrepreneurial photography. This was, of course, Giselle Freund's thesis as early as 1936, in her dissertation *La photographie en France au dix-neuvième siècle*, and it says a great deal about the nature of photography scholarship to note that it has received no updating for the past fifty years.[24]

Perhaps one of the reasons that the disappearance of all these photographers from the field (and they did not just abandon the calotype — most of them abandoned photography altogether) has received relatively little attention is that it subtly undercuts so many assumptions of the aesthetic camp. As Rosalind Krauss has pointed out: "The concept *artist* implies more than the mere fact of authorship; it invokes as well the steps one must go through to earn the right to claim the condition of being an author, *artist* somehow grammatically being connected with the notion of vocation. . . . If this, or at least some part of it, is what is necessarily included in the term *artist*, could we then imagine someone who was an artist for just one year?"[25] To the photo aesthete, the true believer, the answer would, of course, be "Yes." (See, for example, Janis's dictionary entry on Maxime Du Camp.) Krauss goes on to question the appropriateness of other art-historical unities currently applied with such heady abandon, namely *career* and *oeuvre*. It is precisely on these rocks that the entire construction of a calotype aesthetics may be seen to founder. For if one wants to argue that the calotypists were able to march to their Apollonian drummer because they were a "happy few," free from the demands of commerce, free to choose, as it were, and armed with elaborate aesthetic theories as well, what does it say about their purported status as *auteurs* that most of them quit with twenty to forty years of life still before them?[26]

Judging from all the evidence, it is far more plausible to posit this ten- to fifteen-year flourishing of the calotype in terms of fad and fashion, rather than as a mythic golden age of artists of uniformly brief creative life spans. That much of the work they produced is of high quality is not all that mysterious: outright mistakes in photography are not generally conserved, and the factors that determined the survival of calotypes (institutional commission, use in books and folios, registry in the Dépôt Légale of the Bibliothèque Nationale, type and nature of the depicted subject, etc.) are themselves a historical enactment of a selection process. We should consider, too, that the general run of calotypist — educated, cultivated, and often with some art training — was such as to make the production of well-composed, pictorially sophisticated images a virtual given. (Have we not recently seen the

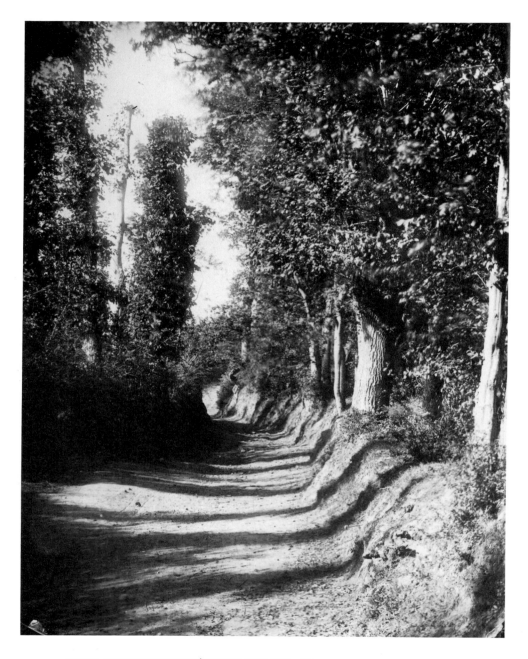

LOUIS-ALPHONSE DE BRÉBISSON (1798-1872), *STUDY OF A FOREST PATH*, CA.
1855, ALBUMEN ON GLASS NEGATIVE, 22.7 × 17.3 CM. CAISSE NATIONALE DES
MONUMENTS HISTORIQUES ET DES SITES.

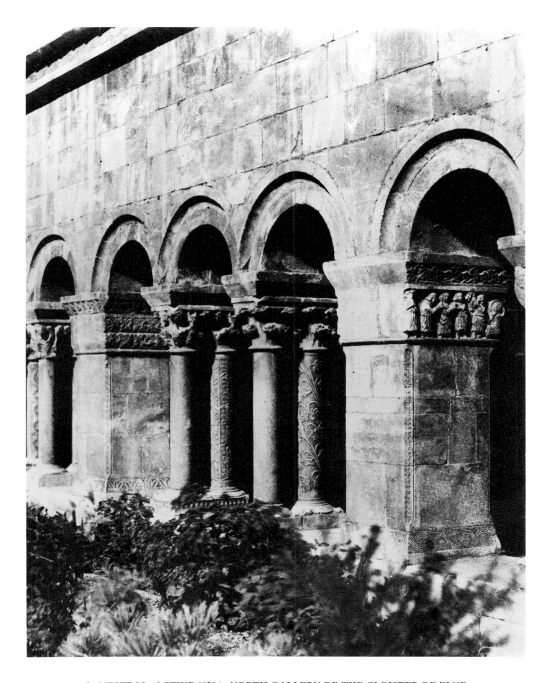

O. MESTRAL (ACTIVE 1850s), *NORTH GALLERY OF THE CLOISTER OF ELNE,*

1851, CALOTYPE, 34.2 × 25 CM. CAISSE NATIONALE DES MONUMENTS

HISTORIQUES ET DES SITES.

emergence of several art critics as *bona fide* art photographers?) In the same way that Second Empire gentlemen had elegant handwriting and a high level of literacy, so too did they possess a knowledge of Marcantonio and Titian (linear and painterly). The renunciations of photography by men such as Roger Fenton or Victor Régnault, as well as the silent departure from the scene of the others, suggests that they saw their patrician preserve in some way imperiled by the relentless increase in photographic practice. Or, looked at slightly differently, perhaps the assimilation of photography into every imaginable sphere of knowledge and discourse (so enthusiastically predicted and desired by men such as François Arago) came—even subliminally—to be perceived as a Frankenstein's monster? Whatever the reason for the collapse of this first period of the accomplished amateur, the point to be made is that during the heyday of the Société Française de Photographie or the Royal Photographic Society, photography was considered fashionable, trendy, and up-to-date. It was not the calotype technology as such but, rather, amateur photography itself which was the caviar of the few. What guaranteed the prestige of the photography produced by the gentlemen of the Société Française or the Royal Society was precisely its distance from commerce, from mass production, from contingency. This mandarin attitude was to become the prototype—the very mold—for the discourse of art photography thereafter. The insistence on amateurism as the *sine qua non* of photographic *art* recurs in the formation of the Linked Ring, the Photo-Secession, in the pronunciamentos of Alfred Stieglitz, in the canonization of the "noncommercial" color photography of William Eggleston. If a division of mid-century photography is to be made at all, it should clearly be made along the lines of users and uses, not by the labored invention of an imaginary aesthetics.

The collective enterprise of constructing an aesthetic history of the calotype involves a variety of strategies in addition to the imposition of conventional art-historical methodologies. Because the entire machinery of the art historicization of photography's history is predicated on an elaborate winnowing process (which of the thousands of extant images shall pass to the temple of Art?), the selection process effectively replaces an analytic process. As it happens, the art historians involved in this venture may be said to have had much of their work done for them, to the extent that the André Jammeses and, more recently, the Phyllis Lamberts[27] of this world have (so to speak) been there before. The Houston/Chicago "Paper and Light" exhibition is a case in point. In 1978 Richard Brettell was asked to organize an exhibition of British calotypes drawn from the photography collection of the Humanities Research Center at the University of Texas, Austin (a.k.a. the Gernsheim Collection). Working with a group of graduate students, Brettell initiated research and preparation for the exhibition, but expanded it in scope. When, in 1980, Brettell was offered a curatorial position at the Art Institute of Chicago, the exhibition was requested by David Travis, although now it was reconceived as encompassing "the calotype as such." As the exhibition was finally constituted, about 25 percent of it consisted of material from the collection of André Jammes, a somewhat smaller percentage of images

INSTALLATION VIEW OF THE EXHIBITION "PAPER AND LIGHT." COURTESY

OF THE MUSEUM OF FINE ARTS, HOUSTON.

from the collection of Phyllis Lambert, another quarter from the Humanities Research Center, and the remainder from the National Gallery (Ottawa), The Science Museum (London), as well as from a few miscellaneous private collections. Presumably, the extension of the exhibition was due both to the fact that French calotypes are nicer to look at and more numerous than British ones (Talbot, Annan, and Hill and Adamson notwithstanding) and also that the Gernsheims' collection was not equal to the aesthetic rigors of the new history of photography.

The *Art of French Calotype*, even more than the "Paper and Light" exhibition, bears witness to the fact that most current photographic scholarship seeks no higher calling than the ratification of the taste of collectors and dealers and—to say it one more time—conflates the activity of the connoisseur with that of the historian. Eight sources for the illustrations reproduced in *The Art of French Calotype* are given, all but three of them (Bibliothèque Nationale, Caisse Nationale des Monuments Historiques, and the Société Française de Photographie) consisting of the major collectors and dealers in France.[28] Directly underneath is a sentence that reads: "Works for which the location is not indicated are in private collections."

Inasmuch as the very first page of the book announces that it is "a collaboration be-

21

tween a French collector and an American art historian" and that "the actual writing of the book was carried out by E. P. Janis," we must ask why the fact that half the calotypes reproduced almost certainly come from Jammes's collection has been masked with the elision "private collections."[29] In fact, only a quarter of the book's reproductions derive from public collections, despite the fact that the Cabinet des Estampes of the Bibliothèque Nationale has a quite substantial collection. I cannot but wonder whether Princeton University Press, or the authors themselves, ever questioned the appearance, if not the propriety, of a supposedly scholarly book so intimately bound with the holdings of an individual collector.

Selection processes, like canons, function as much to exclude as to include, and it is clear that the aesthetics of the calotype being promulgated is ours, and not that of the nineteenth century. Absent from *The Art of French Calotype*, no less than from the various museum exhibitions, are examples of the kitschier modes of Second Empire art photography: soft-core odalisques, costumed tableaux, and the like. Thus, while the new aesthetic construction embraces photographs such as Jean-Charles Langlois's depictions of the dirt fortifications of the Crimean War as art ("Langlois does not indulge so much in the rich encrusted textures which the other photographers so often chose to fill their frames. The beauty of his work owes to its laconic compositions of forms starkly isolated in a dry, airless space"),[30] it dismisses certain unambiguously "artistic" images because they do not accord with current taste. While I, too, prefer Langlois's gritty *réportages* to J.-F. Moulin's camp extravaganzas, the point is that this particular aesthetic construction takes no account of the very real differences between the photographic discourse of the Second Empire and our own. Reproductions of works of art, for example, and various experiments in photomechanical reproduction, were routinely exhibited along with other photographs, and often discussed in similar language. Furthermore, the photographic commentaries of critics like Ernest Lacan are significant for their failure to qualitatively distinguish between that which, to contemporary eyes, appears as kitsch and those now considered to be photographic masterpieces. This is further evidence that early photographic critics were far more concerned to function as propagandists for the medium than to maintain—or even make—rigorous aesthetic distinctions.

In this regard, it is interesting to read an essay like Roy Flukinger's "The Calotype and the Photography Exhibition of the Society of Arts, London, 1852–53," one of the three essays in the text *Paper and Light*. Discussing the nature of the exhibition and its contributors, Flukinger seems sincerely baffled that there should be so many entries by obscure, unknown (to us), or, even worse, photographers such as Pecquerel (represented by sixty-one images) when those now viewed as Olympians were meagerly represented or not represented at all. Needless to say, had John Szarkowski been its curator, the exhibition would be far more comprehensible to us. Because the art history of photography hinges on modern preferences, it finds problems where none exist, and fails to see the problems that do.

The relentless pursuit of the aesthetic—at the expense of any other consideration of the uses, functions, and discourses of nineteenth-century photography—inevitably leads to distortion and error as well as to significant omission. Reading *The Art of French Calotype*'s dictionary entry on Auguste Salzmann, I was struck by the fact that his collaborator Durheim (who, Salzmann wrote in his text, stayed behind in Jerusalem and completed fifty of the prints in the ensemble) has been summarily dropped from the record. The happy few, it appears, become the happy fewer when *auteurisme* is at stake.

Aestheticism is an ideology, whatever fantasies art and photography historians may have about it. And surely one need not be a historical materialist to take issue with a view of French photographic activity in the Middle East that could have been written from the colonialist perspective of the 1850s: "Travel to Egypt kept the technical tradition [of the calotype] going long after its apogee elsewhere. Egypt's intense sunlight cajoled sluggish chemicals, and the ever-still and silent monuments seemed particularly impervious to the ravages of time. Compared to the radical changes affecting the face of Paris, the eternal calm in the shade of an all-seeing sphinx seemed to offer profound solace to the modern French traveler."[31]

Needless to say, the eternal calm of the sphinx was being disturbed not only by the processes of modernization and urbanization within Egypt itself, but also by the imperial ambitions, interests, and investments of England and France that were inseparable from, and indeed underwrote, the activities of those nations' photographers. In its refusal to deal with such issues—in its refusal to even acknowledge that such issues exist—*The Art of French Calotype*, academic pretensions notwithstanding, functions exclusively on the register of connoisseurship. Princeton University Press, however, has no reason to be proud of itself for passing off a gourmet guide as serious historical scholarship.

The world of art/photo historians being a small and clubby one—perhaps not unlike the Société Française de Photographie milieu of the mid-1850s—it is in no way surprising that symposiums such as those in Houston and Princeton are characterized by familial agreement on the salient points, with nary a dissident voice to be heard. Janet E. Buerger's somewhat more contextual approach to the calotype (as evidenced in her organization of "The Era of the Calotype" at the Eastman House) lent her modest and sensible presentation at the Houston symposium a decidedly radical tinge. Maria Morris Hambourg, then in the Photography Department of the Museum of Modern Art and involved in the continuing Atget cycle, delivered a paper entitled "The French Calotype and the Picturesque." Although she is an Atget scholar (and who would have believed twenty years ago that as a photography scholar one could specialize in the life and work of a single photographer?), her presence at this symposium, no less than her subject, might at least be partially accounted for by her having been a student of Eugenia Parry Janis. Her talk was essentially an elaboration of Janis's contention that "a paper negative in the camera intrinsically produced 'picturesqueness,' "[32] and a discussion of the *Voyages pittoresques* tradition as it presaged or paralleled photography. Janis herself gave a presentation of "The Photo-

MAXIM DU CAMP (1822-94), *THE SPHINX,* **1851, CALOTYPE, 15 × 21 CM. FROM**

EGYPTE, NUBIE, PALESTINE ET SYRIE: DESSINS PHOTOGRAPHIQUES

RECUEILLIS PENDANT LES ANNÉES 1849, 1850, 1851. **CABINET DES ESTAMPES,**

BIBLIOTHÈQUE NATIONALE.

graphic Idealism of Gustave Le Gray," in which she plumbed in depth the *théorie des sac-rifices* and other aspects of Le Gray's aesthetic. James Borcoman, curator at the National Gallery in Ottawa, presented a similar pictorial *effet* thesis,[33] and Richard Brettell made reference to the work of William Ivins in order to talk about the calotype as a print medium.[34]

The symposium at Princeton consisted of Eugenia Parry Janis, André Jammes, Robert Sobieszek, Roger Taylor, Marjorie Munsterburg (a former student of Janis's who has worked for the Lambert/CCA collection), Françoise Heilbrunn (*Conservatrice de Photographie* at the Musée d'Orsay, Paris, who, after having been appointed to the position, was sent to Princeton to study with Peter Bunnell, who organized the symposium),[35] and Joel Snyder. Suffice it to say that there were no surprises, other than the pleasant one of

Roger Taylor's discussion of the British topographic view between 1850 and 1880. Inasmuch as two million of these views were produced in the second half of the century in Britain alone, Taylor was relieved of all aesthetic burden and was free, instead, to discuss this massive industry in terms of its social history and its cultural functioning. After Taylor, things went into a predictable decline. Whether the nadir of the event was Robert Sobieszek's *aesthetic* reading of the physiognomic horror pictures of Dr. Hugh Diamond and Duchenne de Boulogne ("Duchenne de Boulogne also passes from a purely scientific interest into one that displays an artistic motivation or at least an artistic effect"), which depict (primarily) women incarcerated in asylums being prodded with electrodes and calipers,[36] or whether it was an attack on the so-called contextualist camp (which, such as it is, was unrepresented) is hard to say. What emerges from these symposiums is the dispiriting recognition that a kind of academic Gresham's Law is in effect. It is perhaps not so much that bad or *ersatz* scholarship drives out the good, but that under the hegemony of the aesthetic, other questions, other approaches, can barely be articulated, much less addressed.

Since so much of the history of photography is presently being constructed within the museum, it is only to be expected that the terms of that history will inevitably fall within the museum's framing (in both senses) discourse. An exhibition such as Peter Galassi's "Before Photography" at the Museum of Modern Art, which opened in 1981 and traveled widely, is a virtual case history of how the museumification (with apologies to the reader) of photography functions not just to rewrite history, but to effectively erase it. Fundamentally, Galassi was involved in fabricating an academic and scholarly justification for the curatorial preferences and critical apparatus of MoMA's photography department. "Before Photography" was thus constructed to provide precisely the thesis that the museum required: to wit, that the history of photography, essentially and ontologically, is not only engendered by art, but is, in fact, inseparable from it. That this extremely dubious proposition (arrived at, I might add, and argued for in the accompanying text by a combination of slide-library *legerdemain*, omission, and distortion) was received with hosannas by most photography historians, some art historians, and all dealers and collectors, was entirely predictable.[37] Marjorie Munsterburg, in fact, published a fulsome gloss on Galassi's text in the *Journal of Visual Communications*, and *Before Photography* is now footnoted in all manner of photo-history productions. Not surprisingly, of the thirty-five canonical photographs carefully garnered to demonstrate the "modern pictorial syntax of immediate, synoptic perceptions and discontinuous unexpected forms," twenty came from the collections of Jammes, Wagstaff, Crane, *et al.*

But despite the accretion of photography exhibitions and acquisitions within the museum, despite the fact that photography now appears to most people self-evidently to belong within it, the residual traces of an *arriviste* mentality are much in evidence. This can be recognized in the rather overdetermined installation and design of the various photography exhibitions themselves. The subdued lighting (to avoid fading of prints), the walls

painted bistre, or taupe, or burgundy, or even (in the case of the Chicago installation of "Paper and Light") the hand-written calligraphy for some of the wall labels—all this attests to the diverse strategies employed to manufacture and project the notion of aura onto photography. Wall labels, too, are written to enforce this near-mystical approach to nineteenth-century photography, as amply demonstrated by Brettell's mounted statement at "Paper and Light": "When hung together, the images produced by the French and British photographers reveal a unified world seen through the medium of the calotype, a world of stillness and clarity in which the past and the present are united and in which visual documents become works of art." Visual documents do not, of course, become works of art the way caterpillars become butterflies; rather, they are *deemed* works of art through the complex and interconnected needs and desires of the culture which is apprehending and consuming them. That the museum and market *require* that photography be art should be understood as the generative force in the new history of photography.

HENRI LE SECQ (1818-82), *DIEPPE HARBOR*, CA. 1855, MODERN PRINT FROM

PAPER NEGATIVE BY CLAUDINE SUDRE. CABINET DES ESTAMPES,

BIBLIOTHÈQUE NATIONALE.

So pervasive is this need, and so irresistible its seduction, that even an exhibition like Janet Buerger's "The Era of the Calotype," which made a half-hearted attempt to present mid-nineteenth-century photography in some semblance of context, was not too strikingly different from the others. Although the title should have provided an ideal opportunity to display everything from deathbed portraiture to medical, scientific, commercial, and stereographic photography, the general tenor of the selections was weighted toward contemporary taste as insistently as were the exhibitions at Princeton and Chicago. Buerger, too, accepts the notion of a calotype aesthetics, and the lack of a firm commitment to, or grasp of, alternative approaches undercut some of her concessions to context (e.g., under a wall label on "transportation" were Le Secq calotypes of the harbor at Dieppe, images clearly intended as "art").

That the museum should be involved in the construction of the history of photography is in and of itself a problematic development. The mandate of the museum is an aesthetic one, and one does not reasonably expect a museum to be involved with a sociology, a semiotics, or a social and cultural history of photography. It thus devolves upon scholars and historians to take the larger view, to explore these increasingly marginalized but nonetheless critical aspects of photography. When scholars unquestioningly accept these terms as their own, when they believe that the meanings of photographs, individually or collectively, reside within their edges, they function not as scholars but as middlemen between the market and the museum. It is in no way surprising that the last photograph in the catalog, *Nièpce to Atget*, is by Atget, or that Eugenia Parry Janis as well as John Szarkowski should invoke him as the presiding muse of art photography. Atget has become the conduit through which select aspects of photography's past can be magically joined to contemporary sensibility and a unitary (and mythical) tradition created. Similarly, Atget himself can now be processed art historically, and can be seen to have possessed that chestnut and hallmark of nineteenth-century *Kunstwissenschaft*, an *Alterstil*.[38]

The historians who promulgate a univocal art history of photography unfortunately function as hatcheries of the next generation of photography historians. In their evident belief that artists exist in the world just as chickens do (one has only to see one to identify, to recognize, to name it), they are creating an entirely specious construction, innocent of its own premises. It is no wonder that the only enterprise within the entire spectacle of calotypomania that is consistent, authoritative, and free of contradiction is that of the collector — the man for all seasons.

1983

2

Canon Fodder: Authoring Eugène Atget

IN FACT, ATGET'S PARIS PHOTOGRAPHS ARE THE FORERUNNERS OF SURREALIST
PHOTOGRAPHY, ADVANCE TROOPS OF THE BROADER COLUMNS SURREALISM WAS ABLE
TO FIELD. . . . HE BEGAN THE LIBERATION OF THE OBJECT FROM THE
AURA. — WALTER BENJAMIN, 1931

HIS WORK CAN TELL US DIRECTLY EVEN MORE THAN ANDRÉ CALMETTE [*SIC*] TELLS US
OF ATGET'S LIFE. THE PHOTOGRAPHER CANNOT MISS THAT PICTURE OF HIMSELF. IT IS
HIS STAMP AND MAP, HIS FOOTPRINT AND HIS CRY. — BERENICE ABBOTT, 1964

[ATGET] WANTED TO BE CONSIDERED AN AUTHOR; HE WANTED HIS WORK TO HAVE A
GENERAL PUBLIC AND BY EXTENSION TO HAVE THE KIND OF EXHIBITION VALUE THAT
A PAINTING DID. — MARGARET (MOLLY) NESBIT, 1981

AND YET, AFTER HE HAS BEEN CLEARLY PLACED, THE BEST OF HIS PICTURES REMAIN AS
MYSTERIOUS AS BEFORE, TRANSCENDING BOTH THE CATEGORICAL FUNCTIONS THAT
THEY PRESUMABLY SERVED AND THE PAST OUT OF WHICH THEY GREW. THE
CHARACTER OF HIS *OEUVRE*, TAKEN AS A WHOLE—FOR THE BREADTH AND GENEROSITY
OF ITS IMAGINATION, AND THE PRECISION OF ITS INTELLIGENCE—CAN BE CONFUSED
WITH THAT OF NO OTHER PHOTOGRAPHER. — JOHN SZARKOWSKI, 1983

WE CAN ACCOUNT FOR THE TRANSMUTATION OF FACTS INTO ETHER ONLY BY
UNDERSTANDING [ATGET'S] PROGRESSIVE ASSUMPTION OF THE CREATOR'S ROLE.
— MARIA MORRIS HAMBOURG, 1983

The question is: if Eugène Atget had not existed, would he have had to be invented? Such a question ought not be dismissed out of hand as a frivolous one. For if we remark upon the astonishingly perfect fit between the requirements of late modernist photographic theory (requirements that are institutional, canonical, and discursive in nature) and the way Atget appears now to fulfill them so satisfyingly, so naturally, we may gain a clearer sense of how authors are constructed, how canons are constructed, and what interests are served in these two overlapping critical enterprises. In other words, in focusing attention on how Atget is both currently and historically represented, rather than gamely contributing to the uncritical ratification of what I maintain is a process, we will be provided with a clear example of how discourse defines its own object—how, with regard to the specific instance of Atget, cultural production is organized, described, and finally perceived to conform to the needs, myths, and desires of those individuals and institutions empowered to define how cultural production will be understood.

My five epigraphs represent a range of perspectives on the person and the photography of one Eugène Atget—a range that spans fifty years of episodic commentary, formulated from relatively heterodox positions. In juxtaposing these various interpretations of Atget and his photographs, I intend nothing as banal as a demonstration of the subjectivity—or variability—of critical or scholarly appraisal. Nor is there any desire on my part to ask rhetorically that the real Atget please stand up and identify himself. On the contrary, in claiming that, for example, both Walter Benjamin's and John Szarkowski's "Atget" be understood as discursive constructions, I mean to shift attention away from the plurality of interpretations and focus instead on what, to a greater or lesser degree, may be said to inform them all—namely, the desire (never articulated as such) that Atget, the ill-known, the laconic, historical personage, and the 10,000 photographs he left behind him, be encompassed and contained within the honorific "author." In employing the term "author" rather than that of "artist"—the conventional terminology for makers of images—I am following the arguments of such theorists as Michel Foucault and Roland Barthes, in which the concept of authorship is understood to incorporate that of artist. For both men, the analysis of this concept proceeds from the recognition that authorship is a fully historical construction, and therefore, not universal, natural, or eternal. Still more important for the purposes of this essay is Foucault's elaboration of what he called the "author-function":

> These aspects of an individual, which we designate as an author (or which comprise an individual as author), are projections, in terms always more or less psychological, of our way of handling texts: in the comparisons we make, the traits we extract as pertinent, the continuities we assign, or the exclusions we practice.[1]

Considering my collected shards of Atgetiana in terms of similarity rather than difference reveals a shared assumption that there exists a one-to-one correspondence between

Atget the man and Atget's work—Atget, the unproblematic author-father of his own work-offspring. The seeming inevitability of this relationship faithfully reflects that constellation of historical, cultural, and psychological determinations within Western culture that have so profoundly linked property (from the Latin: *proprius*, one's own), patriarchy (in which women and children *belong* to the father), and—most recently minted of this trinity—authorship. But while there is no obvious consensus among these commentators about what Atget may have thought he was doing—indeed, early interpreters tended to assume that he didn't know what he was about at all—there is, nonetheless, an unquestioned adherence to the conventional epistemological notion of author to which the work is believed to bear a reciprocal and indexical relation as the author's creative fingerprint. "It is his stamp and map, his footprint and his cry."[2]

But at the same time that we can identify in these disparate models of the author Atget a shared investment, indeed a profound desire, that Atget *be* an author, so too can we identify the anxiety that hovers within this enterprise, particularly in its most recent, ambitious, and systematic incarnations. This anxiety is recognizable in the ways various commentators attempt to manage, smooth over, and rationalize the objective facts of Atget's career to accord with an idealist but immensely potent mythology of creative authorship. Accordingly, the nettlesome problems that crop up in the fabrication of the author Atget—his refusal of the designation "photographer" (much less that of artist), the qualitative unevenness of his production, its daunting quantity, its great internal diversity, the resemblance of much of it to the work of nineteenth-century photographers (e.g., Charles Marville) or to other contemporaries producing topographical, documentary, or architectural photography (e.g., Karl Abt and Henry Dixon)—require strategies of containment or denial that inevitably engender forms of textual anxiety. Accordingly, whether commentators are committed to the excavation of a surrealist Atget, a primitive Atget, a documentary Atget, a modernist Atget, or a Marxist Atget, what is most crucially at stake is the demand that "Atget" be a coherent and unified subject, the self-possessed and authorizing father of his own work. For to dispense with the author, even to question the notion, is to challenge the metaphysical linchpins of Western culture and their philosophical auxiliaries—the belief in origins and originals, the primacy of the individual, the individual subject as intentional author of his or her own discourse, etc. Both Michel Foucault's interrogation of the author-function and Roland Barthes's (apparently premature) celebration of the author's death stress the subversive and potentially emancipatory implications of repudiating the ideologically naturalized concept of authorship.[3]

But while twentieth-century philosophy, theory, and criticism—in fields as diverse as psychoanalysis, linguistics, semiotics, poststructuralism, and, pre-eminently, feminist theory—have been energetically dismantling Platonic and Cartesian legacies, such projects can only be academic for the culture industry at large. And despite the fact that modern aesthetic philosophy enables us to dispense with the concept of intentionality in our evaluative procedures for cultural artifacts,[4] the need to posit an originating and unified self,

which marks that production as the subject's own, is far more durable. That the operations of cultural legitimation possess economic as well as ideological interests (an Atget photograph is, in every sense, *worth* more than an anonymous one) is but another indication of the force and power implied in the word "investment." Eugène Atget, currently positioned as the exemplar, progenitor, and patriarch of modern photography and celebrated unanimously by the photographic community with an enthusiasm that brooks no question, proves an apt case—or case history—for examining some of the terms of this investment.

Investments are, of course, as much a fact of psychic life as of economic life. And insofar as we are taking note of psychic stakes as much as material ones, it is important to acknowledge the primacy of desire in the interpretive enterprise. What Walter Benjamin wants from Atget's photographs is manifestly different from what Berenice Abbott or John Szarkowski wants from them. Benjamin, both in his 1932 essay, "A Short History of Photography," and in his greatly expanded and more theoretically developed essay of 1936, "The Work of Art in the Age of Mechanical Reproduction," wants photography to be an emancipatory, democratic, politically and culturally demystifying medium. Benjamin lauds Atget in these essays because he "took off his mask [as an actor] and then went on to strip the make-up from reality as well,"[5] producing "the sort of effects with which Surrealist photography established a healthy alienation between environment and man, opening the field for politically educated sight."[6] For Benjamin, the legacy of capitalism's exploitation and expropriation—inscribed (but masked) in its cultural achievements (of which the modern city is one)—was made apparent in Atget's photographs which "become standard evidence for historical occurrences, and acquire a hidden political significance."[7] It was in this sense that he made his famous observation likening Atget's streets to a scene of a crime.[8] The historical joke is assuredly on Benjamin, both for pinning revolutionary hopes on what is now known as the mass media and, even more ironically, for having celebrated Atget's pictures because they "suck the aura from reality"[9] when, fifty years later, it is Atget's photographs that are industriously being pumped with that very aura.

Desire obeys its own laws, and in Berenice Abbott's passionate recognition (a term I will return to) and advocacy of Atget's photography, we can observe how the interpretive desire collapses, eclipses, or elides all other considerations. For example, in her 1964 essay written for *The World of Atget*, Abbott wants to argue for the absolute singularity of Atget's work ("realism unadorned," "straight photography without tricks") and the uniqueness of his professional position ("In Atget's time, photography was so young and so new a medium, that the custom of adopting it solely and formally as a profession was not yet established").[10] The point to be made here is not that Abbott was in some way "ignorant" of the history of photography—photography as a profession (be it in the production of portraits, *cartes-de-visite*, stereographs and views, camera work for official institutions, etc.) was fully established by the 1850s—but that she needed Atget to function

31

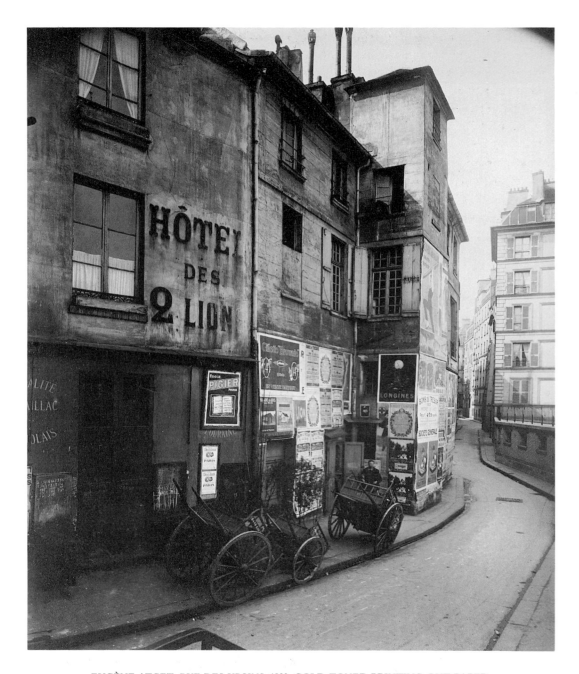

EUGÈNE ATGET, *RUE DES URSINS*, 1923, GOLD-TONED PRINTING-OUT PAPER,

9 3/8 × 7 IN. COLLECTION, THE MUSEUM OF MODERN ART, NEW YORK. THE

ABBOTT-LEVY COLLECTION. PARTIAL GIFT OF SHIRLEY C. BURDEN.

as a validating and authorizing origin for the kind of photographic work *she* wanted to do. Similarly, her nonrecognition of all the "straight," "realistic," and informational photography, which could be readily found anywhere in the late 1920s outside the purview of art photography, testifies even more tellingly to the profound psychological importance accorded to the notion of singularity.

Abbott's text is particularly revealing in its patent contradictions—destabilizing oscillations between what Abbott knows and what she desires. For example, early in the essay Abbott writes: "In reply to my question Atget answered that he never took pictures on assignment [this somewhat begs the issue of shooting for stock or shooting on assignment] because 'people did not know what to photograph.' How true this statement is few can realize, but I am sure many serious photographers today groan with the weight of its truth."[11] Later in the essay, however, Abbott duly notes the breadth of Atget's clientele: "This is a partial list of professions to which he catered: designers, illustrators, amateurs of Old Paris, theatrical decorators, cinema (Pathé Frères and many others), architects, tapestry-makers, couturiers, theater directors, sign painters, editors, sculptors, and painters."[12] In her selection of Atget's photographs, Abbott even includes examples of his standard copy-stand work—photographs of paintings, prints, and other graphic work. By so doing, she not only reveals the contradictions of desire as it collides with objective reality (clearly, her contention that Atget was not a photographer "by trade" is not made in bad faith or with any intention to falsify) but also anticipates the critical "problem" that Atget's professional status would present to later aesthetic hagiographers. If Atget's photographs were produced to meet the demands of his variegated clientele—that is to say, the photographic marketplace—where was there space in which to construe imaginatively the coordinates of his "footprint and his cry"? The consecutive and somewhat tortuous attempts to resolve this contradiction within the Procrustean bed formed by modernist values and aesthetics have constituted the very ground upon which Atget criticism derives its terms and methods.

Abbott attempted to resolve the almost stereotypical conflict between work-for-hire and the more elevated and aesthetically indispensable imperative of "personal vision" under the banner and umbrella of realism: "The first time I saw photographs by Eugène Atget was in 1925 in the studio of Man Ray in Paris. Their impact was immediate and tremendous. There was a sudden flash of recognition—the shock of realism unadorned. The subjects were not sensational, but nevertheless shocking in their very familiarity. The real world, seen with wonderment and surprise, was mirrored in each print. Whatever means Atget used to project the image did not intrude between subject and observer."[13] There are residual traces in this passage of Abbott's familiarity with surrealist theory and practice—the shock of the familiar, a response linked not only to Freud's *Unheimlichkeit* and André Breton's excavation of the "marvelous" but to the surrealist photographs of quotidian or quirky objects.[14] Yet the emphasis is placed on the concept of an unmediated and transparent realism. Here it is important to situate Abbott as a young woman in a

BERENICE ABBOTT, *PRINCESS EUGÈNE MURAT*, 1929.

COURTESY LEE WITKIN GALLERY.

complicated, albeit peripheral, relationship to surrealism. After having briefly worked as Man Ray's assistant, Abbott launched a career as a portrait photographer. Her extraordinary portraits of the 1920s, part of which represent a virtual "Who's Who" of the lesbian *beau monde* and *monde des lettres*, are marked by discreet signifiers of surrealist influence—masks, references to masquerade, portraits *en travestie*, and pervasive plays on sexual ambiguity. Why would the photographer who made these stylish, sophisticated, and sexually complicated pictures, who inhabited a cosmopolitan bohemia of sexual outlaws, expatriates, surrealists, and other avant-garde artists, recognize "in a sudden flash" the importance of Atget's work to her own? Particularly when her own immensely accomplished work, as far as is known, bore no relation whatsoever to Atget's?

I raise such a question not to answer it but to insist that the moment of epiphany that Abbott describes is in no way adequately explained by the paradigm of one realist recognizing another. Moreover, the bulk of Abbott's writing on Atget was produced after she returned to New York and had radically altered her own work with respect to the model provided by Atget—*après coup*, so to speak. That Abbott would have invoked realism as a celebratory term is suggestive when we recall that conventional notions of realism were anathema not only to surrealist artists but to the rest of the avant-garde as well. Furthermore, the surrealist conscription of Atget hinged not on his realism but on the oneiric and defamiliarizing quality of certain of his pictures—their revelation of the mysterious embodied in the ordinary.

Whatever the nature of the social, professional, and artistic positions Abbott occupied in relation to the surrealist milieu, the fact that she was a woman artist (and not wife, mistress, or model) could only have been anomalous in the boys'-club (not to say misogynous) ambience of surrealism. Abbott's embrace of Atget in 1928 must be understood as expressing a multiple refusal—a simultaneous refusal of surrealism, of art photography in its contemporary manifestations, of exoticism (both sexual and cultural), and perhaps even of expatriatism (Abbott returned permanently to America in 1929). Abbott's recognition of Atget is the founding moment, we might say, for the current Atget enterprise. In claiming Atget as her ancestor and inspiration, by insisting on his absolute singularity and difference from all other commercial photographers, Abbott invented her own enabling author/authority to legitimate her own creative imperatives. Needless to say, the essentially private act of choosing one's ancestor has totally different implications from its institutional analogue—the process and mechanisms of canon formation—although, in the case of Atget, it seems as though that first, personal appropriation enabled all that followed.

Had Berenice Abbott not purchased the 5,000 prints and negatives remaining in Atget's studio at the time of his death, it is highly unlikely that we would speak today of Atget's canonical status. While the bulk of the Atget photographs is permanently housed in various French libraries and archives, it is the success of Atget-in-America that has been decisive in positioning him as the canonical figure par excellence. But Atget's fortunes in

35

EUGÈNE ATGET, *BOULEVARD DE STRASBOURG, CORSETS*, 1912, ALBUMEN-
SILVER PRINT, 9 3/8 × 7 IN. COLLECTION, THE MUSEUM OF MODERN ART, NEW
YORK. PRINT BY CHICAGO ALBUMEN WORKS, 1984.

America can in no way be described as a simple trajectory, launched when Abbott returned to America and completed with his current pantheonization by the Museum of Modern Art. On the contrary, Atget's fame has been contingent on such developments as the articulation and consolidation of modernism as *the* photographic aesthetic, the art-historicization of photographic scholarship and its repositioning within the university and art museum, the development of a market (however erratic) for photography-as-fine-art, and the institutional requirement of both market and museum for authorities to underwrite, legitimize, and support their discourses. On the most specific level, Atget's canonization is the product of the converging interests of the individuals—curators, critics, scholars, dealers, and collectors—who promoted him at the historical moment most propitious for the establishment of a new canon.

Until all these conditions fell into place (approximately the end of the 1960s), Atget remained a relatively marginal figure, despite his regular inclusion in photography exhibitions and the publication of at least three books in America dedicated to his work.[15] In other words, although the work of Atget was as *physically* available for canonical treatment in 1960 as in 1970, the discursive conditions necessary for such an elevation had yet to be met. Indeed, prior to the 1970s, knowledge of Atget was largely limited to specialists, connoisseurs, dealers, and some photographers. Significantly, photographers who may have been influenced by his work (Walker Evans, for instance) clearly felt little inclination to publicize the fact; after all, who was Atget? Abbott herself has refused to acknowledge—has indeed actively denied—*any* direct personal influence of Atget's photography on her own work. Now, however, that Atget has come to be widely perceived as a seminal figure for modern photography, acknowledgment of influence can be boldly and unproblematically proclaimed, at least by curators and critics.[16]

Timing is therefore a crucial element in the determination of canons. It is well known, for example, that Berenice Abbott had made numerous attempts to sell what had become, in 1930, the Abbott-Levy Collection. As a working photographer of no great personal means, the burden of superintending the Atget photographs and effectively functioning as unpaid curator must have been enormous. Because she wished to keep the collection intact, a museum purchase was the logical, if not the only, option. It is difficult to imagine that she never approached the Photography Department before 1968, the year in which the collection was actually purchased. Be that as it may, the historical moment in which the Abbott-Levy Collection *did* pass through the portals of the Museum of Modern Art exerted its own determinations on the presentation and reception of Atget. Specifically, the increased emphasis on blockbuster exhibitions, the structural changes in museum financing, the new importance of corporate funding in lieu of individual private support, all contributed to a heightened need to create an artistic star system. A canonical figure, in addition to everything else, was now expected to generate a certain box office.

Because successful canon formation is possible only when the institutions and individuals involved are sufficiently powerful to construct and sustain it, any serious consid-

BERENICE ABBOTT, *BARCLAY STREET ELEVATED STATION*, 1936, 7 1/2 × 9 1/2 IN.

BERENICE ABBOTT/COMMERCE GRAPHICS, LTD., INC.

eration of a canonical author, text, or *oeuvre*—particularly one as newly ordained as Atget—without reference to the interests inscribed in the very production of a canon, risks being a very partial consideration indeed.[17] One of the ways to uncover the base, so to speak, in this particular instance of canon construction is to try to link (and jointly answer) the questions "Why Atget?" and "Why Atget now?"

If the mounting of *four* large-scale Atget exhibitions, and the publication of the accompanying four books in as many years, were not sufficient indication of the MoMA Photography Department's investment in the canonization of Atget, a single sentence of John Szarkowski's on the acknowledgments page of Volume IV of the sumptuously produced *Work of Atget* makes the ambition and investment of this curatorial project abundantly clear. In acknowledging Spring Mill's corporate largesse in substantially under-

writing the series' production, Szarkowski writes that "the value of this project has allowed the Museum to realize what seems to me its most important contribution to date to the record and the interpretation of the art of photography." We might dwell for a moment on the portentousness of the claim that the Atget books and exhibitions represent the museum's "most important contribution to date" vis-à-vis the art of photography. Szarkowski is here more than modest, if not ingenuous, in attributing credit to the museum for realizing this momentous project. Not to put too fine a point on it, the presiding intelligence, the critical rationale, and the theoretical underpinnings of this venture are John Szarkowski's own and may be taken, as doubtless he intends, as his definitive curatorial statement about what the art of photography is. Thus, while the scholarly labor in the archival salt mines which buttresses this re-vision of Atget is the work of women (in succession, Yolanda [Hershey] Terbell, Barbara L. Michaels, and as coeditor of the Atget books, Maria Morris Hambourg), the Atget of the 1980s—Olympian father of exemplary photography past, present, and presumably future—has been effectively *authored* by John Szarkowski.

In making what might seem to be an *ad feminim* reference to a sexual division of labor along the lines of scholarship and stewardship, I mean to enforce, once again, the connection between canons, fathers, authority, and patriarchy. One of the conspicuous features of virtually all canons in the field of cultural production is the relative absence of women and, needless to say, all other Others. The merit of making this unsurprising observation is that it underscores the fact that canons are mechanisms of exclusion as much as inclusion. And as one would logically surmise, nowhere is the numeric ratio between what is incorporated within the canon and what remains outside it more pronounced than in photography. Unlike the traditional fine arts, where the canon is constructed by selecting the "great" artists from the nongreat, accomplishment in photography has historically had little to do with either conscious artistry or consciously being an artist. Unlike painting, for example, most photography is produced for functional and instrumental purposes, not aesthetic ones. Consequently, the activity of extrapolating an art of photography from the literally boundless field of photographic production can be justly described as a process whereby cultural arbiters cull those images by the photographers that they, at the moment, happen to like best. What distinguishes a photographic arbiter like Szarkowski from other curators and critics has to do, first, with the power of his position (not for nothing has Martha Rosler dubbed MoMA "the Kremlin of Modernism") and, second, with his having produced a critical framework to justify, promote, and pedigree his preferences.

The issue of pedigree (like the related issues of ancestry, lineage, influence) is contained within the larger rubric of "tradition," consideration of which looms large in the constitution of canonical figures. Here it is useful to turn to T. S. Eliot's formulation on the nature and workings of a canon, undoubtedly one of the most decisive and influential statements of its kind:

You cannot value [the poet] alone; you must set him [*sic*], for contrast and comparison, among the dead. I mean this as a principle of aesthetic, not merely historical criticism. The necessity that he shall conform, that he shall cohere, is not onesided; what happens when a new work of art is created is something that happens simultaneously to all the works of art which preceded it. The existing monuments form an ideal order among themselves, which is modified by the introduction of the new (the really new) work of art among them . . . whoever has this idea of order . . . will not find it preposterous that the past should be altered by the present as much as the present is directed by the past.[18]

By definition, a canon is a standard, a model, a rule. In Eliot's schema, it provides the measure by which the art of the present may be situated—and evaluated—in accordance with the art of the past; or, we might say *to* accord with the art of the past, for Eliot's is a model that privileges continuity over rupture. Conversely, it provides the terms by which the art of the past may be reassessed or repositioned in keeping with what is deemed important in the present. Finally, it functions as an operative yardstick, which, by virtue of the very authority of a canon, may be assumed to influence contemporary and future work.

John Szarkowski has wholly embraced this profoundly conservative model of the canon (although, I hasten to add, there is no such thing as a "progressive" model) and made it his own. For example, in celebrating the stylistic affiliations of Lee Friedlander in one of his essays on Atget ("the contemporary photographer whose work seems most clearly consonant with Atget's"),[19] Szarkowski is able to argue that such influence can only confirm the value of both:

The first demand that we make of major artists, famous or nameless, is that subsequent artists be moved by his or her work, and take from it. This taking is different from stealing, for when the taking is done by an artist the work taken from is not diminished but enlarged, amplified by worthy progeny. . . . In this sense artistic influence can be seen as an organism that enters the body of tradition and effects its general nature. But in another sense influence is a function of knowledge and the knowledge offered by a complex and radical artistic oeuvre is acquired slowly, as the body of work becomes more fully known, and selectively, according to the state of preparation of the artist who receives the message.[20]

Unlike the agonistic model of [male] artistic influence proposed by Harold Bloom, here is proffered a distinctly upbeat notion of influence as a wholly positive manifestation, the viral metaphor notwithstanding.[21] Similarly, all antecedent production can be recuperated with reference to the canonical figure who casts his benevolent shadow backward as well as forward. Consistent with Eliot's formulation, a Charles Marville photograph looks *different* when seen in the shadow of Atget.[22]

CHARLES MARVILLE (1816–79), *RUE TIRECHAPE*, VIEW FROM RUE ST. HONORÉ

LOOKING SOUTH. COPYRIGHT 1990, ARS, NEW YORK/SPADEM. MUSÉES DE LA

VILLE DE PARIS.

EUGÈNE ATGET, *RUE DE LA MONTAGNE-SAINTE-GENEVIÈVE*, 1925, GOLD-TONED
PRINTING-OUT PAPER, 7 × 9 3/8 IN. COLLECTION, THE MUSEUM OF MODERN ART, NEW YORK.
THE ABBOT-LEVY COLLECTION. PARTIAL GIFT OF SHIRLEY C. BURDEN.

Consequently, one of the interesting repositions of Atget that occurs in the wake of
his elevation to the canon has to do with his temporal placement. In this respect, his work
is viewed as an expression—perhaps even a culmination—of a particular nineteenth-
century mode of production (encyclopedic in concept, in the service not of personal ex-
pression but of empiricist description, integrally related to earlier projects, such as the
Missions Héliographiques, to Charles Marville's work during the transformation of Sec-
ond Empire Paris, or such contemporary projects as Henry Dixon's work in Great Britain
and Karl Abt's work in Frankfurt). At the same time, Atget is perceived as the exemplum
for twentieth-century photography. In keeping with the "timelessness" of canonical fig-
ures, Atget, who did almost all his work in the twentieth century, has appeared in at least

two books of nineteenth-century photography.[23] There, to be sure, his photographs did serve to confirm the aesthetic category in which heterogeneous nineteenth-century photographs were being evangelically positioned—a process hastened, if not determined, by their newfound commodity status. Nonetheless, to perceive Atget in a temporal rather than a timeless perspective is to attempt to retrieve the local and historical specificity the canonical impulse must necessarily deny.

If one aspect of Atget's importance to Szarkowski's curatorial agenda is Atget's ability to preside over and encompass both nineteenth- and twentieth-century styles and modes of production, another element of Atget's production is particularly germane. Szarkowski knows, as well as anyone, that fascinating, compelling, psychically engaging—even beautiful—pictures are to be found within any discursive field. The photography archives of anthropological institutions, the photo file at the United Nations, commercial photo libraries such as the Granger Collection, the photo files of news services or photo agencies such as Magnum all yield—in abundance—photographs that could just as well be on museum walls as those that are currently on display. But since it is the function of museological discourse to articulate what are deemed to be the most exalted values in photography, the process of selection—of forming the canon—is effectively the very gist of the curatorial enterprise. And if one wishes to aesthetically privilege photographs that may exist outside the boundaries of aesthetic intent, on what basis are distinctions to be drawn?[24]

For John Szarkowski, a curator with patrician sensibilities and populist enthusiasms (photography thus being an ideal object of desire), the curatorial dilemma, broadly stated, has been how to construct an aesthetic framework that can eliminate all but a tiny fraction of duly designated art photographs yet distill from the great unwashed multitude of vernacular photographs (commercial, industrial, journalistic, and editorial) those images most resonant with his own sensibility. This, to be sure, is a curator's prerogative, and Szarkowski, more than any other photography curator, has articulated a clearly defined position from within a particularly powerful institution of aesthetic validation. To these critical ends, the strenuous efforts of many young art historians (who, once arrived within photography departments, become photography historians) and the considerable polemical talents of John Szarkowski have been devoted. The critical "resolution" of the contradictions and conundrums posed by the resistance of photography to aesthetic and stylistic classification has been proposed to us in a number of Szarkowskian productions, both visual and textual. Perhaps most influential have been his writings on photography—especially *Looking at Photographs*, *The Photographer's Eye*, and *William Eggleston's Guide*.

Drawing heavily on the type of modernist theory exemplified in the visual arts by Clement Greenberg and modifying his position and preferences as his own thinking evolved, Szarkowski has formulated an all-purpose aesthetic framework from which to build his canon. Predicated upon a foundation of what Roland Barthes might have called

photographicity, in other words, the belief that the art of photography resides in its self-referentiality—its revelation of the internal formal properties ("norms") intrinsic to the medium, its own history and tradition, its ability to reflect or mirror the unique vision of its maker/author—such an elastic schema permits inclusion of vastly different kinds of photographs made in widely disparate contexts. Szarkowski's modernist paradigm compels him to minimize subject matter per se (often referred to as "nominal"), while at the same time celebrating photography's normative transcriptive capacities. The fault lines of contradiction in his argument, whether on behalf of William Eggleston or Atget, are provisionally bridged by recourse to a mystified, indeed *mystical*, language of swooning aestheticism: "the grace of [Atget's] intuition," "the unwelcome presentiment that [Atget's] pictures will not give up their secrets to analysis," the "original grace by which we identify a successful work of modern art," "a view [Eggleston's] that one would have thought ineffable," "the mysterious promptings of an individual sensibility," and so on.

Ineffability, we might say, becomes the fallback position at those moments when the modernist paradigm appears inadequate as an explanation for subjective preference. Additionally, it points to the contradictory and simultaneous critical desires that the author and/or the work be enigmatic, yet also *knowable*—a discrete object of possession, knowledge, and mastery. These two requirements are played out in the reciprocal and interrelated spheres of criticism and scholarship which together function to construct the desired—the desirable—author. Predictably, Atget turns out to possess all the attributes that our culture routinely expects of its great artists. Insofar as artists are figured in both high and mass culture as avatars of individualism, whose sovereign subjectivities transcend the brute facts of human existence, Atget's singularity, originality, and—most crucial of all—personal vision and expression must be assiduously promoted.

So powerful is this ideological investment that even those scholars whose methods and assumptions are derived from ostensibly adversarial perspectives—Marxism, for example—are ineluctably drawn to the confirmation of authorial presence. Thus, Margaret (Molly) Nesbit's essay on Atget's *Intérieurs Parisiens* (a bound volume of photographs which Atget personally edited, assembled, and deposited in the Bibliothèque Nationale) hinges on her assertion that Atget inscribed within it a covert form of self-portraiture, here understood as his political identification with the French working class and its struggles. Because Atget selected and sequenced these images of various empty interiors himself, and listed himself as author/editor, the *Intérieurs* represent a singular exception in Atget's working life. The sixty-odd photographs, pulled from several of his existing subject classifications, depict the apartments of various socio-economic classes. Nesbit, who wrote her dissertation on Atget, argues that the sequencing of images, as well as Atget's use of his own apartment (identified as that of "a worker" in the album), constitutes this portrait of the artist. Additionally, Nesbit makes much of Atget's assumption of the author/editor mantle, claiming that this signals his desire that his photographs participate in the exhibition value of painting, and that in this way Atget makes his bid for the hon-

EUGÈNE ATGET, *DINING ROOM OF A WORKER, RUE ROMAINVILLE*, PARIS, 1910.

CABINET DES ESTAMPES, BIBLIOTHÈQUE NATIONALE.

orific status of author. Despite Nesbit's salutary insistence on, and demonstration of, the actual use-value of Atget's photographs, her desire for Atget's "footprint and his cry" is as compelling as Abbott's.[25] The self-appointed task of the current Atget scholarship (as I interpret it) is, on the one hand, to scavenge every scrap of information, up to and including what Atget ate in his dotage, so that Atget may be *known*. On the other hand, this biographical work of vacuum-cleaning ultimately serves to render homage to the ineffable mysteries of creation, which, being mysteries, are not accessible either to research methodologies or to social history.

But the "mysteries" that Atget presents to his interpreters and exegetes are a function of *their* desires, their interests, and their investments. The problems that Maria Morris Hambourg, Margaret (Molly) Nesbit, John Szarkowski, and, no doubt, many others set out to solve present themselves as such only as a consequence of the kinds of questions they ask. Thus, the elaborate arabesques produced in the process of trying to reconcile the historical fact that Atget was a commercial photographer (whose "worst" and "best" pictures were alike generated in the course of his fulfilling the demands of his clients; who apparently distinguished his photographs only by subject classification) with the exigencies of a personal vision. Szarkowski and Hambourg attempt to work this out by reference to the notion that Atget's labors were geared not to the demands of the marketplace but rather to the goal of explaining "the spirit of his own culture." In other words, his personal vision was consecrated to an idea larger than himself. Consequently, there intrudes that element of disavowal that Freud characterized with the formulation "I know, but nevertheless . . . " For example, Szarkowski acknowledges that Atget's photographs "sometimes" resemble the work of his nineteenth-century predecessors (a gross understatement to anyone who has spent weeks in French archives looking at topographic photography): "When they photographed similar subject matter, their work sometimes looked much like Atget's." Nevertheless, "the character of his oeuvre, taken as a whole . . . can be confused with that of no other photographer."[26]

Only a few sentences separate the first statement from the second, much as Abbott's repetition of Atget's assertion that he didn't do commercial work was followed a few pages later by a list of his clients. On the same page quoted above, Szarkowski expresses a wish that is profoundly revealing of the conceptual difficulty inherent in molding a figure like Atget to conform to the model of author: "To our eyes it would seem simpler and more reasonable if Atget's work had been done by at least two photographers—one who worked with a perceptive but rather pedestrian intellect and another who saw the world with the sure intuitions of a great lyric poet."[27] Indeed it would be simpler and more reasonable if all 10,000 photographs looked artistic, let alone like great lyric poetry; but the fact that by Szarkowski's own reckoning only 20 percent of the photographs are marked by "original grace" only serves to accentuate the misfit of photography-in-the-real-world with photography-in-the-museum.

I am by no means the first critic to be dismayed—and occasionally astounded—at the

spectacle of Atget (and other photographers) being subjected to the most retrograde form of de-historicizing embalming. In an essay originally published in 1981, Rosalind Krauss performed a brilliant dissection of the methods and assumptions accompanying this as-similation, which unfortunately, but not surprisingly, has made little dent in the nature and terms of the Atget re-vision. "Having decided that nineteenth-century photography belongs in a museum," wrote Krauss, "having decided that the art-historical model will map nicely onto these materials, recent scholars of photography have decided (ahead of time) quite a lot."[28] She then proceeded to demonstrate the relentless ahistoricism, the epistemological impropriety, the conceptual incoherence, and, most important, the ideo-logical stakes informing the application of the terms *oeuvre*, *artist*, and *authorship* to the production and person of Eugène Atget. The radical difference in Krauss's approach to Atget, or, for that matter, to photography in general, resides in her vastly different pre-mises. In questioning the hallowed assumptions and values underpinning modernism and applying the critical methods of poststructuralist theory, Krauss emancipates photography from an art-historical straitjacket which effectively limits and constrains the kinds of in-quiry and analysis one might otherwise make. Concluding that the shape, scope, and scale of Atget's photography are functions of an archival discourse, a system of classification and documentation that is anterior to and constitutive of the work produced, Krauss pro-posed a very different solution to the "mystery" of Atget's production:

> The coding system Atget applied to his images derives from the card files of the libraries and topographic collections for which he worked. His subjects are often standardized, dictated by the established categories of survey and historical doc-umentation. The reason many of Atget's street images uncannily resemble the photographs of Marville . . . is that both are functions of the same documentary master plan. A catalogue is not so much an idea as it is a mathesis, a system of organization. It submits not so much to intellectual as to institutional analysis. And it seems clear that Atget's work is the *function* of a catalogue that he had no hand in inventing and for which *authorship* is an irrelevant term.[29]

It follows from this conclusion that an authentically historical understanding of Atget's production—indeed of any photographic production—must be predicated on the principle of the *subject* of the photographs, with no adjectival modification:

> *Subject* is the fulcrum in all of this. Are the doorways and the ironwork balconies Atget's subjects, his choices, the manifest expression of him as active *subject*, thinking, willing, intending, creating? Or are they simply (although there is nothing simple in this) *subjects*, the functions of the catalogue, to which Atget himself is *subject*? What possible price of historical clarity are we willing to pay in order to maintain the former interpretation over the latter?[30]

This is a particularly important point in view of the thematic organizing principle that

Szarkowski chose to impose on both the format of the museum's Atget exhibitions and on the four volumes of *The Work of Atget*. These large rubrics—*Old France*, *The Art of Old Paris*, *The Ancien Régime*, and *Modern Times*—allow the Atgetian deck to be shuffled in a way that produces an impression of Atget's work no less partial, but on an infinitely grander scale, than the four Atget photographs selected by André Breton for publication in the journal *La Révolution Surréaliste* in 1926. A specious thematic unity is thus produced in lieu of the real heterogeneity of the archive; a synthetic unity that displaces chronology, function, and classification to yield style, consistency, and originality.

In examining a far more random selection of Atget's photographs, such as those reproduced in *The World of Atget*, what is immediately striking is their variety. Far from yielding any impression of stylistic unity—or even unity of content—the viewer is struck by their variety. Moreover, the kinds of responses one has to the images are very much determined—as, I would submit, is usually the case in looking at photographs—by their subjects. A morose-looking peddler accompanied by a radiant little girl who swivels around his pushcart, a trio of street-wise prostitutes, a sensuous close-up of capucine leaves provoke entirely different readings, projections, interpretations. That the first photograph could have been made by Lewis Hine, the second by Brassai or Bravo, the third by Paul Strand (differences in cameras and printing notwithstanding) points to the way photography anarchically disrupts the attempt to circumscribe it in formalist or *auteurist* boundaries. The inscription of Atget within this domesticating grid does violence not only to the history that produced him but to the diversity and multiformity of the work he produced.

In conclusion, it should be noted that a canon, in its most oppressive sense, is a pedagogy, a rule, a law. John Szarkowski makes this facet of how a canonical figure functions quite explicit: "To many photographers today, his work stands not only as a heroic and original achievement, but as an exemplary pedagogical lesson, the full implications of which even now are only intuitively perceived." I would suggest that the full implications of this pedagogical lesson, far from being even now only intuitively perceived, are, on the contrary, being resolutely nailed into place. The purpose of this lesson is to affirm, ratify, and validate a certain construction—increasingly contested—of the art of photography. Generally stated, the Atget invented for the 1980s permits Szarkowski to further justify his curatorial preferences (Lee Friedlander rather than, say, Cindy Sherman; Robert Adams rather than Sherrie Levine; Garry Winogrand rather than Barbara Kruger; Nicholas Nixon rather than Richard Prince; and so forth). Conversely, in its retrospective function, Szarkowski's Atget serves to theoretically justify and account for the decanonization of figures once central to art photography—Henry Peach Robinson, F. Holland Day, Clarence White, or, more recently, Paul Caponegro, Minor White, Eliot Porter, Jerry Uelsman, even Ansel Adams. While I personally do not regret the eclipse of these once-glittering stars, evoking their shades reminds us that even for those who espouse it, a canon is never eternal, is always dynamic, and is always—literally—man-made. None-

EUGÈNE ATGET, *LA VILLETTE, RUE ASSELIN, PROSTITUTE*, 1921, GOLD-TONED

PRINTING-OUT PAPER, 9 3/8 × 7 IN. COLLECTION, THE MUSEUM OF MODERN

ART, NEW YORK. PRINT BY CHICAGO ALBUMEN WORKS, 1984.

EUGÈNE ATGET, *ORGAN PLAYER*, 1898-99, GOLD-TONED PRINTING-OUT
PAPER, 9 3/8 × 7 IN. COLLECTION, THE MUSEUM OF MODERN ART, NEW YORK.

PRINT BY CHICAGO ALBUMEN WORKS, 1984.

theless, the emergence of a new canonic configuration—instead of revealing precisely the contingency, historical determinacy, and collective and individual interests which actively produce it—masks its own traces, effaces its own manufacture, appears as a natural, if not a teleological, phenomenon.

Sixty years ago, when Berenice Abbott discovered and claimed Atget for herself, the act of individual selection was both creatively enriching and renewing. But the canonized Atget who is now to be reverently studied and further reified by a generation of academically trained art photographers will be a dead weight on their shoulders. For what is being bequeathed to them is not a living, "organic" tradition but a museological relic who has become—indeed, is being actively, discursively constructed as—the Law.

1986

3

The Armed Vision Disarmed:
Radical Formalism from Weapon to Style

Art photography, although long since legitimated by all the conventional discourses of fine art, seems destined perpetually to recapitulate all the rituals of the *arriviste*. Inasmuch as one of those rituals consists of the establishment of suitable ancestry, a search for distinguished blood lines, it inevitably happens that photographic history and criticism are more concerned with notions of tradition and continuity than with those of rupture and change. Such recuperative strategies may either take on photography *toute entière*, as in the Museum of Modern Art's exhibition "Before Photography," which attempted to demonstrate that photography springs forth from the body of art, or they may selectively resurrect the photography of the past, as in Alfred Stieglitz's exhibiting and publishing of the work of Hill and Adamson or Julia Margaret Cameron to emphasize the continuity of a particular aesthetic. Although a certain amount of historical legerdemain is occasionally required to argue that *a* evolves or derives from *b*, the nature of photography makes such enterprises relatively easy. An anonymous vernacular photograph may look quite like a Walker Evans, a Lee Friedlander may closely resemble a Rodchenko; put side by side, a close, but specious, relationship appears obviously, *visually* established.

Nowhere is the myth of continuity more apparent than in a recent Aperture offering, *The New Vision*, which traces the fortunes and fruits of the Chicago Institute of Design, or, as John Grimes puts it in his essay, "The New Vision in the New World."[1] Although the leitmotif of the book—both in the Grimes essay, as well as in Charles Traub's "Photographic Education Comes of Age"—is the enduring presence and influence of the Founding Father, László Moholy-Nagy (and his founding principles), it is perfectly evident that most of the photography that has emerged from the Chicago Institute of Design has little in common with the production, much less the ethos, of the Dessau Bauhaus. On the contrary, it seems to me that most of the photography that emerged from the Bauhaus

I would like to acknowledge the great help, both bibliographic and conceptual, given me by Christopher Phillips.

52

. .

of the diaspora is more closely linked to indigenous currents in American art photography than to the machine-age ethic that informed Moholy's thinking.

Such reflections are suggested by, among other things, the concluding sentence in the book's first (unsigned) essay, "A Visionary Founder: László Moholy-Nagy," which reads: "The utopian dream Moholy worked for never became a reality, despite his dedication and energy, but his new vision was a powerful legacy, especially for photographers, who could see their 'mechanical' art as the means for objective vision, optical truth, and personal enlightenment."[2] Objective vision and optical truth were indeed linchpins of Moholy's program for photography, even as early as 1925. However, personal enlightenment was not only a notion utterly uncountenanced in Moholy's thinking, but the quotes around the word "mechanical"—the precise attribute that made the camera a privileged image-making technology in the Bauhaus scheme of things—are an obvious signal of a profound *volte-face*.

The problems raised by the kind of photographic history proposed in *The New Vision* are compounded by what appears to be a general confusion about what is signified by photographic formalism. Most photographic *cognoscenti*, when asked what type of photography is represented by the Chicago Institute of Design, at least up to the early 1970s, will respond that it represents the "Chicago School," or "formalism," by which is intended a label that will describe such disparate photographers as Harry Callahan, Aaron Siskind, Ray Metzker, Art Sinsabaugh, Barbara Blondeau, or Kenneth Josephson. To the degree that formalism has undergone (I would argue) the same kinds of permutations and ruptures as did the Bauhaus/Chicago Institute of Design itself, it seemed a useful project to trace generally the radical formalism of Alexander Rodchenko as it was disseminated into Weimar *Fotokultur*, and its additional transformations as it was absorbed and modified in Moholy's practice, within the institution of the Bauhaus. Finally, I was curious to see how the formalism of Aaron Siskind, and some of the later graduates of the Chicago Institute related to that of their European forebears. That this forty-year period traces the change from an explicitly political and aggressively anti-expressionist production to its virtual antithesis is implicit testimony that photography, like all social and cultural production, is not merely the vessel, but is itself constitutive of ideology.

. .

"All art," wrote George Orwell, "is propaganda, but not all propaganda is art." The radical formalist photography forged in the Soviet Union in the span of years immediately before and immediately after the Russian Revolution disclaimed all aesthetic intent and instead defined itself as instrumental in nurturing a new, revolutionary consciousness. "Art has no place in modern life," wrote Alexander Rodchenko in the pages of *Lef* in 1928: "It will continue to exist as long as there is a mania for the romantic and as long as there are people who love beautiful lies and deception. Every modern cultured man must wage war against art as against opium."[3] Refusing the appellation of art, and embracing

ALEXANDER RODCHENKO, *MOCULEA*, 1927, GELATIN-SILVER PRINT,

23.6 × 29.4 CM. COURTESY THE INTERNATIONAL MUSEUM OF PHOTOGRAPHY

AT GEORGE EASTMAN HOUSE.

the medium as an ideal instrument for perceptual renewal and social progress, the photographic work of Alexander Rodchenko and El Lissitzky has nonetheless come to signify more as art than as revolutionary praxis. Despite their having wholeheartedly consecrated their work to the task of social transformation, we view them now as having been—pre-eminently—artists. In this *a posteriori* aesthetic recuperation is inscribed a second death of radical Russian photography: its first effected in its native society by official suppression; its second determined by its rapid assimilation in Western Europe and the U.S.—a victim, one might say, of its own success. Diffused and defused, photographic strategies invented for the service of revolution were quickly conscripted for other uses, other ideologies. It is this latter fate that I wish to discuss here, in part because it reveals so clearly the profound mutability of photographic practice in general, and in part because the fortunes of formalist photography itself provide a paradigm of aesthetic institutionalization—from the barricades to the academy (so to speak) in less than three generations.

This particular migration from margin to center is by no means limited to photography, or even formalist photography. Leo Steinberg's observation that the "rapid domestication of the outrageous is the most characteristic feature of our artistic life, and the time between shock received and thanks returned gets progressively shorter"[4] fairly describes the history of radical art movements in the twentieth century; no art practice has yet proved too intractable, subversive, or resistant to be assimilated sooner or later into the cultural mainstream. Examination of the transformations that occur when a given art movement or idea traverses frontiers and oceans, as well as time, is instructive for the way it compels recognition of the profoundly unstable nature of meaning in cultural production. This is demonstrated with particular clarity when we trace the passage of photographic forms from one society and context to another. Thus, while a historical understanding of the goals, conditions, and determining factors that produced constructivist and productivist photography can be obtained from any book on the subject, the ability to perceive a Rodchenko photograph or an El Lissitzky photomontage as their contemporaries did is as lost to us as though centuries rather than decades separated us from their images.

The radical formalism which inspired and informed the new Soviet photography had little to do with the Anglo-American variety that propelled the photography of Alfred Stieglitz, Paul Strand, *et al.* toward a fully articulated modernist position, although there were common grounds in the two formalisms—shared convictions, for example, that the nature of the medium should properly determine its aesthetic, and that photography must acknowledge its own specific characteristics. Deriving ultimately from Kantian aesthetics, Anglo-American formalism insisted above all on the autonomy, nonutility, purity, and self-reflexivity of the work of art. As such, it remained throughout its modernist permutations an essentially idealist stance. Such concepts, as well as related aspirations to universality and transcendence, accompanied by the parallel construct of the promethean art-

ist, were, however, anathema to the Russian formalists. Resolutely opposed to all metaphysical systems, the Russian literary critics who provided the theoretical basis for the movement focused their attention instead on a systematic investigation of the distinguishing components of literature: those elements, qualities, and characteristics of texts that defined literature *as such*.[5] The radical nature of this critical investigation lay in its strict materialism, impersonality, and anti-individualism, all essential aspects of constructivist and, later, productivist practice. The key concept of *ostranenie* — the making strange of the familiar — developed by Victor Shklovsky in 1916, was formulated solely in relation to literature, but had obvious applications to the visual arts, including photography. The defamiliarization of the world effected in prose and poetry, the renewal and heightening of perception that was understood to be the primary goal of literature, had its natural analogue in the ability of the camera to represent the world in nonconventional ways. Revolutionary culture required new forms of expression as well as new definitions of art, and the camera — both film and still — and its operator served as ideal agents of this new vision.

But while the art photography simultaneously emerging in New York posited a modernist aesthetic that insisted on photography as a medium of subjectivity — even while acknowledging its mechanical attributes — radical practice in both the Soviet Union and in Germany rejected absolutely the notion of the artist's function as the expression of a privileged subjectivity. This repudiation of subjectivity, personality, and interiority was linked not only to revolutionary tenets of collectivism and utilitarianism but to the widespread reaction against expressionism — "a culture of mendacious stupidity," in Raoul Haussmann's assessment. One did not, in fact, require Marxist credentials to reject expressionism: futurism, de Stijl, Zurich and Berlin dada, suprematism, and, of course, constructivism, all in one form or another defined their agendas in opposition to expressionist culture, insofar as its atavism, utopianism, and emotionalism were antithetical to the critical and socially oriented art movements that emerged after World War I. Moreover, the antitechnological stance of expressionism was totally at odds with the passionate enthusiasm for technology, modernization, and urbanism — all that comprised the machine-age ethos — which was to figure so prominently in both Weimar and Soviet culture.

For an artist like Alexander Rodchenko, not yet thirty at the time of the October Revolution, the internal logic of constructivism as well as the imperatives of revolutionary culture led inexorably to the repudiation of easel painting. "The crushing of all 'isms' in painting was for me the beginning of my resurrection," wrote Rodchenko in 1919. "With the funeral bells of color painting, the last 'ism' was accompanied to its grave, the lingering last hopes of love are destroyed, and I leave the house of dead truths. Not synthesis but analysis is creation."[6] A few weeks after the last "laboratory" exhibition of the Moscow constructivists in 1921 ("5 × 5 = 25"), the twenty-five young artists, including Rodchenko (whose work was represented in the exhibition by his three "last paintings" — three painted surfaces, one red, one yellow, and one blue), renounced "pure pictorial practice" altogether, and instead embraced a wholly materialist orientation — productivism.[7]

Osip Brik, the formalist critic and theoretician closely linked to both Rodchenko and the poet Vladimir Mayakovsky, wrote yet another of the many obsequies for easel painting: "We are practitioners—and in this lies the distinctive feature of our cultural consciousness. There is no place for the easel picture in this consciousness. Its force and meaning lie in its extra-utilitarianism, in the fact that it serves no other function than 'caressing' the eye."[8] Although in part a resolution to the "crisis of images" represented, on the one hand, by the absolutism of Malevich's *White on White* of 1918, and, on the other, by the effective closure of Rodchenko's "last paintings," productivism signaled

> a kind of return to the earth after the long cosmic flight of Malevitchian su-prematism and the super-specialization in which non-objective art was recklessly engaged in the years 1915–1918. In fleeing the labyrinth of extreme theorization, the Productivists hoped . . . to lead art back into the heart of society.[9]

Indeed, it was precisely this intense engagement with the larger society at hand, as well as the belief that the artist must function as an active, socio-political being, that contrasted so dramatically with the almost ritualistically alienated stance of the expressionist artist. "The aim of the new art," wrote Ilya Ehrenburg in 1921, "is to fuse with life,"[10] and productivist texts abound with exhortations that the artists turn from the museum to the street, from the studio to the factory. Echoing Mayakovsky ("The streets our brushes/ the squares our palettes"), Rodchenko proclaimed:

> Non-objective painting has left the Museums; non-objective painting is the street itself, the squares, the towns and the whole world. The art of the future will not be the cozy decoration of family homes. It will be just as indispensable as 48-storey skyscrapers, mighty bridges, wireless, aeronautics and submarines which will be transformed into art.[11]

The productivists' stance was thus not so much anti-art, their more excited polemics notwithstanding, as much as it was opposed to the ghettoization of art as an activity of the privileged few for the production of luxury items. With the renunciation of easel painting, Rodchenko turned his attention to the range of materials, technologies, and practices that collectively constituted a reconciliation of creative energies with the felt needs of Soviet society. These activities were, perforce, those that existed in the public sphere: the design of exhibitions and pavillions (including the Workers' Club for the Soviet Pavillion at the 1925 Paris "Exposition des Arts Décoratifs," which introduced the work of the Russian avant-garde to Western Europe), furniture, textiles, theatrical design, typographic and graphic design, including posters, book covers, and advertising,[12] and from 1924 on— photography.

Rodchenko's photography drew equally from notions derived from the formalist circle, presumably through people such as Osip Brik and Sergei Tretiakoff, and from the precepts of productivism itself. Concerning the former influence, the concept of defamil-

iarization has already been cited. Additionally, Roman Jakobson's key concept of the "laying bare of the device"—the inclusion within the work of art of those material or formal elements that reveal its construction—was readily assimilable to a new photographic practice. Much of Rodchenko's most innovative photography from the 1920s is notable for its refusal of "naturalized," conventionalized viewpoints, the insistence that it was a camera lens and not a window pane that yielded the image. Worm's-eye, bird's-eye, oblique, or vertiginous perspectives relate not only to the strategy of defamiliarization, but to an affirmation of the apparatus itself as the agent of this vision.[13] Making the point even more emphatically are photographs by Rodchenko, such as *Chauffeur, Karelia* (1933), in which the photographer himself is represented in the image. Returning to the observation made at the beginning of this discussion—that photographic practices employed in one historical moment may have their significance altogether transformed when employed in another—it should be noted that Rodchenko's presence in the photograph has infinitely more to do with Dziga Vertov's inclusion of the film-making process in *The Man with a Movie Camera* than it does with Lee Friedlander's self-referencing devices.[14] What is being stressed is the manifest presence of the means of production, and, concomitantly, an implicit rejection of the popular perception of a photograph as either transparent or self-generated.

The productivist influences on Rodchenko's photography thus derived more from the mechanical-technical attributes of the medium than from its purely formal possibilities. The camera was obviously a fundamentally democratic instrument; it was easily mastered, produced multiple images relatively cheaply, and represented (like the airplane or radio tower, both powerful and pervasive symbols of technological progress) speed and science, precision and modernity. Most suggestive to Rodchenko, however, was the realization that the camera performed in an aggregate, analytic way, rather than in a unitary, synthesizing one. Rodchenko's statement that creation, not synthesis, was analysis, was based on his conviction that contemporary reality could not be adequately apprehended through essentializing syntheses. In "Against the Synthetic Portrait, for the Snapshot" (1928), Rodchenko argued: "One has to take different shots of a subject, from different points of view and in different situations, as if one examined it in the round rather than looked through the same key-hole again and again"—a notion equally central to the practice of the cubists. Posterity's physical knowledge of the historical Lenin would be known, Rodchenko added, not by a single exemplary oil painting, but through the hundreds of photographs taken of him, his letters and journals, and the memoirs of his associates. Thus, Rodchenko concludes: "Don't try to capture a man in one synthetic portrait, but rather in lots of snapshots taken at different times and in different circumstances!"[15]

By the early 1930s, if not before, the photographic formalism pioneered by Rodchenko fell increasingly under attack. Leon Trotsky himself spearheaded the attack against the Opoyaz group (the literary formalists) in 1925 with *Literature and Revolution*. The *laissez-faire* artistic policy of the cultural commissar Anatoly Lunacharsky, which had

ALEXANDER RODCHENKO, *CHAUFFEUR, KARELIA*, 1933, GELATIN-SILVER
PRINT, 11 1/4 × 16 IN. COLLECTION, THE MUSEUM OF MODERN ART, NEW
YORK. MR. AND MRS. JOHN SPENCER FUND.

sustained the extraordinary production of the Soviet avant-garde, did not long survive him. *Novy Lef*, in whose pages Rodchenko's photographs and photomontages had appeared, for which he had written, and which had published Brik and Tretiakoff, suspended publication in 1930, and the field was eventually left to *Proletarskoe Foto* and the photographic equivalent of socialist realism.

Unlike many of his avant-garde companions of the revolutionary period, Rodchenko survived Stalinism, retaining his position as the dean of the metalwork faculty at Vkhutein. In 1936, submitting to anti-formalist pressure, he declared himself "willing to abandon purely formal solutions for a photographic language that can more fully serve [the exigencies] of socialist realism."[16] Four years later he returned to easel painting, whose subjects came to include mournful clowns. In the space of about fifteen years, Russian formalism had passed from an officially tolerated, if not sanctioned, art practice, conceived as a tool in the forging of revolutionary consciousness, to an "elitist," "bourgeois," "decadent," and "counter-revolutionary" practice that condemned those who employed it to exile, silence, repudiation, or death.

But in the few years before the photographic formalism exemplified by Rodchenko was more or less effectively exterminated in the Soviet Union, it thrived, albeit in transfigured form, within the photographic culture of Weimar Germany. The diagonal compositions, suppressed horizons, tipped perspectives, bird's-eye and worm's-eye views, serial portraits, extreme close-up views, and various technical experiments with the medium had become, by 1930, relative commonplaces in that range of German photographic practice encompassing the popular press, advertising, photographic books, and exhibitions as well as the work of the photographic avant-garde. While much of this photographic activity tends to be unreflectively clumped within general categories such as the *Neue Sachlichkeit* (usually translated as the New Objectivity) or the New Vision (so-called by Moholy-Nagy), I am here concerned with that photographic practice which was most thoroughly informed by the Russian model. Although it is difficult to disentangle the skeins of influence within the cultural crucible of Weimar Germany as well as the various forces that acted upon each other and cumulatively formed the *Fotokultur* of the late 1920s, it is nonetheless clear that the 1922 Soviet Art Exhibition that took place in Berlin had an immense—and immediate—influence.

For the German Left—still in traumatized disarray after the abortive Communist revolutions of 1918/1919, the range of Russian art therein represented was greeted as a front-line communiqué of vanguard practice. To the twenty-seven-year old László Moholy-Nagy, an exile from the Hungarian White Terror (as were his compatriots Georg Lukács and Bela Balázs), then painting in a dadaist/abstract-geometrical vein, the constructivist work in the exhibition struck with the force of revelation. Reporting on the show for *MA* (Today), the Hungarian futurist publication, Moholy wrote: "This is our century . . . technology, machine, Socialism . . . Constructivism is pure substance. It is not confined

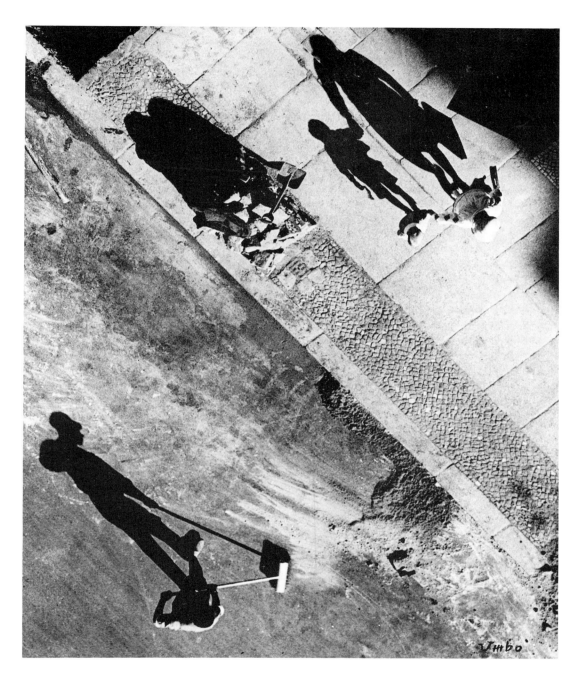

UMBO, *MYSTERY OF THE STREET*, 1928, GELATIN-SILVER PRINT, 11 3/8 × 9 1/4 IN.

THE METROPOLITAN MUSEUM OF ART, FORD MOTOR COMPANY

COLLECTION. GIFT OF FORD MOTOR COMPANY AND JOHN C. WADDELL, 1987.

to the picture frame and pedestal. It expands into industry and architecture, into objects and relationships. Constructivism is the socialism of vision."[17]

In terms of photography and photomontage, it was El Lissitzky who was most active in disseminating the new formalist photography and the precepts of constructivism. Through the trilingual magazine *Veshch/Gegenstand/Objet*, which he published with Ilya Ehrenburg, as well as by his organization and design of such exhibitions as the extraordinary Cologne "Pressa," Russian formalist photography was siphoned into the pluralist brew of German photography. Any precise tracing of the course of the formalist photography theorized and practiced by Rodchenko and El Lissitzky as it was assimilated into German photography must await closer study. But bearing in mind that the function and ideology of such photography were integrally bound together, one can begin to distinguish important divergences by the time the New Vision photography became a dominant force.

At the time of the initial introduction of Russian experimental photography, which is generally dated to the early 1920s, German photography was divided between the retrograde pictorialism of the camera clubs, the rapid expansion of photography in the illustrated press, and advertising—a function both of new developments in camera technology (for example, smaller cameras and faster film, as well as improvements in photomechanical reproduction) and of the use of photomontage by the Left avant-garde (Raoul Haussmann, Hannah Hoch, John Heartfield, George Grosz, and others). Throughout the 1920s, German photography was, in effect, cross-fertilized by radical Russian photography, so that by 1929 and the Deutsche Werkbund "Film und Foto" exhibition—a veritable *summa* of the New Vision—various constitutive elements of Soviet work had been absorbed and, depending on the particular practice involved, transfigured. In effect, the formalism imported into Weimar Germany became splintered into different, occasionally overlapping components. Thus, for example, the use of a vertical rather than horizontal perspective, which for Rodchenko was one particular optical strategy of *ostranenie*—an implicitly political application—was widely employed in Germany. There it signified, among other things, the modernity, urbanism, and technological glamour of elevators, skyscrapers, airplanes, and cranes. "We all felt a demonstrative enthusiasm for lifts, jazz and radio towers,"[18] wrote Hans Joachim in 1930, and, of course, some of Moholy's best known photographs from the 1920s were aerial views shot from the Berlin radio tower. For Rodchenko, who had made aerial views shot from the Moscow radio tower, the tower itself was perceived as "a symbol of collective effort."

Indeed, the entire repertoire of Russian formalist photography was intended as the optical analogue to revolution—quite simply, a revolutionizing of perception in accordance with the demands of a revolutionary society. Although the romance of technology and urbanism was fully a part of Soviet culture, it was, at least in the early 1920s, closer to

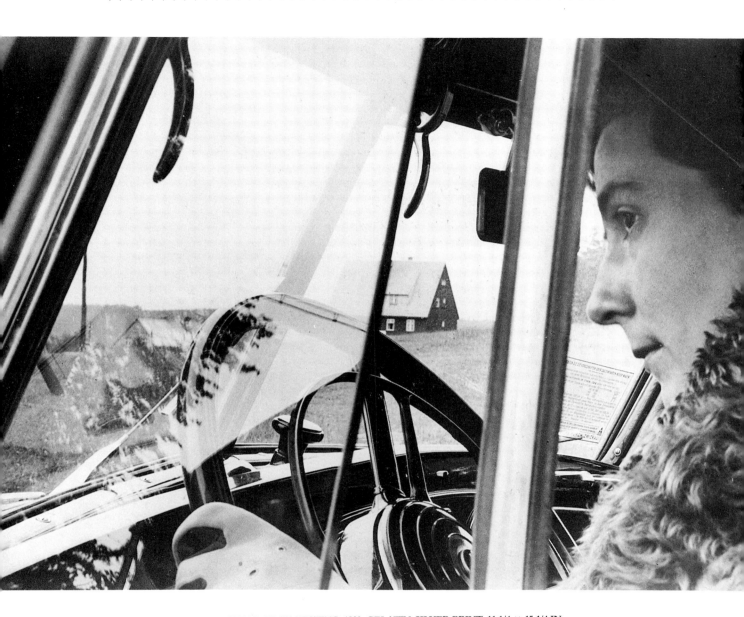

EDMUND KESTING, *FRAU KESTING*, 1930, GELATIN-SILVER PRINT, 11 1/4 × 15 1/4 IN.

THE SAN FRANCISCO MUSEUM OF MODERN ART, MRS. FERDINAND C. SMITH

FUND PURCHASE.

wishful thinking than to reality; this was, after all, a barely industrialized society devastated by revolution, famine, civil war, and foreign invasion, that required the services of Armand Hammer to manufacture even its pencils.

The formal innovations of Russian photography were nowhere more thoroughly grasped or intensively exploited than in the flourishing and immensely sophisticated German advertising industry. In his important essay on the photography of the *Neue Sachlichkeit*, Herbert Molderings discussed the implication of this phenomenon:

> If we consider the "new vision" in the context of its economic and social functions, what the historical content of the "new realism" is becomes clear. Along with heavy industry, the machine which was its substratum and the new architecture which was its result, "neo-realist" photography discovered the world of industrial products, and showed itself as a component of the aesthetic of commodities in a double sense, affecting both production and distribution. Such photographers as Burchartz, Renger-Patzsch, Gorny, Zielke, Biermann and Finsler discovered that an industrial product develops its own particular aesthetic only when the serial principle, as the general basis of manufacture, becomes pronouncedly visible.[19]

It requires but a single intermediary (photographic) step to the commodity fetish:

> Commodities also came to be shown from a different point of view, directly linked to the needs of advertising. The development of *Sachphotographie*—the photographing of individual objects—is recognized as an important achievement of photography in the twenties. . . . Objects hitherto regarded as without significance are made "interesting" and surprising by multiple exploitation of the camera's technical possibilities, unusual perspectives, close-ups and deceptive partial views. . . . The advertising value of such photographs consists precisely in the fact that the objects are not presented functionally and contain a promise of mysterious meaning over and beyond their use-value: they take on a bizarre unexpected appearance suggesting that they live lives of their own, independent of human beings. More than all the fauvist, cubist, and expressionist paintings, it was applied photography which modified and renewed the centuries-old genre of the still-life of the twentieth century: pictorial expression of commodity fetishism.[20]

In the work of Albert Renger-Patzsch (pre-eminently the photographs reproduced in the 1928 *Die Welt ist Schön*), elements that are coeval with, if not derived from, Russian formalism are collapsed into an older, Kantian conception: the belief that immutable and governing laws of form underlay all the manifestations of nature as well as the works of culture (e.g., the built environment) and that the pictorial revelation of these unifying

LÁSZLÓ MOHOLY-NAGY, *FROM THE RADIO TOWER, BERLIN*, 1928, GELATIN-

SILVER PRINT, 11 1/8 × 8 5/16 IN. COLLECTION, THE MUSEUM OF MODERN ART,

NEW YORK. ANONYMOUS GIFT.

65

HEIN GORNY, UNTITLED, 1928, GELATIN-SILVER PRINT,

10 5/8 × 7 7/8 IN. THE SAN FRANCISO MUSEUM OF MODERN ART. GIFT OF

JOACHIM GIESEL.

66

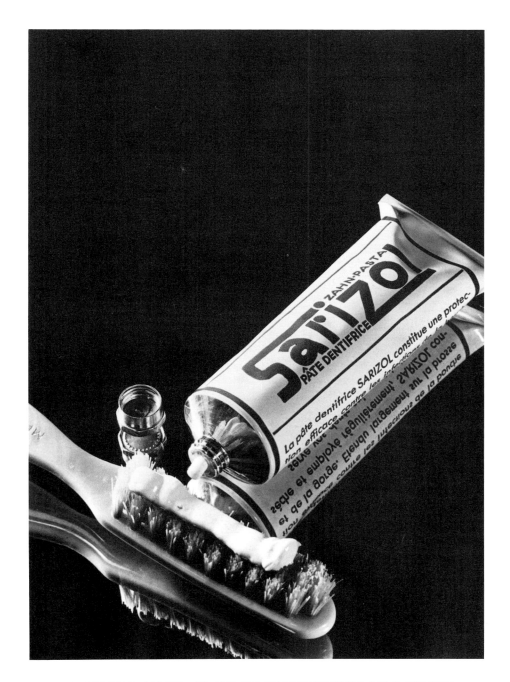

HANS FINSLER, *SARIZOL*, CA. 1930, GELATIN-SILVER PRINT, 8 1/2 × 6 IN. THE

SAN FRANCISCO MUSEUM OF MODERN ART.

structures yields both significance and beauty. Thus, on the one hand, the book provides images of machinery, modern building materials, architecture, textures, and details, photographed to reveal that "it is possible to regard a machine or an industrial plant as no less beautiful than nature or a work of art";[21] on the other hand, images of landscape, animals, and people, photographed to display and underline "that which is typical of the species."[22] The nature of this enterprise is not only essentialist but symbolist, a point made with some emphasis by Carl Georg Heise, who wrote the preface to *Die Welt ist Schön*:

> They [Renger-Patzsch'e finest photographs] . . . are true symbols. Nevertheless we should not forget that it is basically nature and created life itself which bears within it symbolic power of this kind, and that the work of the photographer does not create symbols but merely makes them visible! . . . the last picture is of a woman's hands, raised, laid lightly over one another. Who can fail to recognize the symbolic character of this picture which speaks with an insistence far more powerful than words![23]

Walter Benjamin immediately grasped the implications of Renger-Patzsch's photography and was concerned to distinguish it from progressive and avant-garde practice as exemplified by Moholy-Nagy, and from the work of August Sander, Karl Blossfeld, or Germaine Krull:

> Where photography takes itself out of context, severing the connections illustrated by Sander, Blossfeld or Germaine Krull, where it frees itself from physiognomic, political, and scientific interest, then it becomes *creative*. The lens now looks for interesting juxtapositions; photography turns into a sort of arty journalism. . . . The more far-reaching the crisis of the present social order, the more rigidly its individual components are locked together in a death struggle, the more has the creative—in its deepest sense a sport, by contradiction out of imitation—become a fetish, whose lineaments live only in the fitful illumination of changing fashion. The creative in photogaphy is capitulation to fashion. *The world is beautiful*—that is its watchword. Therein is unmasked the posture of a photography that can endow any soup can with cosmic significance but cannot grasp a single one of the human connexions in which it exists, even where most far-fetched subjects are more concerned with saleability than with insight.[24]

It was, however, in the Bauhaus that the various tributaries of formalist photography were systematically appropriated, theorized, and repositioned with respect to the range of practices and applications that were promoted pedagogically, artistically, and commercially. In much the same way that Weimar Germany was itself a cultural transmission station, the Bauhaus—in its various incarnations, and through its influential propagandists and productions (exhibitions, books, films, magazines, architecture, typography, etc.)—was a powerful cultural depot. With respect to photography, it is Moholy who is the cru-

ALBERT RENGER-PATZSCH, *FLATIRONS FOR SHOE MANUFACTURE*, CA. 1928,

GELATIN-SILVER PRINT, 9 1/16 × 6 11/16 IN. THE J. PAUL GETTY MUSEUM.

cial figure, even though photography was taught as a separate course in the Bauhaus only in 1929, and then not by Moholy but by Walter Peterhans.

Moholy had become friends with El Lissitzky in 1921, a year that witnessed the Russian influx into Berlin; Mayakovsky, Osip and Lily Brik, Ilya Ehrenburg, as well as artists like Nicholas Pevsner, Naum Gabo, and Wassily Kandinsky (hired to teach at the Bauhaus), who, although opposed in various ways to the productivist wing, were nonetheless the standard-bearers of the new Soviet art. By the following year, Moholy was making photograms in collaboration with his wife, Lucia, and producing photomontages. He was also independently repeating much of the same theoretical program as the productivists. Thus, in 1922, the year of his one-man show at the Sturm gallery, he included a group of so-called elementarist compositions, which like Rodchenko's last paintings, signaled not only a rejection of easel painting and its accompanying ethos of originality and subjectivity, but the positive embrace of mechanical methods of production as well. Moholy described his project in strictly matter-of-fact terms:

> In 1922 I ordered by telephone from a sign factory five paintings in porcelain enamel. I had the factory's colour chart before me and I sketched my paintings on graph paper. At the other end of the telephone the factory supervisor had the same kind of paper divided into squares. He took down the dictated shapes in the correct position.[25]

The following spring, Walter Gropius, the director of the Bauhaus, hired Moholy to become an instructor in the metal workshop, making him the exact counterpart of Rodchenko at Vkhutein. Moholy's arrival signified one of the first decisive shifts within the Bauhaus away from the earlier expressionist, utopian orientation aptly symbolized by Lionel Feininger's woodcut logo for the prospectus (a Gothic cathedral), under which Gropius's motto proclaimed, "Architects, sculptors, painters, we must all go back to the crafts." The atmosphere of the Weimar Bauhaus before the departure of its previous director, Johannes Witten, was almost the exact opposite of the functionalism and technologism associated with its later attitudes. The emphasis on crafts and artisanal modes of production in the curriculum was accompanied by vegetarianism, a vogue for oriental religions, and the occasional tenure of itinerant crackpots. Although consecutively expelled from the cities of Weimar, Dessau, and finally Berlin, and considered by the more conservative elements within local governments to be a very hotbed of Bolshevism, the Bauhaus tended to be viewed by the radical Left with a certain amount of contempt. The evaluation of *Starba*, the leading Czechoslovakian architectural periodical, was not atypical:

> Unfortunately, the Bauhaus is not consistent as a school for architecture as long it is still concerned with the question of applied arts or "art" as such. Any art school, no matter how good, can today be only an anachronism and nonsense. . . . If Gropius wants his school to fight against dilettantism in the arts, if he

assumes the machine to be the modern means of production, if he admits the division of labor, why does he suppose a knowledge of crafts to be essential to industrial manufacture? Craftsmanship and industry have a fundamentally different approach, theoretically as well as practically. Today, the crafts are nothing but a luxury, supported by the bourgeoisie with their individualism and snobbery and their purely decorative point of view. Like any other art school, the Bauhaus is incapable of improving industrial production; at the most it might provide new impulses.[26]

By 1923, however, the Bauhaus had undergone a fairly substantial change of direction. No longer "A Cathedral of Socialism," but, rather, "Art and Technology—A New Unity" was the credo. Notwithstanding the fact that the important international journals such as *De Stijl* and *L'Esprit Nouveau* still considered the Bauhaus too individualistic, decorative, and arty, Gropius was resolved to make the Bauhaus a force in architecture, industrial design, and contemporary art. The change of direction and the implementation of Gropius's ideas became fully established only after the Bauhaus's expulsion from Weimar and its re-establishment in Dessau, housed in the landmark buildings that Gropius himself designed.

Given Moholy's patron-saint status in the history of modern photography and his undeniable importance in the propagation of his particular variety of formalism, it is important to remember that Moholy never thought of himself as a photographer—he certainly never referred to himself as such—and that much of his enthusiasm for photography was predicated (at least in the 1920s) on his conviction that the machine age demanded a machine-age art—functional, impersonal, rational. Formalism for Moholy signified above all the absolute primacy of the material, the medium itself. Thus if photography, and indeed all photographic processes including film, was defined by its physical properties—the action of light on a light-sensitive emulsion—formalism could be distilled into a bare-bones recipe for the creation of exemplary works. Written out of this equation was not only any notion of a privileged subjectivity (in keeping with progressive avant-garde theory), but even the camera itself: "It must be stressed that the essential tool of photographic practice is not the camera but the light-sensitive layer."[27]

Moholy's codification of the eight varieties of photographic seeing in his 1925 Bauhaus book *Painting, Photography, Film* indicates to what degree his assimilation of Russian formalist photography tended toward a more purely theoretical and abstract rather than instrumental or agitational conception of "camera vision":

1. Abstract seeing by means of direct records of forms produced by light: the photogram . . .

2. Exact seeing by means of the fixation of the appearance of things: reportage.

3. Rapid seeing by means of the fixation of movement in the shortest possible time: snapshots.

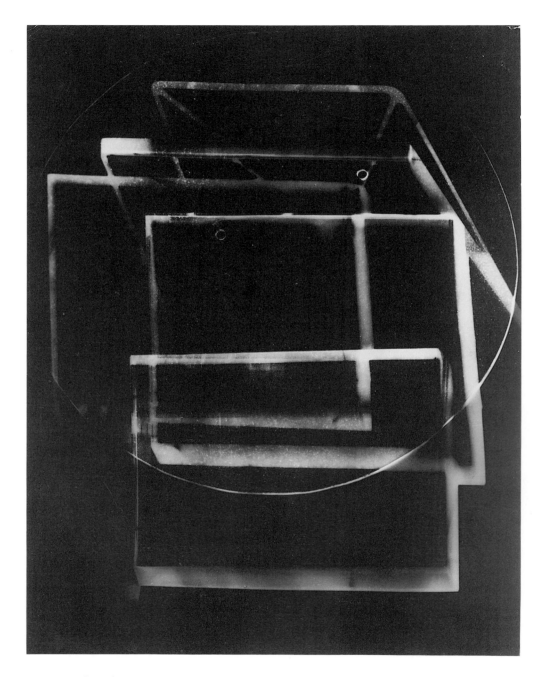

LÁSZLÓ MOHOLY-NAGY, *PHOTOGRAM*, BEFORE 1931, GELATIN-SILVER PRINT,
14 1/2 × 10 1/2 IN. COLLECTION, THE MUSEUM OF MODERN ART, NEW YORK.
GIVEN ANONYMOUSLY.

4. Rapid seeing by means of the fixation of movements spread over a period of time . . .

5. Intensified seeing by means of: (a) micro-photography; (b) filter-photography . . .

6. Penetrative photography by means of X-rays: radiography . . .

7. Simultaneous seeing by means of transparent superimposition: the future · process of automatic photomontage.

8. Distorted seeing . . . [28]

Whereas the technical and formal possibilities of photography were for Rodchenko, too, a wedge to prise open conventionalized and naturalized appearance, a visual device against classical and bourgeois representational systems, for him these constituted specific strategies in the service of larger ends. In Weimar Germany, the photographic production oriented toward those ends was to be primarily that of the photomontagist John Heartfield, whose means, needless to say, were not those of the formalists. To the degree that "camera vision" became itself a fetishized concept in Weimar culture, the political implications of Russian formalist photography were sheared away from the body of New Vision photography.

Moholy's embrace of photography, like Werner Graff's or Franz Roh's, did not in any way distinguish between the uses, intentions, and contexts of photographic production having thus the dubious distinction of anticipating contemporary critical and curatorial practice by a good forty years. In exhibitions such as the seminal "Film und Foto" and in publications such as Roh's *Foto-Auge* or Graff's *Es kommt der neue Fotograph!*, scientific, advertising, documentary, aerial, art and experimental, even police photography, were enthusiastically thrown together into an aesthetic emporium of choice examples of camera vision. Moholy's championship of photography, like that of his contemporaries, had finally more to do with the widespread intoxication with all things technological than it did with a politically instrumental notion of photographic practice. The camera was privileged precisely *because* it was a machine, and camera vision was privileged because it was deemed superior to normal vision. Herein lay the total reversal of terms that had historically characterized the art versus photography debate. "The photographic camera," wrote Moholy, "can either complete or supplement our optical instrument, the eye."[29]

Within the Bauhaus scheme of things, particularly in its Dessau days, photography existed merely as one of a number of technologies for use in the training of designers. Throughout the 1920s, Gropius sought to establish the Bauhaus as a source of actual production as well as a training ground for designers or a wellspring of ideas. In 1926 a limited company was set up by Gropius with a group of businessmen and the participation of some labor unions for the commercial handling of Bauhaus designs and products. Although the *politique* of the later Bauhaus remained collectivist, anti-individualist, and, of

course, emphatically functionalist, these were not necessarily radical positions within the political spectrum of the Weimar Republic. Moreover, the Bauhaus Idea—it was referred to as such at the time—envisioned a society made better through the work of the architects, designers, and craftsmen it produced. This, then, was the legacy that Moholy carried with him when he resurrected the New Bauhaus in the distinctly American terrain of the city of Chicago.

Within his own career Moholy had traveled from the militantly avant-gardist, revolutionary milieu of the *MA* group in Budapest, to the constructivist circle around El Lissitzky in Berlin, to exile in Holland, and later England, to land finally (and improbably) in the Middle West. As an *emigré* artist and educator, his activities between 1937 and his death in 1946 were dominated by his efforts to reconstitute the Bauhaus and the values it represented in a time and a place light years removed from the culture and politics of Weimar Germany.[30] The contradictions that *Starba* had identified in the Weimar Bauhaus between the demands of industry and the conditions of craft, between the different assumptions governing the production of art and the practice of applied arts, remained unresolved and increasingly problematic in the American version. These contradictions underlay the conflicts that seem regularly to have arisen between the expectations and assumptions of the New Bauhaus's initial sponsors (The Chicago Association of Arts and Industries, a consortium of businessmen, and Walter Paepcke, who was one of the principal supporters of the school until 1946) and Moholy's determination to transplant the Bauhaus Idea with as little compromise as possible. Similarly, these contradictions surfaced with every subsequent change of director, staff, enrollment, and student profile. While the curriculum of the Chicago Institute of Design remained basically comparable to its earlier German version (e.g., the first-year foundation course, the experimentation with various media, etc.), the nature of photographic teaching (and practice) became in time a distinct and discrete aspect of the Institute of Design, whose function was less linked to the imperatives of the industrial age than it was to those notions of art production that had preceded the establishment of the Institute in America by twenty years. Added to that was the fact that America after the Second World War was hardly a hospitable environment in which to transplant even the *bien-pensant* Leftism of the Dessau Bauhaus, and that American artists and photographers were in the process of implicitly or explicitly repudiating the politically and socially oriented practice of the previous decade, whose most developed expression had been in documentary form. How then was photographic formalism understood and expressed at the Institute? Was there, we might ask, a new inflection to formalism which made it substantially different from its earlier incarnations and might be seen to link Arthur Siegel, Harry Callahan, and Aaron Siskind? And what, if anything, made the Institute-based formalist practice similar to, or different from, the indigenous American variety—i.e., purist, straight photography—exemplified by Paul Strand after 1915, and the *f*/64 group in the following years?

Reflecting back on the various sea changes to which Russian photography had been subjected in Germany, what seems most conspicuous was the way various components of radical formalism were separated and factored into distinct discursive functions. Seriality, unusual close-ups, and isolated and dramatic presentation of the object were, as we have seen, promptly assimilated into advertising photography; defamiliarizing tactics such as unconventional viewpoints, the flattening and abstracting of pictorial space, all became part of the stylistic lexicon available to commercial photographers, art photographers, designers, and photojournalists—a lexicon, it should be added, that had, by the end of the war, assimilated surrealist elements as well. In a general way, formalism had become a stylistic notion rather than an instrumental one, an archive of picture-making strategies that intersected with a widely dispersed, heroicized concept of camera vision. In the work of Bauhaus and Bauhaus-influenced photographers, one of the most durable legacies of Russian photography was the continued emphasis placed on experimentation. It was this latter characteristic that made Institute photography rather different from American art photography of the 1950s and 1960s. Whether through the encouragement of color photography, or through the various workshop exercises utilizing photograms, light modulators, multiple negatives, photo-etching, collage, and so on, Institute photography encompassed a broad range of photographic technologies and experimentation that distinguished it somewhat from the dominant purism of East and West Coast art photography.

By the early 1950s, as the Institute became more firmly established and as the photography program gradually took pride of place in the curriculum—becoming, in fact, its principal attraction—the indigenous conditions and circumstances of American photography were themselves acting on the Institute. For Moholy, the pedagogical system of the Institute was conceived literally as a training program, a vocational system that would prepare designers, architects, and photographers to go into the world and in some vague, utopian sense, transform it. The enormously gifted Herbert Bayer, designing exhibitions, books, posters, and typography, employed by Walter Paepcke on the advertising series "Great Ideas of Western Man" for the American Container Corporation, was the very model of what Moholy intended his alumni to become and accomplish. But after the initial influx of G.I. Bill students, who studied at the Institute with the expectation of working as commercial photographers or professional photojournalists, the gulf between commercial or applied photography and the progressively rarefied approach to photography coming out of the Institute widened. And although Arthur Siegel (who had been one of the first photography teachers hired by Moholy) moved back and forth between professional photojournalism, teaching stints, and his personal work throughout his career, this form of professional life was to prove more the exception than the rule.

What eventually emerged from the Institute as model careers for serious photographers were those of Henry Holmes Smith, Harry Callahan, and Aaron Siskind; that is to

say, teachers of future generations of art photographers who would themselves end up teaching photography and, to a greater or lesser extent, pursuing their own photographic destinies within an expanding university and art-school network. This alone would have constituted a significant shift away from the Bauhaus Idea, inasmuch as up to that point, the *raison d'être* of the institution was the implementation of its program in the world of industry, design, and manufacturing. Indeed, the very notion of the artist-photographer producing images for a knowledgeable or peer audience was essentially at odds with the dynamic, public, and functionalist concept of photography sanctioned by the German Bauhaus.

Between 1946—the year of Moholy's death—and 1951, when Harry Callahan hired Aaron Siskind, the assumptions and principles governing photographic production at the Institute were already being inflected and altered as much by the American cultural climate as by the very different goals and ideas of the American staff hired by Moholy. Arthur Siegel (who ran the photography department between Moholy's death and 1949) was, in certain respects, the transitional figure, having one foot in the Moholy camp and the other in a mystified, privatized approach to the medium. Published statements by Siegel are such a jumble of the two approaches that it is difficult to distill what he actually meant. Here, for example, is Siegel on his first tenure at the Institute:

> My job, develop a four-year course of study for photographers. (With the help and hindrance of many students and teachers, I tried to weave the threads of European experimental and painting-oriented photography into the American straight technique of object transformation.) This attitude became a web of problems, history, and technique that, together with the whole environment of the school, provided an atmosphere for the gradually unfolding enrichment of the creative photographer. . . . Harry Callahan and Aaron Siskind carry on the rich teaching tradition that I inherited from Moholy-Nagy, Kepes, and others. . . . For if the fifties of photography had lyrical songs, part of the notes originated at the Institute of Design.[31]

Although it is difficult to pinpoint precisely when the nominally formalist framework of the Institute came to incorporate that very subjectivity which it had previously excoriated, Siegel's "personal" work, as well as his statements, suggests that this shift in emphasis was well in place by the end of the 1940s. It is worth mentioning, too, that in Siegel's work one finds a combination of technical experimentation with the medium coupled with a rather ghastly self-expressive intent, illustrated by projects such as the series of color photographs made in 1951, collectively entitled "In Search of Myself," and undertaken, as John Grimes indicates, at the suggestion of Siegel's psychoanalyst.

Harry Callahan's arrival at the Institute in 1946 (he was hired by Moholy himself, shortly before his death) could only have confirmed this direction. A self-taught photographer for whom photography was, according to John Szarkowski, "a semi-religious

calling,"[32] and whose exposure to Ansel Adams and his work in 1941 was both revelation and epiphany ("Ansel is what freed me"),[33] Callahan was as far removed from the machine-age ethic of Bauhaus photography as anyone could possibly be. As early as 1941, with photographs such as the calligraphic study of reeds in water (*Detroit*, 1941), Callahan was single-mindedly developing a body of work that would probably have been little different had he never set foot in Chicago. Characterized by a consistent and intensely personal iconography (the face and body of his wife Eleanor) and great elegance and purity of design and composition, Callahan's photography had more in common with the work of Minor White, or even Stieglitz, than it did with Moholy's. Although one could argue that certain kinds of work produced by Callahan after coming to Chicago—the collages, multiple exposures, series, and superimpositions—were the result of his exposure to Moholy's ideas and the Institute environment, some of this experimentation had, in fact, preceded his arrival. In any case, few would dispute that Callahan's influence on the future orientation of the Institute photography program was profound. Beyond any consideration of the direct influence of his photographs was the fact that he came to exemplify the committed art photographer—equally aloof from marketplace or mass media, content to teach and serve his muse. "The interior shape of private experience,"[34] coupled with a rigorous concern for formal values, effectively constituted Callahan's approach to photography, and this, more than any of Moholy's theoretical formulations, constituted the mainstream of American art photography through the 1960s.

That a subjectivized notion of camera-seeing should have come to prevail at the Institute by the 1940s is not surprising. Reflecting on the political and cultural climate of America in the ten years following World War II, it seems inevitable that the last tenet of radical formalism to have survived the ocean-crossing—I refer here to the belief that the camera was a mechanical (no quotes), objective, impersonal, and rational device fully in keeping with the imperatives of advanced, technological societies—should finally be engulfed by the dominant ethos of art photography. Surely one of the significant factors shaping all noncommercial photography by the end of the decade was that certain kinds of documentary practice had become politically suspect. The influential and politically Left-wing New York Photo League was included in the attorney general's list of subversive organizations by 1947, and many documentary photographers felt that their subject matter alone made them politically vulnerable.

Discussing this period in her essay "Photography in the Fifties," Helen Gee gives a particularly suggestive example in the case of Sid Grossman, the director of the Photo League's School and an acknowledged radical:

> Remaining virtually in hiding, afraid of the "knock on the door," he complained of no longer feeling free to work on the streets. He escaped as often as he could, seeking the solitude of Cape Cod. His work between 1948 and the time of his death in 1955 . . . shows a clean break, a complete change in subject matter.

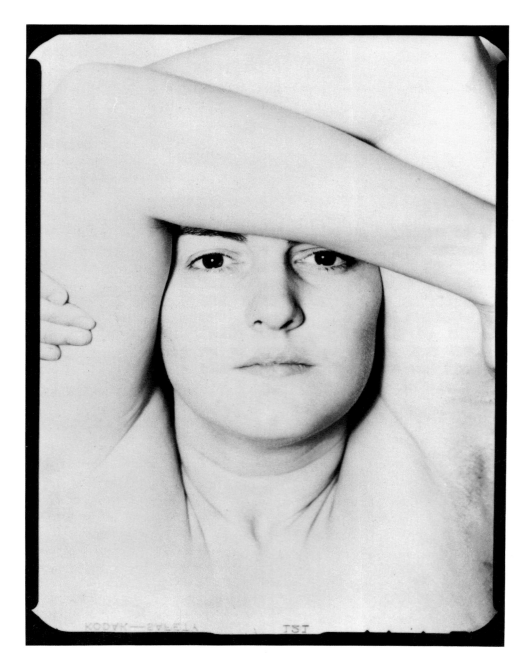

HARRY CALLAHAN, *ELEANOR*, CA. 1947, GELATIN-SILVER PRINT,

4 13/16 × 3 9/16 IN. COPYRIGHT: HARRY CALLAHAN, COURTESY PACE/MACGILL

GALLERY, NEW YORK. COLLECTION, THE MUSEUM OF MODERN ART, NEW

YORK. ACQUIRED WITH MATCHING FUNDS FROM THE JOSEPH G. MAYER

FOUNDATION INC. AND THE NATIONAL ENDOWMENT FOR THE ARTS.

From the lively images of rambunctious teenagers on the Coney Island beaches, he moved to contemplative scenes of sea and sand in Provincetown, a change which appears to be more psychological than geographic. While an extreme example of a shift from a documentary approach to a reflective, interior response to the world, it is symbolic of a change in sensibility that affected American artists, either consciously or unconsciously, during the decade of the fifties.[35]

It is interesting in this light to return to the Szarkowski essay on Callahan, which subtly suggests that Callahan's stature as an artist was somehow reinforced by his refusal of the then-prevalent social documentary mode: "Activist photography in 1941 seemed new, important, adventurous, and there was a market for it. Nevertheless, Callahan was not interested. For him, the problem was located at the point where the potentials of photography and his own private experience intersected. . . . His attitude toward this question has not changed."[36]

But well before the machinery of HUAC, McCarthyism, and the Cold War had been put in place, American art culture was shifting away from agitprop production and the Popular Front program of solidarity with the masses toward the postwar embrace of an international modernism whose most exalted representatives and avant-garde elite were the abstract expressionist painters of the New York School.[37] For many American art photographers who had, in various ways, accommodated themselves and/or modified their work in conformity with the concerns of the Depression years,[38] the later depoliticizing of American culture truly constituted a return to normalcy. The battle to legitimate photography as an art had been consistently waged in terms of the camera's ability to express the subjectivity and unique personal vision of the photographer, and with the postwar valorization of individualism, detachment, and originality, art photographers returned again to their historic agenda.

It is against this background that we need to survey what, *faute de mieux*, we might consider the Callahan-Siskind High Formalist period at the Institute, which may be said to have started in 1951 when Callahan hired Siskind after becoming head of the Photography Department in 1949. In an article on Chicago photography, Andy Grundberg points out that the two men "overthrew or redirected much of Moholy's emphasis,"[39] although I am inclined to think that the process had begun under Siegel, or in any case, before Siskind's arrival. Grundberg further points out that

As enrollment increased and a graduate degree program was added, the New Bauhaus curriculum was de-emphasized. The preliminary course, which mimicked Moholy's original progression in the medium — from photograms to paper negatives, multiple exposures, out-of-focus images, etc. — was retained but lost some importance. Callahan and Siskind both resisted emphasizing experimental techniques (Callahan: "I didn't care anything about solarization and negative prints . . . "; Siskind: "I had no interest in the Bauhaus philosophy. I found all that experimentalism stuff a little uncongenial to me.").[40]

The surprise is that the tradition of technical experimentation, including the mixing of media, remained as strong as it did in the post-Moholy Institute. But inasmuch as Callahan and Siskind were, for the ten-year period between 1951 and 1961, the dominant photographic influences in the school—both through their teaching and the prestige of their work—it is evident that whatever vestiges remained of the earlier concept of formalism and its resolutely anti-idealist substrata were entirely eclipsed by the subjectivization of vision championed and practiced by both men. It might be noted, too, that art photography of the early 1950s is represented by figures such as Minor White, Frederick Sommer (who spent a year at the Institute while Callahan was abroad on a grant), and Ansel Adams, and that *Aperture*, with White as its editor, was launched in 1952.

In retrospect, Aaron Siskind seems so perfectly to represent the cultural and photographic adjustment of the period that one is tempted to present him as the emblematic figure *par excellence* for art photography's postwar retreat from engagement with either social *or* political reality. It is not only in the fact of Siskind's abandonment of the social-documentary work of his Photo League days (exemplified by the Harlem Document project) and his shift to the production of the virtual abstractions from 1944 on that one sees the magnitude of the larger social transformation (Siskind, after all, continued to teach documentary photography at the Institute for years). Rather, the enormousness of the shift is signaled in Siskind's zealous embrace and assimilation of Clement Greenberg's doxology of modernism—the *ne plus ultra* of Anglo-American formalism—as the theory and ground of his work. "First and emphatically," wrote Siskind in his "Credo" of 1956, "I accept the flat picture surface as the primary frame of reference of the picture."[41] And two years later: "As the language or vocabulary of photography has been extended, the emphasis on meaning has shifted—shifted from what the world looks like to what we feel about the world and what we want the world to mean."[42] This interiorized *purified* notion of art-making is, of course, closely linked to similar attitudes current among the New York School artists with whom Siskind was allied, both by friendship and through dealers (he exhibited from 1947 to 1957 at the Charles Egan Gallery). In the same way that action was redirected from the political field to the field of the canvas among abstract painters, Siskind's arena became equally circumscribed. "The only other thing that I got which reassured me from the abstract expressionists," said Siskind in a 1973 interview, "is the absolute belief that this canvas is the complete total area of struggle, this is the arena, this is where the fight is taking place, the battle. Everybody believes that, but you have to really believe it and work that way. And that's why I work on a flat plane, because then you don't get references immediately to nature—the outside world—it's like drawing."[43]

What is striking about Siskind's enterprise is not simply that he produced photographs that look like miniature monochrome reproductions of Klines or Motherwells—if one believes taking a photograph to be just like making a drawing, why not?—but that the macho posturing, the heroicizing of self-expression is so extreme as to border on the parodic. Furthermore, there is manifest a stubborn, indeed a *perverse* denial of the material

. .

processes of photography, grotesquely dramatized and mystified into a Hemingwayesque litany of combat, struggle, fights, battles. Existential chest-thumping aside, that more than an enthusiastic conversion to Greenbergian formalism was involved in Siskind's rejection of the documentary mode (a mode which in no way precludes documentary pre-occupations, *vide* Walker Evans and Siskind himself) is suggested by Siskind's photographs of *writing*, and political writing at that.

> I've done a lot of them [torn political posters]. You may have seen some, they're big political slogans in huge letters, put on walls, and then someone comes along and paints them out and they make these marvelous forms. . . . That goes back to 1955, but since then I've found many more and the interest has gotten more

AARON SISKIND. *YUCHITAN, MEXICO*, 1955, GELATIN-SILVER PRINT,

15 1/8 × 19 1/4 IN. COLLECTION, THE MUSEUM OF MODERN ART, NEW YORK.

GIFT OF THE PHOTOGRAPHER.

81

complex, in that I began to realize to some extent that they are political. I wasn't interested in the politics. . . . I was interested in the shapes and the suggestibility of the shapes.[44]

It is tempting to see in the very extremity of this refusal of political meaning in the world the operation of mechanisms of denial and displacement: first, in the effacement of a specifically political text and the ingenuous denial of its political signification; and second, in the conflation of abstracted forms with transcendent meaning, thereby consigning political utterance to the aesthetic ether of suggestive shapes.

That the formalism espoused by Callahan or Siskind derives from an idealist aesthetics rather than a materialist critical practice is obvious; that their work relates more to the mainstream currents in American art photography should be equally so. Somewhere between the American transcendentalist version of formalism and the Soviet model lies Bauhaus photography: responsive to certain aspects of revolutionary thought, but functioning within, and in the service of, an advanced capitalist society tottering on the brink of Fascist consolidation.

Most of what is meant by "Chicago School" or specifically "Institute photography" is the work of photographers who emerged during the 1960s (exceptions would include Art Sinsabaugh, who graduated in the 1940s, Richard Nickel, who graduated in 1957, and Ray Metzker, class of 1959). Neither Siskind nor Callahan seems to have exercised direct influence on their students' production, insofar as few of their students' work resembles their own. Rather, the influence would appear to center around the assertion—provided as much by example as by exhortation—that art photography, at the highest level, represented the expression of a privileged subjectivity, whose relation to the social world was at most that of cultivated *flâneur*, and the use of the formal properties of the medium to express that subjectivity. Given that radical formalism had been launched with a blanket repudiation of such notions, there is finally very little that remains to link Soviet or Weimar photography with the productions of the Institute. The pedagogic formalism which was developed and refined throughout the 1950s and 1960s provided Institute photographers with certain kinds of building blocks, frameworks, structures—or, at the most trivial level, *schticks*—which, in a general sort of way, might be said to constitute a recognizable look. The emphasis on "problem solving," the concept of serial projects, interior framing devices, and other self-reflexive strategies, emphasis on the design element in light and shadow and positive and negative space, dark printing, certain types of subject matter, technical experimentation, acceptance of color technologies, all are identifiable aspects of Institute formalism. This type of work, and the precepts which inform it, has in turn been widely propagated, largely because most art photographers end up teaching new generations of art photographers. With the quantum leap in photographic education that occurred in the mid- to late-1960s (the number of colleges teaching photography expanded from 228 in 1964 to 440 in 1967), as well as the growth of a photography marketplace, Institute photography was further validated and promoted.

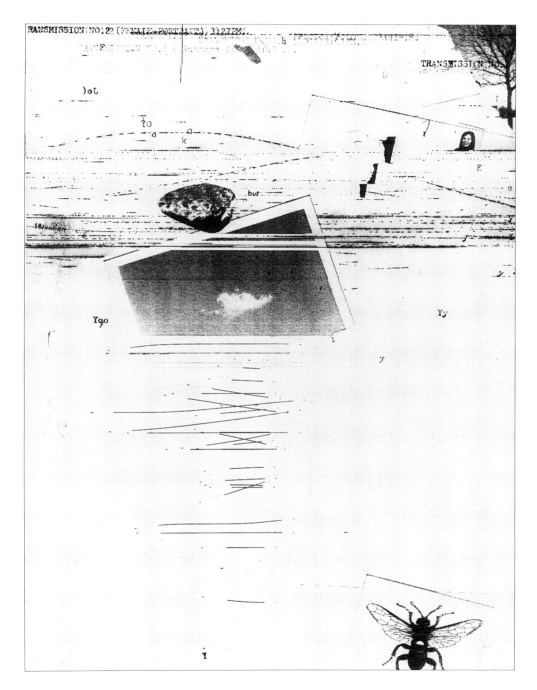

WILLIAM LARSON, *TELEPHONE TRANSMISSION*, 1975, ELECTRO-CARBON

PRINT, 8 1/2 × 11 IN. COURTESY OF THE ARTIST.

There is, of course, no fair way to generalize about the range of work made by as many (and disparate) photographers as Thomas Barrow, Barbara Blondeau, Linda Connor, Barbara Crane, Joseph Jachna, Kenneth Josephson, William Larson, Ray Metzker, Richard Nickel, Joan Redmund, Art Sinsabaugh, Joseph Sterling, Charles Swedlund, Charles Traub, and John Wood, to name only the mere handful with whom I am familiar. I would, however, venture to say that at its best, as in Josephson's "History of Photography" series, an Institute project is witty and intelligent, or, in Metzker's work, graphically striking, but that at its worse—or average, for that matter—such photography reveals only the predictable results of a thoroughly academicized, dessicated, and pedagogical notion of formalism. In neither case, and on the spectrum of best to worst, is it likely to produce anything really interesting. For new art—art that is animated by new ideas and fresh perceptions—is what compels us to revise, alter, or reinvent our critical vocabularies, not reprocess ones from fifty years ago.

And though I am compelled to admit that, in comparison to what passes for formalist art photography nowadays, the Institute photographers cited above can seem mildly interesting, this can only be considered as damning with faint praise. The basic issue is whether Institute formalism, or its MoMA version, for that matter, has not become a *cul-de-sac*. The Institute tradition of experimentation and serial work notwithstanding, what one sees over and over again is a recapitulation of various devices and strategies which exist as guarantors of sophistication and mastery, but rarely exceed the level of academic, albeit accomplished, exercises. And inasmuch as so many of these photographers can be presumed to be serious, intelligent, and committed to their art, I wonder at what point they may begin to question whether the concerns of art photography may properly extend beyond the boundaries of the creative, the self-reflexive, or the subjective? As the tumbrels for the photography boom begin to be heard in the land, as the markets that have supported the post-1960s art photography begin to collapse like deflated balloons, the body of art photography produced in the past twenty years will be subject to ever more rigorous criticism, if it does not slip through the critical net altogether, consigned to oblivion. The formalism which sustained the best work of a Callahan or a Siskind has run its course and become useless either as pedigree or foundation. Walter Benjamin's prescient warning on the results of the fetishizing of the creative seems as applicable to present-day art photography as it was to the photography of Renger-Patzsch and his milieu which had, at the very least, the gloss of newness.

1983

II

PHOTOGRAPHY AND POSTMODERNISM

BARBARA KRUGER, UNTITLED, 1982, UNIQUE PHOTOSTAT, 71 3/4 × 45 5/8 IN.,

WITH FRAME 72 7/8 × 46 3/4 IN. COLLECTION, THE MUSEUM OF MODERN ART,

NEW YORK. ACQUIRED THROUGH AN ANONYMOUS FUND. COURTESY OF

THE ARTIST.

4

· ·

Playing in the Fields of the Image

A CODE CANNOT BE DESTROYED, ONLY "PLAYED OFF." — ROLAND BARTHES

T hat the impulse to pastiche has to a greater or lesser extent replaced the impulse to invent has become unmistakable within a broad range of postmodern practice, manifest in both mass culture and in fine art. Whether expressed in the commercial films of Brian De Palma, or more rigorously and uncompromisingly in the production of independents such as Bruce Conner,[1] whether in the wholesale recuperation of styles derived from the art-history image bank that now comprises a significant proportion of current art production, or in art works that specifically involve the appropriation of pre-existing and ready-made images, as in the video work of Dara Birnbaum[2] or the re-photographed photographs of Sherrie Levine, it is evident that modernist notions of autonomy, authenticity, originality, and self-referentiality are now, for all intents and purposes, less hallowed than hollowed.

Where once such notions functioned as the very warranty of the transcendence and immanence of the work of art, their authority—indeed their validity—is now very much in question. Challenges to the modernist citadel are nowadays regularly hurled from the Right (e.g., Hilton Kramer's swan song for the *New York Times*, "When Modernism Becomes Orthodoxy")[3] as well as from the Left (e.g., Allan Sekula's "Dismantling Modernism, Reinventing Documentary")[4] and perhaps most persuasively, in that it specifically addresses and describes contemporary art practice, from what is latterly termed the post-structuralist position—the criticism of Douglas Crimp, Rosalind Krauss, and Craig Owens.

But while critiques, not to say autopsies, of modernism have become increasingly prevalent, and although substantial bodies of contemporary work are clearly obdurately resistant to any variety of modernist exegesis or formalist analysis, barely a tremor of this ground swell has reached the domain of art photography. To the degree that modernism has historically facilitated and justified photography's ascent, it is not surprising that mainstream art photography should continue to identify its purposes with the modernist tenets that supplied its identity and assured its legitimacy. Moreover, having been for most of its historical life always the bridesmaid and never the bride (or, in an earlier and famous characterization, handmaiden to, rather than full-fledged member of, the fine arts), art

86

photography may be seen to have won the game at approximately the point when the rules were changed. Other interpretations have it that its final, triumphant ascension to parity with the traditional fine arts was achieved precisely *because* conditions were changed.[5]

I am less concerned here to discuss the circumstances and conditions that determined art photography's ultimate vindication than I am to examine the differences between the concerns of contemporary art photographers and those expressed in the use of photography by a growing number of young artists. This operational distinction, which I initially proposed in an earlier essay,[6] is a somewhat problematic one, chosen with some hesitation. I employ it, reservations notwithstanding, not as an automatic valorization of photographic usages by the latter group at the expense of the former, but, rather, as an improvised schema for distinguishing between vastly different—not to say antithetical—conceptual approaches and purposes, means and ends.

The conviction that the art photograph is the expression of the photographer's interior, rather than or in addition to the world's exterior, has been almost from the medium's inception *the* doxa of art photography and a staple of photographic criticism since the mid-nineteenth century. Implicit in the notion of the photographer's expressive mediation of the world through the use of his or her instrument is a related constellation of assumptions: the subjectivity of vision and the camera as medium of that subjectivity; the sovereignty of authorship; the belief that the meaning of a photograph exists autonomously within the boundaries of its frame. That these assumptions are coeval with modernism—what Walter Benjamin called the theology of art—and are, in fact, its photographic analogue, have to a considerable extent determined the ethos as well as the fortunes of art photography. It was, and is, the hegemony of this belief system that integrates within a unified field the photography of F. Holland Day and Garry Winogrand, the criticism of Sadakichi Hartmann and John Szarkowski. Contemporary art photography, or, more specifically, what I would term mainstream art photography, represents for the most part the mining of an exhausted lode. To judge from several years of assiduous gallery going in New York, the field remains pretty much as it was defined over fifty years ago, inevitably producing a multiplicity of academic reprises, retrievals, reworkings, and recuperations, the most recent of these being the so-called new formalist photography. The obsequies now beginning for the halcyon days of the photography boom may have something to do with the general state of institutionally fostered academicism as much as with the collapse of an inflated and overextended market.

To summarize briefly, one might say that the internal logic of the development of the *genus* art photography determined that its critical discourse would be premised on an aesthetic of the *photographic*, whether this aesthetic was thought to derive from the intrinsic beauties and qualities of the medium itself (the spectrum of tones from white to black, the clarity and precision of the camera image, the camera's ability to create spatial and formal abstractions from the random flux of the world, etc.) or, alternatively, as the deployment

of the "artist's choices" inherent in John Szarkowski's ontology of the photographic image (the thing itself, the detail, the frame, time, and the vantage point).

In marked contrast to the art photographer's preoccupation with the aesthetic of the photographic, the artists who began to use photography in the 1960s were infinitely more concerned with photography as such; that is to say, as a mechanically reproducible image-making technology entirely assimilated to the apparatuses of consumerism, mass culture, socialization, and political control. The aesthetic dimension of photography—to the extent that it was present at all (and in the work of John Baldessari, Robert Rauschenburg, Ed Ruscha, or Andy Warhol, it was conspicuous by its absence)—was considered of far less importance than its ubiquitous and normative uses. The forceful recognition that photography constituted an image environment, a complex and ready-made sign system, as much as it was comprised by a plurality of discrete images, provided the impetus (as well as the raw material) for a broad range of art production. Strategies involving the conscription and appropriation of mass-media, vernacular, and advertising images were manifest in pop art, conceptualism, performance art and multi-media work, and, of course, photo-realism. In its purely documentary and transcriptive forms, photography was employed to record site-specific works, events, objects, or actions that had been orchestrated, constructed, or arranged to be constituted anew, preserved, and re-presented in the camera image.

Common to all these variations was the propensity to discard altogether the intentions and aspirations of art photography as traditionally defined and practiced. Whereas art photography had been compelled to define itself in opposition to all the normative attributes and applications of the medium, it was precisely these functions that artists embraced. And within the compass of possible attributes of the photographic image, subjectivity and self-expression—the very hallmark of the art photograph—was emphatically denied. It is this denial, if not the overt repudiation, of the discourse of subjectivity that distinguishes the work of (many) artists from (most) art photographers. The terms of this opposition are therefore not aesthetic ones, inasmuch as aesthetic notions of photography are being jettisoned as thoroughly as expressive ones. Thus, photographic productions as dissimilar in intent and appearance as Victor Burgin's photo/text works, Bernd and Hilla Becher's encyclopedic typology of industrial structures, or Gilbert and George's photographic documentation of themselves as art objects are nonetheless related by their joint repudiation of authorial presence. To be sure, this systematic evacuation of expressivity and subjectivity has numerous antecedents and precedents: dada and Duchamp; constructivism, pop art, minimalism—the list could easily be extended. But what is significant here is that for a number of artists using photography who came of age in the late 1970s, this was less a position arrived at than a point of departure.

For artists such as Vikky Alexander, Barbara Kruger, Richard Prince, and James Welling, whose work I will briefly discuss, the values and assumptions of modernism did not so much impel an active rejection as an *a priori* acknowledgment of foreclosure. Al-

CHRISTO, *VALLEY CURTAIN, RIFLE, COLORADO,* 1970-72. PHOTOGRAPH BY

HARRY SHUNK. COPYRIGHT CHRISTO, 1972. COURTESY OF THE ARTIST.

exander, for example, who is Canadian, remarked that at the Nova Scotia College of Art and Design, which she attended in the mid-1970s, the problem was how to make work of *any* kind. Within a pedagogical context that privileged conceptual art (the college was known as the black and white school), and a sophisticated and politicized apprehension of the mechanisms of cultural production and consumption, one possible route was signaled by the shift in art from production to reproduction. Alexander, Kruger, Prince, and Welling—important differences among them notwithstanding—are, therefore, here considered together insofar as their work engages the issues I have attempted generally to sketch out. Common to their respective practices is an examination of the structures and mechanisms of photographic meaning—in the case of Alexander and Prince, with particular emphasis on the photograph as bearer of cultural mythologies. By foregrounding these mechanisms in their work, they attempt to turn them back in on themselves, encouraging an active and analytic, rather than passive or contemplative reading on the part

of the viewer. Pastiche can thus be seen to function as an instrument of both construction and deconstruction. However, it is important to note that it is in its critical intention and effect that one distinguishes pastiche as an instrument of critical practice from pastiche as a symptom of creative impoverishment, or of routine mass-media production. The boundaries and limitations of these artists' production are implicitly acknowledged in their work, and that is why the epigraph of Roland Barthes with which this essay opened seemed such an apt characterization of their collective intentions.

Alexander's *modus operandi*, shared with a growing number of other artists, is primarily one of appropriation: images are simply lifted, purloined, taken—be it from the television screen, the billboard, the fashion-magazine advertisement. Such, in fact, was the chronological evolution of her appropriative strategies. However, what provided the framework remained consistent: to break down, to decode, to bracket, to deconstruct. The field of the image, particularly in its mass-media incarnations, was thus to be winnowed, the deceptive guise of nature and transparency pared away to expose the strictures and structures of ideology and desire. For Alexander, as for the others, the "playing off" of codes provides the framework of a radical art practice whose forms are based on the recognition that all forms of representation are already in place, already conventionalized. "What," asked Barthes rhetorically in the essay "Change the Object Itself," "are the articulations, the displacements, which make up the mythological tissue of mass consumer

VIKKY ALEXANDER, *NUMÉRO DEUX*, 1981-82, TYPE C PRINT, 36 × 120 IN.

COURTESY OF THE ARTIST.

society?" It is precisely this examination of the "mythological tissue" that provides both motive and method in Alexander's work.

In the past two years, Alexander's work has drawn upon photographs printed in fashion magazines, generally from the more upscale varieties of advertising (e.g., Gianni Versace), the *locus classicus* of both commodity fetishism and the reification of the feminine. Alexander's conscription of the fashion model, the postindustrial icon of Woman whose bone structure and make-up constitute a virtual tribal mask eliciting desire and veneration, is intended to so amplify the image's codes, so underscore its overdetermination, that the image in effect deconstructs itself. In her selection of certain types of mannequin—at once totally specific and totally generalized—and then by cropping, flopping, or otherwise manipulating their placement on an undifferentiated ground, Alexander insists on their iconic status as priestesses of consumer culture. Diptych and triptych formats, which she has also employed, not only reinforce the reading that these are the surrogate Virgins and Magdalens of a secular society, but conjure up ghostly allusions to the formal and compositional devices of traditional religious painting. This crazy-quilt of dissonant image types—with their own associations, mythologies, and significations, spinning off from what Barthes described as the "polysemic" aspect of the photographic image—becomes in Alexander's work the actual subject. For what functions to stabilize— to "normalize"—the picture is the thoroughly conventionalized nature of the representations themselves. In her most recent work, Alexander has joined the high-gloss archetypal mannequin and the high-gloss archetypal landscape. Seamlessly collaged in a work entitled *Monument Valley*, the *National Geographic* beauty of the landscape and the *Harper's Bazaar* beauty of the model effectively subvert each other's presence and simultaneously bracket their respective mythologies. Playing off is here made literal.

If Alexander's strategy is to use the image (or images) against itself, orchestrating her photographic image repertoire like an impresario of pastiche, Kruger's approach is both more direct and more confrontational. Whereas Alexander's mythical terrain is composed of the deceptively benign discourses of femininity, fashion, glamorized sexuality, and glamorized landscape, Kruger's photo/text work makes no concessions to glamor. Furthermore, Kruger's appropriated images tend to be more aggressive, funky, or even violent. Thus, if Alexander is concerned to unmask the devices of seduction, Kruger may be said to unmask the conditions for rape (here understood as a mechanism of power, rather than an act of sexuality). To make invisible social and political forces visible has, of course, been an important goal of politicized art practice at least since the 1920s, and Kruger's work can be seen as linked conceptually and formally to that of John Heartfield's— certainly one of the more successful deconstructors of the photographic image.

In his important essay "On the Invention of Photographic Meaning," Allan Sekula observed: "The overwhelming majority of messages sent into the 'public domain' in advanced industrial society are spoken with the voice of anonymous authority and preclude the possibility of anything but affirmation."[7] It is this voice of impersonal, anonymous,

VIKKY ALEXANDER, *YOSEMITE,* **1981, CIBACHROME, 10 × 20 IN.**

COURTESY OF THE ARTIST.

and masculine authority that Kruger mimics, typically in the form of phrases or individual words in boldface type emblazoned across the image. Like Alexander's, the photographs themselves are appropriated, but instead of the sleekly elegant blandishments of fashion, Kruger generally works with vaguely retro, generic-seeming black and white images — images that seem quite as anonymous (but familiar) as the texts that label them.

That the mass media are agents of cultural control and domination is relatively easy to theorize, but somewhat harder to demonstrate in art practice. What is therefore particularly important in Kruger's work is her use of the technologies and forms of mass communication (for example, billboards, posters, matchbooks, and so forth) to reveal (unmask) the patriarchal base that is a substrate of all institutionalized forms of oppression. Where texts are superimposed on photographs, they are typically declarative and frequently accusative. Thus, a photo of an atomic-bomb test is captioned "Your manias become science," with the words "your" and "science" both in larger typeface and printed

BARBARA KRUGER, UNTITLED, 1982. COURTESY ANNINA NOSEI GALLERY.

black on white, rather than white on black. In another work, a swatch of long blonde hair is impaled on a cluster of spikes mounted on a board. The caption reads "You have searched and destroyed," with the same typeface used for "searched" and "destroyed." In the former work, "your science" is understood to be masculine ("yours"), maniacal, and, via the signifying function of the photograph, utterly destructive. In the latter, the significance of impalation requires no elaboration, but the emphasis on "searched and destroyed" makes the necessary political link between the violence done to women and the violence done to subject populaces.

Kruger's work, which is explicitly political and explicitly feminist, is equally concerned with the mechanisms (semantic, rhetorical, textual, and discursive) of photographic meaning. Consistent with the analyses of photographic meaning proposed by Barthes,[8] Kruger's work demonstrates the contingency of such meanings and their essential instability. This permits her to effect decisive shifts in the meaning of her found images

BARBARA KRUGER, UNTITLED, 1981, 37 × 50 IN. COURTESY OF THE ARTIST.

through the imposition of her cannily composed texts. For example, an image of a (headless) woman with clasped hands bears the legend in uppercase characters "PERFECT." The hands are stressed by the application of a screened rectangle. Is this headless presence the incarnation of 1950s good girl-ness or a vignetted image of prayer as ladder to spiritual perfection? The use of text superimposed on the image, normally thought to fix or anchor meaning, is here revealed to be as ambiguous as the image. However, these texts perform a crucial function in two ways: first, by producing politicized meanings against the grain of the image, and second, by empowering female spectators through a tactical use of linguistic shifters (e.g., "you," "we" etc.).[9] Thus, where the "you" in "Your manias become science" indicts a male "you," the "we" in "We won't play nature to your culture" or in "We have received orders not to move" operates to create a discursive space for female identification and opposition. In Kruger's work, as in Alexander's, the site of representation itself provides the arsenal for insurgency.

94

BARBARA KRUGER, UNTITLED, 1980. COURTESY MARY BOONE GALLERY.

In the case of Richard Prince, whose work plays off the highly mediated and techno-logically sophisticated advertising image, no external space for contestation is proposed. But what is particularly interesting in Prince's methods are his efforts to match—to counter—the highly manipulated and often synthetically composed advertising image with a comparable degree of simulation of his own. In this regard, Kate Linker has sug-gested that the theoretical model for Prince's production be located in Jean Baudrillard's concept of the simulacrum, which surpasses representation and reproduction and, instead, produces a synthetic "hyperreality," "a real without origin or reality."[10] Much of the power of Prince's work derives from his ability to make the theoretical concept of the commodity fetish at once concrete and visible. This is achieved through the technique of rephotography—an appropriative strategy involving various levels of technical medi-ation—but it is important to stress that what determines the effect of such images is a function of *what* has been appropriated and *how* it has been re-presented. The hyped-up, almost hallucinatory quality of his details of cigarette ads, close-ups of expensive watches, shimmering whiskey logos, etc., is isolated, cropped, enlarged, or variously modified in ways that instill a vague but palpable sense of menace. There is an obsessional quality about Prince's work that has little to do with the irony (and its accompanying distancia-tion) that characterizes much appropriative practice. The element of nightmare that subtly attaches itself to the erotic glitter and voluptuousness of the commodity (or the ambience of the commodity) recalls the traditional Christian emblem of Luxuria—the head of a beautiful woman merging into the body of a serpent.

Prince's rejection of traditional notions of authorship, while less programmatic than, say, Sherrie Levine's, has nonetheless originated in a comparable understanding of the conditions of cultural production in spectacular society. Prince's relation to authorship (as

RICHARD PRINCE, UNTITLED, 1980, SET OF THREE EKTACOLOR PRINTS, EACH

20 × 24 IN. COURTESY BARBARA GLADSTONE GALLERY.

well as his own working methods) could well be characterized by a line from his novel *Why I Go to the Movies Alone*:

> His way to make it new was to make it again . . . and making it again was enough for him and certainly, personally speaking, "almost him."[11]

The notion of identity as an unstable "almost him" parallels the perception of reality as both fully conventionalized (already seen, already read) and congealed into a phantasmagoria of images and simulacra. Reality is thus no more able to be located in the world than "authenticity" can be located in the author.

Of these four artists, James Welling is the only one who makes, rather than takes (literally), his photographs. The exquisite, lapidary quality of his pictures, their apparent abstractness as well as their sharply focused perfection would seem superficially to link him more closely to the tradition of high modernist art photography than to the practices of postmodernist appropriators and pasticheurs discussed above. Reviewing his first New York exhibition, one photography critic did, in fact, connect Welling's work to Alfred

RICHARD PRINCE, UNTITLED, 1977-78, EKTACOLOR PRINT, 20 × 24 IN.

COURTESY BARBARA GLADSTONE GALLERY.

97

JAMES WELLING, UNTITLED, 1980, GELATIN-SILVER PRINT,

3 1/4 × 4 1/4 IN. COURTESY OF THE ARTIST.

Stieglitz's cloud studies, the *Equivalents* series, a connection doubtless further suggested by the lack of spatial (which is top, which is bottom?) coordinates in Welling's photographs. But Stieglitz's symbolist intentions have little to do with Welling's own. In this particular series, the field of the image is composed exclusively of glittering facets of white highlights on a black ground. As it happens, these photographs—contact prints—depicted various aspects of sheets of crumpled aluminum foil. Unlike the "found" abstractions of Edward Weston, Frederic Sommer, or, later, of Aaron Siskind, these photographs were intended to be transparently, "mythologically" transcriptive, intended to invoke neither the poetry of the world's surfaces nor its hitherto overlooked beauties. Even less were they designed to function as records of the photographer's subjective, mediating sensibility. Rather, Welling was actually making photographs that were as close to being pictures about nothing as could possibly be contrived. And because the very notion (as well as

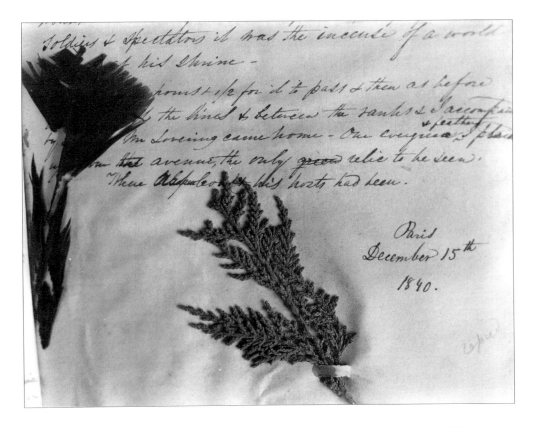

JAMES WELLING, UNTITLED, 1977, GELATIN-SILVER PRINT, 3 3/4 × 4 4 1/2 IN.

COURTESY OF THE ARTIST.

99

construction) of the photograph requires that it possess a subject, a referent, and mandates that it be in some fashion about something in the world, the manifest lack of content in no way blocks or neutralizes the viewer's need to project some meaning. The critical recognition—in both senses of the word critical—that the photographic image simultaneously elicits and frustrates meaning, reveals and veils, is an important component of much postmodern practice and utterly central to Welling's work.[12] What Welling stresses in his photographs is that the photograph possesses meaning (however defined) only *in potentia*: meaning does not fill the image like water in a glass, but, rather, resides in the knowing and decoding activity of the viewer.[13]

It is, therefore, of some consequence to note that Welling had earlier made photographs of writing; specifically, photographs of elegant, nineteenth-century script from a journal. If writing is understood as representation, then the act of photographing writing is itself an operation of pastiche, or, as art world parlance has it, the representation of representation. That this is a central preoccupation in Welling's work seems further confirmed by his most recent photographs.

In these pictures, shards and particles of some white substance (pastry dough, as it happens, but this hardly matters) are scattered on a dark ground. In the high-contrast black and white prints (there are color prints as well), the crystalline particles cluster at the base of the image, suggesting anything from glacial fragments on an inky sea to some strange species of mineralogical phenomena. The variation from image to image is at once minimal and absolute; a different distribution of black, gray, and white tones is, after all, what distinguishes any one black and white photograph from another. In certain images, however, the undifferentiated black ground is revealed as a swath of drapery velvet, the conventional backdrop for the display—and presentation—of luxury objects. The luxury object is, of course, disturbingly and conspicuously absent, supplanted by what a deeply puzzled photography critic in the pages of *Artforum* could only describe as "schmutz." Were a Cartier bracelet to have been planted in those velvet folds, no such bafflement would have ensued. But in Welling's work, the absence of the object is synonymous with the absence of the subject, not as a strategy of ersatz photographic formalism, but as a way of playing off what we expect the photograph to be setting up: a stable meaning, a "naturalized" content.

Welling is here endeavoring to produce what I would describe as a meta-art photograph—simultaneously heightening and recapitulating the canonical conventions of a certain type of traditional art photograph (abstracted form, exquisite printing, ambiguity, hence assumed profundity of meaning) which are then revealed as operative cues, as wholly formulaic as Kruger's bed-ridden suffering woman ("TRADITION") or Alexander's elegant totems. Welling's photographic work is a model of precision and thoughtfulness. That much of it is also sensuously beautiful is a by-product of this enterprise, another type of play-off—in this case, against the archaic codes of art photography. In common with these other deconstructive pasticheurs, his photographs derive their author-

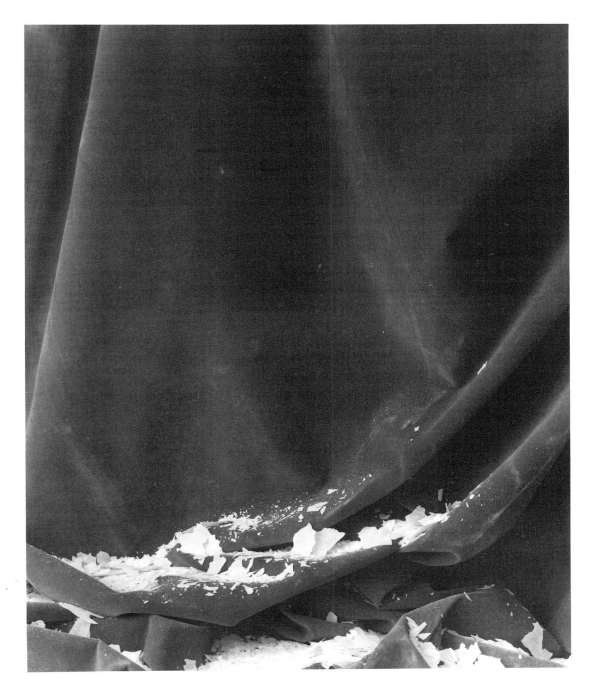

JAMES WELLING, *THE WATERFALL*, 1981, GELATIN-SILVER PRINT, 9 1/2 × 7 1/2 IN.

COURTESY OF THE ARTIST.

ity from their acknowledgment of the structural and institutional determinations of all photographic functions and meanings.

Within the range and context of the kinds of photographic practice I have discussed, the notion of subjectivity and self-expression is not so much disputed as it is considered to be entirely beside the point. The photographer's personal vision, sensibility, or capacity for self-expression is assumed to be of interest only to his or her friends, families, lovers, or analysts. While the aesthetics of consumption (photographic or otherwise) requires a heroicized myth of the (male) artist, the exemplary practice of the player-off of codes requires only an operator, a producer, a scriptor, or a pasticheur.[14]

1982

5

. .

Photography after Art Photography

In 1977, John Szarkowski organized a large photography exhibition at the Museum of Modern Art under the title "Mirrors and Windows," premised on the critical conceit that the 200-odd prints included could be apprehended either as records of some exterior reality (windows), or as interiorized visions revelatory of the photographer's own inner being (mirrors). Critical response to the exhibition was mixed. One persistent refrain, however, was that many of the pictures could easily be shifted from one category to the other and make just as much, or as little, sense.

In retrospect, what seems most curious about the organization of the exhibition—a significantly more ecumenical emporium than its recent predecessors at MoMA—was the inclusion of *artists*, such as Robert Rauschenberg, Ed Ruscha, and Andy Warhol. For like the proverbial foxes in the henhouse, the inclusion of these artists—and, more specifically, the issues raised by their respective uses of photography—posed an explicit challenge to the brand of modernism enshrined in MoMA's Department of Photography.

Common to the photographic usages of these three artists was an insistence on what Roland Barthes termed the *déjà-lu* (already-read, already-seen) aspect of cultural production, a notion alternatively theorized with respect to postmodernist art practice, as a shift from production to reproduction. In contrast to modernist art photography's claims in regard to the self-containment of the image and the palpable presence of the author, works such as those by Rauschenberg *et al.* emphasized in every way possible their dependency on already existing and highly conventionalized imagery drawn from the mass media. Thus, at the same time that modernist boundaries between "high" and "low" cultural forms were breached or obscured (an important component of pop art a decade earlier), the modernist stress on the purity of the aesthetic signifier was effectively jettisoned.

The culture of postmodernism has been theorized in various ways and approached from various perspectives. Whether premised on the shift from industrial capitalism and the national state to managed capital and the multinational corporation, or identified with the new informational economies and the profound effects of mass communications and global consumerism, the occurrence of basic structural changes in society argues for a subsequent alteration in the terms of cultural production. Thus, while it is possible to currently identify an anti-modernist impulse which signals the declining authority of mod-

103

ernist culture, postmodernism has been thought to possess a critical agenda and distinct features of its own.

But however one wishes to theorize postmodernist art (and one cannot speak of a critical consensus), the importance of photography within it is undeniable. More interesting, the properties of photographic imagery that have made it a privileged medium in postmodern art are precisely those which for generations art photographers have been concerned to disavow.

Without in any way wishing to gloss over the very real differences between Rauschenberg, Ruscha, and Warhol, their respective uses of the medium had less to do with its formal qualities per se than with the ways that photography in its normative and ubiquitous uses actually functions. As photography has historically come to mediate, if not wholly represent, the empirical world for most of the inhabitants of industrialized societies (indeed, the production and consumption of images serves as one of the distinguishing characteristics of advanced societies), it has become a principal agent and conduit of culture and ideology.

Accordingly, when photography began to be incorporated in the art of the 1960s, its identity as a multiply reproducible mass medium was insistently emphasized, nowhere more so than in the work of Andy Warhol. Warhol's exclusive use of already existent mass imagery, his production of series and multiples, his replication of assembly-line procedures for the production of images, including the dubbing of his studio "The Factory," and his cultivation of a public persona that undercut romantic conceptions of the artist (Warhol presented himself as an impresario) constituted a significant break with modernist values.

The kind of art production exemplified by Andy Warhol displayed an important affinity to certain aspects of the work of Marcel Duchamp, most prominently with his readymades. Duchamp was concerned to demonstrate that the category of art was itself entirely contingent and arbitrary, a function of discourse and not of revelation. In contrast to any notion of the art object as inherently and autonomously endowed with significance, meaning, or beauty, Duchamp was proposing that the identity, meaning, and value of the work of art were actively and dynamically constructed—a radical refusal of modernist, idealist aesthetics. Following the logic of the readymade, artists such as Warhol, Rauschenberg, Ruscha, or Johns, in re-presenting photographic images from mass culture, moved on to the postmodernist concept of what might be called the "already-made."

Douglas Crimp has directed attention to another aspect of photographic use in postmodernism which he terms "hybridization"—another divergence from the formal categories of modernist aesthetics.[1] While the mixing of heterogeneous media, genres, objects, and materials violates the purity of the modernist art object, the incorporation of photography violates it in a particular way. As an indexical as well as an iconic image, the photograph draws the (represented) world into the field of the art work—thereby under-

ANDY WARHOL, *16 JACKIES*, 1965, ACRYLIC AND SILKSCREEN ENAMEL ON
CANVAS, 80 × 64 IN. WALKER ART CENTER. PHOTOGRAPH COURTESY
OF LEO CASTELLI GALLERY.

mining its claims to a separate sphere of existence and an intrinsic aesthetic meaning.

For art photographers following in the footsteps of Alfred Stieglitz or Edward Weston, of Walker Evans or Harry Callahan, an intrinsic aesthetic yield—an auratic image—is not easily renounced. Indeed, photography's ascent to fine art status was virtually predicated on its claims to aura. Walter Benjamin, who theorized the concept, described it as composed of those qualities of singularity and uniqueness that produced the authoritative "presence" of the original work of art. Aura was the very quality, he argued, that must wither in the age of mechanical reproduction. Notwithstanding Benjamin's conviction of its demise, the continuous valorization of aura in the modern age masks an ideological construction (as does modernist theory), one of whose elements is the inevitable commodification of the art object itself.

While few contemporary photographers linger over aesthetic notions of Form and Beauty in the same way as the landscape photographer Robert Adams (in his recent *Beauty in Photography: Essays in Defense of Traditional Values*), neither are they prepared to go on record as recognizing such terms as historical constructions that today can only serve the purposes of a fetishistic, retrograde, and thoroughly commodified concept of art making. Insofar as contemporary art photography has become as much a creation of the marketplace as an engine of it, it comes as no surprise to encounter the ultimate denial of photography as a mechanically reproducible technology in such phenomena as Emmet Gowin's production of "monoprints"—editions of a single print from a negative. Indeed, a recent press release from the Laurence Miller Gallery announces on the occasion of an exhibition entitled "The One and Only": "Contrary to popular belief that a photograph is but one of a potentially infinite number of prints capable of being printed from a single negative, this exhibition demonstrates that a long and exciting history of one-of-a-kind photographs exists. Two possible themes suggest themselves: unique by process and unique by conscious choice." Needless to say, it is the latter alternative that has, since at least the days of the Photo-Secession, served as an important strategy in realigning photographic discourse to conform to the demands of print connoisseurship.

The generic distinction I am attempting to draw between photographic use in postmodernism and art photography lies in the former's potential for institutional and/or representational critique, analysis, or address, and the latter's deep-seated inability to acknowledge any need even to think about such matters. The contradictory position in which contemporary art photography now finds itself with respect to both self-definition and the institutional trappings of its newly acquired status is nowhere better illustrated than in the head-scratchings and ramblings of museum curators confronted with the task of constructing some kind of logical framework for the inclusions (and exclusions) of photography in the museum. Although denizens of the art-photography establishment are well aware that something disjunct from traditional art photography is represented by postmodernist uses of the medium, the terms in which they are accustomed to thinking prevent them from discerning precisely the issues that are most at stake. And while occa-

sionally, in a moment of media slippage, a photography writer is assigned to review a particularly well-publicized artist such as Cindy Sherman or Barbara Kruger, for the most part there is little discursive overlap between these two distinct domains. But to understand the conceptual impasse that contemporary art photography represents, it is important to trace the assumptions and claims that paralleled (and fueled) its ascent and then to examine the merit and usefulness of these notions as they exist in the present.

It has, for example, long been an uncontested claim in standard photographic history that the work of Paul Strand done around 1916—and more particularly, its championship by Alfred Stieglitz in the last two issues of *Camera Work*—signaled the coming of age of art photography as an authentically modernist, hence fully self-conscious, art form. For while Stieglitz himself had for most of his career made unmanipulated "straight" prints, it was Strand's uncompromising formulation of the aesthetics of straight photography, his insistence that photographic excellence lay in the celebration of those very qualities intrinsic to the medium itself, that has traditionally been viewed as the moment of reorientation and renewal of American art photography.

Stieglitz's epiphanous designation of Strand as the aesthetic heir-apparent would seem a reasonable point of demarcation in the art history of American photography. For although the insistence that the camera possesses its own unique aesthetic has been asserted in various ways since the 1850s, the pictorialist phenomenon supplanted earlier concepts of photographic integrity or purity[2] and instead established a quite different aesthetic agenda. This agenda, however, had a pedigree fully as venerable as that of the proto-formalist one: specifically, the presumption that photography, like all the traditional visual arts, could lay claim to the province of the imaginary, the subjective, the inventive—in short, all that might be inscribed within the idea of the *creative*.

The specific strategies adapted by pictorialist photographers—be they the retrieval of artisanal printing processes, the appropriation of high art subject matter (F. Holland Day crucified on the Cross, Gertrude Kasebier's Holy Families, etc.), or the use of gum bichromate and other substances, with extensive working of the negative or print and the concomitant stress on fine photography as the work of hand as well as of eye—are now generally supposed to constitute a historical example of the misplaced, but ultimately important energies of art photography at an earlier stage of evolution. Misplaced, because, current "markers" and print manipulators notwithstanding, contemporary photographic taste is predominantly formalist; important, because the activities and production of the Photo-Secession were a significant and effective lobby for the legitimation of photography as art. Thus, if on the one hand, Edward Steichen's 1902 self-portrait, in which the photographer is represented as a painter and the pigment print itself disguised as a work of graphic art, is now reckoned to be distinctly unmodernist in its conception, on the other hand, the impulses that determined its making can be retrospectively recuperated for the progressive camp. Viewed from this position, photography's aspiration to the condition of painting by emulating either the subject or the look of painting was considered by the

EDWARD J. STEICHEN, *SELF-PORTRAIT WITH BRUSH AND PALETTE*, 1902, GUM

PRINT (SINGLE PRINTING TECHNIQUE), 26.7 × 20 CM. © 1988, THE ALFRED

STIEGLITZ COLLECTION, THE ART INSTITUTE OF CHICAGO. REPRINTED WITH

THE PERMISSION OF JOANNA STEICHEN.

1920s and the accompanying emergence of the post-Pictorialist generation—Sheeler, Strand, Weston and others—to have been an error of means, if not ends.

What I wish to argue here is that the *ends* of mainstream art photography—its self-definition and accompanying belief system—have remained substantially unchanged throughout all the various permutations—stylistic, technological, and cultural—that it has undergone during its hundred-and-forty-year history. Of far greater importance than the particular manifestations and productions of art photography is the examination of the conditions that define and determine them. What needs to be stressed is that an almost exclusive concentration on the stylistic developments in art photography, no less than the accompanying preoccupation with its exemplary practitioners, tends to obscure the structural continuities between the "retrograde" pictorialism of the earlier part of the century and the triumphant modernism of its successors. Steichen's tenebrous platinum and gum print nude of 1904 entitled *In memoriam* might well seem on the stylistic evidence light years away from the almost hallucinatory clarity of Weston's work of the 1930s, but Steichen's "it is the artist that creates a work of art, not the medium" and Weston's "man is the actual medium of expression—not the tool he elects to use as a means" are for all intents and purposes virtually identical formulations.

Such are the continuing value and prestige of these notions in photographic criticism and history that they tend to be promiscuously imposed on just about any photographic *oeuvre* which presents itself as an appropriate subject for contemporary connoisseurship. Thomson and Riis, Atget and Weegee, Salzmann and Russell, Missions Héliographiques or 49th Parallel Survey—all tend finally to be grist for the aesthetic mill, irrespective of intention, purpose, application, or context.

Insofar as such concepts as originality, self-expression, and subjectivity have functioned, at least since romanticism, as the very warranty of art, the claims of art photography were *a priori* ordained to be couched in precisely such terms. "Nature viewed through a temperament" could be grafted onto the photographic enterprise as easily as to painting or literature and could, moreover, encompass both maker and machine. Thus was met the first necessary condition of art photography: that it be considered, at least by its partisans, as an expressive as well as a transcriptive medium.

Why then the need for a pictorialist style at all? And to the extent that exponents of art photography since the 1850s had established a substantial body of argument bolstering the claims to photographic subjectivity, interpretive ability, and expressive potential, why nearly half a century later was the battle refought specifically on painting's terms?

Certainly one contributing factor, a factor somewhat elided in the art history of photography, was the second wave of technological innovation that occurred in the 1880s. The fortunes of art photography, no less than those of scientific documentary, or entrepreneurial photography, have always been materially determined by developments in its technologies and most specifically by its progressive industrialization.[3] The decade of the 1880s witnessed not only the perfection of photogravure and other forms of photo-

mechanical reproduction (making possible the photographically illustrated newspaper and magazine), but the introduction and widespread dissemination of the gelatino-bromide dry plates, perfected enlargers, hand cameras, rapid printing papers, orthochromatic film and plates, the international standardization of photographic terminology, and, last but not least, the Kodak push-button camera. The resulting quantum leap in the sheer ubiquity of photography, its vastly increased accessibility (even to children, as was now advertised) and the accompanying diminution in the amount of expertise and know-how required to both take and process photographs, compelled the art photographer to separate in every way possible his or her work from that of the common run of commercial portraitist, Sunday amateur, or family chronicler. In this context, too, it should be pointed out that pictorialism was an international style: in France its most illustrious practitioners were Robert Demachy and Camille Puyo; in Germany Heinrich Kühn, Frank Eugene, Hugo Henneberg, and others were working along the same lines, and in the States, Stieglitz and the other members of the Secession effectively promoted pictorialism as the official style of art photography. And while influences ranging from symbolism, the arts and crafts movement, *l'art pour l'art*, and Jugenstil variously informed the practice of art photography in all these countries, the primary fact to be reckoned with is that art photography has always defined itself—indeed was compelled to define itself—in opposition to the normative uses and boundless ubiquity of all other photography.

It is suggestive, too, that the pictorialist and Photo-Secession period involved the first comprehensive look at early photography. Calotypes by David Octavius Hill and Robert Adamson and albumen prints by Julia Margaret Cameron were reproduced in *Camera Work*, Alvin Langdon Coburn printed positives from negatives by Hill and Adamson, Thomas Keith and Lewis Carroll, and exhibitions of nineteenth-century photography were mounted in France, Germany, and Great Britain. These activities were to peak in 1939,[4] the centenary of the public announcement of the daguerreotype, and were to be matched (in fact, exceeded substantially) only in the decades following 1960.

One need not belabor the point to see certain correspondences between the art photography scene of the period of the Photo-Secession and that of the past fifteen years. If gum and oil prints are perhaps not in evidence, contemporary photography galleries and exhibitions are nonetheless replete with the products of 8 x 10 view cameras, palladium prints, platinum prints, dye transfer prints, etc. Such strategies are as much mandated by a thoroughly aestheticized notion of photography as they are by the demands of the art-photography market. To those who would counter such a categorization with remonstrations about the increasing shoddiness of commercially manufactured materials and the need for archival permanence, I would reassert that the photographer's aspirations to formal invention, individual expression, and signatural style are perpetually circumscribed by industrial decisions. Indeed, the very size and shape of the photographic image are the result of such decisions; the requirements of artists were only taken into account in camera design for a brief historical moment well before the industrialization of photography.

DAVID OCTAVIUS HILL AND ROBERT ADAMSON, *REVEREND MR. SMITH*,

CA. 1843, SALTED-PAPER PRINT, 19.5 × 14.6 CM. GERNSHEIM COLLECTION, HARRY

RANSOM HUMANITIES RESEARCH CENTER, UNIVERSITY OF TEXAS AT AUSTIN.

When the legacy of art photography passed from pictorialism to what Stieglitz described as the "brutally direct" photographic production of Strand and his great contemporaries, a crucial and necessary displacement of the art in art photography was required. No longer located in particular kinds of subject matter, in the blurred and gauzy effects of soft focus or manipulations of negative or print, in allegorical or symbolic meanings, the locus of art was now squarely placed within the sensibility—be it eye or mind—of the photographers themselves. Thus, from Heinrich Kühn's "the photographic instrument, the lifeless machine, is compelled by the superior will of the personality to play the role of the subordinate" through Paul Strand's formulation of photography as instrumental "to an even fuller and more intense self-realisation," to Walker Evans's litany of art photography's "immaterial qualities, from the realms of the subjective," among which he included "perception and penetration: authority and its cousin, assurance, originality of vision, or image innovation; exploration; invention" to, finally, Tod Papageorge's "as I have gotten older, however, and have continued to work, I have become more concerned with expressing who I am and what I understand" there exists a continuous strand that has remained unbroken from *Camera Work* to *CameraArts.*

But if the strand has remained continuous, the quality of the art photography produced has not. Few observers of the contemporary art-photography scene would dispute, I think, the assertion that the work produced in the past fifteen years has neither the quality nor the authority of that of photographic modernism's heroic period, a period whose simultaneous apogee and rupture might be located in the work of Robert Frank. Additionally, it seems clear that the collapse of the so-called photography boom may have something to do with the general state of exhaustion, academicism, and repetition evident in so much art photography as much as with the deflation of an overextended market.[5]

The oracular pronouncements of Evans, Stieglitz, Strand, and Weston often have a portentous or even pompous ring, but the conviction that underlay them was validated by the vitality and authority of the modernism they espoused. To the extent that a modernist aesthetic retained legitimacy, credibility, and most importantly, functioned as the vessel and agent of advanced art, it permitted the production of a corpus of great, now canonical, photography. The eclipse—or collapse, as the case may be—of modernism is coincident with art photography's final and triumphant vindication, its wholesale and unqualified acceptance into all the institutional precincts of fine art: museum, gallery, university, and art history. The conditions surrounding and determining art photography production were now, of course, substantially altered. No longer in an adversarial position, but in a state of parity with the traditional fine arts, two significant tendencies emerged by the early 1960s. One was the appearance of photography—typically appropriated from the mass media— in the work of artists. The second tendency was a pronounced academization of art photography both in a literal sense (photographers trained in art school and universities, the conferring of graduate degrees in photography) and in a stylistic sense: that is to say, the

retrieval and reworking of photographic strategies now entirely formulaic, derived from the image bank of modernist photography, or even from modernist painting, thereby producing a kind of neo-pictorialist hybrid.

What was—and is—important about the two types of photographic practice was the distinct and explicit opposition built into these different uses. For the art photographer, the issues and intentions remained those traditionally associated with the aestheticizing use and forms of the medium: the primacy of formal organization and values, the autonomy of the photographic image, the subjectivization of vision, the fetishizing of print quality, and the unquestioned assumption of photographic authorship. In direct contrast, the *artists* who began to employ photography did so in the service of vastly different ends. More often than not, photography figured in their works in its most banal and normative incarnations. Thus, it was, on the one hand, conscripted as a readymade image from either advertising or the mass media in its various and sundry manifestations in the quotidian visual environment, or, alternatively, employed in its purely transcriptive and documentary capacities. In this latter usage, it did service to record site-specific works, objects, or events that had been orchestrated, constructed, or arranged to be constituted anew, preserved, and represented in the camera image.

It is from this wellspring that the most interesting and provocative new work in photography has tended to come. Although this relatively recent outpouring of art production utilizing photography encompasses divergent concerns, intentions, and formal strategies, the common denominator is its collective resistance to any type of formal analysis, psychological interpretation, or aesthetic reading. Consistent with the general tenor of postmodern practice, such work takes as its point of departure not the hermetic enclave of aesthetic self-reference (art about art, photography about photography) but, rather, the social and cultural world of which it is a part. Thus, if one of the major claims of modernist art theory was the insistence on the self-sufficiency and purity of the work of art, postmodern practice hinges on the assertion of contingency and the primacy of cultural codes. It follows that a significant proportion of postmodern art based on photographic usages is animated by a critical, or, if one prefers, deconstructive impulse. The intention of such work is less about provoking feeling than about provoking thought.

That the traditional art photography construct today functions as a theoretical no less than a creative cul-de-sac is revealed in a recent round-table discussion in the pages of *The Print Collector's Newsletter*. Every five years since 1973, six designated photography experts (the one practicing photographer being Aaron Siskind) have compared notes on the current state of the art. The interchange here takes place between gallery-owner Ronald Feldman and Peter Bunnell, McAlpin Professor of Photography and Modern Art at Princeton University:

RF: Well, Peter, do you find Cindy Sherman interesting?

PB: I find her interesting as an artist but uninteresting as a photographer.

RF: Interesting as an artist but not as a photographer?

PB: I don't see her raising significant questions with regard to this medium. I find her imagery fascinating, but as I interpret her work, I have no notion that I could engage her in a discourse about the nature of the medium through which she derives her expression. . . . I've had discussions with artists who have utilized our medium in very interesting ways as independent expression, but I have never perceived them as participants with the structure or the tradition I have referred to here. Of course, that changes or evolves. I think the tension between the structure that originates in an awareness of our own history and that of a number of artists who derive their vitality from the absence of that knowledge is right at the cutting edge. That's where the excitement is and that's where the pressure is coming from contemporary artists.[6]

Professor Bunnell is perhaps right to find Sherman interesting as an artist but not as a photographer. "Our medium" as he describes it, restricted to photography as defined, practiced, and understood within the framework of art photography, has little importance in Sherman's work. *Her* medium of photography—her use of it—is predicated rather on the uses and functions of photography in the mass media, be they in advertising, fashion, movies, pin-ups, or magazines. When Professor Bunnell employs the term "tradition" to indicate what Sherman and others of her ilk are not participating in, he is indicating his belief that the tradition that matters is the one carved out by art photographers (or those who have been assimilated into that tradition), and not the global production of imagery so profoundly instrumental in the production of meaning, ideology, and desire.

The photographic usages I am here designating as postmodernist are in no way to be understood as cohering into some kind of school, style, or overarching aesthetic. Quite the contrary: the kinds of production represented by artists as disparate as John Baldessari, Victor Burgin, Hilla and Bernd Becher, and Dan Graham, or more recently by younger artists such as Sarah Charlesworth, Barbara Kruger, Louise Lawler, Sherrie Levine, Richard Prince, Cindy Sherman, Laurie Simmons, or Jim Welling evidence a considerable range of concerns. What they share is an obdurate resistance to formal analysis or placement within the modernist paradigm. A formulation of common critical ground would encompass a shared propensity to contest notions of subjectivity, originality, and (most programmatically in the work of Levine and Prince) authorship. It is here, perhaps, that it is possible to locate the most obvious departure from the ethos of art photography and here, too, where the Duchampian legacy is most clearly demonstrated. Such work specifically addresses the conditions of commodification and fetishization that condition and inform art production. The purview of such practices is the realm of discursivity, ideology and representation, cultural and historical specificity, meaning and context, language and significance.

That photography should thus figure as a crucial term in postmodernism seems both

CINDY SHERMAN, UNTITLED FILM STILL, 1977, BLACK-AND-WHITE

PHOTOGRAPH, 10 × 8 IN. COURTESY METRO PICTURES.

logical and (at least retrospectively) inevitable. Virtually every critical and theoretical issue with which postmodernist art may be said to engage in one sense or another can be located within photography. Issues having to do with authorship, subjectivity, and uniqueness are built into the very nature of the photographic process itself: issues devolving on the simulacrum, the stereotype, and the social and sexual positioning of the viewing subject are central to the production and functioning of advertising and other mass-media forms of photography. Postmodernist photographic activity may deal with any or all of these elements, and it is worth noting too that even work constructed by the hand (e.g., Troy Brauntuch, Jack Goldstein, Robert Longo) is frequently predicated on the photographic image.

Seriality and repetition, appropriation, intertextuality, simulation or pastiche—these are the primary devices employed by postmodernist artists. Utilized singly or in combination, what is of importance in the context of this essay is the way each device can be employed as a refusal or subversion of the putative autonomy of the work of art as conceived within modernist aesthetics. The appearance of such practices in the 1970s seemed to portend the possibility of a socially grounded, critical, and potentially radical art prac-

BERND AND HILLA BECHER, *WATERTOWERS*, **1980, NINE BLACK-AND-WHITE PHOTOGRAPHS, 20 1/4 × 16 1/4 IN. EACH, 61 1/2 × 49 1/4 OVERALL. COURTESY THE SONNABEND GALLERY.**

116

tice that focused on issues of representation as such. Collectively, use of such devices to prompt dialectical and critical modes of perception and analysis may be termed deconstructive. (This deconstructive impulse is of special importance for feminist theory and art practice in particular, in that the space of representation is increasingly theorized as a crucial site of feminist struggle.) Thus, if postmodernist practice has displaced notions of the self-sufficiency of the aesthetic signifier with a new concern for the referent, it must also be said that it is with the referent as a problem, not as a given.[7]

Within the range of postmodernist art, it is those works that dismantle traditional notions of authorship or which most specifically address the institutional and discursive space of art that best demonstrate a deconstructive orientation. Roland Barthes's 1968 essay "The Death of the Author" remains the *Ur*-text to delineate the implications of the shift away from the author as both source and locus of meaning, asserting instead that meaning is never invented, much less locked in: "We know now that a text is not a line of words releasing a single 'theological' meaning (the 'message' of the Author-God) but a multidimensional space in which a variety of writings, none of them original, blend and clash. The text is a tissue of quotations drawn from the innumerable centers of culture. . . . Succeeding the Author, the scriptor no longer bears within him passions, humors, feelings, impressions, but rather this immense dictionary from which he draws a writing that can know no halt: life never does more than imitate the book, and the book itself is only a tissue of signs, an imitation that is lost, infinitely deferred.[8]

For Barthes, the refusal of authorship and originality was an innately revolutionary stance "since to refuse to fix meaning is, in the end, to refuse God and his hypostases — reason, science, law."[9] Similarly Barthes understood the dismantling of the notion of unique subjectivity as a salutary blow struck against an ossified and essentially retrograde bourgeois humanism. But whether postmodernist appropriation and other related strategies have indeed functioned in the liberating and revolutionary fashion that Barthes's text would indicate is open to question. While unmediated appropriation (exemplified by Levine and Prince) still retains its transgressive edge, pastiche operations are as much to be found in television commercials and rock videos as in Tribeca lofts. Moreover, if the workings of the art marketplace demonstrate anything at all, it is its capacity to assimilate, absorb, neutralize, and commodify virtually any practice at all. Finally, many artists find it difficult to avoid making those adjustments and accommodations that will permit their work to be more readily accepted by the market — a condition, after all, of simple survival.

In attempting to map out a topography of photographic practice as it presents itself now, I have constructed an opposition between an institutionalized art photography and postmodernist art practices that use photography. Such an opposition suggests itself because the working assumptions, and the goals and intentions of the respective approaches thereby reflect back on each other. A critical reading of modernist values does not devolve on the "failure" of modernism, any more than a discussion of postmodernist photo-

117

graphic practice implies a criterion of success. Rather, what is at stake in art photography or postmodernism concerns their respective agendas and how as art practices they are positioned—or how they choose to position themselves—in relation to their institutional spaces. By institutional spaces, I refer not only to the space of exhibition, but to all the discursive formations—canons, art and photography histories, criticism, the marketplace—that together constitute the social and material space of art.

These formations have been crucial agents in the relatively recent repositioning of photography as a modernist art form. Such a massive reconsideration mandates that the apparatuses of canon formation, connoisseurship, *Kunstwissenschaft*, and criticism be marshaled to impose the triple unities of artist, style, and *oeuvre* on the protean field of photography. The principal problem of intentionality (which might appear to sabotage such an enterprise) has been neatly side-stepped by recourse to a modernist formulation of a photographic ontology. Once photography is theorized in terms of inherent properties (time, the frame, the detail, the thing itself, and the vantage point, in John Szarkowski's efficient distillation) instead of its actual uses, any picture and any photographer can in principle enter the canon. This enables the portal of the canon to take on the attributes of a revolving door, and messy questions of intention and context can be effectively banished.

Art photography and postmodernist photography do not, in any case, encompass all the field. The traditional uses and forms continue: documentary practices, reportage, and all the utilitarian and commercial functions photography has regularly fulfilled. Perhaps the most durable legacy of art photography has been its success in establishing that photography is a medium like any other with which an artist might work. But a too-circumscribed conception of how the medium should be used, as well as a blind and unquestioning adherence to the modernist values which historically elevated it, has produced the current impasse of art photography. Refuge from the generally lackluster, albeit plentiful contemporary production of art photography is now routinely taken by recourse to an assiduous mining of the past, the hagiographic re-presentation of the already canonized (the recent spate of texts and exhibitions on Alfred Stieglitz is one such example), and the relentless overproduction of third- and fourth-generation variants of a vitiated academic formalism.

In contradistinction, the most interesting of recent developments is the burgeoning, if not flourishing, of photographic practices that in a certain sense invent themselves for the project at hand. Here the issue is not photography *qua* photography, but its use toward a specific end. This instrumental approach to the medium often entails that photographs are combined with texts, adapted to book or multimedia format, or geared to pointedly critical ends.

By way of example, we might consider some recent work by Vincent Leo, who, in contrast to most other postmodernist artists now using photography, has a background as a practicing photographer. Upon first examination, these black-and-white photographs

appear to belong to the ever-increasing stockpile of derivative variations on the work of the officially designated masters of American photography. More precisely, they look like pastiches of the photographs of Robert Frank. In fact—and here Leo's work separates itself resolutely from the realm of academic pasticheur—they *are* the photographs of Robert Frank. What Leo has done is to cut up the reproductions in Frank's seminal book *The Americans*, reposition and collage different photographs, and then rephotograph the results to yield . . . what?

On the most immediate level, the joke in Leo's photographs is that he is deliberately enacting what legions of contemporary art photographers unreflectively recapitulate. A photographer such as Tod Papageorge working in the manner or tradition of Garry Winogrand, Lee Friedlander, Robert Frank, or Walker Evans is by no means unusual in art photography. On the contrary, the pervasiveness of such "influence" in art photography is attended by remarkably little anxiety. However, as Harold Bloom has observed, a voluntary parody is more impressive than an involuntary one. Leo's direct conscription of his sources serves to undercut pointedly both the myth and mystique of photographic originality.

Although Leo uses the images from *The Americans* as the (literal) building blocks of his own work, his pictures are finally less about the style of Robert Frank or the iconog-

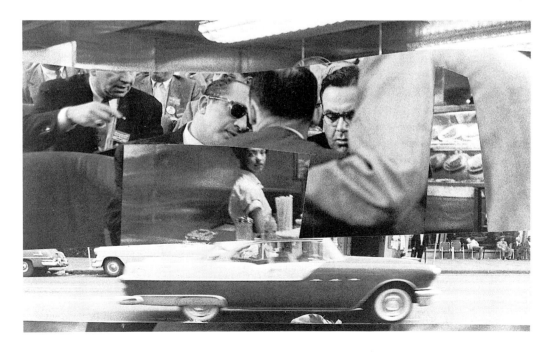

VINCE LEO, UNTITLED MONTAGE FROM ROBERT FRANK'S BOOK *THE*

***AMERICANS*, 1981-84, 16 × 20 IN. COURTESY OF THE ARTIST.**

raphy of *The Americans* than about the discursive positioning of both within art photography. It is this emphasis that most decisively distinguishes the formalist belief that photography is ultimately about photography from Leo's critical demonstration of the way meaning as well as value are produced by photography's very textuality and the discourses around it. Photography, here, is conceived not as defined by its own making, but by what is made of it.

In a wholly different mode, Connie Hatch has produced, among other work, an ongoing photographic project entitled *The De-Sublimation of Romance*. If, as Laura Mulvey argues, woman is constructed as spectacle, as fetish, as object rather than subject of the gaze, Hatch's enterprise is to foreground precisely these operations—to take exactly those conventions of photographic representation (and, even more specifically, that mode of photographic practice most assaultive and appropriative) and turn them inside out.

The conventions that Hatch reappropriates and re-presents are first of all the kind of street photography exemplified by photographers such as Garry Winogrand, Lee Friedlander, and Tod Papageorge—a form of photographic production that is both dominated by men and predicated on the assumption that meaning is fortuitously found in the world and framed in the image. Hatch's rigorous understanding of the way photography works, with particular regard for subject/object relationships and the mastery conferred on the viewer, enables her to perform a critical intervention that goes beyond the revelation of the network of complicity between photographer, spectator, and spectacle. By taking as the very subject of her work the act of looking (or not looking), Hatch draws attention to the warp and woof of power relations as they are inscribed in the operations of the gaze itself: the photographer's, the spectator's, and the gazes represented in the pictures.

Martha Rosler's *The Bowery in Two Inadequate Descriptive Systems*, a work employing text and photographs, is yet another example of photographic work that conforms to no specific rubric, but demonstrates photography's potential for rigorous, critical, and conceptually sophisticated works. Pairing images of Bowery storefronts and doorways emptied of their bums with a lexicon of drunkenness, Rosler effects an incisive critique of traditional social documentary, an examination of the lacunae of representation, and an experiment in refusal as a politically informed art practice. Rosler's work "takes off" on two familiar currents in photography (the liberal humanist tradition of "concerned" documentary, and the formalist celebration of American vernacular culture), but is in no way a critical parody (as is Leo's) or a supplemental critique in any simple fashion. Rosler's laconic, frontal photographs evoke the shade of Walker Evans and certain of his progeny, but pointedly subvert the aesthetic premises that inform their photography. The aristocratic perception of exemplary form to be found in, say, sharecroppers' shanties, does not cross over to the streets of the Bowery.

The pieties of photographic concern are likewise dismantled by Rosler, who remarks in the essay that accompanies the work: "Imperialism breeds an imperialist sensibility in all phases of cultural life." The conspicuous absence of the subjects—the victims—in her

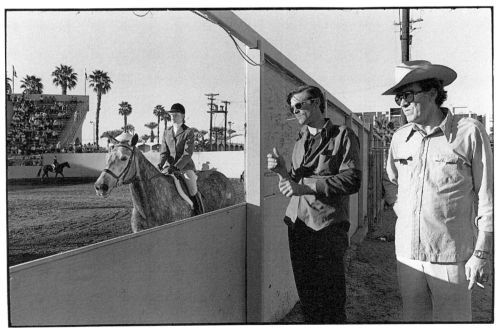

CONNIE HATCH, FROM *THE DE-SUBLIMATION OF ROMANCE*, 1978,

17 × 14 IN. EACH. COURTESY OF THE ARTIST.

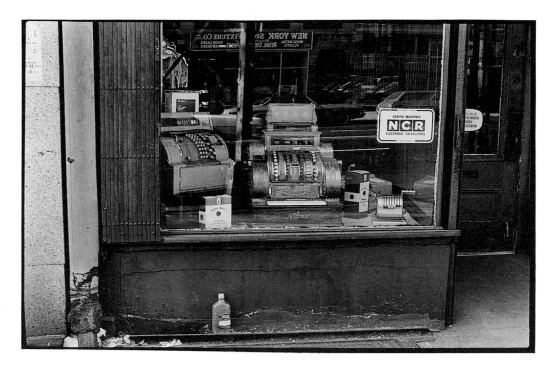

MARTHA ROSLER, LEFT HALF OF TWO-PAGE SPREAD FROM *THE BOWERY IN*

TWO INADEQUATE DESCRIPTIVE SYSTEMS. HALIFAX, THE PRESS OF THE

NOVA SCOTIA COLLEGE OF ART AND DESIGN, 1981. COURTESY OF THE ARTIST.

photographs mentally conjures up their presence in all the representational sites where we have seen them before. And, as Rosler's project implicitly questions, to what end and to what purposes? It is more than moral rectitude that determines the refusal to image the victim as spectacle: it is rather an understanding of the structural complicities such representations propagate.

Leo, Hatch, and Rosler represent only three possible examples of photographic use that exists outside of photography as conventionally theorized and practiced. Such artists tend to be marginalized both within photography and within the mainstream art world. The promise of such work lies in its relative freedom from the institutional orthodoxies of both camps, although it is in its lack of conformity to these orthodoxies that its marginalization inevitably follows. Moreover, the current political environment does not favor critical practices in any medium, and it seems reasonable to predict that the photographic practices that will remain most favored will be those that call the fewest things into question.

```
           stewed

           boiled

           potted

           corned

           pickled

           preserved

           canned

           fried to the hat
```

MARTHA ROSLER, RIGHT HALF OF TWO-PAGE SPREAD FROM *THE BOWERY IN*

TWO INADEQUATE DESCRIPTIVE SYSTEMS. HALIFAX, THE PRESS OF THE

NOVA SCOTIA COLLEGE OF ART AND DESIGN, 1981. COURTESY OF THE ARTIST.

All things considered, it seems justified to conclude that photography after art photography is an expanded rather than a diminished field, in part a consequence of the success of art photography in legitimizing the camera. If at this point, however, art photography seems capable of yielding little of interest, the problems lie entirely within itself. Today art photography reaps the dubious reward of having accomplished all that was first set out in its mid-nineteenth-century agenda: general recognition as an art form, a place in the museum, a market (however erratic), a patrimonial lineage, an acknowledged canon. Yet hostage still to a modernist allegiance to the autonomy, self-referentiality, and transcendence of the work of art, art photography has systematically engineered its own irrelevance and triviality. It is, in a sense, all dressed up with nowhere to go.

1984

6

Living with Contradictions: Critical Practices in the Age of Supply-Side Aesthetics

It should have become abundantly clear in recent years that the function of criticism, for the most part, is to serve as a more or less sophisticated public relations or promotional apparatus. This is less a function of the critic's active partisanship (Diderot and Baudelaire, for example, are historically associated with the artists Greuze and Guys, whom they championed as exemplars) than a consequence of the fact that most contemporary art criticism is innocent of its own politics, its own interests, and its own ideology. In fact, the promotional aspect of most art criticism derives from the larger institutional and discursive structures of art. In this respect, the scholarly monograph, the temporary exhibition, the discipline of art history, and last but not least, the museum itself, are essentially celebratory entities. Further—and at the risk of stating the obvious—the institutions and discourses that collectively function to construct the object "art" are allied to the material determinations of the marketplace, which themselves establish and confirm the commodity status of the work of art.

Within this system, the art critic normally functions as a kind of intermediary between the frenzied pluralism of the marketplace and the sacralized judgment seat that is the museum. Recently, however, even this mediating process has been bypassed; artists such as Julian Schnabel, to take one particularly egregious example, have been propelled from obscurity to the pantheon without a single serious critical text ever having been produced in support of their work. The quantum increase in the scale of the international art market, the unprecedented importance of dealers in creating (or "managing") reputations and manipulating supply and demand, the emergence of a new class of "art consultants," and the large-scale entry of corporations into the contemporary art market have all contributed to the effective redundancy of art criticism. Art stars and even "movements," with waiting lists of eager purchasers in their train, stepped into the spotlight before many art critics knew of their existence.[1] This redundancy of criticism, however, can hardly be under-

I would like to gratefully acknowledge the advice, suggestions, good counsel, and unstinting support of Rosalyn Deutsche in the writing of this essay.

124

stood as a consequence of these developments alone. Rather, the current state of most art criticism represents the final dissolution of what was, in any case, only a fragile bulwark between market forces and their institutional ratification, a highly permeable membrane separating venture capital, so to speak, from blue-chip investment. As a result, art criticism has been forced to cede its illusory belief in the separateness or disinterestedness of critical discourse.

In this essay I am primarily concerned with the condition—and position—of critical practices within art criticism and artmaking in the age of Reagan. In contradistinction to business-as-usual art promotion and the atavistic, cynical, and mindless art production exemplified by pseudoexpressionism, critical practices, by definition, must occupy an oppositional place. But what, we must ask, is that place today? Within the map of the New York art world, where is that place of opposition and what is it in opposition to? Second—and integrally linked to the first set of questions—we must ask what defines a critical practice and permits it to be recognized as such. What, if anything, constitutes the difference between a critical practice and a recognizably political one? If artists as distinct as, for example, David Salle and Sherrie Levine, can both say that their work contributes to a critique of the painterly sign, what common political meanings, if any, ought we attribute to the notion of critical practice? Last—and here is where I am most directly implicated—what is the nature, the terms, even the possibility, of a critical practice in art criticism? Is such a practice not inevitably and inescapably a part of the cultural apparatus it seeks to challenge and contest?

WHEN I THINK OF IT NOW, I DON'T THINK WHAT JULIAN SCHNABEL WAS DOING WAS ALL THAT DIFFERENT FROM WHAT I WAS TRYING TO DO. — SHERRIE LEVINE, "ART IN THE (RE)MAKING," INTERVIEW WITH GERALD MARZORATI, ARTNEWS (MAY 1986)

By way of exploring these questions, and in the interest of providing some specificity to the discussion, I want to concentrate primarily on the evolution and development of postmodernist photographic work from the late 1970s to the present, using it as a case history in which to explore the salient issues. This corpus of work, identified with its now fully familiar strategies of appropriation and pastiche, its systematic assault on modernist orthodoxies of immanence, autonomy, presence, originality, and authorship, its engagement with the simulacral, and its interrogation of the problematics of photographic mass media representation may be taken as paradigmatic of the concerns of a critical postmodernism or what Hal Foster has designated as "oppositional postmodernism."[2] The qualifier "critical" is important here, inasmuch as the conceptualization and description of postmodernism in architecture—chronologically anterior—were inflected rather differently.[3] There, it signaled, among other things, a new historicism and/or repudiation of

125

LOUISE LAWLER, *ARRANGEMENT,* **1982. COURTESY OF THE ARTIST.**

modernist architecture's social and utopian aspirations, and a concomitant theatricalization of architectural form and meaning. In literary studies, the term "postmodernism" had yet another valency and made its appearance in literary criticism at an even earlier date.[4] Within the visual arts, however, postmodernist photography was identified with a specifically critical stance. Critics such as Benjamin Buchloh, Douglas Crimp, Rosalind Krauss, *et al.*, theorized this aspect of postmodernist photographic work as principally residing in its dismantling of reified, idealist conceptions enshrined in modernist aesthetics—issues devolving on presence, subjectivity, and aura. To the extent that this work was supported and valorized for its subversive potential (particularly with respect to its apparent fulfillment of the Barthesian and Foucauldian prescriptions for the death of the author and, by extension, its subversion of the commodity status of the art object), Sherrie Levine and Richard Prince were perhaps *the* emblematic figures. For myself, as a photography critic writing in opposition to the academicized mausoleum of late-modernist art photography, part of the interest in the work of Vikky Alexander, Victor Burgin, Sarah Charlesworth, Silvia Kolbowski, Barbara Kruger, Louise Lawler, Sherrie Levine, Richard Prince, Cindy Sherman, Laurie Simmons, and Jim Welling (to cite only those I have written about) lay in the way their work directly challenged the pieties and proprieties with which art photography had carved a space for itself precisely *as* a modernist art form.[5] Further, the feminist import of this work—particularly in the case of Kruger and Levine—represented a theoretically more sophisticated and necessary departure from the essentialism and literalism prevalent in many of the feminist art practices that emerged in the seventies.[6]

In retrospect, Levine's production of the late seventies to the present reveals both the strength and weakness of this variant of critical postmodernism as a counterstrategy to the regnant forms of art production and discourse. The changes in her practice, and the shifts in the way her work has been discursively positioned and received, are themselves testimony to the difficulty and contradiction that attend critical practices that operate squarely within the institutional framework of high-art production.

Levine's work first drew critical notice in the late 1970s, a period in which the triumph of the Right was as much manifest in the cultural sphere as in the political one. As one might well have predicted for a time of intense political reaction, these symptoms of morbidity included the wholesale resurrection of easel painting exemplified by German, Italian, and American pseudoexpressionism, a wholesale retrenchment against the modest gains of minority and feminist artists, a repression (or distortion) of the radical art practices of the preceding decade, a ghastly revival of the mythology of the heroicized (white male) artist, and last, the institutional consolidation and triumphant legitimation of photography as a fully "auratic," subjectivized, autonomous, fine art.[7]

Against this backdrop, one aspect of Levine's work consisted of directly rephotographing from existing reproductions a series of photographs by several canonized masters of photographic modernism (Edward Weston's nude studies of his son Neil, Eliot Porter's technicolor landscapes, Walker Evans's F.S.A. pictures) and presenting the work

as her own. With a dazzling economy of means, Levine's pictures upset the foundation stones (authorship, originality, subjective expression) on which the integrity, value, and supposed autonomy of the work of art are presumed to rest. Moreover, her selection of stolen images was anything but arbitrary; always the work of canonized male photographers, the contents and codes of these purloined images were chosen for their ideological density (the classical nude, the beauty of nature, the poor of the Great Depression) and then subjected to a demystifying scrutiny enabled and mobilized by the very act of (re)placing them within quotation marks. Finally, the strategy of fine-art-photography appropriations had a tactical dimension. For these works were produced in the wake of the so-called photography boom—meaning not simply the cresting of the market for photographic vintage prints, but the wholesale reclassification of all kinds of photography to conform with notions of individual style and authorial presence derived from nineteenth-century connoisseurship.

It goes without saying that Levine's work of this period, considered *as* a critical practice (feminist, deconstructive, and literally transgressive—the Weston and Porter works prompted ominous letters from their estate lawyers), could make its critique visible only within the compass of the art world; the space of exhibition, the market system, art (or photography) theory and criticism. Outside of this specialized site, a Sherrie Levine could just as well be a "genuine" Edward Weston or a "genuine" Walker Evans. This, in fact, was one of the arguments made from the Left with the intention of countering the claims for the critical function of work such as Levine's and Prince's (Prince at that period was rephotographing advertising images, excising only the text). The force of this criticism hinged on the work's insularity, its adherence to, or lack of contestation of, the art-world frame, and—more pointedly—its failure to articulate an alternative politics or vision.

In 1982, for example, Martha Rosler wrote an article entitled "Notes on Quotes" focusing on the inadequacies of appropriation and quotation as a properly *political* strategy: "What alternative vision is suggested by such work? [She is referring here specifically to Levine.] We are not provided the space within the work to understand how things might be different. We can imagine only a respite outside social life—the alternative is merely Edenic or Utopic. There *is* no social life, no personal relations, no groups, classes, nationalities; there is no production other than the production of images. Yet a critique of ideology necessitates some materialistic grounding if it is to rise above the theological."[8] Rosler's use of the term "theological" in this context points to one of the central debates in and around the definition—or evaluation—of critical practice. For Rosler, failure to ground the artwork in "direct social analysis" reduces its critical gesture to one of "highlighting" rather than "engaging with political questions that challenge . . . power relations in society." Moreover, to the extent that the artwork "remains locked within the relations of production of its own cultural field," and limited to the terms of a generic rather than specific interrogation of forms of domination, it cannot fulfill an educative, much less transformatory, function.

128

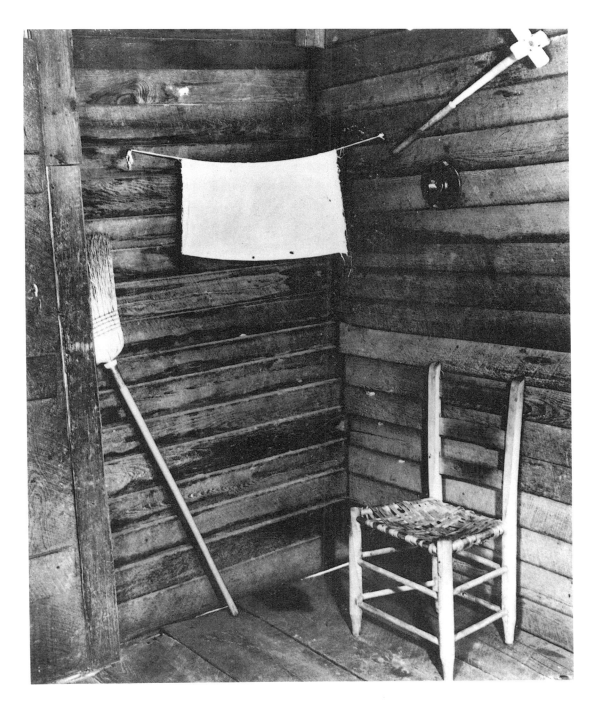

SHERRIE LEVINE, UNTITLED *(AFTER WALKER EVANS: 7)*, 1981, BLACK-AND-

WHITE PHOTOGRAPH, 10 × 8 IN. COURTESY MARY BOONE GALLERY.

129

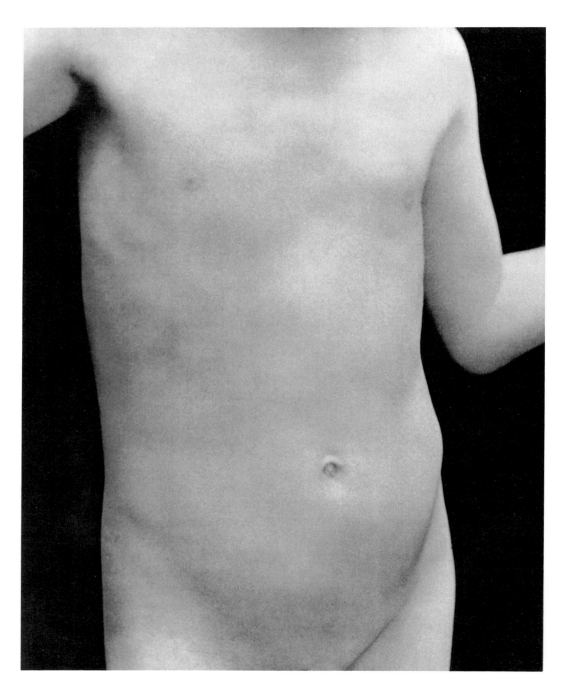

SHERRIE LEVINE, UNTITLED *(AFTER EDWARD WESTON)*, 1981, BLACK-AND-
WHITE PHOTOGRAPH, PRIVATE COLLECTION.

But "theological" in its opprobrious sense can cut both ways. It is, in fact, a "theological" notion of the political—or perhaps one should say a scriptural notion—that has until quite recently effectively occluded issues of gender and subjectivity from the purview of the political. Rosler's objections are to some degree moored in a relatively traditional conception of what constitutes the political in art ("materialistic grounding," "direct social analysis"). Thus, Rosler's characterization of a purely internal critique of art as ineffective because theological can, from a somewhat different vantage point, be interpreted as a theologized notion of the political. It is, moreover, important to point out that while unambiguously political artists (unambiguous because of their choice of content) are rarely found wanting for their total exclusion of considerations of gender, feminist artists are frequently chastised by Left critics for the inadequacy of *their* political content. Nevertheless, the echoing cry of the women's movement—the personal is political—is but one of the remappings of political terrain that have engendered new ways of thinking the political and new ways of inscribing it in cultural production.

But perhaps even more important, to the extent that art is itself a discursive and institutional site, it surely entails its own critical practices. This has in fact been recently argued as the significance and legacy of the historical avant-garde.[9] For Peter Bürger, the Kantian conception of self-criticism is understood not in Greenberg's sense of a *telos* of purity and essence, but rather as a critical operation performed within and upon the *institution* of art itself. Thus, art movements like dadaism and constructivism and art practices such as collage, photomontage, and the Duchampian readymade are understood to be performing a specifically political function to the extent that they work to actively break down the notion of aesthetic autonomy and to rejoin art and life. Bürger's rigorous account of art *as* an institution in bourgeois culture provides a further justification for considering internal critiques such as Levine's as a genuinely critical practice. Cultural sites and discourses are in theory no less immune to contestation, no less able to furnish an arena for struggle and transformation than any other.[10] This "in theory" needs to be acknowledged here because the subsequent "success" of postmodernist photography as a *style* harkens back, as I shall argue, to problems of function, of critical complicity, and the extreme difficulty of maintaining a critical edge within the unstable spaces of internal critique.

In the spring of 1982, I curated an exhibition entitled "The Stolen Image and Its Uses" for an alternative space in upstate New York. Of the five artists included (Alexander, Kolbowski, Kruger, Levine, and Prince), Levine was by far the most controversial and sparked the most hostility. It was, in fact, the very intensity of the outrage her work provoked (nowhere greater than among the ranks of art photographers) that appeared, at the time, to confirm the subversive effects of her particular strategies. But even while such exhibitions or lectures on Levine's works were received outside New York City with indignation, a different kind of appropriation of existing imagery, drawn principally from

the mass media, was beginning to be accorded theoretical recognition across a broad range of cultural production. It was less easy to see this kind of appropriation as critically motivated. Fredric Jameson, for example, could in part identify his conception of postmodernism with the strategies of appropriation, quotation, and pastiche.[11] That these strategies could then be said to unify within a single field of discourse the work of Jean-Luc Godard and the work of Brian De Palma constitutes a problem for critical practice. Not only did such an undifferentiated model suppress a crucial consideration of (political and aesthetic) difference, it also implied the impossibility of purposeful cultural opposition within a totalizing system, a position accorded growing intellectual prestige within the art world through the later writings of Jean Baudrillard. Rooted in such a framework, an appropriative strategy such as Levine's (although Jameson does not mention the specific practice of appropriation) could only figure as a synecdochical symptom within a master narrative on postmodernism.[12]

By 1983, plundering the pages of glossy magazines, shooting advertisements from the television set, or "simulating" photographic tableaux that might have come from either of these media had become as routine an activity in the more sophisticated art schools as slopping paint on canvas. In January of that year the Institute of Contemporary Art in Philadelphia mounted an exhibition entitled "Image Scavengers." Included in the exhibition were representatives of the first wave of appropriators and pasticheurs (Kruger, Levine, Prince, Cindy Sherman) and several other artists whose work could be allied to the former only by virtue of their formal devices. Invited to contribute a catalog essay, Douglas Crimp was clearly disturbed at the domestication of what he had himself theorized as the critical potential of photographic appropriation. Under the title "Appropriating Appropriation," his essay initiated a reconsideration of the adequacy of appropriation as a critical mode. "If all aspects of the culture use this new operational mode," he wrote, "then the mode itself cannot articulate a specific reflection upon that culture."[13] Thus, although appropriative and quotational strategies had now become readily identifiable as a descriptive hallmark of postmodern culture, the terms by which it might once have been understood to be performing a critical function had become increasingly obfuscated and difficult to justify.

By this time, Levine's practice had itself undergone various alterations. In 1982, she had largely abandoned photographic appropriations and was confiscating German expressionist works, either by rephotographing them from book reproductions or by framing the reproductions themselves. In 1983 and 1984, however, she began making handmade watercolor and pencil copies after artbook illustrations, extending her *oeuvre*, so to speak, to include nonexpressionist modern masters such as Malevich and El Lissitzky. Her copies after expressionist drawings, such as Egon Schiele's contorted and angst-ridden nudes, were particularly trenchant comments on the pseudoexpressionist revival; master drawings are, after all, especially privileged for their status as intimate and revealing traces of the artist's unique subjectivity. In 1985, Levine made what might, or might not, be con-

sidered a radical departure from her earlier work and began to produce quite beautiful small-scale paintings on wood panels. These were geometrical abstractions—mostly stripes—which, Janus-like, looked backward to late-modernist works or to minimalism and forward to the most recently minted new wave in the art world—neo-geo. Additionally, she accompanied her first exhibition of this new work with unpainted panels of wood in which one or two of the knots had been neatly gilded.

Mutatis mutandis, Levine had become a painter, although I would argue, still a somewhat singular one. Her work, moreover, had passed from the relatively marginalized purview of the *succès d'estime* to a new visibility (and respectability), signaled, for example, by her cover article in the May 1986 *Artnews*. In several of the comments she made to her interviewer, Levine explained her need to distance herself from the kind of critical partisanship that not only had helped establish her reputation, but—more important—had, to a great degree, developed its position and analysis in relation to her work. Levine's professed discomfort with a body of critical writing that positioned her as a critical, indeed an adversarial, presence hinged on two factors. In championing Levine's work as either a poststructuralist exemplum, or a demolition derby on the property relations that subtend the integrity of the art object, the (mostly male) critics who had written about her had overlooked, or repressed, the distinctly feminist import of her work.[14] But Levine also took issue with the interpretation of her work that stressed its materialist critique. In this regard, Levine insisted that hers was an aesthetic practice that implied no particular quarrel with the economic determinations of cultural production. Consequently, insofar as her critical supporters had emphasized those aspects of her work that subverted the commodity status of the artwork and demolished those values Walter Benjamin designated as the "theology of art," Levine began to believe that her activity *as* an artist was itself being repressed: "I never thought I wasn't making art and I never thought of the art I was making as not a commodity. I never thought that what I was doing was in strict opposition to what else was going on—I believed I was distilling things, bringing out what was being repressed. I did collaborate in a radical reading of my work. And the politics were congenial. But I was tired of no one looking at the work, getting inside the frame. And I was getting tired of being represented by men."[15]

The repositioning of Levine's work, with respect to both its meaning (now presented as a form of anxious obsequy mourning "the uneasy death of modernism") and the nature of her activity (commodity making), is disturbing from a number of perspectives. First, it involves its own forms of historical repression. Thus, nowhere in the article was any reference made to Levine's two-year collaboration with the artist Louise Lawler enacted under the title "A Picture Is No Substitute for Anything."[16] What is troubling about such an omission is that it parallels—no doubt wholly unintentionally—the institutional and discursive repressions that construct partial and falsified histories of art in the first place and in which the exclusion of women and radical practices is particularly conspicuous.[17] Second, it repressed the active support of women critics, such as myself and Rosalind Krauss.

But, more ominously, it traced a move from a position of perceptible cultural resistance to one of accommodation with existing modes of production and an apparent capitulation to the very desires the early work put in question. Whether this move is to be understood strategically (the need to be visible, the need to survive) or developmentally (an internal evolution in the artist's work) is not in itself a useful question. Far more important to consider here are the material and discursive forces that both exceed and bind the individual artist. Whether artists choose to publicly define their positions in opposition to, or in strategic alliance with, dominant modes of cultural production is important only insofar as such definitions may contribute to a collective space of opposition. But, in the absence of a clearly defined oppositional sphere and the extreme rarity of collaborative practice, attempts to clarify the nature of critical practice must focus on the artwork's ability to question, to contest, or to denaturalize the very terms in which it is produced, received, and circulated. What is at stake is thus not an ethics or a moral position but the very possibility of a critical practice within the terms of art discourse. And, as a fundamental condition of possibility, critical practices must constantly address those economic and discursive forces that perpetually threaten to eradicate their critical difference.

Some notion of the juggernaut of these forces can be obtained from a consideration of the parallel fortunes of Levine's earlier photographic appropriations and, indeed, postmodernist photography as a whole. In 1985, for example, three large group exhibitions featuring postmodernist photography were mounted: "Signs of the Real" at White Columns, "The Edge of Illusion" at the Burden Gallery, and most grotesque of all, "In the Tradition of: Photography" at Light Gallery. Not the least of the ironies attendant upon the incorporation of postmodernist photography into the now expanded emporium of photography was the nature of the venues themselves: the Burden Gallery was established in January 1985 to function as the display window of *Aperture*, the photographic publication founded by Minor White and customarily consecrated to modernist art photography; the Light Gallery, a veritable cathedral of official art photography, represents the stable of officially canonized modernist masters, living and dead. The appearance of postmodernist photography within the institutional precincts of art photography signaled that whatever difference, much less critique, had been attributed to the work of Levine, *et al.*, it had now been fully and seamlessly recuperated under the sign of art photography, an operation that might be characterized as deconstruction in reverse.

How had this happened? The Light Gallery exhibition title—"In the Tradition of: Photography"—provides one clue, elaborated in an essay that accompanied the show. Postmodernist photography is here understood to be that which follows modernist photography in the same fashion that postimpressionism is thought to follow impressionism. The first of the two epigraphs that introduced the essay was taken from Beaumont Newhall's *History of Photography*—a sentence describing the conservatism of pictorial, i.e., premodernist, art photography (that which preceded the Light Gallery regulars). The second epigraph consisted of two sentences from one of my essays, "Photography after Art

Photography," asserting that the stakes that differentiate the two modes are a function of their position in relation to their institutional spaces. In much the same way that the modernist hagiographer Beaumont Newhall and I were equally useful in framing the thesis that postmodernist photography is part of an evolutionary *telos* having to do only with the internal development of art photography, so too did the gallery space both frame and render equivalent the two practices. This reduction of difference to sameness (a shorthand description for the eventual fate of most, if not all, initially transgressive cultural practices) was emblematically represented by the pairing—side by side—of a Sherrie Levine rephotograph of a Walker Evans and—what else?—a "real" Walker Evans beneath the exhibition title. That postmodernist photographic work and art photography came to inhabit the same physical site (although with the exception of the Levine/Evans coupling, the two were physically separated in the installation) is of course integrally linked to the nature of commercial space in the first place. In the final analysis, as well as a Marxist analysis, the market is the ultimate legitimizer and leveler. Thus, among the postmodernist work, one could also find excerpts from Martha Rosler's 1977 book project *The Bowery in Two Inadequate Descriptive Systems* (originally published by the Press of the Nova Scotia College of Art and Design). Variously an uncompromising critique of conventional humanist muckraking documentary photography, a text/image artwork, and an examination of the structuring absences and ideological freight of representational systems, *The Bowery* was exhibited at the Light Gallery amid the range of postmodernist photographs and bore a purchase price of $3,500 (purchase of the entire set was required). But what was finally even odder than the effect of going from the part of the gallery in which the Aaron Siskinds, Cartier-Bressons, and Paul Strands hung to the part devoted to the postmodernists was the revelation that postmodernist photography, once theorized as a critical practice, had become a "look," an attitude, a *style*.

Within this newly constructed stylistic unity, the critical specificity of a Rosler, a Prince, a Levine could be reconstituted only with difficulty (and only with prior knowledge). In large part, and in this particular instance, this was a consequence of the inclusion of a "second generation" of postmodernist photographers—Frank Majore, Alan Belcher, Stephen Frailey, and so forth—whose relation to the sources and significance of their appropriative strategies (primarily advertising) seemed to be predominantly a function of fascination. Insofar as stupefied or celebratory fascination produces an identification with the image world of commodity culture no different from the mesmerization of any other consumer, the possibility of critique is effectively precluded. Frank Majore's simulations of advertising tableaux employing props such as trimline telephones, champagne glasses, pearls, and busts of Nefertiti all congealed in a lurid bath of fiftieslike photographic color are cases in point. By reproducing the standard devices of color advertising (with which Majore, as a professional art director, is intimately familiar) and providing enough modification to accentuate their kitschiness and eroticism, Majore succeeds in doing nothing more than reinstating the schlocky glamour of certain kinds of advertising imagery within

SHERRIE LEVINE, UNTITLED *(AFTER WALKER EVANS: 2)*, 1981, BLACK-AND-

WHITE PHOTOGRAPH, 10 × 8 IN. COURTESY MARY BOONE GALLERY.

the institutional space of art. But unlike the strategies of artists such as Duchamp, or War-
hol, or Levine, what is precisely *not* called into question is the institutional frame itself.[18]
The alacrity with which this now wholly academicized practice was institutionally em-
braced by 1985 (in that year Majore had three one-person shows at the International Cen-
ter of Photography, the 303 Gallery, and the Nature Morte gallery) was possible precisely
because so little was called into question.

Although this more recent crop of postmodernist artists could only become visible—
or salable—in the wake of the success of their predecessors, the shift from margin to center
had multiple determinations. "Center," however, must be understood in relative terms.
The market was and is dominated by painting, and the prices for photographic work, de-
spite the prevalence of strictly limiting editions and employing heroic scale, are intrinsi-
cally lower. Nonetheless, the fact remains that in 1980, the work of Levine or Prince was
largely unsalable and quite literally incomprehensible to all but a handful of critics and a
not much larger group of other artists. When this situation changed substantially, it was

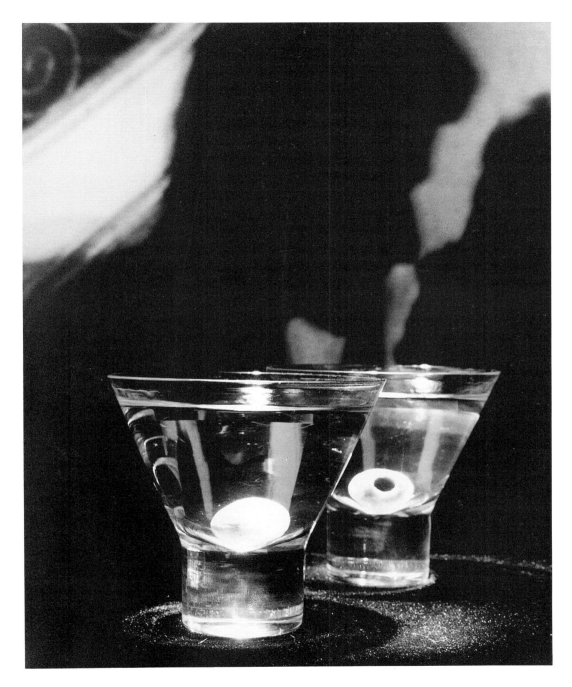

FRANK MAJORE, *COCKTAILS*, **1983, CIBACHROME 20 × 16 IN. COURTESY OF**

MARVIN HEIFERMAN.

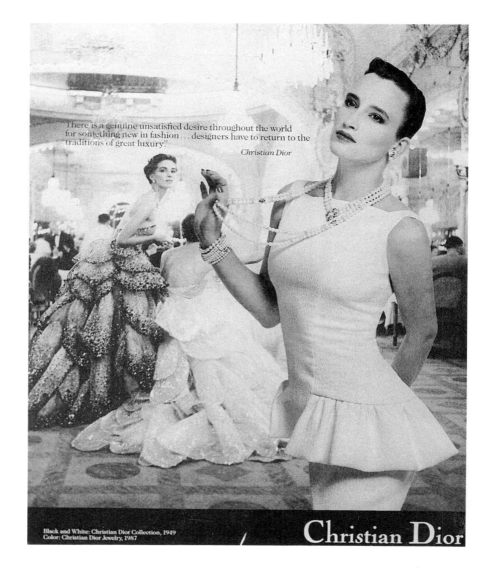

There is a genuine unsatisfied desire throughout the world for something new in fashion... designers have to return to the traditions of great luxury."

Christian Dior

Black and White: Christian Dior Collection, 1949
Color: Christian Dior Jewelry, 1987

Christian Dior

CHRISTIAN DIOR ADVERTISEMENT.

not *primarily* because of the influence of critics or the efforts of dealers. Rather, it was a result of three factors: the self-created impasse of art photography that foreclosed the ability to produce anything new for a market that had been constituted in the previous decade; a vastly expanded market with new types of purchasers; and the assimilation of post-modernist strategies back into the mass culture that had in part engendered them. This last development may be said to characterize postmodernist photography the third time

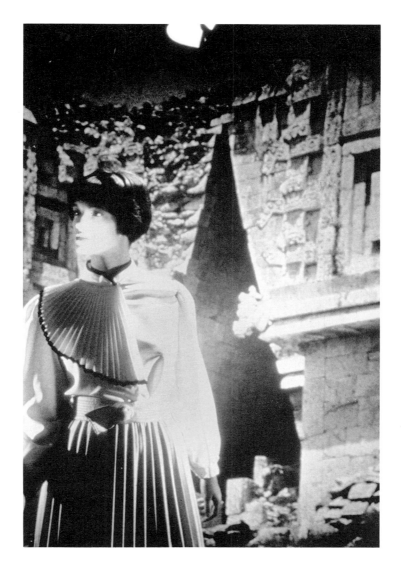

LAURIE SIMMONS, *AZTEC CREVICE*, 1984, 60 × 40 IN.

COURTESY METRO PICTURES.

around, rendering it both comprehensible and desirable and simultaneously signaling its near-total incorporation into those very discourses (advertising, fashion, media) it professed to critique. The current spate of Dior advertisements, for example, featuring a black-and-white photograph from the fifties on which a contemporary model (photographed in color) has been montaged bears at least a family resemblance to the recent work of Laurie Simmons. But where Simmons's pictures derived their mildly unsettling

effects from a calculated attempt to denaturalize an advertising convention, the reappearance of the same montage tactic in the new Dior campaign marks the completion of a circuit that begins and ends in the boundless creativity of modern advertising.

The cultural loop that can be traced here is itself part of the problematic of critical practice. The more or less rapid domestication and commodification of art practices initially conceived as critical has been recognized as a central issue at least since the time of the Frankfurt School. This means that irrespective of artistic intention or initial effect, critical practices not specifically calibrated to resist recuperation as aesthetic commodities almost immediately succumb to this process. In this respect, the only difference between the fate of postmodernist photography and previous practices is the rapidity of the process and the ease, if not enthusiasm, with which so many of the artists accommodated themselves to it.

As was the case with its pop-art predecessors, the first wave of postmodernist photography pillaged the mass media and advertising for its "subject," by which I include its thematics, its codes, its emblems. These were then variously repositioned in ways that sought to denaturalize the conventions that encode the ideological and, in so doing, to make those very ideological contents available to scrutiny and contestation. Thus, Cindy Sherman's black-and-white movie stills—always her and never her—aped the look of various film genres to underscore their conventionality, whereas her infinite tabulation of the "images of women" they generate revealed their status as equally conventionalized signs producing a category (woman) and not a subject. Additionally, the cherished notion of the artist's presence *in* the work was challenged by the act of literally inscribing the author herself and revealing her to be both fictional and absent.[19] Similarly, Richard Prince's rephotographs of the "Marlboro Man" advertisements, which he began to produce in the early years of the Reagan administration, pointedly addressed the new conservative agenda and its ritual invocations of a heroic past. Here, too, the jettisoning of authorial presence was a component of a larger project. By focusing on the image of the cowboy—the individualistic and masculine icon of American mythology—Prince made visible the connections among cultural nostalgia, the mythos of the masculine, and political reaction. Recropping, rephotographing, and recontextualizing the Marlboro men permitted Prince to unpack the menace, aggression, and atavism of such representations and reveal their analogical link to current political rhetoric.

In contrast to practices such as these, work such as Majore's abjures critique, analysis, and intervention on either its purported object—the seductiveness of commodity culture, the hypnotic lure of simulacra—or the material, discursive, and institutional determinations of art practice itself. Not surprisingly, the disappearance of a critical agenda, however construed, has resulted in an apparent collapse of any hard-and-fast distinction between art and advertising. In pop art, this willed collapse of the aesthetic into the commercial function carried, at least briefly, a distinctly subversive charge. The erasure of boundaries between high and mass culture, high art and commodity, operated as an as-

CINDY SHERMAN, UNTITLED FILM STILL, 1979, BLACK-AND-WHITE

PHOTOGRAPH, 10 × 8 IN. COURTESY METRO PICTURES.

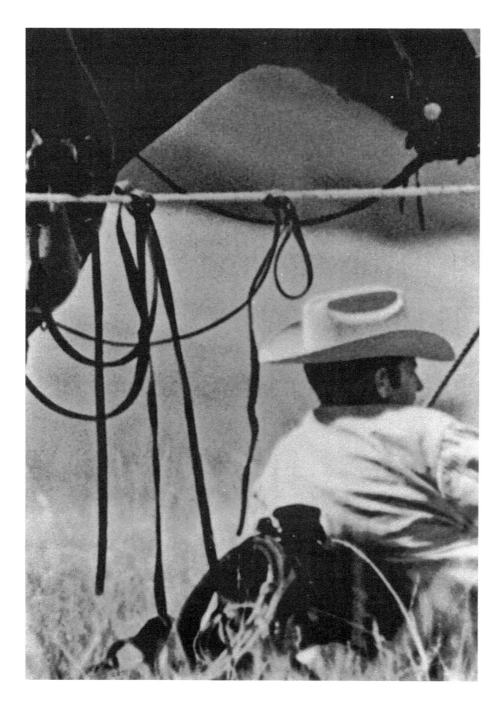

RICHARD PRINCE, UNTITLED (COWBOY), 1980-84, EKTACOLOR PRINT,

24 × 20 IN. COURTESY BARBARA GLADSTONE GALLERY.

tringent bath in which to dissolve the transcendentalist legacy of abstract expressionism. Moreover, the strategic repositioning of the images and objects of mass culture within the gallery and museum reinstated the investigation and analysis of the aesthetic as an ideological function of the institutional structures of art. Postmodernism as style, on the other hand, eliminates any possibility of analysis insofar as it complacently affirms the interchangeability, if not the coidentity, of art production and advertising, accepting this as a given instead of a problem.

Perhaps one of the clearest examples of this celebratory collapse was an exhibition mounted in the fall of 1986 at the International Center of Photography entitled "Art & Advertising: Commerical Photography by Artists."[20] Of the nine artists represented, four came from the ranks of art photography (Sandi Fellman, Barbara Kasten, Robert Mapplethorpe, Victor Schrager), two from the first wave of postmodernist photography (Cindy Sherman and Laurie Simmons), and two from the second (Stephen Frailey and Frank Majore). William Wegman, whose work has encompassed both video and conceptualism, falls clearly into none of these camps. As in the numerous gallery and museum exhibitions organized in the preceding years, the new ecumenism that assembles modernist art photography and postmodernist photography functions to establish a familial harmony, an elision of difference to the profit of all.

Addressing the work of Frailey, Majore, Simmons, and Sherman, the curator Willis Hartshorn had this to say:

> The art of Stephen Frailey, Frank Majore, Laurie Simmons and Cindy Sherman shares a concern for the operations of mass media representation. For these artists to work commercially is to come full circle, from art that appropriates the mass media image, to commercial images that reappropriate the style of their art. However, for the viewer to appreciate this transformation implies a conscious relationship to the material. The viewer must understand the functions that are being compared through these self-referential devices. Otherwise, the juxtapositions that parody the conventions of the mass media will be lost.[21]

Now firmly secured within the precincts of style, postmodernist photography's marriage to commerce seems better likened to a love match than a wedding of convenience. Deconstruction has metamorphosed into appreciation of transformation, whereas the exposure of ideological codes has mellowed into self-referential devices. And insofar as the museum, in the age of Reagan, can institutionally embrace and legitimize both enterprises—art and commerce—Hartshorn is quite right in noting that a full circle has been described. For those for whom this is hardly cause for rejoicing, the history of postmodernist photography is cautionary rather than exemplary.

The notion of a critical practice, whether in art production or criticism, is notoriously hard to define. And insofar as critical practices do not exist in a vacuum, but derive their

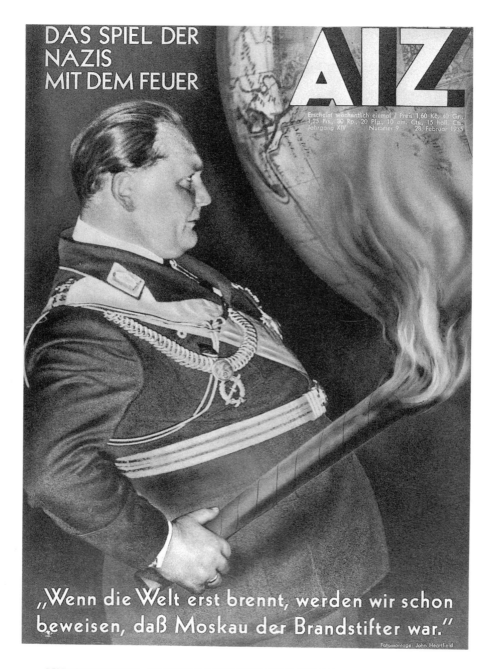

JOHN HEARTFIELD, *AIZ* COVER, DECEMBER 1935, ROTOGRAVURE, 37.9 × 26.7 CM.

COURTESY INTERNATIONAL MUSEUM OF PHOTOGRAPHY AT GEORGE

EASTMAN HOUSE.

forms and meanings in relation to their changing historical conditions, the problem of definition must always be articulated in terms of the present. Gauging the *effectiveness* of critical practices is perhaps even more difficult. By any positivist reckoning, John Heartfield's covers for *AIZ* had no discernible effect on the rise of fascism, although he was able to draw upon two important historic conditions unavailable to contemporary artists (a mass audience and a definable Left culture). Still, the work of Heartfield retains its crucial importance in any consideration of critical practice insofar as it fulfills the still valid purpose of making the invisible visible and integrally meshing the representation of politics with the politics of representation. In other words, its critical function is both externally and internally inflected.

Although Heartfield is clearly a political artist, few contemporary artists concerned with critical practice are comfortable with the appellation *political*: first, because to be thus defined is almost inevitably to be ghettoized within a (tiny) art-world preserve; second, because the use of the term as a label implies that all other art is *not* political; and third, because the term tends to suggest a politics of content and to minimalize, if not efface, the politics of form. It is for all these reasons that throughout this essay I have chosen to employ the term critical practice in lieu of political practice. That said, the immediate difficulty of definition must still be addressed, and it is made no easier by the fact that a spate of recent practices—so-called simulationism, neo-geo, postmodernist photography in all its avatars—lays claim to the mantle of critical practice. Whether one is to take such claims at face value is another matter. But if we assume that critical practices conceptually assume both an activity and a position, the emphasis needs be placed on discursive and institutional function. In this regard, Walter Benjamin's rhetorical question of 1938 is still germane: "Rather than ask, 'What is the *attitude* of a work to the relations of production of its time?' I should like to ask, 'What is its *position* in them?' "[22] The relevance of this question is that it underscores the need for critical practices to establish a contestatory space in which the *form* of utterance or address speaks to otherwise unrecognized, or passively accepted, meanings, values, and beliefs that cultural production normally reproduces and legitimizes. Insofar as contemporary critical practices operate within a society in which, as Victor Burgin observes, "the market is 'behind' nothing, it is *in* everything,"[23] the notion of an "outside" of the commodity system becomes increasingly untenable. This would suggest that the definition or evaluation of a critical practice must be predicated on its ability to sustain critique from within the heart of the system it seeks to put in question.

If we are to grant that a range of postmodernist photographic work that emerged at the end of the 1970s did in fact initially function as a critical practice, it did so very much within these terms. First of all, unlike other contemporaneous critical practices that positioned themselves outside the art world and sought different audiences (for example, Fred Lonidier's *Health and Safety Game*, Jenny Holzer's *Truisms, Inflammatory Essays*, and *Survival* series, the London Docklands project, Mary Kelly's *Post-Partum Document*, and D. Art's *Form Follows Finance*, to mention only a few),[24] postmodernist photography for the

most part operated wholly within the parameters of high-art institutions. As the photographic work of Sherrie Levine clearly demonstrates, the critical specificity of such practice is only operative, can only be mobilized, within a particular context. Its instrumentality, in other words, is a consequence of its engagement with dominant (aesthetic) discourses whose constituent terms (and hidden agendas) are then made visible as prerequisites for analysis and critique. As circumstances change (for example, with the assimilation of appropriation into the culture at large), so too does the position of the artwork alter.

But within the overarching category of immanent critique, it is important to distinguish between those practices that elucidate, engage with, or even contest their institutional frame, and those that suspend or defer their institutional critique in the belief that such critique is already implied within the terms of their focus on the politics of representation. Representation is, after all, itself contextually determined, and the meanings thereby produced and disseminated are inseparable from the discursive structures that contain and enfold them. Consistent with the terms of Peter Bürger's formulation, there is by now a lengthy history of art practices of the former type, ranging from those of the historical avant-garde through more recent production exemplified by Michael Asher, Daniel Buren, Marcel Broodthaers (d. 1976), Hans Haacke, Louise Lawler, and Christopher Williams. It is, I think, of some significance that the work of these artists has more or less successfully resisted the reduction to stylistics to which postmodernist photography so rapidly succumbed. This is in part due to the fact that, with the exception of Buren, these are all *protean* practices, whose changing forms are determined by the issues the work addresses, its venue, its occasion, the historical moment of its making. This formal flexibility not only militates against the fixity of a signature style but emphasizes the tactical and contingent aspect of critical practice that defines and redefines itself in response to particular circumstances. Working with contradictions entails not only a strategy of position as such but a degree of maneuverability as well.

This in turn suggests that art practices predicated on the production of signature styles rather than constantly modified interventions may be especially vulnerable to neutralization of their purported critique. The history of postmodernist photography overall would appear to confirm this analysis. As various theorists have argued, a position of resistance can never be established once and for all, but must be perpetually refashioned and renewed to address adequately those shifting conditions and circumstances that are its ground.[25]

It is one thing, however, for a critic to map out what she or he believes to be the necessary conditions for a critical practice and quite another to actively deal with, assess, or articulate a position in relation to the work she or he actually confronts. Here, both critic and artist, situated within the restricted realm of high culture, are from the very outset enmeshed within a particularly dense matrix of contradiction. Once the decision is made to operate within the institutional space of art rather than outside it, critical writing

HANS HAACKE, *METROMOBILTAN*, 1985, THREE BANNERS AND PHOTOMURAL,

140 × 240 × 60 IN. COURTESY JOHN WEBER GALLERY.

and critical art are alike caught up in and subject to the very conditions such work attempts to contest. This is particularly the case with critical advocacy. Critical practice, if it is not to reduce itself to the tedium (and moralism) of the jeremiad, must be equally concerned with advocacy and partisanship. My own critique of the triviality and conservatism of official art photography was integrally related to my support of alternative photographic practices. This support, in turn, inevitably became part (a small part) of a cultural apparatus of undifferentiated promotion in the service of supply-side aesthetics. Critical advocacy, irrespective of the terms in which it is couched, is either from the outset part of the commodity system (for example, in the format of the museum or gallery exhibition catalog, or the commercial art magazine essay or review) or secondarily appropriated to it (as in the assimilation of critical writing into art journalism or the gallery press release). This means that critical writing, regardless of the writer's politics, can in no way consider itself as independent of the cultural apparatus it seeks to contest. This is not,

however, to claim that there are no differences. Nor is this to suggest that critical writing is to be reduced to the opposite poles of partisanship or attack. On the contrary, ideally the work of the critic and the work of the artist—to the degree that they both conceive their practices critically—are theoretical, if not actual, collaborations. As is true of art practices with which such criticism collaborates, learns from, and shares its agenda, working with contradictions necessitates a practical sense of what those contradictions imply—what they enable and what they preclude.

Thus, although the prevailing conditions of cultural production are hardly cause for optimism, neither are they cause for unrelieved despair; it is, after all, the very existence of discernible contradictions that allows for the possibility of critical practices in the first place. That said, perhaps the most daunting of all the contradictions that critical practices must negotiate is the direct consequence of rendering problematic the concept of the political in art. In this regard, the writing of Brecht, the practice of Heartfield, and the prescriptions of Benjamin can no longer be looked to as the *vade mecum* of critical practice. For if we accept the importance of specificity as a condition of critical practice, we are thrown into the specifics of our *own* conditions and circumstances in the sphere of culture. To the extent that these include a refusal of inside/outside dichotomies ("the market is *in* everything"), an interrogation of the notion of prescription itself (authoritative modes, practices, models), a recognition of the contingency and indeterminacy of meaning, and a general acknowledgment of the inescapable complicity of all practices within cultural production, it becomes increasingly difficult to say with any assurance what critical practices should actually or ideally seek to do. Needless to say, the putting in question of traditional conceptions of political correctness, of determinate and fixed positions of address, of exhortative or didactic modes of critique, has been exclusively the project of feminism and a part of the Left. The regnant Right knows no such uncertainty as it consolidates its position with increasing authoritarianism, repressiveness, and certainty. To have thus put in question the conditions of political enunciation within cultural production at a moment of extreme political reaction is perhaps the most daunting contradiction of all.

1987

III

RETHINKING DOCUMENTARY

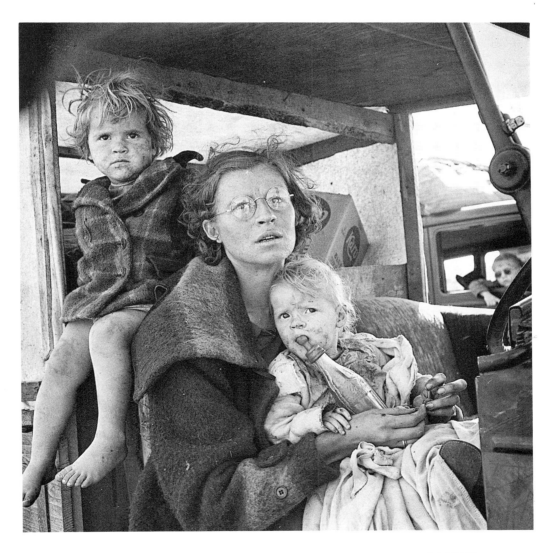

DOROTHEA LANGE, *A MOTHER AND HER CHILDREN*, TULETECKE, SISKYOU

COUNTY, CALIFORNIA, 1932. LIBRARY OF CONGRESS.

7

A Photographer in Jerusalem, 1855: Auguste Salzmann and His Times

If ripeness is all, no better illustration could be found than in the trajectory photography has described from its simultaneous birth in the two most industrialized and powerful countries in the world. Engendered by science,[1] with ambitions to art, and popularly believed to incarnate the absolute measure of optical truth, its success was guaranteed. Indeed, it is significant that almost all of photography's eventual uses were foreseen at its very outset. And while the traumatic implications of photography constituted a largely suppressed discourse in the mid-nineteenth century, the general awareness of its magnitude and import was widely expressed. Histories of photography appeared as early as 1856, and in France alone there were by 1854 eight or nine photography journals in addition to coverage in the press.[2] Photographic exhibitions were regularly held and widely attended, and there were at least two court cases in France which attempted to determine if photography was subject to copyright law.[3]

The excitement and self-consciousness generated by photography in France reached a watershed of sorts in the period between 1850 and 1865. The decade of the fifties is thus a crucial one in the history of photography, having witnessed one of the highest levels of artistic achievement in the medium's history as well as the use of photography for the creation of new forms and structures for the organization of knowledge. The decline of both the level of quality and serious inquiry by the mid-sixties is traditionally linked to photography's evolution from an artisanal stage to an intensely commercialized and industrialized one.

The rediscovery of the extraordinary flowering of what Nadar was the first to refer to as French primitive photography has been the inevitable consequence of the appropriation of all of photography into the art market. Formerly the esoteric preserve of scattered collectors, afficionados, and a handful of scholars, these images on paper or on glass are now being retrieved from the archives, libraries, government offices, and private attics where they have been resting (and in some cases, disintegrating) for over a hundred years. Recently assimilated to the world of museum, gallery, and corporate and private collections to a degree doubtless undreamed of by the long-dead photographers themselves, these

fragile images are now the subject of anxious efforts of conservation, a historical pendant to those of the Royal Photographic Society of Great Britain's Fading Commission of 1855.[4] But although these images may have originally been produced for widely different purposes to serve vastly different ends, the terms of their rediscovery have largely functioned to obscure such distinctions. For nowhere have the institutional methods of conferring aura been more clearly revealed than in the apotheosis of early photography, a process initiated by collectors, succeeded by galleries and museums, and now being academicized by a new generation of photographic historians and graduate students. The tendency to lump together willy-nilly under the unifying rubric of art the photographic work of physiologists and physicians (Marey and Duchenne de Boulogne), entrepreneurs and artists (Disdèri and Le Secq), archaeological documentarians and the makers of tourist views (Salzmann and Braun) has resulted in the neglect, if not obfuscation, of important questions of intent, context, and production. Because the terms of the contemporary photography world involve the assimilation of photography *toute entière* into an art discourse, it should not be surprising that these are equally the terms of the rediscovery and reassessment of early photography. To a significant degree, this process was anticipated in the very nature of the photography-as-art discourse as it has evolved in the past fifty years. When Edward Steichen mounted an exhibition of aerial views and bombardments made during World War I by the military, he was effectively stating that the art of the photograph is not contingent on intentionality. Inevitably, connoisseurship has to a great extent taken the place of criticism or analysis.

In discussing the work of Auguste Salzmann—a photographer whose principal body of works lends itself especially well to the connoisseur's act of formal delectation—I am less concerned with demonstrating its high quality than in trying to place its maker within a specific context of photographic production in the early years of the Second Empire. Many of the questions that are raised by work such as Salzmann's are not presently answerable. It does seem, however, that a meaningful approach to the history of photography needs to stress the context—in the broadest sense—of both its production and its reception.

Like many of the acknowledged masters of French primitive photography, Auguste Salzmann (1824–72) is both exemplary and enigmatic. As far as is currently known, he produced only two bodies of photographic work: 174 calotypes of Jerusalem and its environs printed by Blanquart-Evrard and published with a text in 1856 under the title *Jérusalem: Étude et reproduction photographique de la ville sainte*, and, some years later, a volume on the objects and frescoes excavated from the Necropolis at Camiros (Rhodes), which contained only a few photographic reproductions of the art works to illustrate the text. From contemporary biographical dictionaries we know that he was an unremarkable painter of orientalist and landscape subjects with some knowledge of archaeology. After 1856 he virtually disappears from the scene (with the exception of the Camiros book, which appeared between 1858 and 1860) both as painter and photographer. Nothing is

AUGUSTE SALZMANN (1824-72), *JERUSALEM, VALLEY OF JOSAPHAT*, 1854-56,

SALT PRINT FROM PAPER NEGATIVE, 23.3 × 33.1 CM. NATIONAL GALLERY OF

CANADA, OTTAWA. FROM *JÉRUSALEM: ÉTUDE ET REPRODUCTION*

PHOTOGRAPHIQUE DES MONUMENTS DE LA VILLE SAINTE DEPUIS L'ÉPOQUE

JUDAÏQUE JUSQU'À NOS JOURS.

thus far known about the remaining sixteen years of his life. Although he received a gold medal for his photographic panorama of Jerusalem displayed in the photography pavillion of the Exposition Universelle in 1855 (the largest photography exhibition mounted to that date), the photography critics of his day seem not to have considered the formal qualities of his photographs markedly different from those of any other well-regarded photographer.

In all these respects Salzmann is typical of that generation of photographers whose greatest work was produced in the decade 1850–60. This second generation came of age at a period when the process of printing from paper negatives had been considerably refined since Fox Talbot's initial invention. Even more important, the calotype in France was al-

152

most immediately granted an aesthetic legitimacy by artists and connoisseurs, which the daguerreotype, with its plethora of undifferentiated detail, mirrorlike precision, and generally small scale, was denied. Delacroix's conversion to the new medium was largely brought about by the calotype process and its sophisticated practitioners, not by the principally commercial daguerreotypists, whom Baudelaire was to scourge in his *Salon of 1859* ("A vengeful God has granted the wishes of the crowd. Daguerre is becoming its messiah").

The calotype produced singularly beautiful images; the paper on which it was printed, either salted or albumenized, determined relative degrees of softness or precision. The negative itself could be waxed to provide greater sharpness (a technique invented by Gustave Le Gray) and sensitized up to two weeks before exposure. The additional merit of its portability compared to the glass plates used for the contemporary wet-collodion process (although both techniques necessitated a darkroom *in situ*) made it a logical if not inevitable choice for photographing abroad.

Salzmann's professional training as a painter is typical of the photographic milieu of the fifties. Nègre, Le Secq, Le Gray, Fenton, Baldus, Flachèron, Constant, Vallou de Villeneuve, and many others started out as painters—the first four, in fact, came out of the atelier of Paul Delaroche. It was, of course, the same Delaroche, early enthusiast of the daguerreotype, who is remembered more now for his cry "From today, painting is dead" than for his *Death of the Duc de Guise*. Others were trained as architects (Normand) or illustrators and designer-engravers (Nadar and Marville). It is a testimony to their sense of the vitality and potential of the new medium that this group of young artists abandoned their easels and embraced photography. It is probable that neither their talent nor commitment to the prevailing *juste milieu* painting (none of these men, with the exception of Vallou de Villeneuve, were in any way associated with the realist school) was very great and that they saw in photography a form of expression that had not yet produced either an Ingres or a Delacroix—indeed, even a Vernet—against whom to invite invidious comparison. Photography, as opposed to daguerreotypy, represented an open field, an artistic *tabula rasa*, in which the very nature of the debate—art or technology—functioned as a spur to creation.

But like Salzmann, within ten, or at most fifteen, years, a significant number of the most gifted photographers of this period had either overtly repudiated or quietly ceased their production. As early as 1856, Henri Le Secq, considered by many to have been the greatest of the early photographers, had quit altogether and henceforth devoted himself to his museum of ironwork. Le Gray left Paris in 1859, eventually became a drawing instructor in Egypt, and thereafter produced only a few known photographs. Regnault renounced photography; Nègre left Paris for his native Arles, where most of his work was consecrated to perfecting methods of mechanical reproduction. The Bisson *Frères* went out of business in 1864; Mestral vanished; Baldus devoted himself largely to photomechanical reproduction; and Blanquart-Evrard closed his Imprimerie in Lille in 1864. Al-

though all accounts attribute the body count to the effects of commercialization ushered in by Disdèri's exploitation of his *carte-de-visite*, this seems too pat and mechanistic to account entirely for the phenomenon. The bourgeoisie who flocked to have *cartes-de-visite* made at a few francs each did not belong to the same milieu that bought prints by Le Gray at as much as 100 francs each. By the same token, the subscribers who ordered the sumptuous albums produced by Blanquart-Evrard were not those who bought the scenic views of Adolphe Braun & Cie. Last, most of the well-heeled *savants, notables,* and *nobles* who made up a substantial part of the membership of the Société Française de Photographie were not making their living from photography and were thus in no way affected by the activities of Mayer & Pierson, Disdèri, and the other commercial photographers.

If the abrupt and unexplained closure of these photographic careers is problematic, perhaps even more so are those photographic careers that, also like Salzmann's, produced a single body of beautiful and formally innovative images that, as far as is known, were preceded neither by preliminary experimentation nor followed by later development. Such is the case of Maxim Du Camp, whose photographic album *Egypte, Nubie, Palestine et Syrie* was Blanquart-Evrard's first publishing and printing venture (1851); of Félix Téynard; John B. Greene; and Louis de Clercq, who also photographed in Jerusalem.

With respect then to the choice of the calotype, his training as a painter, the apparent brevity of his photographic career, even his disappearance from the scene, Auguste Salzmann represents what might be considered a paradigm of photography's early history.

The enigmatic aspect of Salzmann's production resides in the marked contradiction between his professed intentions (purely documentary) and the quality of the work itself (not so much nondocumentary as *anti*-documentary); that, and the fact that this body of photographs which seems as stamped with a personal vision as any produced in the nineteenth century was, according to Salzmann's accompanying text, a collaborative work. An assistant named Durheim, about whom nothing is known, worked with him and remained in Jerusalem to complete another fifty calotypes after Salzmann, stricken with fever, was forced to leave. Of the 174 photographs printed by Blanquart-Evrard, no one has been able to separate stylistically those made by Salzmann from those made by Durheim. Collaborative photography has, of course, always been acknowledged as an important aspect of early photography, Hill and Adamson being the very model of such a partnership. But that Salzmann should indicate, as casually as he did, that fifty of the images were made by his assistant strongly suggests that Salzmann's intentions had nothing to do with the use of the camera as a device of personal expression or individual style.

Salzmann's mission in Jerusalem was typical of all the other photographic missions of the period—an act of scientific documentation and objective reporting to be rendered with the impartial and truth-telling eye of the camera. Specifically, he was charged by the Ministry of Public Instruction with the documentation of the holy city and its environs to validate the theories of his friend Louis Ferdinand de Saulcy, who had initiated the project and to whom Salzmann dedicated it. These theories concerned the dating by stylistic attribu-

tion of various Jewish, Islamic, and Christian architectural works, theories that had been published by de Saulcy in 1851, illustrated with drawings, and largely rejected by the archaeological milieu to which they had been addressed.

De Saulcy seems to have thought that this rejection was due to the inadequacy or assumed subjectivity of his visual documentation. In a letter published in the newspaper *Le Constitutionnel* in 1856, which was reprinted the same year in the *Bulletin* of the Société Française de Photographie, he stated that he had asked Salzmann, "history painter, archeologist, and savant," to undertake the photographic documentation. How this ultimately became an official commission by the Ministry of Public Instruction is unclear. The intermingling of the worlds of officialdom and photography was such that the connection could have been made in any number of ways.[5] With the conspicuous exception of the fiercely republican Nadar, photography and bohemia had little to do with each other in the Second Empire.

Nowhere was the implicit confidence in the objective truth of the camera's vision more clearly demonstrated than in the French government's official sponsorship of various photographic missions. Photography in France had from the beginning been granted official recognition, sanction, and patronage The decade of the fifties began with the launching of the Missions Héliographiques under the aegis of the Commission des Monuments Historique headed by Prosper Mérimée.[6] Napoleon III, himself totally indifferent to art, was keenly aware of the public relations, if not propaganda, purposes which photography could serve. Under direct imperial commission were such projects as Charles Nègre's photographs of the Imperial Asylum at Vincennes, Le Gray's series of army maneuvers at Châlons, Baldus's documentation of the Rhône floods of 1856, and such icons of imperial piety as Le Gray's portrait of the Empress Eugènie at her *prie-dieu*.

The enormous production (both official and private) of photographic documentation of architecture, historic sites, and ruins was to a certain extent fueled by the passion for documentation itself. The mid-nineteenth century was the great period of taxonomies, inventories, and physiologies, and photography was understood to be the agent par excellence for listing, knowing, and possessing, as it were, the things of the world. Like physiology in its sociological application (no fewer than 200 books appeared between 1839 and 1860 bearing the word *physiologie* in the title, encompassing everything from Brillat-Savarin's *Physiologie du gout* to Ernest Lacan's *Physiologie du photographe*) or, for that matter, phrenology, photography was a method of comprehending the world in terms of its exterior appearance. Photography itself was the technical analogue to the absolute belief in the legibility of appearances, a belief whose philosophical expression was, of course, positivism and whose artistic expression was realism and naturalism.

But this belief in the definitive truth of the photograph is a curious phenomenon. That the photograph of the 1850s did not produce color or clouds or anything moving, that the world it depicted was largely vacant, was very quickly taken for granted and such deficiencies discussed almost exclusively in the context of the critical debate that focused

GUSTAVE LE GRAY, *EMPRESS EUGÈNIE AT ST. CLOUD*, 1856. RÉUNION DES
MUSÉES NATIONAUX, CHATEAU DE COMPIÈGNE.

on photography versus painting. Even with respect to architectural views, the photographer could not generally do interiors and could take only those views possible with a large camera mounted on a tripod. Nonetheless, the prevalent belief that photographic documentation constituted an unassailable and objective truth was largely unchallenged throughout the century. It was, in fact, the very quality of unmediated verisimilitude that was perceived as its greatest weakness as an art form. Thus, when Salzmann wrote in his text that "the photographs are not narratives [*récits*], but facts endowed with a conclusive brutality," he was describing the attributes that photographs were thought to have rather than the particular quality of his own work, which, in its abstraction and suppression of documentary information, appears to contradict Salzmann's stated goals.

.

"Anybody," wrote Walter Benjamin, "will be able to observe how much more easily a painting, and above all sculpture or architecture can be grasped in photographs than in reality."[7] This realization was fully formed by the early 1850s and many of the best photographers of the period—including the artist-photographers—photographed works of art with the same assiduity and commitment as they brought to their own work. Charles Marville was for many years the official photographer of the Musées Nationaux, in which capacity much of his photographic work was what we would call copy-stand work. The copying of paintings, engravings, and sculpture was viewed as a serious photographic enterprise in its own right.[8] Benjamin further pointed out:

> At about the same time as the formation of the technology for reproduction the conception of great works was changing. One can no longer view them as the productions of individuals: they have become collective images, so powerful that capacity to assimilate them is related to the condition of reducing them in size. In the final effect, the mechanical methods of reproduction are a technology of miniaturization and help man to a degree of mastery over the works without which they are no longer useful.[9]

It is revealing to contrast Benjamin's retrospective account of the implications of a technique for miniaturization with a contemporary one. Addressing Napoleon III and his court in 1862, Viollet-le-Duc, in rhetoric that recalls nothing so much as M. Homais at the Agricultural Fair, stated:

> In France perhaps no other government has shown a greater interest in the arts than that of the present. Within the space of a dozen years more buildings have been constructed than since the time of Louis XIV. Painting has been able to create one of the greatest chapters in history; sculpture has become exalted; our museums have been further enriched; our libraries made still more vast and capable of receiving the ever-increasing number of users. The discoveries of exploratory expeditions have thus been passed on to artists and scholars immediately. And to

ACHILLE QUINET, *CHURCH OF SAN MARCO*, 1865, ALBUMEN PRINT

FROM GLASS NEGATIVE. CABINET DES ESTAMPES, BIBLIOTHÈQUE NATIONALE.

add to our good fortune, photography has placed in our hands the masterworks of all periods and all cultures, just as the great exhibitions of London and Paris have brought to light a vast quantity of art normally hidden in private collections. . . . [Further] the railroad has allowed us to see more monuments in a week than it would have been possible to visit in a month.[10]

That Viollet-le-Duc, connected through the Monuments Historique with some of the most gifted photographers of the period, should have uniquely stressed the ability of photography to place "in our hands the masterworks of all periods and all cultures" is indicative of the awareness that photography, like the expeditions and the railroads, was an agent of cultural transmission. Thinking along similar lines, the art and photography critic Francis Wey had proposed in 1851 that the Louvre consecrate a gallery to photographs of important paintings by French artists not represented in French museums. Thus, Mal-

raux's Imaginary Museum was presaged a century earlier; in both cases the governing impulse effects a standardization; all works of art, monuments, sites, and objects are ultimately reduced to the status of image.

Benjamin's use of the verb *grasp* is also suggestive. As has been pointed out often enough, the camera can be used appropriatively, and Salzmann's photographic mission to Jerusalem should be understood within this larger framework. The appropriation of the world by the camera during the Second Empire—a period of rapid colonial expansion and imperialist adventures—was not unremarked at the time. The discourse of Second Empire imperialism was couched in terms either of a *mission civilisatrice* or, most conspicuously in the case of Palestine, in a systematic denial of the existence of native inhabitants.[11] The photographs of the Middle East that appeared in greater and greater numbers from the beginning of the 1850s depicted essentially vacant spaces, empty cities and villages. Although it was the conditions of early photography that determined the human absence, it is reasonable to assume that such photographic documentation, showing so much of the world to be empty, was unconsciously assimilated to the justifications for an expanding empire.

In urging the government to subsidize photographic missions abroad, Francis Wey, writing in 1851, described them as "conquêtes pacifiques." And in no part of the world were these peaceful conquests made so frequently as in the Middle East. Salzmann's mission in Jerusalem took place even as the war in the Crimea was being waged, a war which was presented to the French people as being fought to defend the holy places. Between 1850 and 1863, Egypt, Syria, and Palestine received legions of photographers: Du Camp, Déveria, Frith, Téynard, Banville, Greene, de Clercq, Bedford, Benecke, Maunier, Beato, Trémaux—and these are only the well-known ones. Certainly one of the tributaries to this tide was the contemporary interest in orientalist subjects which had originated in the eighteenth century and peaked with French romanticism. But after the publication of Lerebours's *Excursions daguerriennes* (engravings made from daguerreotypes that appeared between 1841 and 1844) it was the wonder and fascination elicited by places and monuments "miniaturized" by the camera which both maintained and contributed to the widespread interest.

Salzmann was thus not the first and certainly not the last young Frenchman with a camera to fix the ancient stones of Jerusalem with his lens. We assume that de Saulcy's choice of the thirty-year-old Salzmann was knowledgeable, as it is unlikely he would have requested a photographic documentation of such ambition and personal importance had he not been convinced of Salzmann's skill. And although Salzmann was not a member of the Société Française, and may not have even photographed before, the distinction between amateur and professional was not yet strongly drawn. Du Camp, for example, had been taught by Le Gray to take photographs immediately before his voyage and specifically in order to record it. "To learn photography," he wrote, "is no great thing; but to transport the equipment on the back of mules, camels, and men was a difficult

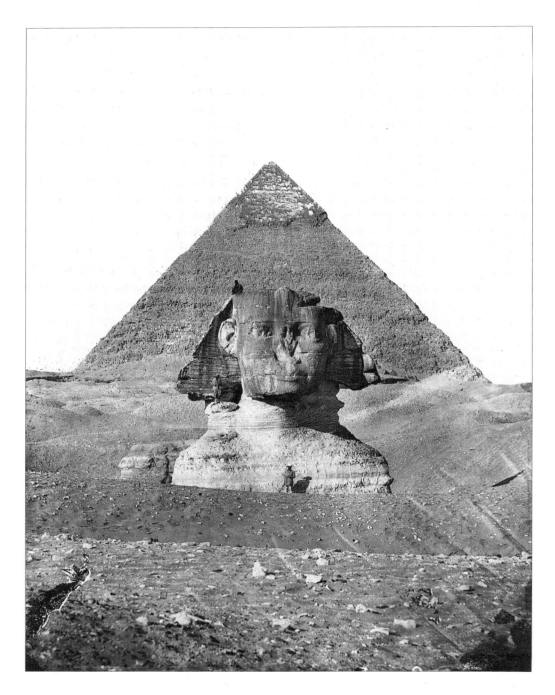

ARMAND DE BANVILLE, *GIZA: SPHINX AND THE PYRAMID OF CHEPHREN,*

1863. CAISSE NATIONALE DES MONUMENTS HISTORIQUES ET DES SITES.

problem."[12] It was probably infinitely more important to de Saulcy, then, that Salzmann had some background in archaeology and was sympathetic to his theories.

In January of 1854 Salzmann arrived in Jerusalem after a three-week voyage. The little currently known about these months of photographing derives almost exclusively from de Saulcy's letter in *Le Constitutionnel* and the few hints in Salzmann's text. Neither of these sources provides a key to the images, not the barest allusion to his artistic goals and purposes nor any reference to justify the supposition that he conceived of his photographs in such terms. And yet what has struck almost every contemporary viewer is how utterly different these photographs are from others of the same period, even those using the same process and depicting the same subject. Such a comparison reveals more than the ability of photography to express individual vision. It shows, rather, the extent to which Salzmann was departing from the customary conventions of photographic composition. That standard practices were derived essentially from rules for the organization of pictorial space in painting was due as much to the number of photographers with training in the traditional fine arts as the fact that the battle to legitimize photography was waged on painting's terms. Many of the photographic texts and treatises of the period—from Le Gray to Disdèri—specifically instruct the photographer in principles of pictorial composition. Even though photography imposed its own necessities and, implicitly or explicitly, its own *topoi*, photographers were very much guided by traditional ideas of what constituted good design, balanced composition, and spatial coherence. Most important, however, was legibility, for if this was the intent of mid-nineteenth-century painting, it was especially understood to be the intrinsic merit and excellence of photography. From the most humble to the most self-consciously artistic practitioners, landscape and archaeological photographers generally delineated a progression from foreground through middleground to background and framed their images to articulate and emphasize the principal subject. In photography of specifically documentary intention, as was Salzmann's, these were cardinal virtues.

But the documentary intention of Salzmann's photographs is seemingly belied by the images themselves; the visual information that a photographic record is ideally suited to convey is markedly, almost perversely absent. The ubiquitous standing figure—fellaheen, porter, guide, or companion—who appears in archaeological photography to indicate scale is never present in Salzmann. Views are cropped in such a way that the colossal appears diminutive, the small monumental. Landscape either dwarfs the photographed site or is virtually eliminated; the visual signposts one requires to judge scale, terrain, distance, placement, and context are, in short, almost completely suppressed.

What Salzmann has created instead is an abstract vision of textures and surfaces in which the ostensible subject is engulfed or submerged, either by a plenitude of overall surface detail or an overwhelming landscape. By frequent use of high horizon lines or the elimination of horizon altogether, the image is pushed toward the surface plane and all suggestion of spatial depth negated. Often when photographing rock-cut tombs and grot-

AUGUSTE SALZMANN, *VILLAGE OF SILOAH*, 1854–56, SALT PRINT FROM PAPER

NEGATIVE, 23.2 × 31.6 CM. NATIONAL GALLERY OF CANADA, OTTAWA. FROM

JÉRUSALEM: ÉTUDE ET REPRODUCTION PHOTOGRAPHIQUE DES MONUMENTS

DE LA VILLE SAINTE DEPUIS L'ÉPOQUE JUDAÏQUE JUSQU'À NOS JOURS.

toes, Salzmann organizes the image around a black void, as in the *Tomb of the Judges*, where the almost startling opacity of the rectangular tomb mouth contrasts with the wide range of tonalities of all the other modulated gray surfaces. The use of shadow in the *Tomb of the Judges*, as in so many of the other photographs, is not so much employed for the articulation and exposition of mass as for purely formal purposes; there is no way to determine whether the tomb entrance is shallow or immeasurably deep—an element of archaeological information that could have been given if Salzmann had chosen. Beyond the emphatic blackness of these various portals and tombs, the eye cannot follow and is refused entrance into the image in which they are both compositional center and optical barrier. Salzmann's placement of the camera is often selected because it draws areas that are at different distances from his lens into a contrived and planar unity; in the *Tomb of the Judges*, the rock

AUGUSTE SALZMANN, *TOMB OF THE JUDGES*, 1854–56, SALT PRINT FROM PAPER
NEGATIVE, 23.4 × 33.2 CM. NATIONAL GALLERY OF CANADA, OTTAWA. FROM
*JÉRUSALEM: ÉTUDE ET REPRODUCTION PHOTOGRAPHIQUE DES MONUMENTS
DE LA VILLE SAINTE DEPUIS L'ÉPOQUE JUDAÏQUE JUSQU'À NOS JOURS.*

outcropping at the right optically leads into the tomb face which is then linked to the
stones of the hillside. As is typical with Salzmann's work, the tomb itself might be five
feet high, or fifteen; no way of gauging it is provided.

In the view of the *Village of Siloah*, the piling up of surfaces and texture militates
against any reading of depth. What is stressed is the different qualities of stone, finished or
rough, bricklike or massive, pebbly or smooth. In photographs such as *The Pool of Siloah,
Canal Cut in the Rock*, Salzmann's inventive and sophisticated use of shadow is particularly
evident. Here the space is dramatically simplified through the use of contrasting light and
shadow areas to divide the image into quadrants. It is, at the same time, almost impossible
to derive any information about the canal which is the ostensible subject of the
photograph—where it goes, how it has been cut, even exactly where it is. Possibly Salz-

AUGUSTE SALZMANN, *POOL OF SILOAH, CANAL CUT IN THE ROCK*, 1854–56,
SALT PRINT FROM PAPER NEGATIVE, 23.4 × 32.9 CM. NATIONAL GALLERY OF
CANADA, OTTAWA. FROM *JÉRUSALEM: ÉTUDE ET REPRODUCTION
PHOTOGRAPHIQUE DES MONUMENTS DE LA VILLE SAINTE DEPUIS L'ÉPOQUE
JUDAÏQUE JUSQU'À NOS JOURS.*

mann was caught up with what he could do with the camera, how by balancing bleached-out lights with various darks he could create formal designs for which no prototype—either in painting or photography—existed.

A comparison between a photograph of the same subject by Salzmann and Louis de Clercq is useful for what it reveals of Salzmann's strategies of framing and cropping. De Clercq photographed in Jerusalem five years after Salzmann and like him produced a single known body of work (the four volumes that comprise *Le voyage en Orient*, 222 photographs altogether). De Clercq's photographs were printed on albumen paper and Salzmann's on salt paper, but both employed paper negatives and comparable cameras. The subject is the Gate of Damascus (Bab-el-Ahmoud). Where de Clercq has chosen a frontal view of the structure and constructed a carefully composed progression from foreground

to middle ground to the architecture, Salzmann, quite typically, has chosen an oblique view. By framing the gate more tightly, he eliminated the view of the city that lies behind it, which is indicated in the de Clercq by the minarets on the left and the domes on the right. Salzmann depicts the portal itself as another of his black voids, while de Clercq is concerned to show that it is recessed and several feet deep. Salzmann swathes the right slope of the stony ground in shadow, which also shrouds the side of the right flank of the gate. In employing more extreme contrasts of light and shadow, texture is almost bleached out on the left and strongly emphasized in the central pathway to the door. Unlike de Clercq, it is the surface texture and expressive possibilities of intense light and shadow to which Salzmann seems drawn. De Clercq uses shadow principally for information; thus the pool of shadow in front of the main gate signifies a hollow; at the same time that it strengthens the composition it provides information.

We do not know what Salzmann's public or the Ministry of Public Instruction thought about his *Jérusalem*. Critical response to his panorama exhibited at the Exposition Universelle and a series of Jerusalem photographs exhibited the following year in Brussels was positive, but the qualities on which the critics elaborated pertained to their truth, their verisimilitude, their attention to detail. Evidently the photographs were understood by de Saulcy, by the Ministry, and by the critics as having accomplished their documentary purpose. As is clear from his letter in *Le Constitutionnel*, de Saulcy considered his theories vindicated by the images, although in fact his dating has never been accepted, having been, as his critics charged, totally inaccurate.

What finally are we to make of a work such as Salzmann's? In what terms should we discuss it and how is it to be evaluated and understood, both in relation to the photographic production of his contemporaries and its meaning for us now? In what way are we to understand such photography as documentary?

The weight of the evidence is that, irrespective of how the photographs appear to us now, Salzmann was not intentionally working in an art tradition. Unlike many of his contemporaries who were, he did not even sign his negatives. That his photographs appeared under the title *Study and Photographic Reproduction of the Holy City* explicitly refers to a documentary impulse. And it cannot be overemphasized that in the mid-nineteenth century photographs were seen as and understood to be factual documents, a far stronger determinant of their reception than what individual photographs may have looked like. In view, then, of what is known about both photographic practice and theory in the early years of the Second Empire, and the very little currently known about Salzmann and his mission, it is unwarranted to project onto these photographs a concept of artistic intentionality for which there is no evidence. On the other hand, the awkwardness of considering such images under the rubric "documentary" raises questions about the utility, or even the logic, of dividing photography between poles of aesthetic or documentary intent and effect.

Although Salzmann was never entirely forgotten—he is discussed, for example in

Raymond Lécuyer's classic *Histoire de la photographie* of 1945—the beginning of his prominence as one of the most highly esteemed of the French primitive photographers begins with the publication of an article on *Jérusalem* by André Jammes in 1965. Jammes, a scholarly collector and connoisseur, was careful to point out that for Salzmann the central concern was whether the stones and structures he was photographing were Jewish, Roman, or Christian. However, in the time that has elapsed since the appearance of Jammes's article, the general apprehension of photography has undergone a considerable shift, clearly evidenced in the way early photography is now viewed. So powerful has been the impulse toward reification of the photographic image that the overriding tendency is to assess the photographs of the past in the terms of the present.

LOUIS DE CLERCQ, *DAMASCUS GATE*, 1858-59, CALOTYPE. NATIONAL GALLERY OF CANADA, OTTAWA. FROM *LE VOYAGE EN ORIENT, VILLES, MONUMENTS ET VUES PITTORESQUES: RECUEIL PHOTOGRAPHIQUE EXECUTÉ PAR LOUIS DE CLERCQ*, 1858-59. PREMIER ALBUM.

The art history of photography now being created (and I refer here to recent exhibitions, catalogs, and exhibition reviews as much as texts) is an endeavor that depletes the photographs of their original meaning and fills them with a new one. This new meaning—aesthetic—involves a double distortion. Proposing an art history of photography, in which photography is understood as a history of distinct genres and styles, supposes that one can make a distillation of the cultural solution from which discrete images will precipitate out. But because the history of photography is, in reality, integrally bound up with numerous discourses—those of science, of geographic expansion and imperialism, of reproduction, of architecture, of archaeology, and so forth, the extraction of art ends finally with the suppression of all the others. The discourse of art as it intersected

AUGUSTE SALZMANN, *DAMASCUS GATE*, 1854-56, SALT PRINT, 5 15/16 × 8 3/8 IN.

THE J. PAUL GETTY MUSEUM. FROM *JÉRUSALEM: ÉTUDE ET REPRODUCTION*

PHOTOGRAPHIQUE DES MONUMENTS DE LA VILLE SAINTE DEPUIS L'ÉPOQUE

JUDAÏQUE JUSQU'À NOS JOURS.

167

with photography was only one of many, but to an ever increasing extent it is being treated as though it were the only one.

As serious inquiry into the effects of a global environment of photographic imagery has only recently begun, it augers ill that photography's intersection with other discourses is already being written out of the historical account. Further, the imposition of an art history of photography creates fanciful misreadings; a tendency, for example, to confer on mid-nineteenth-century photographers the status of modernist artists *avant la lettre*, which distorts in fundamental ways the context in which their work was produced. While modernist art in France occupied a cultural adversary position, photography, then as now, was everything and everywhere. The smiling Communards who posed for the camera would shortly thereafter be executed when the photograph was in other hands.

Although the impulse to view Salzmann (or Greene, or Charney, or Téynard . . .) as an artist-photographer seems justified by the beauty of the photographs, this titular elevation is an ahistorical projection of contemporary attitudes and assumptions about photography that inevitably has more to do with the imperatives of the current market boom than with the goals and values that informed his work. To liberate Salzmann from history in order to retrieve him for art is to suppress the circumstances and conditions that made Salzmann's work possible. A single plate from *Jérusalem*, removed from the folio volume where it was intended to be seen as an ensemble, remains a fragment of what should be preserved as an integral whole. In the great rush to discover the art of photography's past, we run the risk of destroying its history.

1981

8

. .

Who Is Speaking Thus? Some Questions about Documentary Photography

What is a documentary photograph? With equal justice one might respond by saying "just about everything" or alternatively, "just about nothing." In support of the former reply, one could argue that insofar as any photographic image expresses an indexical relation to whatever appeared before the lens at the moment of exposure, that image is a document of *something*. From this expansive position, no photograph is more or less documentary than any other. Conversely, one could argue that the conception of photography as a faithful and unmediated transcription of physical appearances (residual traces of the ancient faith notwithstanding) has long since been abandoned. We therefore now take for granted that the camera produces representations—iconic signs—translating the actual into the pictorial. While photographs remain the only form of pictorial evidence routinely admitted in the courtroom, the once universal belief in the camera's truth has been belied by everything from outright trumperies to the poreless faces of *Vogue* models.

But irrespective of its logical inconsistencies, amorphousness of definition, and epistemological vagueness, the category "documentary" remains in service as a workable, although untheorized, rubric. However, between the apparently unmediated (but still highly mediated) images of the electronic surveillance camera—the degree zero of camera as visual registry—and, for example, the emphatically personal and "expressive" photographs of postrevolutionary Iran taken by Gilles Peress, lies a very large and very gray area. We need to map this area more precisely in order to examine the assumptions, both implicit and explicit, that underlie this practice both historically and in the present.

To speak of documentary photography either as a discrete form of photographic practice or, alternatively, as an identifiable corpus of work is to run headlong into a morass of contradiction, confusion, and ambiguity. "Documentary" is itself a recent entry into the photographic lexicon;[1] it is not employed with any regularity before the late 1920s, nearly a century after its invention. Because the majority of photographic uses previous to the term's introduction were what we would now automatically designate as documentary, it becomes clear that the documentary concept is historical, not ontological. Moreover, the word's permutations are testimonial to the way photographic uses, and the

169

meanings ascribed to them, are constantly in flux, repositioned and reoriented to conform to the larger discourses which engender them.

The late arrival of the category documentary into photographic parlance implies that until its formulation, photography was understood as innately and inescapably performing a documentary function. Self-consciously defined art photography aside, to nineteenth-century minds the very notion of documentary photography would have seemed tautological. Indeed, the historic agenda of art photography throughout the nineteenth and much of the twentieth centuries was to counter the popular view of photography as a brute transcriptive medium with claims for its subjective and expressive mediations. It is thus not surprising that when the notion of documentary was adapted to photographic practices as a specific genre, it was only after symbolism and aestheticism (in the stylistic form of pictorialism) had dominated photographic discourse for more than thirty years.

To make some sense of what is and has been meant by documentary, we need to examine it from three perspectives. As a historical construction it must be situated within the framework of its contemporary discourses, practices, and uses. How is the notion of documentary photography to be retrospectively differentiated from the plural field of nineteenth-century production? Is documentary to be narrowly defined as an investigative or didactic enterprise or broadly defined to include all nonaesthetic and informational uses? Is the avatar of documentary photography the police mug shot possessing evidentiary status,[2] the horse race's photo finish, or photography animated by social concern? Such questions suggest another framework altogether—that photography be approached semiotically. As part of a larger system of visual communication, as both a conduit and agent of ideology, purveyor of empirical evidence and visual "truths," documentary photography can be analyzed as a sign system possessed of its own accretion of visual and signifying codes determining reception and instrumentality.[3] A range of factors can be considered including those that contribute to what Roland Barthes described as *l'effet du réel* as well as those types of subject matter that have come to effectively signify the documentary enterprise. Last, we would want to examine the position of documentary photography within the discursive spaces of the mass media (and, more recently, within the discursive spaces of the gallery and museum) in order to better grasp the role it plays, the assumptions and attitudes it fosters, the belief systems it confirms.

These three lines of inquiry all finally converge—and to a certain extent devolve—around the problem of realism; for it is pre-eminently photography's ostensible purchase on the real that materially determines both its instrumentality and its persuasive capacities. Bertolt Brecht's observation that "realism is an issue not only for literature: it is a major political, philosophical and practical issue and must be handled and explained as such" needs to be factored into the photographic field. There, to be sure, it will require its own forms of analysis and critique—photography is, after all, a medium of mechanical reproduction—but there are obvious homologies to realist constructions in other media.

Reflections of this kind are intended not to recuperate some notion of an authentic,

Juniors of photography

pure, or uncompromised documentary practice, but, rather, to sketch out the terms in which such photography has functioned both in the past and in the present. For the paradox that underlies those documentary practices that have defined themselves as critical of the status quo, or at very least reformist in intention, is that they normally operate within larger systems that function to limit, contain, and ultimately neutralize them. The issue here is not co-option as such, but the structural limitations of conventional documentary imagery to disrupt the textual, epistemological, and ideological systems that inscribe and contain it. Consequently, as Martha Rosler observed, "Documentary photography has been much more comfortable in the company of moralism than wedded to a rhetoric or program of revolutionary politics."[4] For those who call for a new militant documentary practice cognizant of both the representation of politics and the politics of representation,[5] a thorough awareness of what traditional documentary modes put in place is a prerequisite to any practice that attempts to go beyond it.

The status of photography at its birth hinged on what was thought to be its capacity for objective transcription. Photographic literature from the following two decades compulsively, almost ritualistically, repeats a litany of photographic truth. The world and its objects offered itself to the camera's lens, promising an encyclopedic visual registry—an inventory to be put at the service of science, commerce, physiognomy, empire, and art.[6] *wrote about.* Photographs from those early years include pictures of everyday objects, the contents of studios and libraries, corners of cottage gardens, farm implements, unremarkable architecture, the flotsam and jetsam of daily life, excluding only that which moved too rapidly for the long duration of exposure. In direct contrast to those images that clearly point to the desire to commemorate the singular and the unusual (freaks and wonders, the famous and powerful, the exotic, the Other) these pictures imply a fascination and delight in the act of photographic representation itself. That such images have been recently recuperated as art—for art—says a great deal about contemporary photographic discourse, but sheds little light on the meaning of these photographs as historical objects.

By the 1860s, photographic practice of the kind we now routinely label as documentary was thoroughly established: Désiré Charnay's pictures of Mayan ruins and Madagascan natives, Samuel Bourne's photographs of India and Nepal, Felice Beato's war photographs from the Crimea and the Opium Wars, Matthew Brady's staff's reportage on the Civil War, Francis Frith's plates of Egypt and the Holy Land, all are animated by the desire to fix and register a perceived reality into the two-dimensional space of representation.

But what, we must ask, is the real of representation? And, even more important, to what uses were these representations put? Discussing the social uses of photography, the French sociologist Pierre Bourdieu commented: "In stamping photography with the patent of realism, society does nothing but confirm itself in the tautological certainty that an image of reality that conforms to its own representation of objectivity is truly objective."[7] Accordingly, photography functions to ratify and affirm the complex ideological web that at any moment in historical time is perceived as reality *tout court*. Thus,

points to mention

171

the photographs depicting the "empty" spaces of Palestine and Egypt become themselves an important (visual) tributary of the progress of empire, the photographs depicting the exotic native Other become fuel for the *mission civilisatrice*. Similarly, the photographs of incarcerated hysterics commissioned by Dr. Charcot at the hospital of Salpêtrière prove and demonstrate at one and the same time the specular morphology of hysteria.[8]

Although these are somewhat loaded examples (emphasizing the particularly oppressive instrumentalities of the medium) they are in no way exceptional. The success of photography as an image-making technology—its amazingly rapid expansion and assimilation to all discourses of knowledge and power—was precisely a function of its confirmatory aspects. This in turn suggests why we cannot legitimately speak of a nineteenth-century documentary practice that in any way functioned against the grain of dominant ideologies. It would not have occurred to, say, Friedrich Engels, to have supplemented *The Condition of the Working Class in England* with photographs of the squalid housing conditions of Manchester.

DÉSIRÉ CHARNAY, *PALACE OF THE NUNS AT UXMAL*, FACADE OF THE NORTH WING, ALBUMEN PRINT. FROM CHARNAY, *CITÉS ET RUINES AMÉRICAINES*, PARIS, 1863. CABINET DES ESTAMPES, BIBLIOTHÈQUE NATIONALE.

Point to mention.

This did, however, occur to Jacob Riis in 1887 as part of his activity of police reporter and "crusading" journalist, and it is primarily for this reason that the retrospective construction of the documentary mode traditionally begins with him.[9] In this model for documentary, the genre is defined within the framework of reformist or ameliorative intent, encompassing issues such as public address, reception, dissemination, the notion of project or narrative rather than single image, etc. Thus defined, Riis (1849–1914) appears as the logical candidate for progenitor insofar as his work was produced to provide the sensational visual supplement to his 1890 reformist tract *How the Other Half Lives*. Having worked as a police reporter, and then as a free-lance journalist for the New York City daily press, Riis took (and commissioned) photographs for only a few years at the end of the

FELICE BEATO, *CHINA, THE TAKU FORTS AFTER THE ANGLO-FRENCH ATTACK*, 1861 (SECOND OPIUM WAR), PAPER PRINT FROM COLLODION ON GLASS NEGATIVE. CABINET DES ESTAMPES, BIBLIOTHÈQUE NATIONALE.

173

ALLAN HUGHAN, *MUSICAL EVENING GIVEN BY FRENCH OFFICERS IN THE ILE*

DES PINS, NEW CALEDONIA, CA. 1870–71, ALBUMEN PRINT FROM GLASS NEGATIVE,

48 CM. × 32 CM. FROM HUGHAN, *SOUVENIRS AU VOYAGES DE LA MISSION D'EXPLORATION*

ENVOYÉE EN NOUVELLE CALÉDONIE PAR LA COMPAGNIE DE LA NOUVELLE

CALÉDONIE, CABINET DES ESTAMPES, BIBLIOTHÈQUE NATIONALE.

JACOB RIIS, *MIDNIGHT IN LUDLOW STREET*, 1888–90, GELATIN-SILVER PRINT MADE

FROM ORIGINAL NEGATIVE, 9 1/2 × 7 5/8. MUSEUM OF THE CITY OF NEW YORK.

1880s. These photographs (frequently taken with the recently invented magnesium flash that permitted the photographer to work in dark interiors) were reprinted as half-tone illustrations for the book or projected as lantern slides. In her important article "Making Connections with the Camera: Photography and Social Mobility in the Career of Jacob Riis," Sally Stein produced a detailed and wholly persuasive account of the latent, rather than manifest, meanings of Riis's photographs. This analysis was interwoven with a scrutiny of Riis's writing to the extent that both activities could be seen to converge within a dense matrix of bourgeois social anxieties and the need to assuage them. This matrix was constituted by the threat posed by large numbers of poor, unassimilated recent immigrants, the specter of social unrest, the use of photography as a part of the larger enterprise of surveillance, containment, and social control, and the imperatives of "Americanization." Within this framework, Stein examined the role played by Riis's personal ambition and his assumption of the mantle of crusader as an agency of social ascent. By rigorously

surveying the contextual field in which this body of work functioned, Stein made a major contribution to the ongoing critique of traditional documentary forms, one of whose chief emphases is an interrogation of the subject/object relations that such photography normatively puts in place.

For example, in describing Riis's predilection for imaging his subjects in ways that deny any notion of the photographic act as a transactional one, Stein makes the following observation: "We can indeed marvel at the consistency of Riis's photography in which so few of the exposures presented a subject sufficiently composed to return the glance of the photographer. That he rejected those rare photographs in which the subject did happen to look back suggests how premeditated this effect was. . . . The averted gaze, the appearance of unconsciousness or stupefaction, were only a few of the recurring features which gave Riis's pictorial documents stylistic unity and ideological coherence in relation to the text."[10] By refusing to reiterate the conventional pieties surrounding representations of the poor and the marginal, and by bringing to light hidden agendas inscribed in such photography, Stein reveals a secondary level of signification that radically questions a too-easy conflation of "victim photography" with progressivism and reform. But the issues explored by Stein in relation to this specific corpus of photographs have a far more general application. We must ask whether the *place* of the documentary subject as it is constructed for the more powerful spectator is not always, in some sense, given in advance. We must ask, in other words, whether the documentary act does not involve a double act of subjugation: first, in the social world that has produced its victims; and second, in the regime of the image produced within and for the same system that engenders the conditions it then re-presents.[11]

The discourse of documentary that places Jacob Riis at its origin lays a certain stress on the notion of instrumentality (as though all other forms of photography were not inevitably instrumentalized). This conception of documentary photography is one whose prestige and influence has variously expanded and shrunk, had its ideological parameters altered, and its constitutive terms modified and retooled. In the 1930s, a period in which (at least in America) documentary forms in film, photography, and letters were most privileged, both liberals *and* radicals conceived of the form as adequate to explicitly defined political ends. Notwithstanding the contemporary critique of photographic transparency and autonomy launched by Bertolt Brecht and Walter Benjamin (fueled, when not specifically modeled, on the theories of the Soviet avant-garde), the prevalent conception of a politicized documentary focused largely on subject matter. The perceptual and representational critique generated by art movements as various as cubism, dada, surrealism, constructivism, and, of course, photomontage, cannot be said to have had much influence on either the theory or the practice of documentary.

Accordingly, projects such as the Farm Security Administration's documentary enterprise,[12] a large-scale, federally funded propaganda machine initially conceived to foster support for New Deal relief programs, took for granted that a photography of advo-

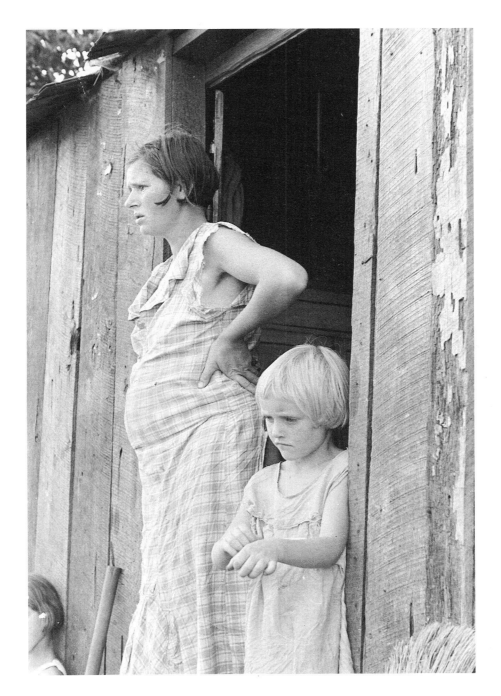

ARTHUR ROTHSTEIN, *SHARECROPPER'S WIFE, ARKANSAS*, 1935.

LIBRARY OF CONGRESS.

DOROTHEA LANGE, *MIGRANT AGRICULTURAL WORKER'S FAMILY*, 1936.

LIBRARY OF CONGRESS.

cacy or reform should effectively concentrate on subject matter. The subject was, in all senses, the given; Roy Stryker, the director of the project, not only stipulated the specifics of region, milieu, or activity when making assignments, he often further indicated what type of mood, expression, "feeling" he was after—what we would now term the rhetoric of the image. Those photographers, like Walker Evans, who had their own aesthetic agendas did not fare well at the F.S.A.

While in no way disputing the fact that the ways in which Riis represented his subjects were markedly different from those employed by Lewis Hine, and, later, the F.S.A. photographers, we are nonetheless confronted with some unchanging tropes. One such trope consists of the depiction of the subject—and the subject's circumstances—as a pictorial spectacle usually targeted for a different audience and a different class. Another concerns the immobilizing effect produced by presenting the visual "fact" of individual vic-

timization or subjugation as a metonym for the (invisible) conditions that produced it. Such an effect may be produced irrespective of good intentions, personal or institutional politics, or ameliorative intent. Moreover, to the extent that photography is less able to deal with collectivity than with individuality, work such as the F.S.A. project demonstrates a probably inevitable slippage from the political to the anecdotal or the emblematic. Indeed, the very working methods of some of the F.S.A. photographers attest to a preference for the poignant over the militant. When subjects smiled into the camera, they were stage-managed into more somber poses; sharecroppers who wore their best clothes to be photographed were told to change into their ragged everyday wear, persuaded not to wash begrimed hands and faces for the camera.[13]

As William Stott points out, there was a distinctly doctrinal aspect to the F.S.A. project. Insofar as the mandate of the program was to bolster popular and governmental support for New Deal relief policies, it was images of the "worthy" as opposed to the "unworthy" poor that were promoted. Commenting on the work of Dorothea Lange, the film-maker Pare Lorentz noted the following: "She has selected with an unerring eye. You do not find in her portrait gallery the bindle-stiffs, the drifters, the tramps, the unfortunate, the aimless dregs of a country."[14] In other words, the appeal made to the viewer was premised on the assertion that the victims of the Depression were to be judged as the deserving poor, and thus the claim for redress hinged on individual misfortune rather than on systematic failure in the political, economic, and social spheres. Lange, married to the economist Paul Schuster Taylor (with whom she collaborated on books such as *An American Exodus*), knew as well as anyone that the conditions she photographed were the consequences of capitalist crisis and neither acts of God nor arbitrary misfortune. Nonetheless, as a photographer her instinct was to individualize and personalize—to present her subjects as objects of compassion and concern.

The photographer's desire to build pathos or sympathy into the image, to invest the subject with either an emblematic or an archetypal importance, to visually dignify labor or poverty, is a problem to the extent that such strategies eclipse or obscure the political sphere whose determinations, actions, and instrumentalities are not in themselves visual. Moreover, photographs retain their specificity only briefly; much of the graphic legacy of the F.S.A. is currently embalmed in a collective nostalgia about the 1930s, or enshrined as a humanist monument to the timeless struggle against adversity, or revered as a record of individual photographic achievement.[15] Child laborer, tenant farmer, disenfranchised black, the (once) living subject whose existence testified to the injustice and abuses bred within a political and social system, now becomes testimony to the photographer's eye and the photographer's art.

But the fact that a photograph's context is a powerful determinant of its perceived meaning is only one aspect of the problem. Furthermore, it should be stressed that the influences on photographic meaning produced by the framing context extend beyond the obvious polarities of gallery wall or magazine page. For within that latter space, the sur-

rounding editorial environment, the nature of caption and text, the sequencing of images, and the competing mass of other images (e.g., the ads that might appear on the same page) variously influence the way in which the images will be read and interpreted.

In her now-classic essay on documentary photography, Martha Rosler points out that "imperialism breeds an imperialist sensibility in all phases of cultural life."[16] Indeed, one of the principal emphases of her argument concerns the way in which dominant social relations are inevitably both reproduced and reinforced in the act of imaging those who do not have access to the means of representation themselves. Further, in the absence of a progressive or reformist political and social environment such as that which fostered the work of Lewis Hine or the F.S.A., documentary photography becomes differently inflected. "The exposé, the compassion and outrage fueled by the dedication to reform has shaded over into combinations of exoticism, tourism, voyeurism, psychologism and metaphysics, trophy hunting—and careerism."[17]

But while photographers compose and organize their images to yield certain meanings, rarely is a photograph's subject neutral or unmarked to begin with. Added to the significance of subject matter on the level of denotation and connotation, and to the significance produced by contextual factors, are those elements supplied through mechanisms internal to the apparatus which also serve to structure meaning. These mechanisms in and of themselves produce certain effects, perhaps the most important one in photography being Barthes's "reality effect." In part, this derives from the fact that photography, like all camera-made images such as film and video, effaces the marks of its making (and maker) at the click of a shutter. A photograph appears to be self-generated—as though it had created itself. We know the photographer had to have been on the scene—indeed, this serves as a further guarantee of the image's truth—but the photographer is manifestly absent from the field of the image. Instead, we are there, we are seeing what the photographer saw at the moment of exposure. This structural congruence of point of view (the eye of the photographer, the eye of the camera, and the spectator's eye) confers on the photograph a quality of pure, but delusory, presentness. A photograph, as Victor Burgin once remarked, is an offer that cannot be refused.[18] Moreover, unlike hand-made images in which the depicted image lies on the surface of the paper or canvas, the image in a photograph appears to be *in* it, inseparable from its ground; conceptually, you cannot lift the image from its material base.[19] Phenomenologically, the photograph registers as pure image, and it is by virtue of this effect that we commonly ascribe to photography the mythic value of transparency.

A further structuring instance lies in the perspective system of representation built into camera optics in photography's infancy. Modeled on the classical system of single-point monocular perspective invented in the Renaissance, camera optics were designed to yield an analogous pictorial structure. While natural vision and perception have no vanishing point, are binocular, unbounded, in constant motion, and marked by loss of clarity in the periphery, the camera image, like the Renaissance painting, offers a static, uniform

AARON SISKIND, *MAN IN BED*, 1940, GELATIN-SILVER PRINT, 8 5/8 × 12 IN.

COLLECTION, THE MUSEUM OF MODERN ART, NEW YORK.

MS. SOPHIE BLACK.

field in which orthogonals converge at a single vanishing point. Such a system of pictorial organization, by now so imbued in Western consciousness as to appear altogether natural, has certain ramifications. Chief among these is the position of visual mastery conferred upon the spectator whose ideal, all-seeing eye becomes the commanding locus of the pictorial field. This spectatorial position of perspectival and pictorial mastery has been theorized as being an inherently ideological construction. "The world is no longer an 'open and unbounded horizon.' Limited by the framing, lined up, put at the proper distance, the world offers itself up as an object endowed with meaning, an intentional object, implied by and implying the action of the 'subject' which sights it."[20] Such analyses of the apparatus bring us a good deal closer to understanding why the use of the camera has historically engendered a vocabulary of mastery, possession, appropriation, and aggression; to shoot a picture, to take a picture, to aim the camera, and so forth.

If we accept the formulation that there are ideological effects inherent in the apparatus, and that these effects typically devolve on relations of mastery, scopic command, and

the confirmation of subject positions, the notion of a political documentary practice premised on subject matter alone is rendered even further problematic. For such a theorization of photography insists on the complicity of representational structures in a variety of ideological formations that will always impose a point of view independent of the personal politics of a photographer and the particular intention of the work. Furthermore, if we consider the act of looking at photographs with respect to gender or the operations of the psyche—the complex acts of projection, voyeurism, investiture, fantasy, and desire that inform our looking—we are obliged to abandon the earlier, innocent belief that the documentary camera presents us with visual facts that were simply "out there" and which we now, simply and disinterestedly, observe and register.

By invoking the question "who is speaking thus?" in relation to the documentary enterprise, my intention has been threefold. First, to establish the contingency and historical relativity of the category documentary which can then be seen as "spoken" within a particular historical frame. Second, albeit in highly summary fashion, to indicate that individual documentary projects, themselves products of distinct historical circumstances and milieus, "speak" of agendas both open and covert, personal and institutional, that inform their contents and, to a greater or lesser extent, mediate our reading of them. It is properly the work of historians and critics to attempt to excavate these coded and buried meanings, to bring to light those rhetorical and formal strategies that determined the work's production, meaning, reception, and use. Nonetheless, it is incumbent upon an intelligent viewer to reject a specious universalist reading that functions to "innocent" photography of its ideological labor, its (normative) dissemination of the doxa. Last, the documentary photograph, like any other, is "spoken" within language and culture; its meanings are both produced and secured within those systems of representation that *a priori* mark its subject—and our relations to the subject—in preordained ways. The fact that a photograph appears to speak itself, as do realist forms in general, should alert us (as Roland Barthes tirelessly pointed out) to the working of ideology which always functions to naturalize the cultural.

The recent critiques of traditional documentary forms, from which many of the ideas in this essay have been drawn (notably the work of Victor Burgin, Martha Rosler, Allan Sekula, and Sally Stein), are, significantly, critiques from the Left. Perhaps even more important, the three latter critics are committed to a renewal, rather than revival, of documentary practice predicated on a full awareness of the role played by context, subject/object relations, and the various structuring mechanisms that determine photographic meaning. It should be noted too that Rosler, Sekula, and Stein have all produced their own documentary projects, although apologists for traditional forms of documentary might be loathe to recognize their work as such.[21] While certain of the ideas underpinning the call for a militant, oppositional documentary can be traced backward to Brecht's and Benjamin's insistence that reproductions of reality were powerless to say anything about that reality and that an authentically political photographic practice must be "set up" and

"constructed" (as, for example, in the photomontages of John Heartfield), this is only one, by no means inclusive theme. Of even greater importance has been the attention paid by proponents of a radicalized documentary to issues of audience, reception, and address accompanied by a concomitant conviction that a politically instrumental form must work against passive contemplation or voyeuristic consumption of the images.

It seems increasingly justified to speak of a new generation of photographers who are committed to rethinking documentary in a rigorous and serious way. Although it is not possible to characterize generally approaches to the form as disparate as those employed by Deborah Bright, Carol Condé and Karl Beveridge, Connie Hatch, Lisa Lewenz, Fred Lonidier, Martha Rosler, Allan Sekula, and Elizabeth Sisco (to name only a few), there are nonetheless a few common denominators. Among others, these would include an insistence on maintaining control over the work in terms of exhibition, publication, or distribution. While a photographer such as Dorothea Lange was well aware of the multiple determinations of photographic meaning (indeed, it was Lange who formulated the notion of a "tripod" of meaning—image, caption, text), she had, in fact, very little control over the use of her images except in the books she collaborated on. In addition, this new form of documentary takes account of photography's textuality; its embeddedness within discursive or institutional systems that the photographer must try to comprehend in advance. It is no doubt for this reason that textual strategies play such an important role in work as distinct in form and content as Fred Lonidier's *Health and Safety Game* or Martha Rosler's *The Bowery in Two Inadequate Descriptive Systems*.

There is some irony in the fact that at the same time as much recent criticism and theory (and certain art production) is increasingly concerned with the instrumental and ideological functioning of photography, these new forms of documentary practice find themselves progressively marginalized within the precincts of both the photography and art world. In addition to the inevitable problems of venue and exposure, such enterprises are beset by questions and problems of self-definition, intent, form of address, and practical functioning. That these concerns emerge so insistently is a function of the seriousness and ambition of the work, not of its weakness. Pushing the boundaries of documentary form as conventionally understood, and asserting the textuality of photographic imagery, such work attempts to function critically in a double sense; externally, in that it deals with social and political realities, and internally, in that its critical operation is turned equally, inwardly, upon itself.

1986

9

. .

Reconstructing Documentary: Connie Hatch's Representational Resistance

Above my desk, affixed to my bulletin board, is a poster from an exhibition entitled *Photo Politic* which took place five years ago at P.S. 1 (The Institute for Art and Urban Resources, in Long Island City). The poster is itself an enlarged photographic reproduction of a press photograph (Agence France-Presse) on the top of which the exhibition title has been superimposed, and at the bottom, in smaller type, the necessary information about it. Three middle-aged men in suits stride in our direction (that is to say, the photographer's) through two flanking lines of photographers who, with arms folded over their chests, keep their cameras ritualistically inactive at their feet. This is a documentary photograph, albeit a posed one, of a photographer's strike, the visual evidence of which was supplied by that photographer who, in the brutal parlance of labor relations (or class war), acted as a scab.

Of course it is not nearly as simple as that. The photograph may well have been staged to facilitate the goals of the strike; the photographer who took the picture may have been acting in the interests of the strike—an ally or participant rather than a strikebreaker. In any case, Raymond Barre's photo opportunity (for it is the French prime minister under Giscard d'Estaing who occupies the middle of the picture) was in this instance also a photo opportunity for the striking photographers.

That the photograph is now ornamenting my bulletin board after having served as publicity for an art event, after having, quite probably, been reproduced in French newspapers and magazines at the time of the strike, pointedly illustrates the permutations that photographs typically undergo. To the shifts in meaning that occur in the photograph's physical situations—its incarnations in newsprint or exhibition space—must be added the shifting field of meaning produced in the process of reception as it passes through successive grids constituted by language, social and political climates, cultures, and the consciousness of the individual viewer. Leaving aside for the moment any discussion of what is figured in the term "documentary photograph," we are presented here with a picture of an event, an instant in time, the contemplation of which poses more questions than it answers. What Roland Barthes referred to as the fundamental polysemy of photographic images creates meanings that cannot but be as ambiguous and subjective as they are protean.

EXHIBITION POSTER, *PHOTO POLITIC*, COURTESY P.S. 1.

Doubtless that is why Barthes was so fascinated by the medium—far less tyranny of the *logos* than in, say, literature.

The specific political realities that converged in the choreographed spectacle of the photographer's strike are for all intents and purposes inaccessible to a viewer such as myself, ignorant of the nature, issues, or resolution of the strike. Yet the anchoring legend—*Photo Politic*—no less than the component elements of the picture (the prime minister surrounded by the Garde de Sceaux, Alain Peyrefitte, and an unidentified minister, the Elysée Palace from which the men have just exited after the weekly cabinet meeting, the striking

185

photographers) prompts an interrogation of the image that hinges on where we choose to locate the politics of this particular photo. The fact that with little background knowledge it is nonetheless clear that the photograph depicts men of power surrounded by men who supply representations of those men in power suggests yet another dimension of the photo politic; there are, for example, thirty-seven men in the photograph, and not a single woman. That both the exercise of power and the representation of it should be jointly masculine preserves is hardly noteworthy, but the absence of a single woman photographer within a group of thirty-four is something to think about. How do we account for this absence?

On the most obvious level, the scarcity of women photojournalists within the ranks of the French press is no more or less remarkable than a comparable underrepresentation in the ranks of any other profession not identified as a feminine one. Thus, in noting that throughout the history of photography women have rarely functioned as professional photographers, although frequently employed in entrepreneurial concerns as "operators," assistants, or assembly-line labor for printing and processing, we could account for this absence by reference to the familiar social and cultural constraints that have materially determined woman's estate. The *Photo Politic* picture might, in this sense, be understood in yet another documentary capacity as depicting, both actually and symbolically, the exclusion of women as image-makers, as producers of representations. But what, if anything, changes if we imagine the place of that authorial cipher—"Photo Courtesy of Agence France-Presse"—to have been occupied by a woman? Such a speculation inflects the question of gender in relation to the photograph somewhat differently insofar as gender now operates on both ends of the camera. So too does the status of the documentary photograph shift, if not founder, when we allow for the sexual identity of the photograph's viewer.

To the ambiguity of photographic meaning and the acknowledgment of sexual difference as a factor in production and reception, we need to take account of the contextual determinations of photographic meaning. Returning once more to the photograph, I would further point out that a purely formal examination (and appreciation) of the image can itself elevate this photograph into the realm of the aesthetic: photography-as-modernist-art-form. For silhouetted in the glassed portal of the Elysée Palace is both the reflection of the *tricolore* (such photographic commonplaces have been critically sacralized in the term *mise en abyme*) and the world behind the photographer projected and framed between the columns. Entire careers in contemporary photography have been constructed on less than this, and as John Szarkowski's book *From the Picture Press* or Mike Mandel and Larry Sultan's *Evidence* so eloquently demonstrated, the formal serendipities, the allusive properties, and the narrative promise of captionless photos are as likely to be found in the morgue of the *New York Daily News* as in the archives of MoMA's Department of Photography.

This partial range of reflections and observations that the *Photo Politic* photograph

sets in motion is ample testimony to the problems, ambiguities, and conundrums that hover, acknowledged or not, around epistemological constructions such as "documentary photography," instrumental intentions (e.g., political or art photography as discrete practices), and the discursive mutability of photography in general. These issues far exceed the question of what has been represented within the photographic frame and turn on subject/object relations, spectatorial address and reception, venue and context of presentation, and the power relations inscribed in the agency of the look—the viewer's, the photographer's, the photograph's. To fully reckon with the complexity and difficulty of these distinct but interrelated elements is to better understand why critical practices employing photography have been so rare an occurrence in the medium's history, as rare, evidently, as the work of professional women photographers.

This essay is, in one sense, about the work of Connie Hatch, three of whose projects demonstrate the process of working out and working through a critical practice cognizant both of the politics of photography and the sexual politics of photography. In another sense, it is about the conditions of politicized photographic practice as they have been theorized in the past by Bertolt Brecht and Walter Benjamin, and how those conditions have been modified in the present as a consequence of new theoretical infusions and with respect to changed historical circumstances. This contextual frame is important in that it illumines the difficulties—conceptual and practical—inherent in radical, oppositional photographic production. It further suggests that what might otherwise appear to be some innate intractability or resistance of the medium itself to such uses has perhaps more to do with the belatedness of the recognition that photographic representation entails its own politic.

Although it is certainly true that recent critical practice recognizes this necessity, described by both Victor Burgin and Allan Sekula as signaling the shift from the representation of politics to the politics of representation, this was not an insight born with postmodernism. Dada and surrealism, constructivist and productivist photography in the USSR, and most photomontage practices variously grappled with (and in many cases actively attempted to subvert) the mythological truth value and supposed autonomy of the photographic image. The great accomplishments of artists as diverse as Man Ray and El Lissitzky, Hannah Hoch and John Heartfield were fueled by their analytic, critical, and resolutely anti-positivist approach to the medium. However, not before the militant avant-gardism of the post–World War I period was it possible to at least partially address some of the underpinnings of photography's ideological functioning. But by the 1920s, artists using photography with some form of oppositional, transgressive, or vaguely anarchic intent had grasped that photography does not so much confirm our experience of the world (as it was understood to do in the mid-nineteenth century) as it actively constructs it. Such a recognition determined that interventions be made within the apparently seamless field of the image, whether by recourse to language, scissors, darkroom chemistry, or a combination of all three.[1]

But while surrealists, dadaists, or other vanguard artists occupied themselves with dismantling, reconstructing, or otherwise tinkering with photographic norms, the photographic practice that would become known as documentary embraced—and indeed elevated to an ethical principle—the notion of photography as evidentiary truth.[2]

It thus becomes necessary to distinguish practices such as Heartfield's from that of, say, Dorothea Lange's on the level of an internal critique of the medium as much as on the level of formal strategy. Despite its awkwardness, it is useful to designate the former as an example of a critical practice that uses photography in opposition to those traditional documentary modes that do their work by imaging subjects or events and presenting themselves (more or less artfully) as visual evidence of the problem at hand.[3] Notwithstanding the extent of the rhetorical devices employed, stylistic or formal innovation, or compositional legerdemain, conventional notions of documentary are predicated on the belief in photographic transparency mediated only by those choices made by the photographer. Modernist photographic theory necessarily stresses the importance of these mediations since what is most crucially at stake is the presence of the author in the work. The twentieth-century documentary tradition, itself coeval with photographic modernism, thus constructs a type of nature-viewed-through-a-temperament model, in which both nature and the temperament are conceived as stable unities that guarantee each other's truth.

It was, however, the conception of the documentary photograph as a neutral transcription of the real that Walter Benjamin, nearly fifty years ago, summarily dismissed as inadequate to political purposes. In a sentence quoted as frequently as its sense has been ignored, Benjamin commented (in relation to a photograph of the Krupp armaments factory) that "less than ever before does a reproduction of reality tell us anything about that reality and therefore something has to be *constructed*, something artificial, something set up."[4] Contemporaneously, John Heartfield translated the same insight into a radical photographic practice that has remained to this day an *exemplum virtutis* for artists of the Left. For Benjamin and for Heartfield, the rejection of a conventional documentarian approach was as much informed by their understanding of the limits of photographic transcription as by their political understanding of reality as constructed, masked, and dynamically produced through the mystifying veil of ideology.

It is significant that modernist photographic theory wants nothing to do with photomontage. Writing in 1934 on what he construed as the aesthetic (indeed, one could almost say the *ethos*) appropriate to photography, Lewis Mumford questioned whether photomontage could even be considered a photographic practice at all: "As for the various kinds of *montage* photography, they are in reality not photography at all but a kind of painting, in which photography is used—as pastiches of textiles are used in crazy-quilts— to form a mosaic. Whatever value the montage may have derives from painting rather than the camera."[5] And although he did not stigmatize it by name, Siegfried Kracauer's essay "Photography" makes clear that along with other "experimental" forms such as photograms, any messing about with the putative integrity of unmanipulated photogra-

phy is, in his opinion, linked to the most retrograde of nineteenth-century practices.[6] Such texts reveal modernism's explicit bias toward the ontological at the expense of the instrumental. And insofar as modernist photography theory, for historically determinate reasons, has been a profoundly conservative discourse, shaped by its defensive relationship to traditional art forms, the lessons and accomplishments of photomontage have been effectively written out of the mainstream of modern photography.

Benjamin's call for something constructed, something set up, and Heartfield's application of this program are both premised on a recognition of the manifest inadequacy of the single unmanipulated photograph to represent the contending real relations of power and interest that are themselves constitutive of reality. Marx's famous analogy in which ideology is likened to the operations of the camera obscura made clear in a single phrase the critical limits of an inventory of appearances. Absent from Benjamin's critique, however, is an examination of the ways that the photographic apparatus and its resultant image structurally function to construct and interpellate the viewing subject. For the problem confronting any genuinely radical cultural production is not simply a matter of transforming existing forms through the insertion of some new politicized content or subject matter, but rather to intervene on the level of the forms themselves, to disrupt what the forms put in place. The disruptive strategies of dada and photomontage were addressed to precisely these ends. Thus the Barthesian exhortation to "change the object itself" effectively complements the Brechtian concept of *Funktionierung* (functional transformation). But such transformations must additionally extend, as Benjamin stressed in the essay "The Author as Producer," to the productive apparatus itself and the larger institutional and discursive space of which it is a part. This proposes a different set of problems for each art form and concomitantly differing methods. Citing Brecht's analysis, Benjamin insisted that institutional transformation must be inseparable from the formal and political intent of the work: "We are faced with the fact . . . that the bourgeois apparatus of production and publication can assimilate astonishing quantities of revolutionary themes, indeed, can propagate them without calling its own existence, and the existence of the class that owns it, seriously into question."[7]

For Brecht and for Benjamin, failure to address the institutional apparatus led to an inescapable collusion with its authority and power irrespective of the producer's individual politics: "Tragedies and operas are constantly being written that apparently have a well-tried theatrical apparatus at their disposal, but in reality they do nothing but supply a derelict one. 'The lack of clarity about their situation that prevails among musicians, writers, and critics,' says Brecht, 'has immense consequences that are far too little considered. For, thinking they are in possession of an apparatus that in reality possesses them, they defend an apparatus over which they no longer have any control and that is no longer, as they believe, a means for the producers, but has become a means against the producers.' "[8]

Although neither Benjamin nor Brecht is in this instance discussing the terms and

conditions of photographic production, one can readily see the connection to the work of traditional documentarians. Thinking that they are in possession of an apparatus that possesses them is, in fact, an apt characterization of most photographic users, and goes to the heart of the problem inscribed in the legacy of the photography of social protest and reform exemplified by Lewis Hine, the F.S.A. and their descendants in the present day.

While Benjamin understood that photography routinely and perhaps inescapably functions by aestheticizing all that it pictures, he was not primarily concerned to pursue the internal dynamics of the photographic image. But to turn something into a picture is an activity located not only within the provinces of the aesthetic and the social, but equally within the province of the psychic; the dynamic act of reading a photograph and producing meaning from it animates trajectories of power and desire, mastery and projection, that run between the perceiving eye, the subjective I, and the visual field, all of which must be factored into our understanding of photographic production and reception. It is here that the supplemental insights of semiotics, linguistics, psychoanalysis, and poststructuralist theories of representation, incorporated into the body of feminist theory, reveal the lacunae, the blind spots, in Benjamin's productivist program for a politicized photography. For if we allow that the photographic image be understood as *a priori* marked by the production of ideology, and already structured ideologically—irrespective of content—a political *and* feminist use of the medium requires that the ideological effects of the apparatus be somehow conceptually reckoned with in the work. Thus, while Benjamin may be seen to have roughly mapped out many of the structural requirements for a radical practice, a specifically feminist inflection posits a need to go beyond the "laying bare of the device" in order to intervene or interrupt the conventionalized, naturalized spectacle that the device en-genders. Here, as elsewhere, introducing the terms of a feminist perspective, critique, or analysis insistently calls into question the conceptual framework upon which entire categories of objects, relations, and practices have been traditionally conceived. It is, pre-eminently, this feminist perspective that brings into the sharpest relief the blind spot in Benjamin's analysis. For the opposition of a patently constructed image with a normatively transcriptive one collapses as soon as the notion of a gendered subject is introduced; the category of documentary itself is rendered even more problematic the moment we introject the issue of sexual difference in the construction of photographic meaning by photographer and spectator alike. Added to earlier theoretical work in film theory on the ideological baggage inherent in the apparatus and the semiotic analysis of photography undertaken by Barthes, the insertion of gender categorically moots the conventional notion of documentary, understood as an indexical window on the real, yielding a fixed message to a sexually undifferentiated spectator.

This expanded field of inquiry thereby encompasses that discursive space of the *Photo Politic* photograph in which the absent women and the imaged men are equally available to an analysis that is authentically a politics of the photo. Theoretical analysis, however, can rarely function as an obvious blueprint for art practice.[9] Feminist film and literary theory,

190

for example, is typically most rigorous and most explicitly political in its deconstruction of existing texts that reproduce dominant patriarchal and capitalist values. In a prescriptive sense, on the other hand, feminist critics rightly call for oppositional cultural practice that manifestly conforms to the terms of the analysis. The verbal forms "to intervene," "to rupture," "to fissure," "to interrupt," "to subvert" are frequently, and occasionally glibly, invoked without giving due consideration to the enormous difficulties—conceptual, structural, and material—that inescapably attend such an enterprise.[10] Moreover, if Benjamin was struck by the apparently boundless capacity of the bourgeois apparatus of production to assimilate and even propagate revolutionary themes, this capacity for cultural absorption and neutralization is even more pronounced today. The emphasis placed by Benjamin and Brecht on institutional transformation is a necessary correlate of any oppositional practice, one that tends to be elided within certain feminist cultural practices that would limit the meaning of the term institution to the discursive space of representation itself.

Connie Hatch's work is particularly useful to consider for the ways it illustrates the processes of thinking through the terms, conditions, and possible strategies of a critical art practice. Committed to an investigation of the mechanisms of domination and oppression both internal and external to the apparatus, Hatch draws from the older tradition of social documentary the notion of instrumentality and accessibility, but reworks it through the critical filter constituted by the awareness of what the apparatus itself sets up, puts in place. The three projects discussed in this essay—*Form Follows Finance*, a collaborative multi-media project on the consequences of gentrification and development in a San Francisco neighborhood, *Serving the Status Quo: From Stories We Tell Ourselves, Stories We Tell Each Other*, a trio of slide-audio pieces, and *The De-Sublimation of Romance*, an open-ended series of paired photographs—represent three different approaches to what Hatch herself calls strategies of representational resistance. The importance and the ambition of these works lie not simply in the breadth of the issues formally incorporated within them—issues of language as well as iconic representation, labor and class politics as well as sexual ones—but in the invention of forms to embody these concerns while at the same time navigating between the twin threats of enforced marginalization and aesthetic co-option.

WHATEVER IS UNNAMED, UNDEPICTED IN IMAGES, WHATEVER IS OMITTED FROM

BIOGRAPHY, CENSORED IN COLLECTIONS OF LETTERS, WHATEVER IS MISNAMED AS

SOMETHING ELSE, MADE DIFFICULT TO COME BY, WHATEVER IS BURIED IN THE MEMORY

BY THE COLLAPSE OF MEANING UNDER AN INADEQUATE OR LYING LANGUAGE, THIS

WILL BECOME, NOT MERELY UNSPOKEN, BUT UNSPEAKABLE.

— ADRIENNE RICH, *THE TRANSFORMATION OF SILENCE INTO LANGUAGE AND ACTION*

. .

THE ACQUISITION OF THE ALIEN WILL IS A PREREQUISITE OF ANY RELATION OF

DOMINATION. — KARL MARX, *THE GRUNDRISSE*

. .

It has been said of Connie Hatch's work that it falls through the cracks, and this seems to me, as far as it goes, to be a generally apt assessment and, moreover, one which is suggestive on a number of levels. To begin with, Hatch's formal art education was pursued within a photography program—specifically, the master's program in photography at the San Francisco Art Institute, from which she graduated in 1979. Such training typically produces art photographers; that is to say, photographers more or less wedded to a continuance of the modernist tradition of camera work, be it within the framework of the manifestly aesthetic and self-expressive, or that of "straight" documentary or journalistic practice.

It is important to bear in mind that while postmodernist art practices have evidenced an increasing use of (or reference to) photographic imagery, the kinds of work represented by such disparate postmodernists as John Baldessari, Victor Burgin, Barbara Kruger, Sherrie Levine, and Richard Prince, to name just a handful, have virtually nothing to do with those photographic practices that have poured out of photography programs over the last fifteen years. Indeed, the working assumptions, the conceptual assumptions no less than the formal means of postmodernist photography can be seen in many ways as a repudiation or overthrow of the modernist values that underpin institutional art photography and its more "vernacular" progeny (for example, street photography).

This schism between the issues and intentions inscribed within art photography or straight photography, and those now conventionally associated with postmodernism, contributes to the peculiar placelessness of Hatch's work. On the one hand, projects such as *The De-Sublimation of Romance* and *Form Follows Finance* derive from existing and institutionally sanctioned traditions of art photography (so-called snapshot aesthetic or street photography in *De-Sublimation*; the classical documentary project in *Form Follows Finance*). On the other hand, the compass of the works' formal, strategic, and conceptual concerns is more frequently associated with contemporary postmodernist art practice. Hatch thus ends up as something of an anomaly within the photography world, and equally an anomaly in the mainstream art world within which her work appears as simply "photographic." It is significant that her present teaching position at CalArts is in the Visual Arts Department, rather than in Photography.

To the placelessness constituted by her work's morphological resemblance to "straight" photography, but conceptual affinity to a critical postmodernism, must be added the explicitly political dimension of her projects. Here, the relative marginality of *all* cultural practices that are explicitly political must be emphasized. In this context, I would consider Hatch to occupy a comparable position to that of other political artists using photography, such as Carol Condé and Karl Beveridge, Fred Lonidier, Martha Ros-

ler, Allan Sekula, and several others. Like Hatch, these artists have no clearly defined place within either postmodern art practice or traditional photography, which additionally tends to suggest that overtly political and oppositional practices are unassimilable within either. While the boundaries between what constitutes photography *tout court* and those critical postmodernist practices that use photography are both provisional and inevitably somewhat relative, it is significant to me that Hatch's work distinguishes itself from both postmodernism proper and from the explicitly political practices cited above. Often these latter involve the extensive use of text, a practice that provides both for the amplification and anchoring of meaning (or questioning of meaning) and implicitly subverts the modernist assumption of photographic autonomy and self-reflexiveness. Here we might think of Benjamin's prediction of the increasing importance of the caption as the device for establishing photographic meaning. In the case of Condé and Beveridge, their chosen form is photomontage, often with supplementary texts or audio accompaniment. Hatch, however, remains somewhat apart from these other artists insofar as she is attempting to conscript conventional and institutionalized photographic genres for radical ends, to appropriate not simply images (as is routinely, if not formulaically, done within postmodernism), but normative *modes* of representation. This would tend to link her more closely with that version of postmodernism that conscripts mass media forms for deconstructive purposes. But if Hatch's work is justly described as falling between the cracks, I would modify this characterization somewhat by suggesting that to situate oneself or one's work in the cracks—in the margins—provides a singular space from which to survey the field(s). Another way of thinking about her work, so difficult to place and classify, is to regard it as positioned in the convergence of discourses, rather than squarely within any one of them. This seems as much true of the formal and material attributes of her work (to what aesthetic category does a slide/audio work belong? A multi-media presentation?) as it is of the different kinds of issues and concerns embedded in each of her works.

Finally, occupying a space in the cracks must be understood as a strategic move, one that may effectively work to block operations of commodification. (Hatch does not produce works that can be sold as art objects; her preferred form of presentation is a slide show incorporating elements of performance.) Perhaps even more crucially, the vantage point accorded by outsider status, an in-betweenness of media as well as cultural topography, intensifies and sharpens the critical vision, contributes to its breadth and inclusiveness. To refuse to supply the apparatus, as Benjamin and Brecht enjoined, may in fact be possible only by affirming one's place in the peripheral spaces outside the emporium of high culture.[11]

Of the three major projects cited, *Form Follows Finance*, was the work most closely related to traditional documentary form. Its subject was a survey of the South of Market Street district, a San Francisco neighborhood that had for decades provided a home for working-class families, the elderly, recent immigrants, various light industries and busi-

nesses serving the nearby financial district, and, most recently, artists. With the construction of the Moscone Convention Center in 1981 (which itself displaced a community of 5,000 residents and 700 small businesses) and the construction of the neighboring Yerba Buena project, the South of Market area was progressively opened up to real-estate speculation, development, and gentrification with the inevitable destabilizing and destructive consequences on what had hitherto been a stable and diversified working-class community.

Form Follows Finance represented an attempt to reinvent documentary practice by continually supplementing it; its conception and evolution developed along aggregate lines. It was as though, confronted with the manifest inadequacy of the single still photograph to address invisible relations of power, Hatch and her collaborator, Janet Delaney, elected to cast a wider net: to extend the boundaries of documentary in such a way as to inscribe the forces and processes of inner-city imperialism, and to orient the project outward toward the community mobilizing to resist them. This attempt to both expand and instrumentalize a documentary survey vividly demonstrated the incompatibility of the politics of resistance with a photographic practice that could be recuperated as an art practice. Moreover, the effort to augment and in some way internally critique the documentary form was constrained by the parameters of the project, a certain inconsistency of formal means, and the contradictory approaches taken by the other participants in the project.

Nonetheless, it is instructive to briefly consider *Form Follows Finance*, for to the extent that it illumined both the structural limitations of documentary format and the crucial issue of institutional neutralization, it may have ultimately contributed to the more hybrid and audacious forms of Hatch's subsequent work.

It is significant that *Form Follows Finance* was a collaborative project, authored by D. Art (the D standing for documentary) and open through its duration to other participants. For in this instance, the refusal of individual authorship was as much about the refusal to position the work as an authoritative master narrative, generated from an all-encompassing singular point of view, as it was about the allegiance to collective rather than individualistic values. Accordingly, the form that the project evolved, characterized by adaptability to different venues and contexts, open-endedness and inclusiveness recalls Brecht's proposal in the introduction to the *Versuche* that "certain works ought no longer to be individual experiences (have the character of works) but should, rather, concern the use (transformation) of certain institutes and institutions."[12]

By playing off against one another a collectivity of representations (including that of the media) and attempting to depict the dynamics of gentrification counterpointed by the memorabilia, snapshots, oral and written histories of the neighborhood's residents, D. Art intended to support and bolster resistance to a process ("progress") officially presented as inexorable and natural. Insofar as it was an ongoing *process* that was the subject of the work, an examination of the discursive construction of gentrification was an inte-

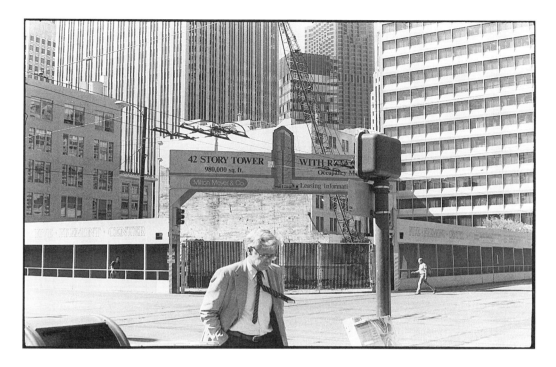

CONNIE HATCH, FROM *FORM FOLLOWS FINANCE*, DOWNTOWN SAN

FRANCISCO, 1982, 16 × 20 IN. PANEL WITH TEXT. COURTESY OF THE ARTIST.

gral aspect of the effort to produce an authentically analytic documentary enterprise. Photographs of boarded-up businesses, construction sites, the demolition of existing housing, the results of possible arson, portraits of the neighborhood's threatened inhabitants—such images alone were inadequate either as indictments of a systematic process or as analytic tools to understand that process. Consequently, Hatch became drawn to the issue of language as it figured in both the production and the reproduction of ideology. Thus in *Form Follows Finance* the language of the San Francisco media in justifying and ratifying the neighborhood's destruction (newspaper articles bore headlines such as "Take a Tour Along Streets of Squalor" and "Slums: Cancer South of Market") became a clear locus for integrating language—both the dominant media's and Hatch's—into the typically "visual" field of political documentary.

However, when the completed *Form Follows Finance* exhibition was initially unveiled at San Francisco Camerawork, the agitational potential of the exhibition and the political analysis it proposed were compromised by an exhibition space whose regular exhibitions and audience were principally geared to art photography. The inescapable conclusion to be drawn from the exhibition of *Form Follows Finance* is that even the most ex-

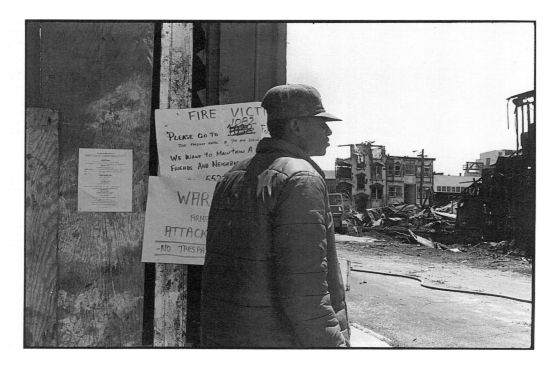

CONNIE HATCH, FROM *FIVE ALARM NEIGHBORHOOD*, SAN FRANCISCO, 1981,

16 × 20 IN. PANEL WITH TEXT. COURTESY OF THE ARTIST.

plicitly conceived political cultural practices are liable to neutralization by the greater institutional weight of a space consecrated to art, even, in this case, an "alternative" one. For political artists working now, acknowledgment of these terms poses a series of hard choices. To position such work entirely outside of the institutional spaces of art is to be condemned to invisibility or, at best, marginality; to function within it subjects the work to the discursive determinations that the institution imposes. But for Hatch, working through this dilemma is precisely what articulates and forges political consciousness itself.

In the extended, open-ended photographic project *The De-Sublimation of Romance*, begun in 1975 and consisting of paired images which Hatch normally presents as projected slides, an interrogation of photographic position is systematically employed to expose— literally and metaphorically—the operations of looking as they both inform and structure the place of men and women in the space of the image and the space of the world.

That the sexual politics of looking should provide the subject of *De-Sublimation* is consistent with the way feminist theory and practice have evolved toward ever greater attentiveness to the structural conditions of representation. Accordingly, the compass of

the *De-Sublimation* project includes the agency of the apparatus, the agency of the photographer, and the complex web of codes, investitures, and projection in which are captivated (and implicated) photographer, viewer, and subject alike.

In these photographs, the spectator's identification with the camera's point of view, the structurally determined condition whereby the spectator looks from the place of the photographer, who has been effaced from the image, becomes for Hatch the fulcrum of complicity, contradiction, and critique.

Analogously to the way *Form Follows Finance* takes off from and reworks the standard assumptions of the documentary project, *De-Sublimation* too derives from an institutionalized and more or less codified practice, importantly positioned within art photography, that has come to be known as "street photography." Implying a good deal more than the mere act of taking photographs on the street, this tradition counts among its founding fathers[13] such luminaries as Walker Evans, Henri Cartier-Bresson, Robert Frank, and William Klein; more recent exemplars include Tod Papageorge, Lee Friedlander, and the late Garry Winogrand (with whom Hatch studied at the University of Texas).

Hatch's re-vision of the practice of street photography proceeds from the question I earlier invoked in relation to the *Photo Politic* picture: what changes when it is a woman who operates the camera? A woman on the street with a camera is not only different from a man on the street with a camera, she is different from a woman on the street without a camera. Because Hatch's photography is predicated on a dialectical critique of the structuring *and* suturing mechanisms of the camera, the issue of looking is for her, the photographer, profoundly tied to the act of taking pictures herself, as interested spectator and perhaps most important as woman-with-a-camera. To wield the camera is inevitably to assume a different position in relation to what one sees, and as many of the photographs in *De-Sublimation* attest, to actively alter and effect the worldly spectacle before the lens.

Accepting the formulation that the spectator's act of looking at an image activates a process of psychic investiture organized around either narcissistic or voyeuristic identification, the transactional mode (for example, the photographic portrait in which the volitional subject gazes into the camera) would seem to privilege a narcissistic identification, while the unposed and spontaneous appearance of street photography would favor voyeuristic modes. Neither position is, however, necessarily rigid or thoroughly separate from the other, and indeed part of the psychological fascination of photographs involves the motility, the oscillation between these positions.

In the *De-Sublimation* pictures, these dynamics of the look are considered not as givens, but as problems. Hence the troubled "posing" in certain of the photographs, or the orchestration of exchanged or refused looks within the series functions to promote the spectator's awareness of the non-neutrality, the non-innocence of the look. And it is, moreover, Hatch's insistence on her own investment in the look and the acknowledgment that she deploys the camera for her own ends, that ineluctably draws the spectator into an

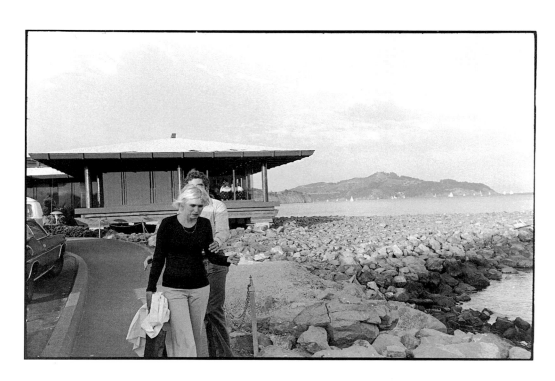

CONNIE HATCH, FROM *THE DE-SUBLIMATION OF ROMANCE*, 1979, GELATIN-

SILVER PRINT, 14 × 17 IN. COURTESY OF THE ARTIST.

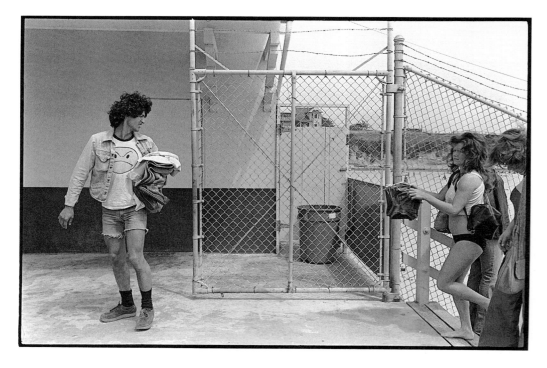

CONNIE HATCH, FROM *THE DE-SUBLIMATION OF ROMANCE*, 1979, GELATIN-

SILVER PRINT, 14 × 17 IN. COURTESY OF THE ARTIST.

analogous acknowledgment of sexual difference in looking, difference in seeing. In chronicling the look of the look, what Hatch calls "gender dilemmas" in the "purview of discontent," the viewer is positioned as knowing accomplice, as secret sharer. Such a practice is oriented less toward a playing off of pleasure/unpleasure oppositions than it is toward effecting a politicized viewing that is formally constructed to integrate sight with insight.

The *De-Sublimation* photographs are for the most part depictions of men and women looking (or not looking), interacting (or not interacting) with one another, frequently accompanied by the inscription of the photographer (Hatch's cast shadow, or the gaze of the subject directed at the camera) within the visual field. But what can easily sound like a banality of photographic modernism in a generalized, written description (Lee Friedlander produced an entire book around precisely this device) has an altogether different effect in the pictures themselves. At the risk of distorting a project that is premised on both the multiplicity and pairing of images, I would here single out two individual photographs emblematic of the series itself and especially revelatory of the stakes that underpin it.

Entirely untendentious, but nonetheless conducive to political reading, the first of these photographs is characterized by a bleak and unrhetorical evocation of anomie and subjection. The picture depicts a young woman carrying a child, walking past a motel-room entrance and window, surveyed by a young man standing before the doorway. Face, body, and comportment suggesting self-absorption, resignation, and depression, the woman seems unaware of her double surveillance. The little girl she carries appears poised on the brink of tumbling from the supporting arm as she reaches for the small camera that the woman holds in her other hand. Although the young man is clearly looking at the woman and is positioned frontally to the picture's spectator, his gaze is hidden, masked by the long fringe of his hair.

In reading such an image, the determination of meaning and significance hinges on operations of symbolization (including linguistic ones) and projection. That the woman may be viewed as "burdened" with the child, while the man, probably about the same age, has his hands in his pockets, provides the terms for mobilizing the politics of the image. But far more suggestive is the stagelike space in which the action occurs. The world is here literally a stage in which the action depends on the nonawareness of one of the protagonists whose sex, whose class, and whose burdens—psychic or material—provide the spectacle on both sides of the image.

In the second example, Hatch's conviction that the act of photographing—and in this instance, a *woman's* act of photographing—constitutes an intervention rather than a transcription was disquietingly borne out when she began to photograph a girl on crutches standing within a street-level window set back a few inches from the exterior wall. A man in a raincoat wandered up to Hatch and the girl, then walked over to the girl and started to talk to her. Hatch then made the exposure which at that instant captured the girl, looking toward Hatch, smiling somewhat self-consciously, with her hands—awkwardly?

CONNIE HATCH, FROM *THE DE-SUBLIMATION OF ROMANCE*, 1977, GELATIN-

SILVER PRINT, 14 × 17 IN. COURTESY OF THE ARTIST.

defensively?—crossed over her chest, crutches resting under her arms. The man, in pro-
file, leans over her, in the act of speaking to her. After he left, the exposure made, the girl
told Hatch that she thought the man was known to Hatch. Hatch had thought the man
was known to the girl. What had happened in those seconds when he spoke with the girl
as she presented herself to the camera was veiled by the raincoat: he had exposed himself
to her.

The multiple meanings of the word exposure converge in the image and the anecdote
of the crippled girl and the flasher. The invisibility of the sexual affront reiterates all the
other invisible operations constructing gender, domination, subjectivity, compliance, and
complicity. The aporia of gender exposed in the *De-Sublimation* photographs and the cru-
cible of vision in which it is staged mark the limits of still photography to reveal these
structural relationships. Just as *Form Follows Finance* had collided with the boundaries of
the traditional documentary form, so did *The De-Sublimation of Romance* strain continu-
ously against the register of the visible. It was thus a logical, if not inevitable, step—one
prepared, fueled, and fertilized by the previous projects—for Hatch to conceive her next

200

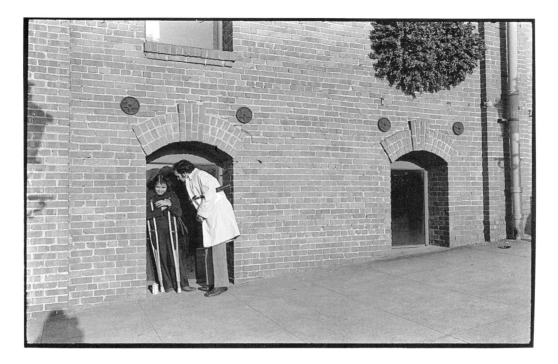

CONNIE HATCH, FROM *THE DE-SUBLIMATION OF ROMANCE*, 1979, GELATIN-

SILVER PRINT, 14 × 17 IN. COURTESY OF THE ARTIST.

work with the full incorporation of language and the abandonment of the still image format altogether.

The slide/audio trilogy *Serving the Status Quo: From Stories We Tell Ourselves, Stories We Tell Each Other*, unsettling, troubling, and haunting, is deceptively simple to describe. Four people—a working-class couple in the suburbs of Burleson, Texas; a young lesbian New Music composer who supports herself as a computer technician; and a fortyish waitress in an exclusive San Francisco women's club—talk about their lives and their work. As we listen to their self-narratives, the black-and-white slides click by, dissolving into one another, presenting us with pictures of the subjects at work, at home, at leisure. These are not exceptional lives in either a positive or negative sense, neither marked by objective tragedy or particular good fortune. Chris and Faye Edwards, Frankie Mann, and Marta Dane are meant neither as representative types nor as exemplary individuals. But where any one segment of the trilogy might permit the spectator to maintain a distance, a sense of privileged detachment predicated on his or her class, work, "life-style," or sexual identity, the trilogy in its entirety works to break it down. The nuclear family ensconced in the

201

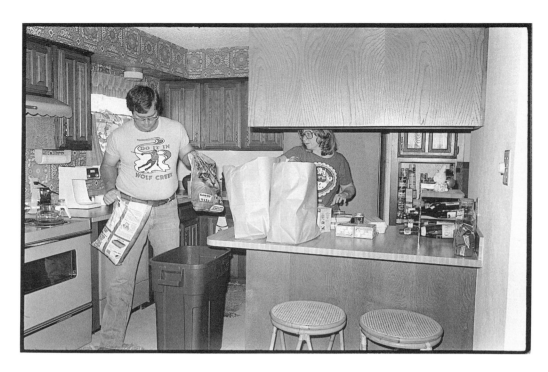

ranch-style house, the sexually transgressive artist/bohemian, the aging, single woman are speaking of, and are enmeshed within, the contradictions of capitalism and patriarchy, labor and gender, as are we all.

Insofar as these contradictions are the real subject of the work, there is no catharsis and no resolution. The narrative structure of the subjects' speech is more closely linked to the spiral movement of the psychoanalytic discourse than the trajectory of the classical narrative. This disruption of narrative expectation is paralleled by the periodic disjunction of the audio track with the projected image; as with the photo/text pieces in *Form Follows Finance*, image and speech do not have necessarily either an analogous or a mutually illustrative relationship to each other. This accords with the most profound aspirations of the work: the articulation of contradiction in forms that we must recognize as our own.

Part I of the trilogy is entitled *Work/Possessions: One Family* (1979). Chris Edwards works as a line-splicer for the telephone company; his wife, Faye, is, for the moment, a homemaker; there is a new baby. With one income, Chris is compelled to put in long overtime hours to support "all of the material things that I have acquired and am making payments on." As Chris describes his exhaustion, his sense of being spiritually hostage to his possessions, his physical estrangement from domestic space—the space of wife and

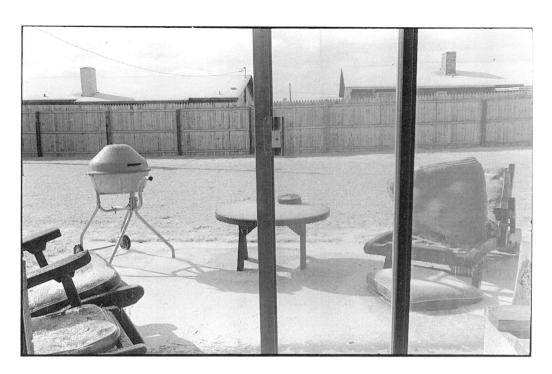

CONNIE HATCH, FROM THE AUDIO-IMAGE TRILOGY *SERVING THE STATUS*

QUO, PART I, *WORK/POSSESSIONS: ONE FAMILY*, 1979.

COURTESY OF THE ARTIST.

CONNIE HATCH, FROM THE AUDIO-IMAGE TRILOGY *SERVING THE STATUS*

QUO, PART I, *WORK/POSSESSIONS: ONE FAMILY*, 1979.

COURTESY OF THE ARTIST.

child—the camera provides the inventory of appearances, the people, the house, the car, the barbecue.

For Faye, who has escaped grinding poverty by working at an unspecified office job since her teens, the position of homemaker represents, at least symbolically, a socio-economic ascent, a nominally more privileged position. "I don't want to go back to work," she says at one point. "I've told everybody, most of everybody, financially if I have to, then I will. I always thought there wasn't anything for me but work, since I've worked twelve years for the same company, but that's not true, not now." Three images are projected during the course of her speech: a shot of Chris and Faye unloading bags of groceries in the kitchen, a foreground view of the house from the backyard showing the lawn furniture and the barbecue, and Faye alone, leaning on the glass patio door, arm supporting a furrowed brow. As her speech continues, the following two images depicting Faye alone in the house further strengthen the perception of the woman imprisoned within the home. The dissonance between Faye's stated preference for remaining at home with the baby has previously been indicated in her confession of feelings of inadequacy and anxiety toward the baby ("just because you're a mother doesn't mean you know what to do"). Faye projects, as does Chris, a pervasive sense of being overwhelmed by the appurtenances (including parenthood) of middle-class life. A tacit notion of "failure"—her failure—is reinforced by Chris saying, without rancor, "She didn't take any home economics or housekeeping or anything like that . . . which I think she's found out is a mistake." The image that appears immediately before this statement is of Faye, hugely pregnant, at the supermarket checkout. Distraught and harried-looking, she is manipulating two shopping carts, filled to overflowing. The two shots that accompany her statement depict Faye at the sink, dishwasher opened and diaper bag on the counter, then another shot of her in the kitchen looking directly at the camera with an expression poised ambiguously between the quizzical and the defiant.

These samples of Hatch's contrapuntal plays of image and speech, and the formal infrastructure in which they exist, may give some indication of the complexity and ambition of the trilogy. On a purely formal level, instinctive recourse to use of the word "shot" to describe what is a still (albeit projected) photograph conveys the quasi-cinematic quality of the trilogy. And inasmuch as the spectator views these slide/audio works in a darkened room or auditorium, the viewing situation is more akin to cinema than to photography. This situation in turn sets up an expectation for narrative which is further sustained by employing the word "story" in the title, the voice-track accompaniment, and the internal tension of the subjects' speech. This setting up of expectation, in this case, for narrative resolution, is then deliberately frustrated and complicated through several devices. Chronological sequencing is not respected; we see, for example, Faye pregnant while she is talking about the present, shots of different seasons that violate any notion of continuity. Periodically, the same photograph resurfaces when the speaker may be radically contradicting something said earlier when the same shot was employed. And—a related

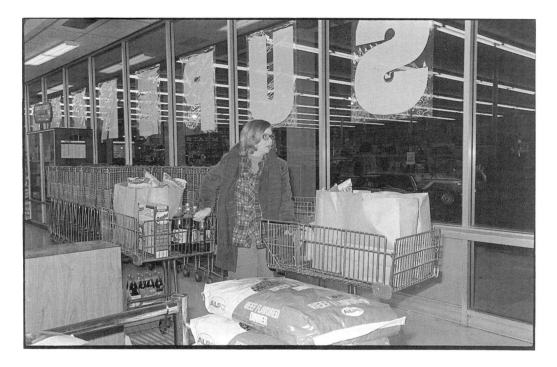

CONNIE HATCH, FROM THE AUDIO-IMAGE TRILOGY *SERVING THE STATUS*

***QUO*, PART I, *WORK/POSSESSIONS: ONE FAMILY*, 1979.**

COURTESY OF THE ARTIST.

strategy—the image may be used in total contradiction to what is being said. The last image in *Work/Possessions*, for example, portrays Chris and Faye in their bedroom, he sitting on the bed, she standing on the opposite side of the room looking irritated and disgruntled. Their cat is perched awkwardly on the end table. The voice-over is Faye's: "I'm very happy . . . with my new baby." The image is almost identical to an earlier one in which man, woman, and cat are presented as a harmonic ensemble.

But while Hatch is concerned to complicate narrative or to frustrate (not fulfill) certain expectations of it, she is still working within it. What is constructed within the trilogy is not so much an anti-narrative, as a counter-narrative; counter to expectations, counter to conventions, and, even more significant, counter to what she terms the master narrative which is the imaginary (but coercive) model to which all lives fail to conform. The master narrative is nothing less than the weight and authority of dominant ideology; the contradictions that fissure it are the gap between the lived and felt experience of human beings that are trapped within it. The classic problem of radical photographic practice articulated by Benjamin—the need to render the invisible visible—is, in the trilogy, approached not so much through the realm of the specular (as it is in the *De-Sublimation*

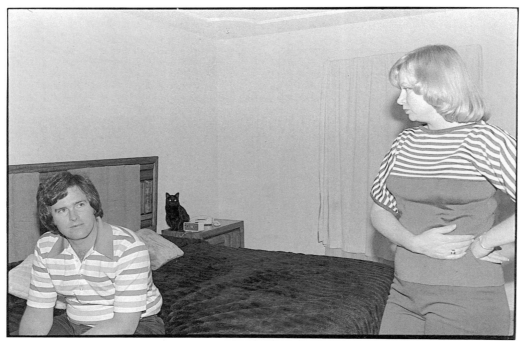

CONNIE HATCH, BOTH FROM THE AUDIO-IMAGE TRILOGY *SERVING THE STATUS QUO, PART I, WORK/POSSESSIONS: ONE FAMILY,* 1979. COURTESY OF THE ARTIST.

206

project), but through the realm of the aural. For the speaking subject always knows more than he or she thinks they know. The (invisible) mechanisms of domination and control are conjured in the interstices, as it were, of everyday language. These contending stories are thus the framework within which a dialectical, that is, a politicized, understanding can be fostered.

The scrambling of temporal continuity, the dissonance of image with speech, and the reiteration of individual shots are formal strategies obviously linked to Brechtian notions of the alienation effect and defamiliarization. But they should also be perceived as self-reflexive mechanisms to stave off the spectator's desire to perceive what is being unfolded as a truth unknown to the participants and revealed to the spectator. For if one central preoccupation in Hatch's work is the revelation of contradiction, an equally important one is that of complicity—the viewer's, the participants', and the artist's. In the three parts of the trilogy, there is no sense of the subjects having been caught unawares, spontaneously captured by an unobtrusive camera and tape recorder. The presentation to the camera, to Hatch, and ultimately to ourselves, is in myriad ways established as a theatricalization (the interiors were, in fact, shot with highly artificial strobe light which gives equal illumination to everything in the image) of the self, implicated with acting, with narcissism, and with masquerade. To the extent that we are made aware of the contradictions in these self-presentations, however, the easy pleasure of the spectacle is tainted by the queasy complicity of being the spectator/recipient not of unwelcome, intimate revelations, but of desolate, familiar commonplaces.

The issue of complicity, integrally bound in photography to that of voyeurism, is one that Hatch is acutely aware of, but can in no way wholly defuse, contain, manage, or control. It threatens frequently to exceed the structures she attempts to impose with the purpose of compelling a constant awareness in the spectator of these mechanisms of power and mastery. In the act of viewing these others, hearing their stories, there can be no simple solution, no avoidance of the spectator's relative supremacy through recourse to reassuring humanist notions of "identification," much less empathy. Even more disturbingly, the operations of cultural imperialism, inevitably mobilized when spectators belonging to a more privileged class or milieu are proffered the spectacle of the lives of the other, can be put in question, but cannot be altogether vanquished. The Brechtian solution, in which the "realistic" individualized character is entirely banished and replaced with the impersonal type, is perhaps the most satisfying and least problematic form of "embodying" political questions. But a formal device of this nature is not only inapplicable to documentary practice, but effectively dismantles it. There is, nonetheless, a ghostly echo of the Brechtian theater in Hatch's efforts to theatricalize her subjects' presentations and to forge identificatory paths not with the individual characters, but with the discursive contradictions their narratives express.

Money and exploitational labor (by the corporation, in the home) are the leitmotifs of the first part of the trilogy; in the second part—*Adapt*—sexual identity is the locus of con-

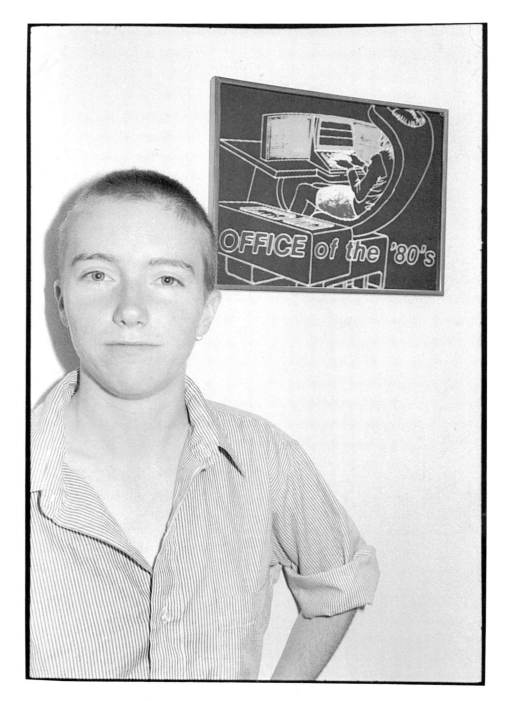

CONNIE HATCH, FROM THE AUDIO-IMAGE TRILOGY *SERVING THE STATUS QUO*, **PART II,** *ADAPT*, **1980. COURTESY OF THE ARTIST.**

tradition and, in contradistinction to the Edwardses' acceptance of norms, a potential base for active struggle. For Frankie Mann, militant lesbian, musician, and composer, economically self-sufficient by virtue of her professional occupation, the world is manifestly a more open place. Mann's feistiness, her extravagant contempt for the men she works for in the straight business world, and her astute recognition of its dynamics, including the hierarchical sexual division of labor, make her initially appear as a successful guerrilla of sexual difference.

The central contradiction that emerges here lies in Frankie's expressed revulsion for all that constitutes the signs and attributes of masculinity, and her assumption of a relatively butch persona. Frankie's cropped hair, her air of swagger and defiance, and—not least—her boyish clothing insist on an identification with the signifiers of masculinity, even as she emphatically disavows it. At one point, energetically repudiating any supposed identification with the masculine, she states, "I've had people say to me that it's so appropriate that my name is 'man.' As if I wanted to be male! I just want to make the point that I do not. If the slightest bit of me were male, I'd commit suicide." The shot accompanying "as if I wanted to be male!" depicts Frankie, beer can in hand, sprawled on a sofa, body language suggesting nothing so much as the adolescent male colonizing physical space through an excess of aggressive energy incompletely contained.

In *Adapt*, the generality hazarded through the inquiry into the specific revolves both on the title and the concept of sexual identity—or, rather, the presentation of sexual identity—as a form of masquerade. Frankie's dress and comportment, promoting the descriptive identification of "dyke," may or may not accurately reflect her internal identification, much less her lived sexuality. It does, however, constitute an elaborate staging of the self that must inevitably inflect all contacts in the world, particularly those in the straight business world of dominant white men and subordinate women. The latter are presented in Frankie's speech as another species of the other, although regarded with sympathetic outrage at their exploitation and oppression within the office hierarchy.

This association of dress, masquerade, and social/sexual role surfaces regularly in the trilogy. Discussing the oppression of the women workers in the office, Frankie says, "and this is just one little office in a whole sea of offices where women my age and older are absolutely oppressed and keep the whole thing together on absolutely slave wages. It's basically all white men, who aren't doing a damn thing and they're just dressing right." To "dress right" as a businessman is, of course, to be as fully implicated in the construction of a persona as is Frankie, but this exploration of masquerade in the trilogy is intended to have wider ramifications. In all three stories, the subjects—I ought now to say her characters—are absorbed in the task of adapting themselves to match the model of desire: for the Edwardses, the chimera of a picture-perfect domesticity; for Frankie, the unambivalent equanimity of lesbianism conceived as a state of loving women, not of hating men, and existing within a *hortus closus*, an enclosed and protected "female" space wholly apart from the exigencies of labor, money, men. The stresses and strains of adaptation are

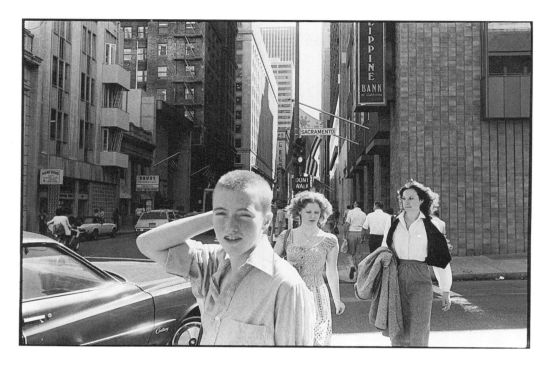

CONNIE HATCH, FROM THE AUDIO-IMAGE TRILOGY *SERVING THE STATUS QUO***, PART II,** *ADAPT,* **1980. COURTESY OF THE ARTIST.**

provoked not simply by the alienation of the subject from his and her labor, but from the collision of consciousness (including sexual identity) with internalized, impossible models.

"The women who feels herself a wound when she bleeds," wrote Theodor Adorno, "knows more about herself than the one who imagines herself a flower because that suits her husband."[14] But what of the woman, like Frankie, who acknowledges neither her identification with the wound, nor with the false solace of the flower? Frankie's matter-of-fact narration of her family history, a harrowing account of a brutal wife- and child-beating authoritarian father, alcoholic, victimized mother, and gun-toting, psychotic brother (imprisoned for an unspecified offense), has the quality of a feminist folktale emblematizing male aggression and female victimization. But it additionally points out the impossibility of any unproblematic identification process available to Frankie. If male and female attributes are symbolically constellated around poles of violence and aggression, on the one hand, vulnerability and subjugation on the other, how can Frankie represent her gender identity discursively? Only through contradiction. Consequently, Frankie's rhe-

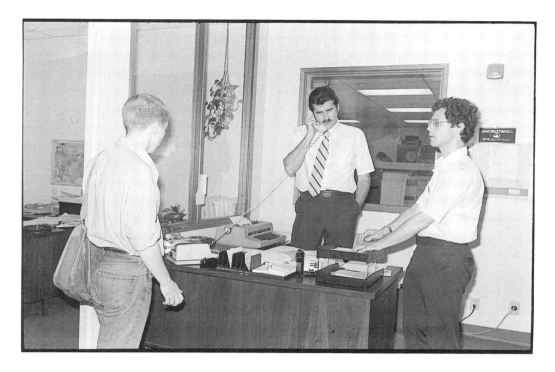

CONNIE HATCH, FROM THE AUDIO-IMAGE TRILOGY *SERVING THE STATUS QUO*, **PART II,** *ADAPT*, **1980. COURTESY OF THE ARTIST.**

torical refusal of the masculine, repeated throughout the tape, cannot be resolved in an embrace of the feminine. The category "lesbian," which in a Greimas square formulation could be considered a logical resolution (lesbian being both nonmale and nonfemale within a heterosexual society), proves equally unstable.

Sexual identity, paralleling the disjunction between Frankie's statements and her self-presentation, constantly oscillates, as do her pronouncements on her relation to technology (important both in her composing and in her wage-earning) bouncing between passionate engagement and breezy dismissal. This irresolution on the level of identity is doubled on the level of formal structure, insofar as the form of each part of the trilogy refuses narrative closure or internal equilibrium. Deprived of catharsis or resolution, the spectator's relation to the story is marked by an equivalent dissonance and tension which militate against the objectivization of the other, and conversely encourage an identification with the contradictions thus revealed. The impossibility of Frankie's "positions," defined as a series of sexual and social relations, has its correlative in the problematic constructed in the spectator's relation to her.

The third tape of the trilogy, *Night Spot: After Vietnam*, is both the longest and most profoundly disturbing. The subject of *Night Spot* is Marta Dane, a former exotic dancer currently working as a *maître d'* (recently promoted from waitress) at a private women's club in San Francisco. The implications of serving the status quo are here given particular—and literal—emphasis through Marta's specifically feminine labor: sexual entertainment for the American troops serving in Vietnam, uniformed service for the well-to-do patrons of the Metropolitan Club. Here, as in the rest of the trilogy, the subject's position within class, gender, and occupation becomes a palpable mine field in which painful eruptions of alienation, disaffection, and perceived entrapment are regularly detonated in the process of self-presentation. Moreover, these eruptions are politically neutralized within Marta's discourse (as they are not in Frankie Mann's) because of her greater investment in the *mythos* of the master narrative. Marta Dane regularly invokes her unrealized dream of conventional marriage and domesticity while recounting a life history that implicitly testifies to ambivalence, if not outright rejection, of such terms. Marta is presented as a woman enraged by her position of occupational service and yet in thrall to a no less repressive fantasy of domestic service to husband and family. Fantasy, masquerade, and the disruptions of the unconscious are emphasized in *Night Spot* to a much greater extent than in the other two tapes. When fantasy is explicitly articulated ("To me, I remember as a kid, I'd collect all these pamphlets. I'd write to Chambers of Commerce . . . Georgia, Louisiana, Florida, exotic lands"), Hatch intervenes with a grimmer, no less ironic reality (in this instance, a map of Southeast Asia, where the adult Marta would fuel other kinds of fantasies). Marta later narrates her fantasy of "becoming" an Indian woman—an Indian wife—through a longed-for marriage with her Calcuttan lover. Photographed trying on her collection of saris, the masquerade of an imaginary Indianness echoes the masquerade of a sanctioned femininity. ("Being in India for the first time, I was impressed with the fact that the Indian women were respected and protected and honored. They were the center of the home, they received their identity from their husbands . . . and I felt very strongly that it would be the most wonderful thing in the world to be an Indian woman.") The speech of the unconscious, in the classical manifestation of parapraxis, disrupts Marta's story on at least one occasion ("when I started [working at the Metropolitan Club] I thought, well I needed the money so I thought I'll do it for about six months just to get a little money together, and then go off and do something respectful") as do her periodic outbursts of shrill, nearly hysterical laughter. *Night Spot* is, in fact, an attempt to create a work that fully addresses the field of the subject through the interlocking formations of language, the unconscious, and the specular. Insofar as the Imaginary is also the site of ideological operations, Marta's speech, restlessly circling around fantasies of domestic sanctuary and redemptive romance, is regularly punctuated by a form of protest that cannot be articulated as such. This accounts for the unsettling sensation of entrapment, confinement, and defeat that the tape produces.

As if to stress the reciprocally sustaining relationship of representation and ideology,

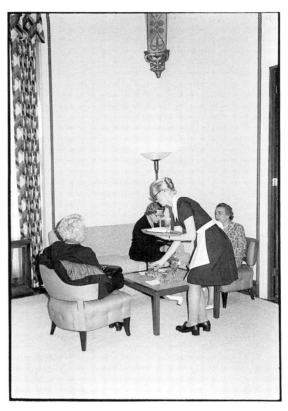

THE STAR, Hongkong, Sunday, November 7, 1965.

Ballet led to glamour job

AMERICAN singer-exotic dancer Marta Dane didn't believe she could ever become a glamorous, talented artist when she accepted her first engagement in Canada.

"Right after high-school I had been teaching ballet for two years, but I was not happy with the job," says Marta.

"It was my mother who convinced me to accept that offer.

"Of course she thought I just needed a change, and then I would have come straight back home.

"I have been working steadily for 11 years instead, mostly abroad."

NIGHT SPOT

Marta has very little in common with the usual floorshow artist, and wearing everyday clothes, she is often taken for a teacher by many,

● MARTA DANE

of a literary nature.
Three years ago she
adopted a 12-year-old

"It's difficult to describe their happiness when they

CONNIE HATCH, FROM THE AUDIO-IMAGE TRILOGY *SERVING THE STATUS QUO*, PART III, *NIGHTSPOT*, 1980. COURTESY OF THE ARTIST.

Hatch pointedly includes in her photographs of Marta those icons of femininity (a white wedding at the Metropolitan Club, a painting of a Madonna and Child on a wall in front of which Marta performs exercises to keep her body in shape) that furnish the realm of the Symbolic. Similarly, Hatch is concerned to demonstrate that Marta herself, as a human being, is conscripted to the register of representation, most specifically in her guise of "exotic" dancer. However, the publicity photos of Marta that Hatch structures into the tape, which show her face transformed by make-up into a tribal mask of the erotic, her body ornamented with the fetishistic paraphernalia of the striptease (feather boa and pasties), are linked to other variants of masquerade: the saris, the black uniform of the Metropolitan Club, even the leotard for Marta's dance exercises. Amid a semiotic clamor of representations, Hatch insists on the reality of labor; the inequities and exploitation inscribed in

213

 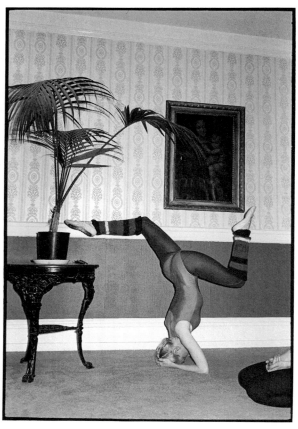

CONNIE HATCH, FROM THE AUDIO-IMAGE TRILOGY *SERVING THE STATUS QUO,*

PART III, *NIGHTSPOT,* **1980. COURTESY OF THE ARTIST.**

Marta's "service" are visually associated with that of the black workers at the club as much as with the other women workers. At one point in *Night Spot*, the themes of oppression and denial, service as ideological as well as material labor, and subordination in class, gender, and racial terms are brought together. Discussing her work at the club, Marta says the following: "I enjoy myself more when I wait on men, don't you?" Hatch here places a photograph showing a club waitress confronting the camera while a male guest behind her appears to be in the act of harassing her and a male bartender in the far background remains oblivious. Marta's voice then continues, "You're putting yourself in a situation where there's a comparison. You're a female, they're a female, what am I doing here and what are they doing there? I deserve it as much as they do, so you have this resentment building up. It's there, you can't get away from it." This is accompanied by a shot framed

214

from a doorway into the dining room of the club where one sees the club members dining. In the foreground, in the space of service (presumably the kitchen or the pantry space), a black busboy and a white waitress gaze impassively into the camera.

Theodor Adorno's conception of one of the principal purposes of art in late capitalism — to give aesthetic form to the contradictions systematically engendered by it — would seem to describe the form and contents of *Serving the Status Quo: From Stories We Tell Ourselves, Stories We Tell Each Other.* From the contradictions inscribed in the work's title (a work of cultural criticism and political critique that asserts complicity rather than opposition) to the discursive contradictions of daily speech, to the formal contradictions performed by the image/voice disjunctions, to the contradictions of the Imaginary and the Symbolic as they are played out both in subjectivity and social relations, *Serving the Status Quo* posits no "outside" of ideology, no obvious guideposts for transformational action. It does, however, propose that in the processes of recognition and an analytic and abstract identification, the necessity of opposition and struggle can be collectively affirmed. This in no way diminishes the intensely political effect of the work. "It is not the office of art to spotlight alternatives," wrote Adorno, "but to resist by its form alone the course of the world, which permanently puts a pistol to men's heads."[15] (And, we would have to add, to women's also.) That Hatch is as deeply concerned to represent the internal mechanisms of the alien will (incorporated into consciousness itself) as she is to represent its worldly agencies is a measure of the formal rigor, ambition, and resonance of these troubled stories.

Hatch's work in its entirety makes clear that the Benjaminian formula for radical cultural practice — making the invisible visible — can no longer be understood as a matter of supplementing, reconstructing, or repositioning the normative givens of representation in such a way that the real relations of power and domination are functionally exposed. And to the extent that much of her work focuses on issues of gender, the lacunae in the radical cultural theory of the 1930s are made particularly clear. Moreover, Hatch's preoccupation with the dynamics of photographic representation — with what it puts in place — is a cogent reminder that attempts to use photography to effect demystifications or deconstructions must additionally combat the ideological effects of the apparatus itself. Jacqueline Rose has succinctly summarized this problem with the question, "How to effect a political transformation when the terms of that transformation are given by the very order which a revolutionary practice seeks to change?"[16] The range of postmodernist feminist practices employing simulation, quotation, mimicry, reversal, or representational refusal is motivated — implicitly or explicitly — by a recognition of the totalizing forms and structures of representation.

The importance of Hatch's work lies not so much in some art-critical conception of "success," be that understood as a formal criterion or as a polemical one. Rather, the significance of her practice lies in the attention given equally to the institutional conditions of cultural production (a radical practice must be integrally constituted to resist commodifi-

CONNIE HATCH, FROM THE AUDIO-IMAGE TRILOGY *SERVING THE STATUS QUO, PART III, NIGHTSPOT*, 1980. COURTESY OF THE ARTIST.

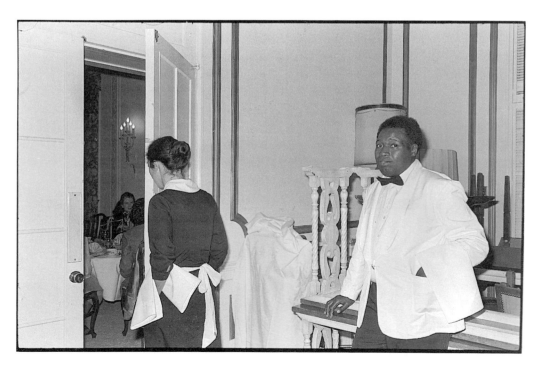

CONNIE HATCH, FROM THE AUDIO-IMAGE TRILOGY *SERVING THE STATUS QUO, PART III, NIGHTSPOT*, 1980. COURTESY OF THE ARTIST.

cation), the emphasis placed on the spectator's active engagement in the process of signi-fication (politicizing the spectator requires that the work encourage the production of meaning rather than the consumption of meaning), and an internal critique of those modes of representation that have historically functioned to naturalize, authorize, and validate the status quo.

The marginality of Hatch's work within the purview of both the art and photography world has only partially to do with its unclassifiable forms. This, in fact, is one of its rep-resentational resistances: a refusal to conform to the tidy rubrics of conventional art prac-tices. But far more important, Hatch's work is informed by a declared militancy that takes account of the oppressive operations of the social and political order no less than it does of the internal operations of the psychic order. Hatch's three projects discussed in this essay are to my mind a neo-Brechtian enterprise which has been profoundly informed—and in certain ways transfigured—by the insights of radical feminism. As Roland Barthes has de-scribed Brecht's theater,

> all Brecht's plays end on an implicit "find the solution" addressed to the specta-tor in the name of that decipherment to which the spectacle's materiality must lead him: *consciousness of unconsciousness*, consciousness the audience must have of the unconsciousness prevailing on the stage—that is Brecht's theater . . . the role of the system is not to transmit a positive message (this is not a theater of the signified) but show that the world is an object to be deciphered (this is a the-ater of the signifier).[17]

The decipherment that Hatch's work demands, a reading troubled by the claims it makes on the spectator's relation to what is shown (or spoken or written), is meant to encourage the shift from privatized melancholy to collective militancy.

1986

IV

PHOTOGRAPHY AND SEXUAL DIFFERENCE

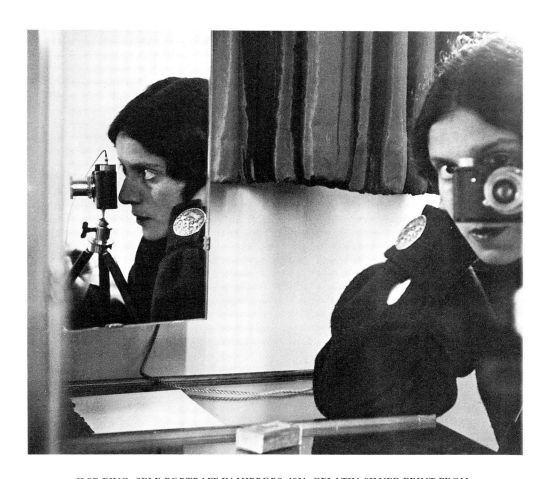

ILSE BING, *SELF-PORTRAIT IN MIRRORS*, 1931, GELATIN-SILVER PRINT FROM

THE 1940S, 10 1/2 × 12 1/8 IN. COLLECTION, THE MUSEUM OF MODERN ART,

NEW YORK. JOSEPH G. MEYER FUND.

10

Reconsidering Erotic Photography:
Notes for a Project of Historical Salvage

Conventional histories of photography avoid altogether the issue of pornographic and erotic production, but this is a subject of considerable interest from a number of perspectives. The entwined problematics of representation and sexuality, so prominent in current critical debate, are insistently raised by this genre. Moreover, the nature of the subject functions to elicit the investigator's own stake in an explicitly sexual visual field. Hence, there can be no reassuring illusion of neutrality, no refuge in a meta-discourse that exempts or purges the interest of the scholar or critic from the implications of his or her looking. For the feminist viewer of erotic or pornographic imagery, there can be no question of neutrality in the first place. Notwithstanding the equally lengthy tradition of homosexual erotica, in the modern world the vast majority of such images are of women made by men for the use of men. As such, they participate in a larger cultural enterprise of which the pornographic representation is only one, highly specialized example. This means that any engagement with this category of imagery inevitably circles back to the central issue—the discursive construction of "woman" as a set of meanings which, once launched into the world, circulates within it and takes on a quasi-autonomous life of its own.[1]

In broaching the issue of erotic and/or pornographic photography within a historical frame, my intentions are twofold. First, to suggest that the sexual economy of looking—particularly the look directed at the woman's body—overarches the contingent and relative distinctions between culturally sanctioned and illicit forms of representation. This suggestion is premised on those feminist analyses that argue for the agency of patriarchal structures—psychic and social—which inform the act of looking. These analyses, in turn, are predicated on the assertion that the active gaze is both formed and informed by the determinations of sexual difference which *a priori* construct the subject positions designated as the masculine and the feminine. Consequently, the feminine—differentially conceived as Other to the masculine norm—takes *its* place in visual representation as object-of-the-gaze, while the position of active subject-of-the-gaze is generally the masculine prerogative. Crucial to this analysis is its anti-biologistic approach; masculine and feminine, active and passive, are understood to be subject *positions*, not biological givens. A

220

woman can thus look from the masculine subject position; a man can be represented in a feminine subject position (as is frequently the case in homosexual erotica, or in some recent fashion advertising).

A structural conception of this order inevitably undercuts the arguments and programs of anti-pornography lobbyists (whether feminist or not) that are founded on the conviction that there exists a crucial and objective distinction between acceptable and unacceptable images of women and that this distinction devolves on content. The logic of this position necessarily engenders a politics of censorship which would outlaw that class of images deemed violent, demeaning, or otherwise harmful. In contrast to this position, feminist analyses that concern themselves with the "deep structures" that inform both looking and representation are far less certain about the difference between "good" or "bad" images and even more doubtful about the political utility in differentiating them for censorship purposes. Fifteen years of feminist work on representation as a signifying system (much of it developed in literary and film theory) suggests that since the act of representation and its reception occurs *within* a patriarchal framework, even ostensibly innocuous or inoffensive images will be marked by its terms. Thus, whatever the elements that differentiate an art photograph of a female nude encountered in a museum from a photographic pin-up, both types of image may posit a similar—if not identical—set of subject/object relations, and induce or foster fantasies that are themselves symptoms of the unequal ordering of sexual difference. Insofar as the various mechanisms of representation function to position women as object-of-the-gaze—be it the voyeuristic gaze of mastery, imaginary knowledge, or possession, or the fetishistic gaze that simultaneously denies and commemorates sexual difference—the act of looking itself will be articulated through these psychic and social structures.

From this perspective, a recognition of the instability of the boundaries between the erotic and the pornographic, the aesthetic and the salacious, may be taken as evidence of the arbitrariness and contingency of the attempts to distinguish them. This is not, however, to claim that there are no differences. Rather, the point is that the structural determinations of the look, and the discursive strategies common to the representations themselves, indicate that the problems of oppression, subordination, and objectification do not exclusively reside in the given contents of an image. Images, in other words, do not causally produce a world of female objects and male subjects; rather, they may articulate, naturalize, and confirm an oppressive order whose roots are elsewhere. A generalized notion of "violence" as the defining characteristic of pornography, theorized and advanced by feminist pro-censorship groups, ignores the more subtle problems of what has recently been designated as the imperialism of representation—the violence that may inhere in the representational act itself.[2]

Photographic technologies—which would also include film and video—seem especially to conform to this diagnostic. If we are willing to allow that this activity of visual capture already comprehends relations of power and mastery (implied, among other

things, by the aggressive vocabulary of photography—to shoot, to take a picture, to aim the camera, etc.), it may well be that erotic and pornographic imagery manifests these relations with particular clarity. This is itself a compelling reason to make it a subject of feminist inquiry.

Consequently, a second reason for seriously considering the repressed history of erotic and pornographic production lies in its direct relevance for a feminist, revisionist history of the medium. Specifically, an inquiry of this sort provides some of the tools for an analysis of the particular role that photography has played in what, for lack of a better term, I would call the spectacularization of the female body, a phenomenon that is as intimately linked to the rise of commodity culture as are the development and expansion of photography itself.

That erotic and pornographic photographs were produced almost from the medium's inception should come as no surprise. That it does so is a testimonial only to the near-total elision of this fact from the standard histories in the field. Once one knows of the early existence of such production, however, hints and traces of its flourishing existence can be deduced in various ways. Let us take, for example, the well-known passage from Charles Baudelaire's famous denunciation of photography from his Salon of 1859:

> It was not long before thousands of pairs of greedy eyes were glued to the peep-holes of the stereoscope, as though they were the skylights of the infinite. The love of obscenity, which is as vigorous a growth in the heart of natural man as self-love, could not let slip such a glorious satisfaction.[3]

As Gerald Needham first proposed,[4] it may well be that the popular love of obscenity that Baudelaire invoked in his essay was literally, as well as metaphorically, intended. It is not at all unlikely that Baudelaire was referring to various types of erotic imagery which were produced in massive amounts during the July Monarchy, Second Empire, and Third Republic.[5] Indeed, it seems reasonable to assume that almost as soon as there were viable daguerreotypes, there were pornographic ones. For obvious reasons, it is difficult to calculate the actual scale of this industry, but there is reason to think it was substantial. Stephen Heath, for example, cites a report from the London *Times* of 1874 in which a police raid on a single shop seized more than 130,000 obscene photographs.[6] If we assume that the overall scale of illicit imagery was anywhere as great as such a figure suggests, certain questions immediately propose themselves. Did photographic technologies themselves engender demand and supply, or did they rather fulfill a pre-existing demand? Insofar as the art historian Beatrice Farwell has characterized mid-nineteenth-century France as experiencing a "media explosion" exemplified in the Baudelairean cult of images, were such photographs a variant of pre-existing forms or a new form altogether?[7] Is erotic and pornographic photography, considered in relation to older precedents, best understood as technologically different but representationally the same, or fundamentally different in both senses?

By way of navigating these complex and underresearched questions, let us begin with a consideration of a single image—a readily available one—reproduced on page 31 of the fifth edition of Beaumont Newhall's *The History of Photography*. Newhall included this 1845 daguerreotype of a naked woman seen from the back with the understanding that it was an *académie*—that is, an academic nude study. The prototype for such an image was an artist's drawing or painting from the living model, usually depicted in a conventionalized pose considered classic or noble. Until quite late in the nineteenth century, the production of accomplished *académies* was one of the foundation stones of academic training.[8] In its daguerreotype version, an image of this sort might have been used by an artist in lieu of the model, or possibly intended as an aesthetic object in its own right. Eugène Delacroix, for example, used such photographic *académies* in his own sketches and painting, working directly from the photographs made by his friend Eugène Durieu.[9] If this daguerreotype indeed falls within the classification "*académie*," we could conclude certain things about it. To begin with, we would assume that it was a legal image, one that could be openly exhibited and sold (at least within the walls of the Ecole des Beaux Arts). We would further assume that it was understood by its viewers to represent its subject—the body of the woman—aesthetically, metamorphosing and sublimating the naked body into the high art category of the nude. Finally—and this follows from the previous two points—we would be able to conclude that this image is to be discursively situated within the framework of the aesthetic, a framework that is both institutional and epistemological.

But how secure is this classificatory system? This particular daguerreotype is anonymous, precluding any attempt to contextualize it more precisely in relation to a known body of work by a known individual. Practically speaking, the cropping of the figure is such as to make its utility for an artist somewhat dubious; the legs are cut off at the thigh, and the hand that is visible is half obscured. A comparison with a suite of *académies* made by Eugène Durieu, using a male model, signals at once that the highly conventionalized poses and clear frontal presentation of the body that exemplify the standard *académie* produce an effect quite different from that produced by the woman in the daguerreotype.

Admittedly, the Eastman House daguerreotype is a somewhat equivocal example of the genre, but the point could be made equally with less ambiguous ones (note, for example, the difference in effect produced by Durieu's female in contrast to his male model). Surely this difference in effect between male and female nude has to do with the way women's bodies have been coded—been made to signify—*as* the sexual, just as women are epistemologically designated as "the sex." Through such codings does the image of the woman come to function discursively as the sign of sexual difference itself. While men can also be eroticized by the camera (or by the brush), the image of the male body does not in and of itself conventionally connote the erotic. (I stress the term *conventionally* throughout this essay insofar as all the regimes of representation here discussed presume—and work to construct—a male, heterosexual spectator.) Photography, a medium popularly believed to directly transcribe the real, naturalizes the codes it employs to a far greater extent than do

ANONYMOUS, *ACADEMY*, CA. 1845, DAGUERREOTYPE. INTERNATIONAL

MUSEUM OF PHOTOGRAPHY AT GEORGE EASTMAN HOUSE.

other forms of visual representation. In seeking, therefore, to analyze the ways in which photographs produce their meanings, it is necessary to pay close attention to the syntax, the rhetoric, the formal strategies by which their meanings are constructed and communicated.

Returning to the comparison of the Newhall and Durieu nudes, we must allow for the differences that are a consequence of the different photographic technologies employed. Thus, the daguerreotype—the "mirror of nature"—is literally a mirrorlike surface. The image is, consequently, grainless and preternaturally sharp, delineating every blemish and freckle of the woman's skin. Durieu's pictures, on the other hand, are calotypes (paper prints from paper negatives) which have in addition suffered the ravages of time, including the fading of the prints. Although calotypes were produced that were quite sharp, the Durieu prints are especially grainy and shadowy. These formal distinctions, however, are dramatically eclipsed by more pertinent ones.

Primarily, these have to do with the conventions that inform these two presentations of the body—conventions that are themselves subject to the codes inscribing sexual difference. Everything in the presentation of Durieu's male subject announces his identity as a professional artist's model—his extremely articulated musculature, the staged and artificial quality of the poses, his apparent disregard of the camera or viewer's presence. Furthermore, the point of view from which the photographs are taken diminishes any sense of the sensuous and pliant qualities of flesh, distancing the spectator from the corporeality of the body. Furthermore, the physical distance of the camera from the model works to dissolve the specificity of the body into the more abstracted realm of the type, generalizing his features and reducing any sense of an individual personality. What is intended and produced is a generic *figure*, rather than an individuated and tangible body.

In contrast to this form of representation, the Eastman House daguerreotype presents itself as nothing so much as an offering of the flesh—a display of the woman's body that calls attention precisely to its quality of sensual display through the use of such devices as the lace bed covering. The expanse of the lace coverlet not only "sets off" the body it partially frames, but it further heightens the illusion of tactility with its play of textures. Positioned so closely to the picture plane, the woman's body invites an intimate rather than objective viewing relationship which is further reinforced by the smallness of the daguerrean plate. Visual intimacy is here a function not only of spatial proximity, but also of an implied psychological proximity. This effect is, in part, produced by the emphasis on a portion of the woman's body that is itself sexually charged. Additionally, the woman's face—even in profile—suggests her awareness of another's gaze, although her look is directed off-camera, outside the picture frame. It is perhaps this aspect of spectatorial address that is most significant, for as Annette Kuhn has pointed out: "In offering itself as both spectacle and truth, the photograph suggests that the woman in the picture, rather than the image itself, is responsible for soliciting the spectator's gaze."[10] This is, of course, one of the most decisive attributes of photographic, as opposed to graphic, representation.

JEAN-LOUIS MARIE EUGÈNE DURIEU (1800-74), *ACADEMY*, CA. 1853-54,

CALOTYPE, 16.5 × 11.3 CM., MODELS POSED BY EUGÈNE DELACROIX. CABINET

DES ESTAMPES, BIBLIOTHÈQUE NATIONALE.

226

JEAN-LOUIS MARIE EUGÈNE DURIEU, *ACADEMY*, CA. 1853–54, CALOTYPE, 16.5 ×
11.3 CM., MODEL POSED BY EUGÈNE DELACROIX. CABINET DES ESTAMPES,
BIBLIOTHÈQUE NATIONALE.

227

ANONYMOUS, *NUDE*, CA. 1848, DAGUERREOTYPE. MUSÉE D'ORSAY.

For while the solicitous gaze is a staple in pre-photographic erotica as well, the status of the photograph as trace of the real heightens the illusion of personalized address. In sum, all the elements of the daguerreotype—on both denotative and connotative levels—function to encourage an investment in the sight of the woman that exceeds the formal/aesthetic category that is signified by the term *académie*.

Whether this image was thus categorized by the photographer who made it in order to foil official censors, or whether it was so classified by collectors or curators is less important for my purposes here than my wish to demonstrate the uncertainty of the classification in the first place. In many respects, the Eastman House daguerreotype closely resembles a number of others from the collection of Gabriel Cromer, which are now part of the Eastman House Collection. These include stereoscopic daguerreotypes—exquisitely hand-colored—of naked or partially clothed women which were emphatically not intended as *académies* but instead occupy that uncertain and shifting ground between the erotic and the pornographic. While there is no gainsaying the *art*—or at least the artfulness—of these photographic luxury objects, the erotics of looking are in every way emphasized. Voyeuristic components of the look, for example, are immeasurably heightened by the stereopticon apparatus, which masks out everything but the image. The act of viewing becomes, or is in any case experienced as, a private activity. The fabulous illusionism of the stereo daguerreotype, particularly when the image is colored, is manifest not only in an intense effect of three-dimensionality, but in the way the image entirely fills the viewer's visual field. Baudelaire's reference to the "pairs of greedy eyes . . . glued to the peepholes of the stereoscope, as though they were skylights of the infinite" takes on special meaning if one has viewed stereoscopic daguerreotypes.

The instability of classificatory distinctions may be further demonstrated by comparing another back view—this one a stereoscopic daguerreotype—with the Eastman House nude. The former (hand-colored in the original) will doubtless strike the viewer as more explicitly erotic in effect than the Newhall example, but on the basis of what conceptual schema can this be argued? We might say that the placement of the woman's body elicits a fantasy of sexual penetration, but why should the relatively minor physical shift from a reclining to a supine position so radically alter the erotic implication of the image? Under what definition and under what terms can Newhall's *académie* be detached from this other image world of women's bodies? It is precisely in light of these difficult distinctions that we need attend to the erotics of looking rather than attempting to empirically locate the erotics in the contents of the image and leaving it at that. For notwithstanding a careful analysis of the construction of any given image, in the final instance its meaning will be determined by the viewer's reading of it, a reading as much determined by the viewer's subjectivity as by the manifest and latent contents of the image.

Writing of a Giacometti sculpture, the French critic Jean Clair has this to say: "Vision is not only a passive, feminine receptacle where the real gets photographed, but it is also a phalloid organ able to unfold and erect itself out of its cavity and point towards the visible. The gaze is the erection of the eye."[11]

ANONYMOUS, *NUDE*, CA. 1852-53, HAND-COLORED STEREOSCOPIC

DAGUERREOTYPE. COLLECTION UWE SCHEID.

"The gaze is the erection of the eye." Clair's statement emphasizes the phallicism of the look, "this phalloid organ" that seeks to penetrate the hidden recesses of the feminine. Surely the strategic positioning of the woman's buttocks in the stereo daguerreotype invites this visual penetration even as it works to conjure up the imaginary, projected act of anal penetration. Clair's characterization of the gaze as visual erection is particularly apt in relation to photographs that are effectively *about* the revelation of the woman's genitals. Conventionally, male genitals are deemed an explicitly sexual sight only in a state of arousal. Female genitals are not only more hidden (and arguably more forbidden), but can be seen only from vantage points that generally require an elaborate positioning and display of the body—legs splayed, supine or reclining position, etc. Reinforcing the spectator's fantasy that it is the real woman, rather than the photograph of her, that provokes the gaze, so too does this exposure of her genitals invest her with both guilt and complicity.

Whether the model is clothed or naked, expressive or impassive, the purpose of the photograph—its instrumentality—lies in its tantalizing display of what can be penetrated only in imagination. However, this is one of the paradoxes of explicitly sexual photographs of women. In offering this forbidden sight to (masculine) scrutiny and investigation, the image appears to produce knowledge: this is what it looks like. But simultaneously it thwarts the more profound question—the riddle (or threat) of femininity itself—which is neither answerable nor representable. Furthermore, the visual presence of the woman's body is inseparable from her literal absence. "A photograph, however much

230

ANONYMOUS, STEREOSCOPIC PHOTOGRAPH, CA. 1855. CABINET DES

ESTAMPES, BIBLIOTHÈQUE NATIONALE.

it may pretend to authenticity, must always in the final instance admit that this is not real, in the sense that what is in the picture is not here, but elsewhere. This very quality of absence may augment the voyeuristic pleasure of the spectator's look. On another level, though, the artifice of the photograph will ensure that his desire remains ungratified. Since he knows it is artifice, how can he be sure after all that it really is telling him anything about femininity, about women's pleasure? The question remains unanswered: he is condemned to endless investigation."[12] In a certain sense, the erotic or pornographic image always fails to deliver the goods. Akin to the desire produced by the commodity fetish, the image will ceaselessly provoke desire in the consumer but will perpetually defer closure, resolution, satiety.

Nineteenth-century photographs that display women's genitals are obviously less ambiguous in terms of classification than images that don't. But even here, there are distinctions to be drawn, as in the case of female *académies*. What permits the recognition of the erotic or the pornographic in any given historical moment would seem to reside in a mode of address, a syntax, a rhetoric of the image. Nonetheless, a consideration of the structure of the look and the desire for closure and knowledge are no less germane to those images one would never categorize as pornographic. This is why arguments that attempt to distinguish between the acceptably—indeed, the valorized—erotic (the erotic thus conceived as a derivation of *eros*—love) and the unacceptably pornographic (the word's linguistic derivation signifying the writing or speech of prostitutes—hence, venal sexuality)

231

perpetually founder. Similarly, attempts such as John Berger's to argue that certain representations of nude women (Rubens's *The Little Fur* or Rembrandt's *Bathsheba*, for example) produce a different kind of spectator because the real women who posed for the paintings were loved by the artists, are profoundly unconvincing.[13]

These difficulties suggest that a sliding scale of concepts such as the aesthetic/erotic, the erotic proper, or the pornographic (as well as distinctions within these categories such as soft-core, hard-core, etc.) can never be wholly reduced to a question of *content*, i.e., the representation of what is normally forbidden to be represented. As Beverly Brown has argued, a reduction of the problem to one of representing the forbidden or transgressive does little to clarify the issue: "There are . . . problems with the idea of a scale of increasingly explicit representations of the body, where representation is [conceived] essentially as a transparent medium giving more or less access to the object. This might seem unexceptionable insofar as we can all recognise pornography 'on sight'. But let us not mistake recognisability for a simple givenness of content. Recognisability does not depend just upon what and how much is shown—otherwise we would not be able to distinguish between pornographic, artistic, medical representations of sexual acts and naked bodies."[14] Although I am in fact suggesting here that recognizability is itself a problematic, I am in total agreement with Brown's assertion that it is not content as such that is the determining factor. As Brown, Cowie, Kuhn, and others have argued, erotic and pornographic modes of representation are profoundly implicated with the structures of fantasy and thus involve a more or less elaborate *staging* of desire. This may be accomplished with elaborate strategies of *mise en scène*—tableau, narrative, props, or more simply by recourse to certain forms of gesture, pose, expression, or use of detail.

It goes without saying that these images are the product of *male* desire and fantasy. And insofar as I am arguing for a structural homology between licit and illicit representations of the female body, I am particularly concerned with their shared status as *photographic* representations. Consequently, it is important to distinguish erotic and pornographic photography from its precedents, including its immediate ones in lithography. Here I would insist that the invention of pornographic or erotic photography cannot be adequately considered merely as an extension of a pre-existing genre by a new medium, any more than photography can be adequately considered as simply one of the many nineteenth-century advances in printmaking technologies and mechanical reproduction. On the contrary, all discussion must proceed from the recognition that photography produces a wholly different visual paradigm from that of the older graphic arts, and it is precisely the differences in this paradigm that we need to acknowledge in any discussion of the medium and its uses.

Obviously and importantly, the crux of the difference lies in photography's semiotic status as index, or motivated sign. (Footprints and fossils are typically given as examples of indexical signs.) In other words, the photograph's direct and causal linkage to its referent determines its ontological difference from other iconic systems. Insofar as the pho-

tographic picture is the trace of a once-present person or object, the spectator is inevitably situated in a certain—however ambiguous—relation to the real. The traditional pornographic representation, whether from the frescoed walls of Pompeii, or the individual image from the lithographic press, has no such purchase on the real. However potent or arousing to the viewer, the hand-made image offers evidence of its own mediation, whereas it is in the nature of photographic representation to normally efface it.

Hence, it is the ramifications of the dual nature of photographic imagery—indexical and iconic—that historically underwrite all debates in and around the medium: its status as art, its status in law, its claims to science, its utility to power, its range of instrumentalities. Most important for a discussion of "transgressive" photography, this double identity as index and icon needs to be reckoned with as part of a comprehensive historical understanding of the effects of such imagery and, even more urgently, for the contemporary project of understanding the politics of representation, an enterprise of great import for feminism.

That the subject of the erotic or pornographic image was a real person, posing or performing in front of the lens, undoubtedly altered the viewer's experience of it. But equally, this indexical property of the photograph was also a problem for any aesthetic approach to the naked body. Insofar as the category "nude" presupposed an elaborate and highly stylized set of mediations, how was photography to manage them? Bearing in mind the fact that the female nude was governed by rigid codes pertaining to the representation of sexual difference (most tellingly, the elimination of body hair and the suppression of the vagina), it is not surprising that there was some controversy about whether the photographic nude was, by definition, oxymoronic. In the early years of the Second Empire, the propriety of the photographic nude was actively debated, the result being that the prestigious Société Française de Photographie banned them from their own exhibitions. Needless to say, solutions were found; backviews and strategic bits of drapery are the tropes of the photographic nude until well into the twentieth century.

In this photographic sphere, as in others, one approach was developed with reference to pre-photographic models from the graphic arts, while another seems to have been very much an invention of photography itself. Indeed, one of the most striking characteristics of Second Empire photographic erotica is that all the conventions of pose and body display we are familiar with from contemporary imagery—the beaver shot, the masturbating woman—appear fully formed, as it were, in its earliest incarnations. It is as if these ritual displays are invented *for* the camera, in relation to its technical abilities and technical deficiencies. As with all other aspects of photographic history, we are thus obliged to consider what forms of representation photography expanded upon, elaborated, or altered, and what forms it may have inaugurated. Within the realm of sexually coded imagery, there is reason to think that erotic representation demonstrates a shift from a conception of the sexual as an activity to a new emphasis on specularity—the sexual constituted as a visual field rather than an activity as such. This would suggest links to other cultural devel-

F. JACQUES MOULIN OR ACHILLE QUINET, *NUDE*, CA. 1856. SAM WAGSTAFF

COLLECTION, THE J. PAUL GETTY MUSEUM.

ANONYMOUS, CA. 1855, HAND-COLORED STEREOSCOPIC DAGUERREOTYPE.

COLLECTION GÉRARD LEVY.

opments in the nineteenth century: the invention of department stores with their open and extravagant display of goods and sophisticated window dressing, the popularity of illusionistic spectacles ranging from the diorama to magic-lantern shows, and so forth. Moreover, from its earliest years, photographic activity was itself intuitively perceived as sexually charged. Popular plays that cast the photographer as seducer (Meilhac and Halèvy's 1865 *Le Photographe*, for example), as well as satirical drawings and cartoons that played upon the erotics of the camera eye, all attest to an accrual of sexual meaning to photography.[15]

In some instances, these two modes—activity and spectacle—would appear to converge, for example, in the depiction of either masturbation or "lesbian" sex. In these images, what is promised to the spectator is a hidden/forbidden knowledge: this is what women do alone, this is what women do together. But what appears to be an activity is, in fact, another version of spectacle, not simply because the image is patently simulated or static or non-narrative, but because of the imperatives of spectatorial address which dictate that this be staged as a sight. Women together, for example, are typically posed in ways that provide the viewer with maximum visual access to their bodies, which is sometimes augmented by the use of mirrors. The implicit requirement that the women be *for* the presumed male viewer, rather than for each other, belies the claim that such images illustrate lesbian sexuality. Instead they produce yet another variant of the feminine as spectacle, as erotic display.

235

ANONYMOUS, CA. 1850, HAND-COLORED DAGUERREOTYPE.

J. PAUL GETTY MUSEUM.

If photography fosters and facilitates a conception of the erotic as a sight, I would suggest that it also constructs an erotics of the fragment, the body part. Indeed, images of the fragmented body—notably, those that isolate the genitals or sexually coded parts of the body—are an important subgenre of pornographic photography. It is, of course, a commonplace of photographic criticism to acknowledge the fragmenting operations of the medium, even to the extent of characterizing this feature as one of photography's cardinal norms. But to analyze the implications of these operations in relation to the image of the female body is to open the discussion to considerations that are absent from more purely formal considerations of photographic effect. The question then becomes something like this: how and in what ways does the isolation of parts of the female body intersect with other structures (of vision, of meaning, of psychic projection) to further establish and secure the object status of women in representation? Consistent with the

236

arguments I have presented throughout this essay, this would suggest that theoretical analyses should be oriented more toward a consideration of similarities in different genres of photography rather than with their differences. Consequently, mainstream mass-market stereos and *cartes-de-visite* depicting actresses, dancers, entertainers, and demi-mondaines, framed and matted art photographs of female nudes, and the covert production of erotic and pornographic images could well be perceived as existing on a generalized continuum which collectively produces the category "woman."[16] As an ideological operation, this production in turn intersects with and is assimilated to other discourses, other forms of knowledge—another reason for the necessity of broadly contextualizing work on photographic meaning.

Last, a historical retrieval of the kind this essay proposes is a necessary component for understanding the development of commodity culture. For it is surely through an investigation of the mass-media incarnation of woman-as-spectacle that we may be enabled to theorize the possible links between the emergence of consumer culture, the fetishism of commodities, and the role that more or less sexualized images of women play in the evolution of both. The historical period that produces the media explosion exemplified by the invention of photography itself is one in which the heightened fetishism of the woman's body, accompanied by fantasies of possession and imaginary knowledge, comes to be attached to the commodity. It is hardly necessary to underscore the fact that the conscription of images of women to and for the purveyal of commodities has been a cultural development of enormous significance and one in which photography has been a crucial agent. The eroticizing of the commodity and the commodification of women are cultural phenomena that cannot be studied apart from each other.[17] Historically, this erotic lure became absolutely literalized with the advent of advertising that unambiguously conflated the image of the woman with the commodity, uniting both within the sign of (unfulfillable) desire. Finally, the covert circulation of erotic and pornographic images cannot be understood to occupy a space apart from mainstream imagery. Rather, it must be thought of as a visual subculture that subtly infiltrates mainstream, acceptable forms of representation. The legacy of this infiltration process is now everywhere to be seen, having permeated almost all aspects of our visual environment. To identify the problem of women's oppression or violence against women with the pornographic modes we can recognize "on sight" is to greatly oversimplify the matter. On the contrary, it may well be that the most insidious and instrumental forms of domination, subjugation, and objectification are produced by mainstream images of women rather than by juridically criminal or obscene ones. In arguing, therefore, for a historical retrieval and examination of illicit imagery, while shifting the terms of the discussion around licit ones, I am emphasizing the *systemic* quality of objectification and fetishism in the representation of women. The pressing need, it seems to me, is not to locate and censor a "worse offender" class of images, but rather to better understand—in order to effectively combat—the complex network of relations that meshes power, patriarchy, and representation.

1987

237

11

Just Like a Woman

In the fifty-seven years that have passed since Simone de Beauvoir produced her monumental study of women's estate, feminist theorists and scholars, artists, writers, and poets have continued to explore the consequences of that Otherness that de Beauvoir saw as constitutive of femininity within patriarchy. And as variable, contingent, and mutable as the concepts of femininity and masculinity may be—a function of discourse and not of biology—the former is inevitably positioned as Other, the latter invariably as the One. Thus, whether feminine Otherness is celebrated and valorized, or perceived as a

238

structure of oppression and subjugation, its prevalence as an apparently universal social and cultural given has not been disputed.

De Beauvoir's discussion of the stakes and consequences that attend the construction of woman as Other has since been reformulated through an analysis of the concept of sexual difference. Such an investigation focuses on how this difference comes into being, and how it is put into play. In addition, it heightens awareness of the radical alienation of women from language and, indeed, from all the symbolic systems in which a culture's reality is represented. For as the English rendering of the de Beauvoir quote tellingly demonstrates, in the very act of specifying a condition of femininity, language asserts the primacy of the masculine term. If the "alien point of view" that women have historically accepted is that of the man, and if language and image are already marked by that view, we must ask ourselves how and in what terms can the Other become the One?

These are the kinds of questions that have supplemented de Beauvoir's existentially informed discussion of feminine alterity, subjecting it to ideas taken from a variety of theoretical contexts: from Freudian and post-Freudian psychoanalytic theory; from structural linguistics and anthropology; from semiotics, deconstruction, and poststructuralism.

One of the consequences of the deployment of these critical methodologies is to have questioned—even more forcefully, to have radically undercut—any assumption of a stable or unproblematic content for terms and identities such as "masculine," "feminine," "man," "woman." The concept of a unitary and unified identity—the transcendental subject of Western philosophy—has itself been jettisoned, psychoanalysis having been the first and perhaps most important discipline to do so. Bob Dylan may confidently invoke those attributes conventionally descriptive of woman (what she is *like*), but the impulse of most contemporary thought is to insist precisely on its nondeterminacy. In the broadest sense, the influence of these ideas has been to redirect the inquiry into femininity away from the object itself (i.e., locating the "authentic" feminine) to the grounds, the stakes, the apparatuses, the mechanisms of its construction and articulation. As such, attention is focused on the production of subjectivity, and the production of meaning. Any claim to absolute knowledge, to the fixing of origins, to the authority of master narratives, to certainty, is categorically refused. The tradition of Western philosophical investigation that Nietzsche had characterized as "the unshakable faith that thought, using the thread of logic, can penetrate the deepest abysses of being" is hereby foreclosed.[1]

At its most extreme, such an enterprise achieves a kind of epistemological closure in the assertion that there is no real outside of representation, or in its somewhat less totalizing version, no access to the real unmediated by representation. Such hypotheses cannot but derail the quest for an essential nature, of the man, the woman, the human being.

Contemporary feminist theory has been profoundly affected by the influence of these new theoretical positions. Conversely, contemporary theory has been profoundly influenced by the epistemological critique of phallocentrism offered by feminisim. The various critiques of the sign, of representation, and of the subject that form these critical investi-

gations, have obvious implications for an examination of the cultural construction of femininity through the agency of representation.

Jacques Lacan's notorious pronouncement that woman doesn't exist (*La femme elle n'existe pas*) is thus a logical corollary to the recognition that sexuality and desire, subjectivity and meaning are all constructed in language. And to the extent that the category woman is understood to be a wholly discursive production (and within patriarchy, a differential one—a being defined by her relationship to lack), any conceptualization of the "real" woman is logically both unknowable and unspeakable.

In prefacing a discussion of the photographic work of Francesca Woodman with a necessarily cursory invocation of certain theoretical issues that currently inform feminist theory, I am bowing to the need to provide a frame of reference, a conceptual schema, in which to consider it. Unlike contemporary artists using photography (be it appropriated or newly produced) such as Connie Hatch, Barbara Kruger, Louise Lawler, Sherrie Levine, Martha Rosler, Cindy Sherman, and others who might explicitly define their work as both feminist and critical, Woodman's work announces neither a manifestly political agenda nor a specifically feminist orientation. Nonetheless, the nature of Woodman's photography, its thematic preoccupations, its disturbing iconography, the subject/object relations it explores—all coalesce to encourage and to support a feminist reading. In emphasizing the intersections between a body of work whose subject is in fact the body, with a body of theory that renders the body problematic, I intend no hard and fast correspondences, no fixed equivalence. Rather, I am attempting a reading that provokes reciprocal echoes, parallels, and allusions between the work of theorists and the work of an individual artist whose relation to these theories, supposing it to have existed at all, is unknown.

The power of Woodman's images, their intensity and their beauty, does not in any case derive from their compatibility with theoretical ideas. Nonetheless, reference to these ideas has the capacity to reveal other dimensions of the work, to offer an enriched perception of their meaning, and, perhaps most important, to establish a contextual dimension that places the art of Woodman in relation to her contemporaries and her successors.

Produced from early adolescence until the time of her death, Woodman's photography is the work of a prodigy. As such it is particularly difficult to place. Prodigies in photography are singularly rare, women prodigies virtually unheard of. The ambition, the sophistication, and the complexity of her work are significant. Her work does not conform to a developmental model of cultural production in which one can distinguish a passage from juvenilia to artistic maturity. By her late teens she appears to have clearly defined the parameters of her work: an assiduous inventory and exploration of the woman's body as icon of desire. In selecting the camera as her medium, Woodman was choosing a technology that is itself inseparable from those operations of fetishism and objectification that Woodman consistently worked to dissect.[2] Thus, the tension between photography's

FRANCESCA WOODMAN, NOS. 1, 2, 5, 6 FROM THE SERIES *SELF-DECEIT*, ROME,

1978. ALL PHOTOGRAPHS REPRODUCED IN THIS ESSAY ARE COURTESY

GEORGE AND BETTY WOODMAN.

own structural norms and limitations, and the intensity of Woodman's efforts to make it do something else is what provides the edge in her work.

This palpable straining against the confines of the single still image appears to have been an important component in the development of her project. First of all, it led her to abandon the high modernist idea of a single self-contained photograph as an end in itself. The overwhelming majority of Woodman's photographs are serially conceived; themes and motifs circulate, are elaborated, modified, reworked. Additionally, the philosopher's stone of art photography — the purely visual — was scrapped; many of Woodman's photographs bear cryptic texts, shards of narrative or description. In her artist's books such as *Some Disordered Interior Geometries*, the photographs are part of a larger system; they play a crucial, but by no means exclusive role. Finally, in later work such as the extraordinary and monumental blueprint diptychs and triptychs, Woodman effectively invented a new form. Projecting 35-mm slides on light-sensitive paper, Woodman created images that have the grainy, tenebrous effect of pinhole camera pictures, but the commanding and heroic scale of murals.

Woodman's photography has thus not much in common with mainstream art photography of the 1970s or with the formalist modes privileged in art schools such as the Rhode Island School of Design (where Woodman studied), or with the Bauhaus-derived experimentalism fostered by the Chicago Institute of Design.

But if Woodman's photography does not factor readily into the art-photographic mainstream, neither does it demonstrate any obvious resemblance to the photographic work now designated as postmodernist. While Woodman regularly stresses the status of the photograph as representation, and often includes other representations within the field of the image, strategies of appropriation or direct quotation do not appear in her work. Reference to mass culture or to advertising is altogether absent. Woodman's images, which are always staged, are intense and obsessional; the grim ironies or cool detachment of postmodern photographic practice are nowhere in evidence.

If Woodman's photography recalls any other body of work, even superficially, it might be surrealist photography.[3] But even granted her knowledge of such material, what is crucial is her deformation of it. Because if the body of the woman occupies a privileged place within surrealist practice, it is essentially the body as imagined, feared, and desired by men. This, however, suggests the interesting possibility that Woodman envisaged her project as an enterprise of reproducing the image produced by men: looking with a woman's eyes and trying to reconstruct what a man sees. It is precisely this kind of description that leads away from surrealism and art photography, and urges instead that the work be considered as it may have been informed by feminine, if not feminist, concerns. Thus, in seeking to "place" Francesca Woodman, it is perhaps most useful to ground a consideration of the work specifically in the terms it posits. Further, reading Woodman's art through the prism of feminist thought — the philosophy of the Other — affords a perspective from which to consider her work with reference to the problems posed by the search

242

FRANCESCA WOODMAN, UNTITLED, NEW YORK, 1979-80.

for a feminist aesthetics or poetics. To have recognized the image of the woman's body as "written"—an integral part of Woodman's artistic accomplishment—is one thing; to learn to write it differently is another. In considering Woodman's photography, with its gothic undertones of extremity and excess, it is important to acknowledge that this initial act of radical perception is the necessary preamble to the emergence of a second act of exemplary transformation.

Running throughout the body of Woodman's work are three central and overarching themes. First, and perhaps most compelling, is Woodman's staging of herself as the model for herself, the artist. In this alternating movement between active, creative subject—a producer of meaning—and passive object—a receiver of meaning—are metaphorically enacted the difficulty and paradox that attend the activity of the woman artist. Moreover, this seesaw of subject/object positions involves another set of relations: those of the artist and the model to the camera. Accordingly, Woodman's work reckons with the camera as a third term in the construction of an elaborately coded femininity.

Another theme in Woodman's photography is the constant insistence on the woman's body as both a sight (a spectacle) and a site (of meaning, desire, projection). Last, Woodman appears wholly to have grasped, and taken as the very substance of her work, the operations of fetishism as they are mobilized in the metamorphosis of female flesh into image. In choosing to assert rather than deny or avoid the fetish status of the female body, Woodman's photographs are vulnerable to the charge of collusion with those very operations. I would argue, however, that through strategies of defamiliarization and disruption—excess, displacement, disordering—Woodman exposes the overdetermination of the body as signifier, thereby significantly altering the spectator's relationship to it.

There is a sense in which all three of Woodman's themes are integrally related, indivisibly bound. The youthful, beautiful Francesca Woodman experiences herself as the object of the gaze, magnet and locus of the desires and fantasies of others. And at the same time, as an artist, a photographer, she is the author of work that is specifically about the visual, the realm of the scopic. Her pictures, like those of any photographer, are produced by looking and arresting the look. The orchestration of these looks—those of the photographer, the camera, the spectator—functions to produce different subject positions. Feminist film theory, using psychoanalytic theory as a tool, has interpreted these positions through the operation of sexual difference.[4] These looks, these subject positions, are accordingly understood as *gendered*. Thus, active looking—the mastering look of the photographer, the voyeuristic or fetishistic look of the spectator (whose position is mandated by the photographer's and from which it cannot be separated)—is understood as occupying a masculine position. In her alternating occupancy of the active position of artist/photographer and the passive position of object/model, Woodman's activity raises many of the problems of feminine subjectivity and creativity, invoked, for example, in the question "what (if anything) changes when it is a woman who wields the camera?" Implicit in such a rhetorical query are others: Do women see differently, be it as artists or spectators?

What contradictions are described when women assume what is posited as a masculine position? Is the act of looking or imaging, because active, inevitably a masculine position?[5]

In placing herself, her body, in front of the lens, Woodman does in fact collapse the distinction between seer and seen, subject of the gaze and object of it, artist and model. But far from producing any ideal synthesis, or surmounting the terms of these positions, occupying them both serves only to reassert their essential difference.

By electing to function as her own model, by casting herself as an image (for there is no attempt at portrait-like characterization or psychological delineation), Woodman was adapting to her purposes a device shared by artists as dissimilar as Cindy Sherman, Les Krims, and Hannah Wilke. As such a grouping indicates, this strategy can yield entirely different results and be marshaled for wholly different purposes. Consequently, Woodman's use of it needs to be critically perceived in light of her other two overarching thematics. By staging her body in ways that appear deliberately calculated both to generate and emphasize what Laura Mulvey termed its "to-be-looked-at-ness,"[6] Woodman links the psychic objectification she deliberately and literally enacts (self becoming other) with the specular objectification (human being becoming image) inherent in photographic representations. Further, in furnishing her image-self, or its surrogate, with the paraphernalia of fetishism (garter belts, boas, stockings, shells, eels, calla lilies, and so forth), Woodman constructs a metonymic chain that ultimately terminates in the imaged feminine body, presented to the spectator as itself the ur-fetish object. By way of example, we can consider a photograph dated 1979 which unambiguously adapts the conventional iconography of fetishism. The supine nude, stretched across a Victorian chaise lounge, offers her body to the gaze of surveillance, mastery, and imaginary possession. Here is presented a staple of erotica, with a pedigree as exalted as the Rokeby Venus or as debased as a *Playboy* centerfold. But by girding the torso with three garter belts instead of one, by suspending superfluous stockings from the wall, Woodman creates a disturbance in the field. The fantasy tableau, the little theater of the fetish, becomes deranged. Its familiar props, through a deceptively simple additive principle, now become strange and alienating. If a multiplication of phallic symbols signals castration fear, as Freud asserts, might not a multiplication of fetish paraphernalia evoke a comparable dread?

This interlocking network of fetishism and castration anxiety, as it constellates around the body of the woman, is frequently delineated in other of Woodman's images. A picture from the series *I Stopped Playing the Piano* (Providence, ca. 1977) depicts a knife-wielding woman, breast bared, a reptilian object cleaving to her chest. Another image in the series *Liza Used to Have Long Hair* confronts the viewer with a seated nude woman, cropped at the eyes, wisps and swatches of hair taped to her body. In another, the body of a nude is bisected by an inky swath of fur boa, obscuring the sex it simultaneously invokes.

Lacan's reminder that "images and symbols *for* the woman cannot be isolated from

245

FRANCESCA WOODMAN, UNTITLED, NEW YORK, 1979-80.

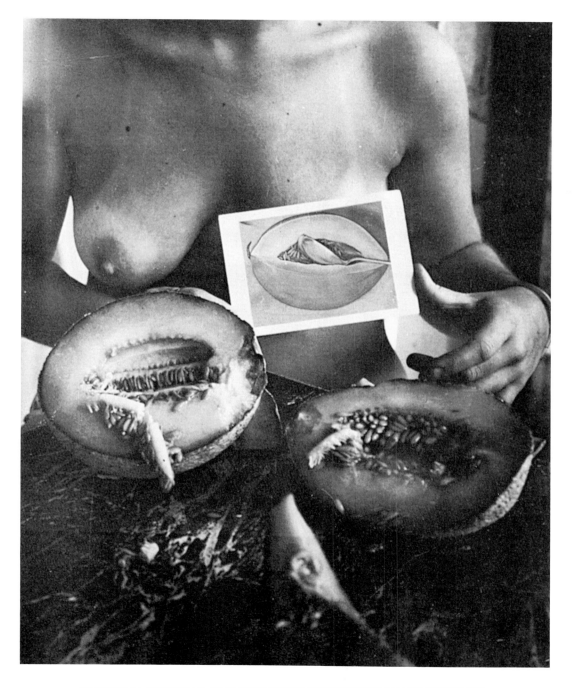

FRANCESCA WOODMAN, FROM THE SERIES *THREE KINDS OF MELON IN FOUR*

KINDS OF LIGHT, **PROVIDENCE, R.I., CA. 1975-77.**

images and symbols *of* the woman" is here apposite.[7] A photograph from the series *Three Kinds of Melon in Four Kinds of Light* (Providence, ca. 1975–77) reveals this imbrication with striking clarity and further illustrates the structural linkage of Woodman's thematics. In this photograph, the conventional metaphorical relationship of breast and melon (woman's body as fruit), and the metonymic relationship of part to whole (breast for woman), far from being unproblematically recapitulated, are complicated, tampered with, disturbed. The halved melons, offered like the breast to the spectator's gaze, reveal their vagina-like interiors. But as the graphic representation of the split melon which covers one breast makes explicit, and as the actual melons suggest, inhabiting the very core of the feminine symbol is the phallus. Recalling Freud's definition of the fetish ("To put it plainly: the fetish is a substitute for the woman's [mother's] phallus which the little boy once believed in and does not wish to forego"),[8] we should not be surprised to find it cropping up, so to speak, in the place of the feminine. For if we subscribe to the hypothesis that the desirable image of the woman contains a certain threat, that it provokes castration fears even as it functions to allay them, the appearance of the phallus in this cornucopia of the feminine signals what is fundamentally at stake in the dynamics of fetishism.

The insertion of a graphic representation of the melon in the photographic space of the real ones, and its placement over the woman's breast, is especially suggestive. Such insertions figure prominently in Woodman's work. Examples include the sequence of *Charlie the Model* (Providence, 1976–77), in which the subject displays a life drawing of himself superimposed over his own body, photographs such as the *Swan Song* series (Providence, 1978), or a photograph of three women, including Woodman, holding photographs of Woodman's face in front of their own, with a fourth portrait taped to the wall. The placement of these other images *en abyme*—a type of internal mirroring or reiteration—serves to assert the textuality of the representations. In Woodman's work this stress on textuality, so crucial in all contemporary theory, extends to the body of the woman itself. Similarly, this apprehension of the woman and her body as blank page, as *tabula rasa*, as a surface on which meaning is inscribed, is a pervasive theme in feminist theory, and a recurring motif in women's writing.[9] Moreover, it underscores the recognition that patriarchy constructs the woman as bearer, rather than maker of meaning.

A sequence of images (Providence, 1976–77) from which two are excerpted here is a virtual paradigm of this operation. The blank page—here a roll of white seamless—is placed frontally in the path of the spectator's gaze, with Woodman positioned alongside it, but off center and looking off to the side. Other images in the series depict Woodman marking and cutting the paper, two slits inscribed in penciled circles. From these openings, in increasing number, erupt leafy, vegetal forms. That these "natural" effusions spring from the paper, marked in such a way as to connote female genitalia, displaces the feminine from the woman to the page, from referent back to signifier, from the biological to the textual.

Similar tropes can be found throughout Woodman's work. In another image, for example, the headless nude torso is kneaded by the hands into an unmistakable parody of a face. The body's placement in front of a charcoal drawing of chairs and an unidentifiable thigh-like shape establishes, yet again, the status of both as representation. The drawing however, produces a specific associative chain: artist's studios, the model, even perhaps the chair the model might be seated in. But unlike the artist's model of tradition, Woodman's model assumes an aggressive, assaultive—a monstrous—incarnation. The scandal of Woodman's torso has less to do with the leering menace of the face than with the suggestion that eyes and mouth are no less sexual than breasts and genitals; desire or fear is in the looking. The psychic space of vision—the domain of the scopic—is itself informed by sexual drives (voyeurism, exhibitionism, and fetishism all hinge on the agency of the look). Woodman's mutations and deformations of the body, whether extreme or subtle, call attention to the erotic underpinnings of the look.

In another photograph (Providence, 1976–77), part of the same series, the crude white mask, placed at the woman's sex, summons the head of Medusa, whose frightfulness Freud designates as "a terror of castration that is linked to the sight of something."[10] Denied that sight, the spectator is instead directed to its surrogate, one that conjures up a death mask as well. What then is the effect of such an image on the woman spectator, who presumably cannot lose what she never had?

FRANCESCA WOODMAN, UNTITLED, PROVIDENCE, R.I., 1976-77.

The difficulty in formulating an answer to such a question is not specific to this particular photograph where both iconography and organization literally reproduce a metaphoric configuration presenting what is typically displaced, sublimated, or repressed. Much of Woodman's work in fact appears to flaunt, with a vengeance, those accoutrements immediately recognizable as belonging to the purview of the fetish. As a female spectator, my own reading of such images consequently hinges on the recognition of their overdetermination, which, like strategies of mimicry, signals a gap or distance in the very act of reiteration. But this should not be confused with parody or with a related strategy of masquerade. Ultimately, the power of Woodman's photographs lies not in wresting new meanings from the lexicon of fetishism (much less in redeeming them), but, rather, in re-presenting that very lexicon so as to effectively block its automatic consumption and acceptance. It would seem reasonable to assume that these blocking operations function differently for male and female spectators, gay and straight, insofar as we ascribe sexual difference in looking. Whether the gaze at the body provoked by Woodman's pictures is inflected narcissistically, voyeuristically, or fetishistically, the nature of that look must inevitably determine the meaning the spectator imputes to it.

Overall, Woodman's variations on both the construction and the inscription of femininity do not stake out an identifiable position for either the male or female spectator. Arguably, it is precisely this ambiguity, the indeterminacy of subject and viewing positions, that charges Woodman's photographs with their unsettling admixture of seductiveness and affront. This ambiguity of address seems particularly apparent in the large number of Woodman's images that elaborate on that most venerable and recurrent topos, the conflation of the woman and her body with nature.

Consistent with her literalizing strategies that make manifest the latent dynamics of fetishism, Woodman renders the forms of this association explicit. One particular suite of images (MacDowell, Summer 1980) traces a successive slippage whereby the woman becomes progressively absorbed into the natural landscape with which she is mythically identified. The rolled birch bark clasped in one shot encases both of Woodman's arms in another. In a subsequent member of the series, the Daphne-like metamorphosis is accelerated; situated within the birch grove, the white verticals of the woman's raised arms become visually meshed with the trees. Similarly, in another member of the series, the woman's outstretched arm describes a boundary in which the real natural world—the conifers bordering the lake—and a "natural" simulation—the ferns that mimic their reflection—are optically joined. What might otherwise be perceived as merely a playful trompe l'oeil effect in photography is given an altogether different inflection by the use of the woman's body as a locus for this visual confusion. The familiarity and ubiquity of the conceptual collapse of woman into nature are here effectively bracketed, stalled, even short-circuited through the subtle suggestion of the nightmare facet of metamorphosis.

It is interesting in this context to compare a recent work such as Barbara Kruger's *We Won't Play Nature to Your Culture* to Woodman's approach. Kruger's confrontational ad-

250

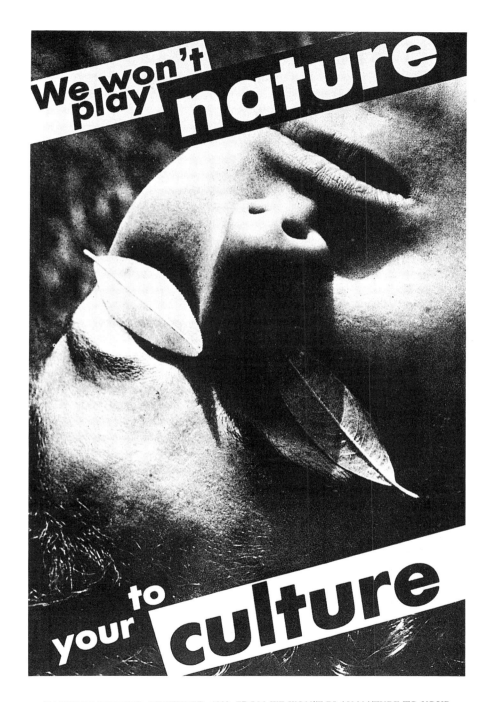

BARBARA KRUGER, UNTITLED, 1982, FROM *WE WON'T PLAY NATURE TO YOUR*

CULTURE CATALOG, INSTITUTE OF CONTEMPORARY ARTS, LONDON, 1983.

dress, effected both linguistically and formally, contributes to the construction of her work as an unambiguous act of radical refusal. Kruger's attempt to direct her work to a female spectator operates along the axis of language. We [women] refuse this relationship. Spectators are thus automatically differentiated and distinguished through the mode of address that constructs a feminine *us* and a masculine *them*. The purpose of Kruger's choice of purloined image—the woman's face with blinded, leaf-covered eyes—is to signify visually the implications of this putative relationship, characterized as both lethal and blinding. In contrast to Kruger's unmistakable stance, Woodman's production in general stages no act of defiant or militant negation, provides no guideposts for an alternate, meliorative construction, indicates no privileged space for the female spectator. Instead, Woodman relentlessly offers up the archetypal allusions, mythologies, emblems, and symbols adhering to the feminine, and infuses them—charges them—with dread, with dis-ease.

Woodman's art is thus a troubling and troubled one. Ridden with menace, its lapidary beauty and elegance function as a kind of lure. Nowhere is this clearer than in the numerous series that enact tableaux of entrapment, engulfment, or absorption of the woman in those spaces—both literal and metaphorical—to which she is conventionally relegated. In the *Space*2 sequence (Providence, ca. 1975–76), for example, the body is depicted in, on, and around a glass museum display case. Here, the reified condition of the feminine as aestheticized object is made utterly explicit, as are the stakes. Variations on this theme include one in which the case contains an animal skull, another in which the corpse-like body of the model spills out of a Natural History display cabinet filled with stuffed specimens, birds, a raccoon.

But it is perhaps the *House* series (Providence, ca. 1975–77) where the gothic aspect of Woodman's work is most apparent. In these photographs the woman's body is physically devoured by the house. As in Charlotte Perkins Gilman's *The Yellow Wallpaper*, the space of woman's seclusion and worldly exclusion not only imprisons, it also consumes. Swallowed by the fireplace, layered over by the wallpaper, effaced, occulted, Woodman presents herself as the living sacrifice to the domus. The extremity and violence of these photographs are matched only by a grouping in which the woman's body is defaced—by dirt, by paint, by rubbish—and identified with the scabrous walls and corners against which she is impressed. The desecration of the woman's body that such images enact is tempered by the recognition that this is, after all, the flip side of its idealization. Woodman's linking of the woman's body to the walls and surfaces it seems bonded to repeats the theme of the body as itself a surface. The marking of this body in patriarchal culture, its incarnation as sign, is given a chilling embodiment when Woodman marks it in ways that conjure the impulse to debase and violate which parallels the impulse to worship and adore.

If the *House* photographs function on the register of nightmare, the astonishing blueprint works are conceived in the less charged modality of the oneiric. Thematically, they elaborate on ideas and motifs that surface regularly in Woodman's work: the "found" morphological and formal resemblances between nature and culture, the animate and in-

 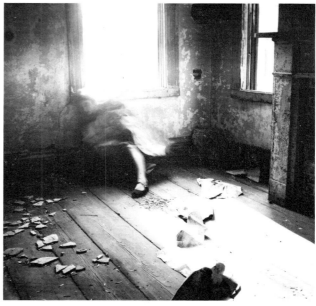

FRANCESCA WOODMAN, FROM THE *HOUSE* SERIES, NOS. 3 AND 4,

PROVIDENCE, R.I., 1975-76.

animate. Here as always, the image of woman is central insofar as it is her body that becomes the dictionary of form to which all others are metaphorically or metonymically linked. However, in one of these works, the figure of the woman is abolished, although the presence of masculine and feminine signifiers is nonetheless established. The triptych to which I refer, the 14-foot-long *Bridges and Tiaras*, is somewhat exceptional in the sense that it is constructed entirely from found images: a schematic rendering of an eighteenth-century bridge design, a filigree-work tiara, and a modern bridge. The three images, enlarged to the same grandiose scale, visually assert a condition of equivalence. Thus the decorative ornament, quintessence of the feminine, is the center image of the triptych, but, more crucially, it is presented in a way that insists on its equal importance. The masculine accomplishment of engineering and large-scale construction is similarly depicted as subject to gendered readings; the eighteenth-century bridge appears far more "feminine" than its industrial-age successor. This relativizing of masculinity and femininity is comparatively rare in Woodman's work where the emphasis is placed so emphatically on the sexual, cultural, and aesthetic construction of femininity. Nonetheless, throughout her work there surface occasional explorations of sexual ambiguity or indeterminacy. This is manifest in suites of her images where sexual codes collide, where the boundaries and certainties of sexual difference are placed in unresolved play.

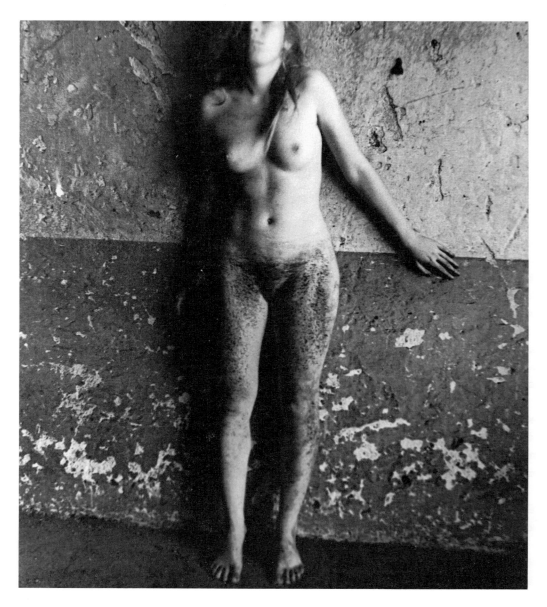

FRANCESCA WOODMAN, UNTITLED, ROME, 1977-78.

Reflecting on the range of Woodman's production in its entirety, I am struck by its encyclopedic recapitulation of images and symbols of and for the woman. But more impressive is Woodman's disturbance and denaturalizing of the attributes that are, in Bob Dylan's phrase, "just like a woman."

Consider, for example, the traditional iconographic coupling of the woman (or the goddess) with the mirror. As an attribute of vanity, or in our post-Freudian age—narcissism—to which women are legendarily thought to be excessively prey, the mirror comes to connote femininity in a manner altogether self-evident. In Woodman's frequent use of mirrors, when they reflect the woman at all, what is produced is simply another image. Hence, the relationship constructed is not between the real woman and her image, but between the spectator and two equally unreal images. What the mirror reflects, or fails to reflect, is always thrown back on the spectator. Reading vanity, or narcissism, into the image is revealed as an interpretive—and thus projective—act. This seems to me to be at once the strength and the limit of Woodman's art. A feminine poetics or aesthetics must by definition presume the existence of a feminine subject whose perception, vision, and creativity are formed through and by her femininity. But if we acknowledge, as Woodman surely did, that femininity is a discursive construction, a social category, a constraining and psychically destructive process imposed from without and painfully internalized, a condition, moreover, defined by its alienation, how is that femininity to be authentically construed? Where, in short, do we locate and ground this femininity apart from the patriarchal structures that "speak" it?

Alternatively, a feminist poetics or aesthetics tends to be far more tentative in its assumption of the mantle of femininity. The philosophy of the Other engenders a politics of the Other, and a feminist aesthetics must draw its mandate from both.[11] A feminist aesthetics can assume no given feminine, can only do its work by dislodging or intervening in the operations that have historically defined and imposed it.

Not the least part of the great accomplishment represented by the artistic legacy of Francesca Woodman is the way it both urgently and eloquently poses these complex issues of relationship between the definition of the feminine and the theories of the feminist. The identifications and projections the work summons or denies are inextricably joined to the investigation of both. The tragedy of Woodman's death is a fact and a given, but the work she produced is a living testimonial, a valuable bequest to other women. Its gravity and its extremity are a legacy of painful knowledge, but its sensuous beauty and dreamlike allusiveness assert, after all, the strength of the will, the pleasure of its maker. Alienated from language, from culture, from image, from body, the woman artist nonetheless manages to speak.

1986

12

Sexual Difference: Both Sides of the Camera

POSTSCRIPT

In the fifteen months that passed from the time I was originally invited by C.E.P.A. in Buffalo, New York, to curate the exhibition "Sexual Difference: Both Sides of the Camera" and write the accompanying catalog essay, it traveled to two other locations, concluding with its installation at the Wallace Gallery at Columbia University in March 1988. For this last venue, it was somewhat enlarged; works by four other photographers not in the original show (Lynn Davis, F. Holland Day, Mark Lewis, and Mitra Tabrizian) were included, along with additional works by Sarah Charlesworth, Diane Neumaier, Richard Prince, and Cindy Sherman.

As such a grouping makes evident, the logic of the exhibition was by no means formal or stylistic. On the contrary, it seemed important to represent a relatively broad and diverse selection of work that cut across different thematic, conceptual, and even national boundaries. In contrast to the landmark 1985 exhibition "Difference: On Representation and Sexuality" curated by Kate Linker and Jane Weinstock, I sought to avoid privileging any one form of critical approach, interpretation, or analysis of the construction or effects of sexual difference, despite the risk that heterogeneity might look like an unreflective pluralism. On the other hand, the exhibition was not intended to be primarily exhortative or didactic; ideally, I would have liked it to be thought of as a series of questions posed to the spectator that would then be echoed in subsequent encounters with photographic imagery.

Although it was a basic assumption of the exhibition that photography (like any cultural practice within patriarchy) normally functions to produce and reproduce dominant ideologies of gender, the photography selected for the show was chosen either because it specified or complicated those subject/object and viewing relations that are instrumental in reaffirming the status quo of gender, or, more militantly, because it attempted to intervene within them. This latter project is, of course, the gist of a feminist intervention within representation. By bringing together such formally disparate work, it was my intention to give some indication of the diversity and range of critical practices that interrogate conventional images of masculinity and femininity.

The greatest risk of such an enterprise—a risk that lies in taking masculinity and femininity as the alpha and omega of sexual difference—is the occlusion or repression of ho-

mosexuality; at the very least in the presumption of a heterosexual spectator. Insofar as feminism alerts us to the falsity—as well as the concomitant oppression—of presuming a universal male spectator, so too does the denial of this other difference entail its own repressive politics. While there is work included in the exhibition that may indeed have presumed a gay male spectator (the Baron von Gloeden is the obvious example here), this does not in itself exempt me from the implications of an analysis that is based on a masculine/feminine opposition and, as such, fails to theoretically address what could be termed the difference within difference. Obviously this is not a lacuna I can here either rectify or discuss; therefore, all the more important to acknowledge it precisely *as* a lacuna.

The genesis of this essay and the exhibition that it accompanies was a conference in which I participated in the fall of 1986, entitled "Women in Photography: Making Connections." Within a short time after the conference began, some of the disaffected participants—myself included—had privately renamed it "Ladies with Cameras." It is the conceptual divide between these two titles with which I want to begin.

While the conference title had suggested to me a triple orientation—women in photography as the object of the camera's gaze, women in photography as consistently marginalized practitioners, and the connections as political and conceptual in nature—in fact, the conference title was meant quite literally. This was to be a "networking" event—hence the connections to be made—and the issue of women in photography was largely limited to its vocational meaning. While in no way disparaging the need or value of such events (women still comprise only a tiny fraction of working photographers), I would nonetheless stress the crucial importance of a consideration of the issue of women as photographic objects and the necessity for making connections that exceed the professional. For the issue of women in photography—as is always the case when gender is mapped onto existing fields, discourses, and practices—profoundly alters their terms and provokes new and difficult questions.

This is particularly striking in the case of photography, a medium which by virtue of its supposed transparency, truth, and naturalism has been an especially potent purveyor of cultural ideology—particularly the ideology of gender. Here we might start with one of the most basic questions that a gendering of photographic discourse suggests: what, if anything, changes when it is a woman who wields the camera? For the organizers and many of the participants in the "Women in Photography" conference, the answer to this question was taken to be largely self-evident. In other words, insofar as women in photography was understood to be a problem—a problem of unequal representation within the ranks of professional photographers—the practical solution was assumed to lie in overcoming those barriers that limit women's participation in the field. Furthermore, the implied corollary to this position—and one by no means limited to the conference organizers—was that photographs taken by women may in some fashion reflect or inscribe

their gender in the photographs they take, whether that difference is understood to reside in their choice of form, content, or in their method of working. Moreover, where images of women in the culture at large were perceived as problematic—fetishizing, objectifying, sexist—the assumption was that bad or false images of women could, should, be countered by positive and true ones.

That such facile and uncomplicated assumptions should have currency in the encounter of feminism and photography as recently as 1986 is disturbing. First, because they fly in the face of fifteen years of feminist theory which began with comparable assumptions and went on to reject them as theoretically and politically inadequate. Second, because such assumptions are grounded, variously, either in an unexamined essentialism or in a positivist model that is both limiting and ultimately deceptive.

It was thus as a form of rejoinder that I conceived of the exhibition "Sexual Difference: Both Sides of the Camera," intending it to complicate any too easy conflation of the fact of sexual difference on one side of the camera with the representation of sexual difference on the other. In part, the nature of these complications follows from the conviction that sexual difference in photography must be addressed—insofar as it operates—in three different sites: on the level of the biological gender of the photographer and his or her intentions, in the construction of masculine and feminine subject positions within photographic representation, and in the unstable and subjective nature of photographic representation as it is received by the sexed spectator—the site where photographic meanings are equally produced. It should be apparent that the act of mapping these three sites in which the operations of sexual difference may be understood to play a determining role in the production of meaning owes a great deal to the work of feminist film theorists. The exhibition title itself is an allusion to E. Ann Kaplan's *Women and Film: Both Sides of the Camera*. Further, a particularly profound debt is owed to the work of Laura Mulvey. Mulvey's discussion of the three looks in the cinema—the look of the camera (the camera eye whose place is taken by the spectator), the look of the spectator, and the look of characters within the film itself—was formulated specifically in relation to the construction of sexual difference. But the difficulty for photographic critics, curators, or image-makers is how to draw upon the insights and analyses of film theory to develop an analogous system of analysis that is applicable to the specific nature of still photography.

Thus, while many of the fundamental insights and formulations of feminist film theory are applicable to photography, many are not. For example, within film theory, explorations of fetishism, of the erotics of looking, of the production of subject positions, of ideological functioning, can all be adapted—more or less—to the specificity of the still camera image. On the other hand, issues of narrative and its crucial links to Oedipal structure, the operations of sound, indeed, the physical, material nature of the film-watching experience itself, cannot be transferred to photography. And between those elements that are germane to both media—say, the mechanisms of fetishism in the representation of women—and those that are not, there is a third category—here I am thinking of the con-

They
Sucked
A
Filthy
Tongue
No
Mother
Could
Ever
Love

MARK LEWIS, *"THEY SUCKED A FILTHY TONGUE . . . "* FROM THE SERIES

BURNING, 1987. EACH WORK: COLOR PHOTOGRAPH AND COLOR-CODED

TEXT, SEPARATELY FRAMED. SIZES VARY: APPROX. 55 × 70 IN. COURTESY OF

THE ARTIST.

cept of suture—that requires some modification and conceptual tinkering to be adequate as a critical tool for photography.

In attempting to confront the issue of sexual difference and photography in an essay and an exhibition, I have felt both projects to be marked by a curious combination of belatedness and prematurity. The sense of belatedness arose from the fact that the moment of intense theoretical debate about sexual difference and its inscription in (cinematic) representation occurred in the 1970s. While the implications of these investigations and analyses remain very much alive and still fuel feminist theory and criticism, introducing them now into an exhibition of still photography ran the risk of appearing to be an essentially academic enterprise. On the other hand, there have been, to my knowledge, no exhibitions that have taken the subject of sexual difference in still photography as their subject per se. No doubt this had something to do with my simultaneous sense of prematurity, for the fact remains that photographic criticism and art practice have been conspicuously slow to assimilate these theoretical analyses. Not to belabor the point, it must also be said that American art photography *and* its criticism have tended to be resistant to theoretical developments of any stripe whatsoever. This may account for the dearth of photographic work that specifically takes as its subject the nature of photographic representation and its intersection with, or inscription of, the mechanisms of sexual difference. Thus, for me, Connie Hatch's work has had an especially profound importance insofar as it was my encounter with her work which mapped out many of the terms by which to conceive a feminist, critical interrogation of photography that reckoned both with the specificity of the medium and with the larger issues of gender and power that it adumbrates. In curating "Sexual Difference: Both Sides of the Camera", I wanted to put Hatch's work and the work of other artists engaging the same or related issues in a photographic context that made clear what some of those issues were. This suggested a two-part organization in which the first section would exemplify at least some of the terms that are mobilized by considerations of sexual difference which could, in turn, be seen as the object of critical scrutiny and/or intervention in the second section.

Most important, and harkening back to my criticism of the "Women in Photography" conference, I wanted to make clear that sexual difference in photography could not be equated with biological gender on either side of the camera. Accordingly, *Subject Position and the Erotics of Looking* (Part I of the exhibition) was intended to demonstrate that neither the biological gender of the photographer nor the biological gender of the model was necessarily congruent with the sexual and social implications of masculinity and femininity.

The inclusion of photographs by Imogen Cunningham and Baron von Gloeden was calculated to make precisely this point. In the case of Cunningham, on the most obvious if not the most superficial level, we are confronted with a lengthy photographic career whose changing forms and styles (from pictorialism to sharp-focus modernism) are in no way a function of gender. In other words, Cunningham's photographic evolution and de-

velopment exist in the same stylistic context within American art photography as those of her male contemporaries, although biographically speaking, as a woman photographer her experiences, her difficulties, and even her rewards may be assumed to have differed from those of her *confrères*. Where we might wish to locate a manifestation of sexual difference in Cunningham's work is in her choice of the male nude as a photographic subject. It is as though as a heterosexual woman Cunningham resolved to photograph the object of *her* desire—and, indeed, in a number of the photographs from the early 1900s the model was her young husband. The audacity of this decision should not be underestimated; whereas the female nude was a staple theme in art photography, the male nude rarely figured in the salon and exhibition circuit. Moreover, for a young woman to take the male nude as her subject was to transgress all bounds of propriety.

What Cunningham tried to do in photographs such as *On Mt. Rainier* or *On Dipsea Trail* was to take the authoritative convention of the female nude in nature, a convention underwritten by the construction of femininity *as* nature, and reverse its gender. The awkwardness of this transposition, its lack of persuasiveness, is not fundamentally related to any aesthetic deficiency on Cunningham's part. The problem, rather, has to do with the nonreversibility of the convention that associates the body and image of the woman with nature. In this regard, it is significant to recall that when Edward Weston made a rare sortie into the representation of the male nude—the famous studies of his son Neil—the body was isolated, cropped, and positioned against an indifferentiated background. Moreover, the presentational strategies Weston employed were such as to affirm the resemblance of the boy's body to the statuary of classical antiquity. Hence, through formal strategies of abstraction, the nude male body was associated not with the natural world, but with the world of culture, the world of high art. Cunningham's later work dealing with the male nude followed two alternative routes, both of which Weston employed in his treatment of the female nude. In a photograph such as *Side*, she subjected the male body to an abstracting operation that diminished erotic content—however minimal—in favor of formal stylization. In an image such as *Rainwater on Oregon Beach*, Cunningham adapted a familiar Westonian trope in which the body, photographed with preternatural sharpness and precision, is set off against irregular, contrasting, natural forms. Where female nudes are so displayed, the effect of the sand, or rock, or vegetation is to emphasize the sensuality of flesh, a sensuality further "feminized" by the conventional device of presenting the body in a supine or otherwise passive position. What happens then when a male body is so laid out for the spectator's gaze? Does such an image carry an analogous erotic charge?

The response to such a rhetorical question must, of course, always be "for whom?," suggesting that the conditions for coding the body erotically are hardly universal, but instead merely representative of the preferences of the heterosexual male. Hence, the responses to these images are also subjectively located in the viewer and are, therefore, necesssarily informed by the psycho-sexual economy of the person who looks. Although

IMOGEN CUNNINGHAM, *RAINWATER ON OREGON BEACH*, 1967. COURTESY THE

IMOGEN CUNNINGHAM TRUST.

the nude is an aesthetic category precisely to the extent that it sublimates the potential sexuality of the naked body, I would submit that this sublimation is both partial and provisional. For all of these reasons, the photographs of Baron von Gloeden merit serious consideration. Not only do they bespeak the baron's own desire, they also raise crucial questions about photographic subject/object relations which structurally parallel those of the representation of the masculine and the feminine.

Wilhelm von Gloeden, a German aristocrat born in 1856, settled in the Sicilian town of Taormina in 1880. For the next thirty-five years, the baron lived out a fantasy in which Taormina and its youths became a *tableau vivant*, an obsessional evocation of an imagined past of pagan erotica peopled by docile *ephebes*. On the terrace of his villa, in its gardens, on the stony beaches, and amid the ruins and remnants of its Greek and Roman past, von Gloeden posed his models, frequently deploying props such as tiger skins, makeshift togas, urns, garlands of flowers. At least 3,000 negatives were eventually produced (this became, in fact, a commercial operation), not counting those of his cousin Wilhelm Pluschow, who joined the baron in Taormina and set up a photographic shop of his own. Although certain of the baron's celebrants are wont to admire the baron's willful imposition of his fantasy on the (literally) impoverished reality of Taormina, it is important to take account of the more sordid aspect of this relationship. Von Gloeden's money purchased not just models, but bodies. The villa was evidently the scene of orgies and the baron reputedly procured the sexual services of the boys for his numerous guests. That half the population of Taormina (the youthful half) removed their clothes for von Gloeden's camera, impassively followed his stage management, presented themselves as odalesque or as faun, has to do with the relative power of the baron (he had the money and he had the camera) and the powerlessness of his subjects. The unequalness of this transaction is by no means narrowly anecdotal and historical. On the contrary, the terms by which Sicilian peasants became camera fodder for a paying and desiring "master" are not structurally dissimilar to less exotic photographic transactions: artist-photographer and working-class model, ethnographer/anthropologist and native subject, documentarian and down-trodden victim.

In the context of this exhibition, however, the photographs by Baron von Gloeden are intended to demonstrate the "feminization" that often (always?) accompanies the role of object of desire, irrespective of gender. In this sense, feminization may be understood as a consequence of a physical presentation of the body that emphasizes—to borrow Laura Mulvey's famous description of how the feminine is coded—its to-be-looked-at-ness. In other words, the problematics of spectacle are by no means confined to the representation of women. The position of subject-made-spectacle, understood in structural terms, can be filled by any(body). Because the medium of photography tends automatically to set up such viewing relations, it becomes the difficult task of critical, feminist practices to attempt somehow to reckon with them.

The work of Francesca Woodman raises a somewhat different set of issues, but there

BARON VON GLOEDEN, UNTITLED, CA. 1895–1900. COLLECTION CHARLES ISAACS.

are points of intersection with those raised by the photographs of Baron von Gloeden. For example, because Woodman generally chose to use herself as a model, and because she foregrounded the erotics of looking and self-display, the unquestioned relations of mastery and objectification that the von Gloeden photographs manifest are given a kind of retrospective vividness. Furthermore, where an image by von Gloeden assumes an unproblematic pleasure—at least for the spectator—in the model's compliance and his implied availability, Woodman's photographs render these viewing relations in a way that instates their moral ambiguity and psychic complexity. In effect, Woodman's pictures operate to deprive the voyeuristic gaze of at least a part of its aesthetic alibi and to suggest that such visual pleasure is not without a certain price. This price—or so Woodman's work proposes—is pre-eminently identified with the mechanisms of fetishism as they operate in the image of the young, desirable woman.

That the visual economy which ostensibly valorizes the feminine expresses a patriarchal psychical economy that is anything but valorizing comprises the latent meaning of virtually all Woodman's production. Woodman's pictures thus effect their disturbance of the erotics of the look through their pointed insistence on the fetishism that subtends representations of the woman's body. A photograph such as *Three Kinds of Melons in Four Kinds of Light* makes this quite explicit. By conjoining metonyms and metaphors of feminine sexuality (the breast, the cut melons with their vagina-like interiors) with a picture of a melon placed within the photograph and displaying within the picture various phallic-like excrescences, *Three Kinds of Melon* reveals that what dwells at the heart of the symbolized feminine is none other than the need for masculine assertion. Hence, the ultimate stake in the image of the woman is the integrity (or vulnerability) of *masculine* sexuality. Accordingly, whether the woman's body is formally idealized or degraded, its significance, its value, or its threat is a function of masculine fear or desire.

As is the case with all the photographs in the exhibition, individual readings of the Woodman photographs are themselves subject to the workings of sexual difference. And to the extent that we accept the notion of the bisexuality of the unconscious, theoretical constellations such as feminine/passive, masculine/active, voyeurism/sadism, and exhibitionism/masochism are by no means hard and fast or all-inclusive accounts of the different possibilities for spectatorial identification. Indeed, it is the very quality of indeterminacy and mobility of elicited response that partially accounts for the haunting and ambiguous quality of Peter Hujar's photographs of men.

Unlike the photographs by Baron von Gloeden or Francesca Woodman, for that matter, Hujar's photographs do not appear to attribute any fixed meaning to the presentation of the model. Whereas von Gloeden's subjects blur into an array of types, burdened by their theatrical assumption of a Teutonized antiquity, the men in Hujar's sober and non-rhetorical studies have the peculiar quality of being both erotically present and curiously distanced. And even where the pose is one conventionally associated with the feminine—the recumbent nude on the draped couch with his soft, rounded body—the excessive

space, its encompassing emptiness, and the implied self-containment of the body function to turn it into a more or less open field for projection. Further, the moody, contemplative aspect of his pictures—perhaps most striking in the figure of the sheet-covered man intently examining his penis—implies a self-possession of the model that subtly undercuts a viewing position that generally affirms the spectator's relative command and mastery in relation to a subject.

Successful or not—that is not, after all, for me to say—Part I of the exhibition was supposed to invoke the connections between sexuality and looking (looking at, being looked at) that conventional photographic discourse tends to elide. Where the question of femininity as a subject position arises, as well as the conventional forms in which it is expressed, this is a problem to the extent that the feminine position is hardly an equal pendant to the masculine one. In other words, as long as femininity, as a differential construction, is secondary, lesser, lacking, and other, its photographic incarnations cannot but ratify, reassert, and further naturalize social relations based on domination and subjugation. Such an analysis does not require a moralistic renunciation of photography, but, rather, a sensitivity and attentiveness to its signifying systems. It was thus in the second part of the exhibition, entitled *Critical Interventions*, that I sought work that, in one form or another, addressed aspects of the photographic medium that constituted its problematics for feminism.

Diane Neumaier's twenty-part work entitled *Teach Yourself Photography: 50 Years of Hobby Manuals 1935–1985* could well be taken as an emblematic artwork for this section. What Neumaier has done is to scour back issues of *Popular Photography*, *U.S. Camera*, and the like, and rephotograph images and texts that demonstrate, over and over again, that the subject of photography is pre-eminently male, and the object of photography (when it is a human figure) is almost always female. The exception to this rule—and is it really an exception or a subcategory of the feminine?—is provided by the occasional appearance of babies and children.

That men are conventionally the subjects of photography and women its objects is manifestly not news. It is, however, one thing to acknowledge this as a conceptual and political insight and quite another to invent a form that graphically illustrates some of the implications following from the sexual positioning that photography interminably and ritualistically constructs and affirms. For example, Neumaier has selected images that represent men in their role as *homo faber*, represented in the act of possessing, learning, controlling, and manipulating the camera and its accessory instruments. It is not for nothing, after all, that the word "tool" can be used as a synonym for the penis. The camera and its mysteries of lighting, exposure, composition, and special effects are thus the purview of knowledge and power, while women (and children) are generally consigned to what Judith Williamson has described as a kind of nature preserve of sexuality, domesticity, leisure, or indeed "nature" itself.

That these social constructions are underwritten by male fanstasies of mastery and

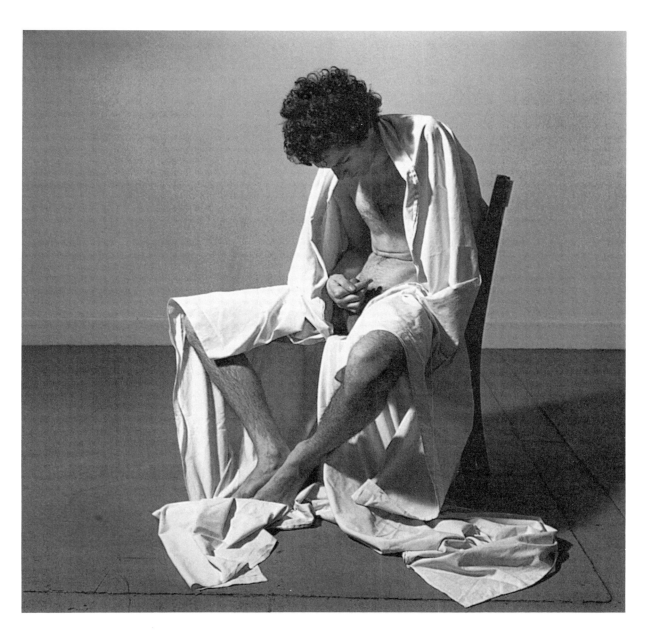

PETER HUJAR, *SEATED NUDE,* **n.d., COURTESY OF THE**

PETER HUJAR ESTATE.

possession is made quite clear in Neumaier's work. One of her particularly funny devices consists of juxtaposing her found images of women with found images of men or photographic apparatuses which bear more or less obvious phallic connotations, thereby revealing the power relations inscribed in the male/photographer and female/model polarity.

That those photographs most emphatically declaring their status as "art" are frequently those in which the woman is nude, supine, fragmented, or otherwise "worked over" (one especially grotesque example depicts a nude torso caged by lines incised in the negative with an x-acto knife) is significant. For while "art" photographs in hobby magazines are obviously not of the same aesthetic or intellectual caliber as those, say, produced by the surrealists, *Teach Yourself Photography* nonetheless prompts reflection on certain of the relations between the two.

Neumaier's epigraph for the work—"She no longer wondered how she fit the picture"—is suggestive of the problem of women and photography both from the perspective of their historic exclusion from the medium and from the perspective of an analysis of the nature of dominant representations of the feminine. Neumaier's approach—consistent with the goals of critical practice in general—is to point out how ideology functions to naturalize the cultural. For example, Neumaier includes in the piece a blow-up of a film exposure diagram (the kind that comes inside every roll of film) which em-

DIANE NEUMAIER, FROM *TEACH YOURSELF PHOTOGRAPHY: 50 YEARS OF*

HOBBY MANUALS 1935-1985, **1987. COURTESY OF THE ARTIST.**

SEXUAL DIFFERENCE

ploys a stick figure schematization illustrating that once again, the man holds the camera and the woman holds the pose. Because we normally don't even perceive the myriad ways that photography is gendered, *Teach Yourself Photography* functions to elicit recognition of social facts that are at once completely visible and consequently—like the purloined letter—completely hidden.

The register on which Neumaier's work makes its critical intervention is that of the comic. An exhibition curated several years ago by Jo Anna Isaak and wonderfully titled "The Revolutionary Power of Women's Laughter" made clear (as did Marlene Gorris's film *A Question of Silence*) that laughter is an effective and potentially transgressive element in the critical arsenal of feminism. In addition to Neumaier, Sherry Milner and Jo Spence are feminist artists whose *modus operandi* is a sharp and intelligent wit that elucidates even as it mocks.

Milner is better known as a video-maker, a proponent of what she calls "cheap media." In the exhibition, she is represented by photomontage works which simultaneously undo and redo the meanings of mass-media imagery. But where a photomontage artist such as John Heartfield used the specific attributes of the technique to unmask the grim political realities hidden or mystified by surface appearance, Milner is concerned to expose elements of the patriarchal unconscious of contemporary capitalism. That within this system woman is both consumer and consumed (*Breakfast of Champions*), that the "objective" gaze of medical science manifests sinister homologies with other gazes (the gaze of surveillance, the gaze of voyeuristic domination)—these are some of Milner's central themes. But the overarching emphasis, as befitting the mass-media imagery which is both her subject and her raw material, is the status of woman as spectacle, whether in the service of selling breakfast cereal or as an all-purpose signifier of the sexual *tout court*. Like Neumaier, Milner is concerned to reveal the latent meanings in mass-media representation that turn on the eroticization of the commodity and the commodification of woman.

In Jo Spence and Terry Dennett's *Remodelling Photo History*, the object of critique is an officially sanctioned notion of discrete photographic genres (e.g., the art photograph, the ethnographic document, the crime photo, etc.). Deftly "remodelled" through the device of restaging them and labeling them, these various genres are made to yield new meanings, an operation that links them to the technique of photomontage. In the thirteen image/texts that comprise the work, Spence is herself the model (Dennett also appears in one sequence). In one of the photographs, for example, Spence has posed herself, nude, in an unmistakable parody of the pose taken by Eleanor, in one of Harry Callahan's most famous images of his wife. Only where Eleanor is depicted in a profusion of lush and jungle-like vegetation—again the trope of the woman as/in nature—Spence has posed herself in an altogether banal and pointedly cultivated field and trenchantly labeled the image "Industrialization." This in turn is paired with another nude image of Spence, in an industrial *terrain vague*, also occupied by electric pylons. By means of such interventions (one of the collectives Spence worked with—the Polysnappers—termed their work "di-

269

dactic montage"), mythic configurations of the feminine are made ridiculous, hence untenable. More important, different correspondences, connections, relations are obliquely proposed: exploitation of land, exploitation of women, domination and capitalization of the environment, women as infinitely exploitable resource, and so forth. Finally, Spence's literal inscription of herself into the photographs suggests that she, as an individual, is subject to the same historical forces, determinations, and sexual and social relations that her photographs attempt to symbolize. This political symbolism is one which is generated from the particular and employs the image of the woman as a paradigm of all other forms of domination, a model to which Marx and Engels themselves subscribed. Thus, the two photographs captioned *Victimization* use the genre of the police scene-of-the-crime photograph (Spence sprawled out nude, under the wheels of a car, next to a sign warning trespassers off private property) with a close-up photograph of Spence's hands doing laundry in a bowl, to set up an infinitely expanding network of meanings that encompasses both domestic and property relations.

The work of Sarah Charlesworth, Richard Prince, and Cindy Sherman, in contrast to that of the first group of artists, is usually situated within that range of contemporary production designated as postmodernist. As such, it evidences a shared preoccupation with the look of mass media, and a deliberate appropriation of that look ranging from strategies of direct confiscation (Prince) to elaborate reconstruction (Sherman). Of the three artists, Sherman is the one whose work is most germane—indeed central—to a feminist project. Nonetheless, insofar as Charlesworth and Prince base much of their work on an interrogation of the means by which the media—above all, advertising—induce spectatorial desire, it inevitably devolves on totemic icons of the masculine and feminine. In Charlesworth's *Images of Desire* series, of which *Satin Gown*, *Red Mask*, and *Black Mask*, are included in the exhibition, fetish-like signifiers of masculinity and femininity are distilled to their smallest signifying units—what Roland Barthes called *lexies*. This is done by cropping, masking, rephotographing, and isolating on a highly keyed or black color field such fragments as a chiffon scarf, a geisha's face, a tee-shirted male torso with an erection, or in this instance—a skin-tight satin evening dress. The glossy, hyped-up presentation serves to accentuate the aggressive eroticism of these cultural signs while insisting, precisely, on their status as signs.

Richard Prince's *Women* can similarly be understood as functioning to denaturalize a heavily freighted cultural sign. A rigorously programmatic and uncompromising appropriator, Prince has here combined three uncannily similar images of fashion models' heads. While direct appropriation in and of itself serves to put quotation marks around the image, asserting both its textuality and its conventionality, the device of serial repetition—a Warholian legacy—further dismantles the integrity or authenticity of the image. The relevance of this tactic has to do with the fact that most mass-media imagery—advertising, fashion, entertainment, etc.—is purveyed by photography. Thus, photographic technologies imply a truth of the ideological that is an extension of photography's

270

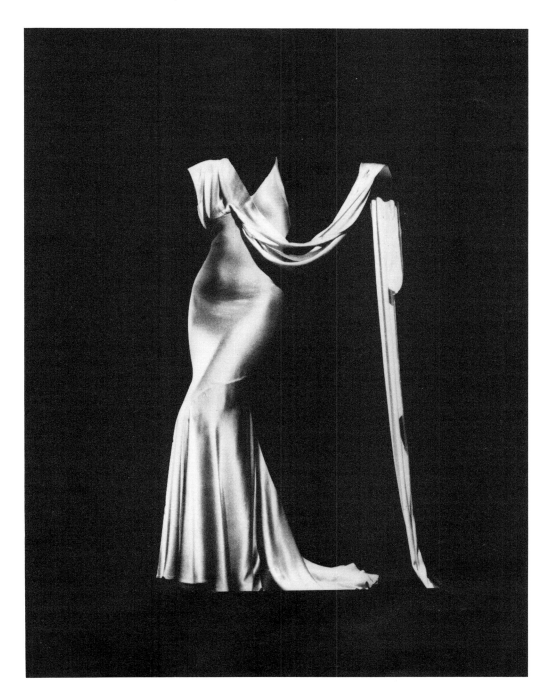

SARAH CHARLESWORTH, *FIGURE*, 1983, GELATIN-SILVER PRINT, 11 × 8 5/16 IN.

COURTESY OF THE ARTIST.

own reality effect. Consequently, the photographic construction of ideal images of masculinity and femininity is especially compelling and persuasive. Prince, moreover, has a particularly well developed instinct for perceiving sameness in difference. And insofar as commodity culture is predicated on the ability to manufacture specious differences, one of Prince's most interesting moves is to isolate these instances of difference in the same. This is particularly clear in his works dealing with male and female models where, notwithstanding variations in hair color, costume and coiffure, what appears to be a heterogeneous array of perfection is, in fact, variations on a standard type.

In Sherman's endless tabulation of the category "woman," difference cuts in and across the work in a number of ways. While her format, *mise en scène*, and the nature of her implied narratives have constantly changed, Sherman has persevered in her practice of starring in those roles traditionally assigned to women, be they sexy ingenue, vulnerable victim, femme fatale, or wart-chinned witch. Always her and never her (for who could identify the real Sherman in the street?), Sherman's pictures undercut the notion of any fixed and stable feminine identity. For if such identities are a function of wardrobe and makeup, and if, further, they are given content and meaning by the viewer's capacity for projection and investiture, where and how is the "authentic" feminine identity to be located? Difference is here constellated along an axis of various feminine roles (revealed to be an empty category) and in terms of the cipher of femininity itself. Last, Sherman's pictures, particularly the ones that trade on the most stereotypical images of women—launch a certain challenge to the male spectator. For as Judith Williamson has argued, to the extent that one accepts the Sherman personae in the guise they are presented, the viewer is an accomplice in the construction of a femininity that has been already exposed as altogether fictitious. This suggests that Sherman's work is constructed to address male and female spectators in different ways.

In Richard Baim's work it is the cultural construction of masculinity that is the object of investigation. The four photographs in the exhibition are taken from a slide/audio work entitled *Rise and Fall* which combines a Wagnerian music track with a three-screen slide projection. Divided into three thematic parts, *Rise and Fall* moves from images of monumental classical ruins, to even more monumentally scaled fascist architecture, interspersed with nineteenth- and twentieth-century classicistic sculpture cropped in ways that make the male figures terrifying in their implied menace and aggressivity. These images subsequently give way to photographs of spectator sports (including blood sports such as bullfighting) to images of people—mostly boys and men—on the streets of various cities. Baim's piece functions metaphorically and allusively; connections that might be made between sequences, which focus on architecture, spectacle, everyday life, sports, fascism, patriarchy, and so forth, are free-floating, speculative, almost playful. Still, the camera's ability to freeze a random moment and gesture, as in the image of the two men chatting as they walk along the street, and Baim's directorial juxtaposition of a statue of a man with a mallet and sword (in reality, a pacifically intended subject: he is beating his sword into a

CINDY SHERMAN, UNTITLED FILM STILL, 1979, BLACK-AND-WHITE

PHOTOGRAPH, 10 × 8 IN. COURTESY METRO PICTURES.

ploughshare) enable the spectator—by recourse to a kind of visual prompting—to specu-late on the possible relations between symbolic representations of the masculine (and what they are used in the service of) and the comportment and gestures of men in everyday life. Baim, although in a manner somewhat different from Milner and Spence, can also be seen as employing principles of montage to elicit meanings that do not necessarily reside in individual images, but instead are produced through relations of contiguity, counterpoint, and juxtaposition.

Broadly speaking, the work of Milner, Spence, Charlesworth, and Sherman takes as its point of departure a pre-existing and ubiquitous image world that deploys pictures of masculinity and femininity which function to establish a culturally sanctioned and delim-ited range of sex-role models. To the degree that the viewing subject can recognize, iden-tify with, and project him- or herself into this image world, a particular construction of gender is effectively secured. Feminism, however, amply demonstrates that for all its power, ideology—sexual or otherwise—is never without its internal contradictions which allow for the various resistances and contestations that perpetually arise. Indeed, the very ability to recognize and postulate the operations of the ideological assumes a position at least somewhat outside it. The specular mechanics of photography bear more than a co-incidental resemblance to those of ideology (as Marx recognized, by famously likening it in its avatar of false consciousness to the workings of the camera obscura). In this regard, one of the most suggestive analogies between the two is the congruence of the camera's point of view with the spectator's, effectively determining that the viewer's place is in every sense given in advance. For feminists for whom the question of women's place, in all its ramifications, is the central problem, the photographic point of view may be con-sidered as a locus where issues of subject position, the interpellation of the subject, and subject/object relations all intersect.

Martha Rosler's floor piece *She Sees in Herself a New Woman Every Day* takes the cam-era's point of view as a device to compel the spectator to stand in the other's place. Shoot-ing down at her own feet, shod in an array of footwear, in a sequence of twelve photo-graphs, she solicits from the viewer an empathetic (re)placement, one facilitated by the work's placement on the floor. Like Sherman, Rosler recognizes that a woman's shift from high heels to workboots carries more than sartorial significance. The title of the work it-self articulates the provisional and protean nature of individual identity. And while the notion of a fixed, stable, and unified identity must be understood as equally mythological for male as well as female subjects, given the determinations of patriarchy and its dissim-ilar effects on male and female subjects, there is reason to suppose that the formation of feminine subjectivity is especially problematic. Psychoanalytically speaking, one of the reasons for this concerns the greater difficulty that the little girl experiences in separating and differentiating from the mother, in contrast to the little boy whose differentiation from the mother is aided by his physical difference. Furthermore, as theorists such as Nancy Chodorow have argued, the boy is subsequently enjoined to assert his masculinity

through his repudiation of the maternal body (and the feminine in general), while the girl is conditioned to identify with it.

The resulting contradictions and conflicts of maternal and filial identification and repudiation are one of the central themes in the audio tape that accompanies Rosler's pictures of her feet. Addressed to "You" (the mother), Rosler's tape effects another displacement/replacement, this time on the level of audition, since the listener is obliged to adopt the position of the castigated mother. While the photographs on the floor are innocuous and matter-of-fact, the tape is a painful and accusative litany of maternal insensitivity and abuse. Shoes figure within the tape in various ways: the mother's old dancing shoes sequestered in a storage closet; a pair of mary-janes that deformed the narrator's feet; the too-large rubber boots purchased to be grown into; the narrator's adult high-heels that "pressed on a nerve" and compelled her to walk home in her stockinged feet. In their cumulative effect, this chronicle of shoes discarded, worn, or suffered becomes an emblem of feminine mis-fitting. Even the recounting of the Cinderella story, which ends the tape, concludes not with the gratification of the fitting of the magic slipper on Cinderella's foot, but with the mutilation of the feet of Cinderella's half-sisters.

In Connie Hatch's open-ended project *The De-Sublimation of Romance*, the politics of looking in relation to sexual difference is the foundation of the work. Its power and effectiveness derive in part from its grim and unflinching exposition of the way the exchange of looks (or refusal of looks) between men and women, the photographer's look, and the look of the spectator, all participate in a complex grid of power relations. In *De-Sublimation*, Hatch has adapted what is surely one of the most voyeuristic and appropriative modes of photography—the so-called snapshot aesthetic—and subjected it to a dissection that hinges on an acknowledgment of the photographer's complicity, the viewer's voyeurism, and the mini-psychodramas captured on the street as events with which we are ethically obliged to reckon rather than merely consume. Thus, in marked contrast to the typical street photographer's aesthetic alibi or ingenuous disavowal, Hatch insists on the photographer's—her own—problematic agency.

Presented in paired sets, Hatch's *De-Sublimation* pictures register the myriad forms by which sexual domination in everyday life is effected by a look, a gesture. Moreover, in foregrounding her own possession of the camera (in a number of the pictures she is present either in the incorporation of her own cast shadow or her presence is signaled by the protagonist's gaze at the camera) we are made uncomfortably aware of the terms of our own voyeuristic participation in the *speculum mundi* photography provides.

Hatch's work is exceptional insofar as it attempts to critically confront the appropriative and objectifying properties of photography on a structural level, as well as on the level of manifest content or in terms of its own internal norms and aesthetic discourses. While the history of the medium offers numerous examples of photographers who have played with the camera's capacity to "bare the device" (a range that would include practitioners from Rodchenko to Friedlander, as well as vernacular and anonymous photographers), it

is a specifically feminist approach to take the camera's fixing of subject/object positions as a problem, rather than as a given. For women, whose position in the economy of looking conventionally resides with the surveyed rather than with the surveyors, the use of the camera to "expose" and capture the social and sexual transactions of others is particularly charged. Rather than attempt to resolve such a contradiction (which, given this particular photographic form, is probably impossible), Hatch instead elects to make it the heart of her work.

The gaze at the woman, or the gaze of the woman, is also of central concern in the work of Dorit Cypis. Cypis's work, however, is somewhat singular in this exhibition because it is ultimately grounded in what I might term a utopianism of the body; in other words, the conviction that there is a reality, a corporeal integrity, that remains at least somewhat outside representation and culture. The actual human body is thus posited as a site of resistance to the social and cultural discursive grids that are imposed upon it. Put somewhat differently, Cypis would appear to be locating the body less in the register of the symbolic order than in the elusive and unknowable register of the real. Hence, however densely coded, however much "written upon," the body is imagined to escape—at least to some extent—the cultural determinations that make it signify.

Consequently, much of Cypis's installation work has been fabricated to incorporate the actual bodies of spectators, whose movements within the site physically alter the images which are simultaneously projected. In other instances, she has used living models whose ritualistic performances are counterpointed with a phantasmatic and ghostly play of her slide projections. In most of her recent work, Cypis employs projected slides or still images that have been composed of overlays, image laid down upon image in such a way that the resulting picture forms a kind of palimpsest in which it becomes impossible to distinguish background from foreground. This interpenetration of images, rather than functioning as a purely formal device contrived to complicate the viewer's perception of the visual field, seems intended to suggest an equivalency between manifest and latent meanings. Further, the notion of the palimpsest might well be considered as Cypis's central metaphor for the body; subject to numerous inscriptions, a palimpsest nonetheless possesses an irreducible ground, a material substrate that escapes a total dissolution into writing.

The photographs by Cypis exhibited in *Sexual Difference* display certain aspects of these formal procedures and thematic preoccupations. A work such as *Centipede*, for example, juxtaposes a photograph of a nude woman with an opened dictionary resting on her pelvis, over her sex. This is combined with another image, a fragment of a Greek vase depicting two men in what appears to be anal intercourse. On the one hand, the co-presence of an image of men performing a sexual act with a photograph of a nude woman could imply, as in the case of Woodman's work, that the image of the woman as object of desire is determined by the structure of male desire. Also, like Woodman, the inclusion of the dictionary on the body affirms the textuality of the represented body, locating it

DORIT CYPIS, *CENTIPEDE*, 1985, WOOD, VACU-FORM PLASTIC, CIBACHROME

COVERED WITH PLEXIGLASS, 30 × 50 × 4 IN. COURTESY OF THE ARTIST.

squarely within semiotic systems. But, on the other hand, and with respect to the overall thematics of Cypis's production, the decision to incorporate a portrayal of a sexual *act* may also be taken as an affirmation of the claims of the body—eruptive, anarchic, even unlawful.

In *Lucy and the Vampire* and in *Psyche and Eros*, Cypis plays with the mythic resonances attending the reversal of the role of the active looker. For as feminist film theorists have frequently demonstrated, and to which numerous fairy tales amply attest, the woman's assumption of the role of the subject of the gaze is a breach in the symbolic order, and this is both threatening and transgressive. In the latter work, a towel-draped model seen from the back (conscripted from a Badedas bath-solution ad) appears to gaze at a distant and relatively minuscule man. By reversing the original order of the ad, in which the man, occupying the left-hand part of the image, was the source of the look, Cypis has effected a radical change in meaning. Whereas the much greater relative size of the woman in the ad was "normalized" by her subject position as object of the male gaze, the reversal makes her monstrous, huge, unnatural. (Here I would note in passing that advertisements and

other mass-media imagery rarely employ scalar or perspectival proportions that permit the woman to dwarf the man.) In *Lucy and the Vampire*, the frightening head of Nosferatu appears to look at both us and the woman, at whom we also look. But her look, at something neither the viewer nor Nosferatu can see, and her self-possessed and half-smiling expression, convey an existence apart from the gazes on both sides of her. The "gothic" trappings of the image and its *mise en scène* allude to the fact that within this genre, Lucy is typically the hapless victim. In Cypis's revision, she triumphantly prevails.

It is entirely appropriate that Louise Lawler's installation should be the last work discussed because Lawler's work functions as a kind of last word within any exhibition framework. This attribute is built into the very structure of Lawler's work, which, apart from any of the other issues the work may engage, is always calibrated to encompass—in a quite literal sense of the word—the larger "framing" institutions in which the art is presented and given significance. The various contexts of the art objects are thus understood to be no less a determining element than the individual objects themselves. Lawler could fairly be described as the quintessentially Derridean artist, addressing herself to the margins, to what lies outside the mythic autonomy of the artwork. Consequently, Lawler's subtle installations operate to upset or complicate conventional dichotomies of inside/ outside, original/copy, part/whole, supplement/esssential, and last, but not least, male/ female. Consistent with what we might term the ethics of deconstruction, Lawler's intent is not to substitute new truths for old, but to circulate and put into play questions that provoke an awareness of the institutional and discursive order of things.

Lawler's contribution to the exhibition immediately prompts questions about what the nature and parameters of a "work" actually are. Allocated a wall, she has had a square painted on it in a contrasting color upon which she has positioned four identical black-and-white photographs of two statues, which are placed to create a cross-like emblem formed by the two edges of each print. This ensemble, however, is clearly intended to relate to the large cibachrome print, also of two statues, and to the intervening photograph depicting an interior view of the Metropolitan Museum of Art. Further, while the large cibachrome bears a short text whose meanings extend to the other pictures—indeed, to the exhibition as a whole—the largest typeface is given over to a wall title that reads "Prominence Given/Authority Taken."

From whence the prominence and to whom the authority? Both the large cibachrome print and the multiplied black-and-white print depict full-figure female statues in the foreground and severe-looking portrait busts of men behind them. In *Sister/Brother*—the photograph in the suite of four—the female figure, a type rather than an individual, is sculpted in an attitude of extreme abjection, seeming to cower beneath the stern and intimidating gaze of the portrait bust. Similarly, the neo-classic female figure in *Eve and Patriarch*, seen in profile, casts her look downward, likewise under the eye of a somber patriarch. Printed on the photograph's mat, Lawler poses the following question: "Is it the location, the model, or the stereotype that is the institution?" Last, the photograph that spatially me-

LOUISE LAWLER, *STATUE BEFORE PAINTING, PERSEUS WITH THE HEAD OF MEDUSA*, 1982, BLACK-AND-WHITE PHOTOGRAPH, 7 1/2 × 7 1/2 IN. COURTESY OF THE ARTIST.

diates between *Brother/Sister* and *Eve and Patriarch* features a statue of Perseus (he who slayed Medusa by stealing her gaze and then decapitating her), cropped just above the genitals and incorporating the sword that he wields. Written on the mat is the allusive title *Statue before Painting, Perseus with the Head of Medusa, Canova.* Behind the statue is the Metropolitan's central stairway leading to the arched entranceway marked "Paintings," one of which can be seen—a Tiepolo, as it happens, depicting the subjugation of an African queen by a Roman hero. As Rosalyn Deutsche has pointed out, both the title and the museum architecture Lawler has pictured not only implicate the current heroization of painting, but conjure a shade of another hierarchization—statue before painting, as in ladies before gentlemen.

Prominence and authority in this multivalent work are thus fully dispersed over and through a range of physical and discursive sites. Prominence, which has a spatial as well as a hierarchically designative sense, is meted out by the artist who gives prominence in her work to representations of feminine abjection. In controlling the photographic crop— what the viewer will see—she also gives prominence to the patriarchal values enshrined in the predominantly all-male preserve of the art museum. Finally, in giving prominence to Perseus's sex organ and sword, guardian of a painting collection that in many respects incarnates the masterful gaze of the male subject, Lawler gives prominence to the hidden liens between phallus, fetish, and painting (Freud, of course, used the Perseus and Medusa myth to theorize fetishism and its relation to the look).

But prominence given is by no means exclusively the purview of the artist and her choices. For prominence is given to *her* by me, the curator, who requested the work, and by C.E.P.A., the institution which exhibits it, by the art world audience which assesses it, and so forth. Similarly, the patriarchal authority figured in the photographs is by no means confined there. In the same way that it is necessary to distinguish between patriarchy—as system, as structure, as institution—and male human beings, so too must the multiform and infinitely dispersed forms of authority be acknowledged, up to and including its manifestations—although frequently not even recognized as such—in one's own activities.

If in curating an exhibition of this kind I have given prominence to a range of work, most of it explicitly feminist, it may be, as Lawler suggests, an inevitable consequence of the enterprise that authority is somehow taken. But as much of the exhibited work implies, the imbalanced world of sexual difference is not to be rectified by simple reversals. Or, as Audre Lorde has stated, "The master's tools will never dismantle the master's house." To the extent that photography has been a particularly effective master's tool, it is incumbent upon feminist art practice to try to use it in different—critical—ways. As a feminist and a critic, wearing, in this instance, a curatorial hat, I would less wish to assert a dubious authority than to affirm a collective solidarity with the project of claiming the camera for more humanly satisfying ends.

1987

NOTES

Notes

· ·

Foreword

1. This division between consideration of the photograph as pure document or as pure aesthetic object has some relationship to the antithesis established by W. J. T. Mitchell in "The Ethics of Form in the Photographic Essay" (*Afterimage*, January 1989, 8), although it is by no means identical. Says Mitchell: "The relationship of photography and language admits of two basic descriptions, fundamentally antithetical. The first stresses photography's difference from language, characterizing it as a 'message without a code,' a purely objective transcript of visual reality. The second turns photography into a language, or stresses its absorption by language in actual usage." Mitchell is, of course, considering the photo essay as a specific instance of the complex relationship between words and photographs, rather than photographic history and criticism.

Introduction

1. How else to account for the scarcity of books examining the epistemological, cultural, sociological, or psychological implications and impact of photography? Susan Sontag's now-classic *On Photography*, to my knowledge the first book-length consideration in English on photography as such, was not published until 1977. In the Editor's Introduction to a special issue of the journal *October*, published in 1978 and consecrated to photography, the editors, with no little irony, wrote: "Only now, we are instructed, is Photography truly 'discovered,' and now it is that we must set to work, establishing an archeology, uncovering a tradition, constituting an aesthetic. It is to be redeemed by the scholarship and speculation of our time, from the cultural limbo to which for a century it has been consigned." Giselle Freund's *Photography and Society* was not translated into English and published until 1982. And Pierre Bourdieu's *Un Art moyen*, which has never been translated into English, appeared in 1965. See Susan Sontag, *On Photography* (New York: Farrar, Straus and Giroux, 1977); Editor's Introduction, "Photography: A Special Issue," *October 5* (Summer 1978), 3; Giselle Freund, *Photography and Society* (Boston: David R. Godine, 1980); Pierre Bourdieu, *Un Art moyen* (Paris: Les Editions de Minuit, 1965). I include here only book-length discussions which appeared before 1980; the essays of Walter Benjamin and Roland Barthes on photography are cited throughout the text.

2. However, there is an important theorization of the autonomy of art which comes from the Left; namely, the aesthetic theory associated with the Frankfurt School and perhaps most closely identified with Theodor Adorno: "What is social about art is its intrinsic movement against society, not in its manifest statement. . . . Insofar as a social function can be ascribed to art, it is its functionlessness." Cited in Peter Bürger, *Theory of the Avant-Garde* (Minneapolis: University of Minnesota Press, 1984), 10. Nevertheless, the ways in which the autonomy of art was theorized by the Frankfurt School have little in common with the aesthetic theories of Anglo-American formalism and modernism, rooted as the former is in Marxist thought, and hinging on concepts of critique and negation. See in this regard Susan Buck-Morss, *The Origin of Negative Dialectics: Theodor W. Adorno,*

Walter Benjamin and the Frankfurt Institute (New York: The Free Press, 1977), and Martin Jay, *The Dialectical Imagination: A History of the Frankfurt School and the Institute of Social Research 1923–1950* (Boston: Little, Brown and Co., 1973). See also the related debates collected in the anthology *Aesthetics and Politics*, Ernst Bloch *et al.* (London: New Left Books, 1977).

3. A recent, and by no means exhaustive sampling of books on cultural production premised on these methodologies might include: Pierre Machery, *A Theory of Literary Production* (London: Routledge & Kegan Paul, 1978); Terry Eagleton, *Literary Theory* (Minneapolis: The University of Minnesota Press, 1983); Janet Wolff, *The Social Production of Art* (New York: New York University Press, 1984); Jane Tompkins, *Sensational Designs: The Cultural Work of American Fiction* (New York: Oxford University Press, 1985); Jonathan Culler, *On Deconstruction: Theory and Criticism after Structuralism* (Ithaca: Cornell University Press, 1982); Judith Newton and Deborah Rosenfelt, eds., *Feminist Criticism and Social Change: Sex, Class and Race in Literature and Culture* (New York and London: Methuen, 1985); Gayle Greene and Coppelia Kahn, *Making a Difference: Feminist Literary Theory* (New York and London: Methuen, 1985); Hester Eisenstein and Alice Jardine, eds., *The Future of Difference* (New Brunswick, NJ: Rutgers University Press, 1985); Elaine Showalter, ed., *The New Feminist Criticism: Essays on Women, Literature, Theory* (New York: Pantheon, 1985).

4. A number of Allan Sekula's essays have developed the various ramifications of these divisions, with particular emphasis on the uses of photography in the service of surveillance, social control, eugenics, and so forth. See Allan Sekula, "The Body in the Archive," *October 39* (Winter 1986), 3–64. See also John Tagg, *The Burden of Representation: Essays on Photographies and Histories* (Amherst: The University of Massachusetts Press, 1988).

5. See Bruce Kaiper, "The Cyclograph and Work Motion Model," in *Still Photography: The Problematic Model*, eds. Lew Thomas and Peter D'Agostino (San Francisco: NFS Press, 1981), 57–63.

6. In this respect, photographic discourse is the mirror image of mainstream art history. See Griselda Pollock, "Artists, Mythologies, and Media . . . Genius and Art History," *Screen*, vol. 21, no. 3 (1980), 57–96. [See also her essay "Vision, Voice, and Power: Feminist Art History and Marxism," in Pollock, *Vision and Difference* (London: Routledge, 1988).]

7. Insofar as I am concerned with the contingency of historical discourse, it is worth noting that Rodchenko, who was totally absent from the previous four editions of Beaumont Newhall's *History of Photography*, graces the cover of the fifth edition. I would argue, however, that when Rodchenko again becomes available for study and delectation (his importance was acknowledged by Alfred H. Barr and the Museum of Modern Art in the 1930s) it is through the conduit of contemporary formalist photographers such as Lee Friedlander.

8. In retrospect, this would seem to have been pre-eminently the accomplishment of feminist practices, in all media, from the late 1960s on. See in this regard, RoseLee Goldberg, *Performance Art from Futurism to the Present* (London: Thames and Hudson, 1988); Lucy Lippard, *From the Center* (New York: Dutton, 1976); Mary Kelly, *Post-Partum Document* (London: Routledge & Kegan Paul, 1983); [Rozsika Parker and Griselda Pollock, *Framing Feminism* (London: Pandora Books, 1988).]

9. See Victor Burgin, "Photography, Phantasy, Function," in Burgin, ed., *Thinking Photography* (London: Macmillan, 1983), 177–216.

10. Emblematic of this dubious genre is the recent work by the art photographer Rosalind Solomon, published as *Portraits in the Time of AIDS* (New York: Grey Art Gallery and Study Center, New York University, 1988). Her brief prefatory statement is revelatory of the ingenuous parasitism of "victim photography": "When I began AIDS portraits in May 1987, I conceived this new subject as a continuation of the hospital portraits I made in 1976 in Chattanooga, Tennessee. The project also connected with some of my more recent work: the nursing home portraits of Peru and Mexico: the homeless portraits of San Diego and New York," n.p. A similar itinerary has been followed by the art photographer Nicholas Nixon, who has progressed from view camera pictures of the New

Notes

· ·

Foreword

1. This division between consideration of the photograph as pure document or as pure aesthetic object has some relationship to the antithesis established by W. J. T. Mitchell in "The Ethics of Form in the Photographic Essay" (*Afterimage*, January 1989, 8), although it is by no means identical. Says Mitchell: "The relationship of photography and language admits of two basic descriptions, fundamentally antithetical. The first stresses photography's difference from language, characterizing it as a 'message without a code,' a purely objective transcript of visual reality. The second turns photography into a language, or stresses its absorption by language in actual usage." Mitchell is, of course, considering the photo essay as a specific instance of the complex relationship between words and photographs, rather than photographic history and criticism.

Introduction

1. How else to account for the scarcity of books examining the epistemological, cultural, sociological, or psychological implications and impact of photography? Susan Sontag's now-classic *On Photography*, to my knowledge the first book-length consideration in English on photography as such, was not published until 1977. In the Editor's Introduction to a special issue of the journal *October*, published in 1978 and consecrated to photography, the editors, with no little irony, wrote: "Only now, we are instructed, is Photography truly 'discovered,' and now it is that we must set to work, establishing an archeology, uncovering a tradition, constituting an aesthetic. It is to be redeemed by the scholarship and speculation of our time, from the cultural limbo to which for a century it has been consigned." Giselle Freund's *Photography and Society* was not translated into English and published until 1982. And Pierre Bourdieu's *Un Art moyen*, which has never been translated into English, appeared in 1965. See Susan Sontag, *On Photography* (New York: Farrar, Straus and Giroux, 1977); Editor's Introduction, "Photography: A Special Issue," *October 5* (Summer 1978), 3; Giselle Freund, *Photography and Society* (Boston: David R. Godine, 1980); Pierre Bourdieu, *Un Art moyen* (Paris: Les Editions de Minuit, 1965). I include here only book-length discussions which appeared before 1980; the essays of Walter Benjamin and Roland Barthes on photography are cited throughout the text.

2. However, there is an important theorization of the autonomy of art which comes from the Left; namely, the aesthetic theory associated with the Frankfurt School and perhaps most closely identified with Theodor Adorno: "What is social about art is its intrinsic movement against society, not in its manifest statement. . . . Insofar as a social function can be ascribed to art, it is its functionlessness." Cited in Peter Bürger, *Theory of the Avant-Garde* (Minneapolis: University of Minnesota Press, 1984), 10. Nevertheless, the ways in which the autonomy of art was theorized by the Frankfurt School have little in common with the aesthetic theories of Anglo-American formalism and modernism, rooted as the former is in Marxist thought, and hinging on concepts of critique and negation. See in this regard Susan Buck-Morss, *The Origin of Negative Dialectics: Theodor W. Adorno,*

Walter Benjamin and the Frankfurt Institute (New York: The Free Press, 1977), and Martin Jay, *The Dialectical Imagination: A History of the Frankfurt School and the Institute of Social Research 1923–1950* (Boston: Little, Brown and Co., 1973). See also the related debates collected in the anthology *Aesthetics and Politics*, Ernst Bloch *et al.* (London: New Left Books, 1977).

3. A recent, and by no means exhaustive sampling of books on cultural production premised on these methodologies might include: Pierre Machery, *A Theory of Literary Production* (London: Routledge & Kegan Paul, 1978); Terry Eagleton, *Literary Theory* (Minneapolis: The University of Minnesota Press, 1983); Janet Wolff, *The Social Production of Art* (New York: New York University Press, 1984); Jane Tompkins, *Sensational Designs: The Cultural Work of American Fiction* (New York: Oxford University Press, 1985); Jonathan Culler, *On Deconstruction: Theory and Criticism after Structuralism* (Ithaca: Cornell University Press, 1982); Judith Newton and Deborah Rosenfelt, eds., *Feminist Criticism and Social Change: Sex, Class and Race in Literature and Culture* (New York and London: Methuen, 1985); Gayle Greene and Coppelia Kahn, *Making a Difference: Feminist Literary Theory* (New York and London: Methuen, 1985); Hester Eisenstein and Alice Jardine, eds., *The Future of Difference* (New Brunswick, NJ: Rutgers University Press, 1985); Elaine Showalter, ed., *The New Feminist Criticism: Essays on Women, Literature, Theory* (New York: Pantheon, 1985).

4. A number of Allan Sekula's essays have developed the various ramifications of these divisions, with particular emphasis on the uses of photography in the service of surveillance, social control, eugenics, and so forth. See Allan Sekula, "The Body in the Archive," *October 39* (Winter 1986), 3–64. See also John Tagg, *The Burden of Representation: Essays on Photographies and Histories* (Amherst: The University of Massachusetts Press, 1988).

5. See Bruce Kaiper, "The Cyclograph and Work Motion Model," in *Still Photography: The Problematic Model*, eds. Lew Thomas and Peter D'Agostino (San Francisco: NFS Press, 1981), 57–63.

6. In this respect, photographic discourse is the mirror image of mainstream art history. See Griselda Pollock, "Artists, Mythologies, and Media . . . Genius and Art History," *Screen*, vol. 21, no. 3 (1980), 57–96. [See also her essay "Vision, Voice, and Power: Feminist Art History and Marxism," in Pollock, *Vision and Difference* (London: Routledge, 1988).]

7. Insofar as I am concerned with the contingency of historical discourse, it is worth noting that Rodchenko, who was totally absent from the previous four editions of Beaumont Newhall's *History of Photography*, graces the cover of the fifth edition. I would argue, however, that when Rodchenko again becomes available for study and delectation (his importance was acknowledged by Alfred H. Barr and the Museum of Modern Art in the 1930s) it is through the conduit of contemporary formalist photographers such as Lee Friedlander.

8. In retrospect, this would seem to have been pre-eminently the accomplishment of feminist practices, in all media, from the late 1960s on. See in this regard, RoseLee Goldberg, *Performance Art from Futurism to the Present* (London: Thames and Hudson, 1988); Lucy Lippard, *From the Center* (New York: Dutton, 1976); Mary Kelly, *Post-Partum Document* (London: Routledge & Kegan Paul, 1983); [Rozsika Parker and Griselda Pollock, *Framing Feminism* (London: Pandora Books, 1988).]

9. See Victor Burgin, "Photography, Phantasy, Function," in Burgin, ed., *Thinking Photography* (London: Macmillan, 1983), 177–216.

10. Emblematic of this dubious genre is the recent work by the art photographer Rosalind Solomon, published as *Portraits in the Time of AIDS* (New York: Grey Art Gallery and Study Center, New York University, 1988). Her brief prefatory statement is revelatory of the ingenuous parasitism of "victim photography": "When I began AIDS portraits in May 1987, I conceived this new subject as a continuation of the hospital portraits I made in 1976 in Chattanooga, Tennessee. The project also connected with some of my more recent work: the nursing home portraits of Peru and Mexico: the homeless portraits of San Diego and New York," n.p. A similar itinerary has been followed by the art photographer Nicholas Nixon, who has progressed from view camera pictures of the New

England and Appalachian poor, to the terminally ill patients in a hospice, and now (predictably) to people with AIDS. See Peter Galassi and Nicholas Nixon, *Photographs 1977–1988* (New York and Boston: The Museum of Modern Art and the New York Graphic Society, 1988).

11. Teresa de Lauretis, *Feminist Studies/Critical Studies* (Indianapolis: Indiana University Press, 1987), 10.

12. Hilton Kramer, "A Ghastly Exhibition at Columbia," *The New York Observer* (April 23, 1987), 1. The review is of my exhibition "Sexual Difference: Both Sides of the Camera."

13. The classic essay on this venerable *topos* within patriarchal culture is Natalie Zemon Davis's "Women on Top" in her *Society and Culture in Early Modern France* (Stanford: Stanford University Press, 1965).

14. See in this regard Elizabeth Cowie, "Women as Sign," in *M/F*, no. 1 (1978), 49–63.

15. One strand within feminist theory is, in fact, specifically concerned to postulate the links between specularity, the privileging of vision, and patriarchy. See Luce Irigaray, *The Sex Which Is Not One*, trans. Catherine Porter (Ithaca: Cornell University Press, 1985), and *Speculum of the Other Woman*, trans. Catherine Porter (Ithaca: Cornell University Press, 1985). There is, as well, sophisticated and persuasive argument for a form of feminist iconoclasm in the visual arts exemplified by Mary Kelly's work.

16. Guy Debord, *The Society of the Spectacle* (Detroit: Black & Red, 1983), 34.

17. It is in this sense that the epistemological and utopian aspirations of feminist criticism may be seen to converge. For this insight and many others, I am indebted to Tania Modleski's unpublished conference paper, "Some Functions of Feminist Criticism: On the Scandal of the Mute Body."

Calotypomania

1. For these observations on the ethics of art history, I am indebted to Linda Nochlin.

2. Erwin Panofsky sketches the evolution of art history from Winckelmann's *Geschichte der Kunst des Altertums* of 1764 (the first book to use the term "history of art") through the 1950s in an essay entitled "Art History in the U.S." However, Panofsky considers art history to have come of age in America in the decade 1923–33. See Erwin Panofsky, *Meaning in the Visual Arts* (New York: Anchor Books, 1955).

3. A general sampling would include the following and is by no means an exhaustive list: Martha Rosler, "Lookers, Buyers, Dealers, and Makers: Thoughts on Audience," *Exposure*, vol. 17, no. 1 (1979), 10–25; Douglas Crimp, "The Museum's Old, the Library's New Subject," *Parachute 22* (Spring 1981), 8–12; Allan Sekula, "The Traffic in Photographs," *Art Journal*, vol. 41, no. 1 (Spring 1981), 15–25, and "On the Invention of Photographic Meaning," *Artforum*, vol. 8, no. 5 (January 1975), 37–45 [both essays reprinted in Sekula, *Photography Against the Grain: Essays and Works* (Halifax: The Nova Scotia College of Art and Design, 1985)]; Michael Starenko, "Photography and Other Art Historical Lacunae," *Afterimage*, vol. 9, no. 7 (February 1982), 6–7; Rosalind Krauss, "Photography's Discursive Spaces: Landscape/View," *Art Journal*, vol. 42, no. 4 (Winter 1983), 311–19 [Reprinted in Krauss, *The Originality of the Avant-Garde* (Cambridge: MIT Press, 1985)]; my own "Tunnel Vision," *The Print Collector's Newsletter*, vol. 12, no. 6 (January/February 1982), 173–75, and "A Photographer in Jerusalem: Auguste Salzmann and His Time," *October 18* (Fall 1981), 91–107, reprinted in this volume.

4. See, for example, *Art Journal*, vol. 42, no. 4 (Winter 1983), a special issue devoted to "the crisis in the discipline."

5. See Douglas Crimp's analysis of this development in "The Museum's Old, the Library's New Subject."

6. By Gernsheim, at any rate: "I was pleased to be acclaimed as the Berenson of photography." This is from a fascinating interview with Gernsheim in *Dialogue with Photography*, ed. Paul Hill and Thomas Cooper (New York: Farrar, Straus, and Giroux, 1979), 196. Very interesting too is the following passage (p. 181) from the same interview: "Once bitten by the collector's bug, you can't leave off. Having been an inveterate collector in other art fields, I applied the same criteria to photography. I only bought what appealed to me, yet with the connoisseur's eye for quality. There were no books to guide me and no public collections. [Was Gernsheim really ignorant of the existence of the Victoria and Albert Museum, the Bibliothèque Nationale, The Société Française, the Royal Photographic Society, Nadar's memoirs, etc.?] I had to pioneer the field myself. . . . While knowledge and money may be acquired, discernment and taste are gifts which some people have and others lack. All four are prerequisites of a good collection." Compare this with André Jammes's essay "On Collecting Photographs," in *The First Century of Photography: Niépce to Atget, From the Collection of André Jammes* (Chicago: The Art Institute of Chicago, 1977), 10. "Twenty-five years ago it was impossible to study the history of photography without putting together the basic materials oneself. Thus, thousands of documents of uneven aesthetic value were necessary in order to establish the framework in which the master had evolved."

7. See Marta Braun, "A History of the History of Photography," *Photo Communiqué* (Winter 1980/81), 12–14, and Christopher Phillips's indispensable "The Judgement Seat of Photography," *October 22* (Fall 1982), 27–63.

8. This notion of a "golden age" in early photography exemplified by the work of the French calotypists is central to Jammes's writing and collecting. It also figures in Nadar's memoir, *Quand j'étais photographe*, written in the 1890s. Eugenia Parry Janis embraces it unquestioningly: "This study deals with the allure of the paper negative. We have investigated mid-nineteenth-century French paper negative photography as other historians might examine early nineteenth-century English watercolor or late fifteenth-century German engraving, that is—in order to gain an understanding of an art in its Golden Age." André Jammes and Eugenia Parry Janis, *The Art of French Calotype* (Princeton: Princeton University Press, 1983), xiii.

9. *La Photographie, des origines au début de xxième siècle*, sale catalog (Geneva: Nicholas Rauch, 1961). Insofar as no source is given for the photography offered in this auction, Christopher Phillips has suggested that it may in fact have been from Jammes's own collection.

10. This appears to be a tradition carried through to the next generation. Jammes's daughter Isabelle received the first (to my knowledge) *doctorat* in France for work in the history of photography, having produced a catalog raisonné entitled *Blanquart-Evrard et les origines de l'édition photographique Française* (Geneva: Librairie Droz, 1981). She currently directs the Fondation Lartigue housed within the Musée d'Orsay.

11. For example, the photographic collection of the Canadian Center for Architecture, itself the brainchild of Seagram heiress Phyllis Lambert, is barely nine years old and consists of more than 25,000 "masterworks" of photography, the majority from the nineteenth century. The Gilman Paper Corporation's collection, also rather new, boasts another princely holding, albeit much smaller. One of the consequences of the photography boom is that museums and libraries are rarely in a position to compete against corporate or private collections. Additionally, bound volumes and folios of hand-tipped photographs are frequently dismembered by dealers, whether they operate out of booths in the *puces* of Paris or galleries on 57th St. This has been the fate of albums such as Braquehais's extraordinary one on the French Commune and the demolition of the Vendôme Column (dismembered by Daniel Wolf), Carleton Watkins's Columbia River album (sold as individual plates by the Weston Gallery), etc. The new prestige and value of nineteenth-century photographs is thus a two-sided phenomenon: preservation of individual images at the expense of discursive

wholes. Nonetheless, although collectors and dealers talk constantly about the extreme rarity of good nineteenth-century material, the large amounts of material compiled by Lambert and the CCA, The Gilman Corporation, as well as individual collectors such as Sam Wagstaff, Arnold Crane, and Jammes (not to mention what already exists in institutions such as the Bibliothèque Nationale, the Société Française de Photographie, the International Museum of Photography at the George Eastman House, etc.), make one wonder exactly what is meant by the concept *rare*. To put things in some perspective, there are, for example, fewer than thirty Vermeers in the entire world.

12. *The First Century of Photography*, 8.

13. André Jammes, *Alfred-Nicolas Normand et l'art du "calotype,"* exhibition catalog (organized by l'Inspection Générale des Musées Classés and the Service des Rélations Publiques de la Société Kodak Pathé, n.d.). This "happy few" hypothesis is reiterated by Janis in *The Art of French Calotype*: "Because [the calotype] was at first largely ignored in France, it enjoyed a certain independence on the periphery, becoming the art of the experimentalist, the devotee, the lover of variables—the 'happy few' working to please themselves and delight one another," 16.

14. *The Art of French Calotype*, xiv.

15. See in this regard Christopher Phillips's discussion, "A Mnemonic Art? Calotype Aesthetics at Princeton," *October 25* (Fall 1983), 35–62.

16. As most undergraduates in art history are aware, Wöfflin's metastylistics (*Principles of Art History*) are inadequate even for mannerist painting of the sixteenth century, much less for photography. Photo historians, however, are greatly enamored of a system that enables them to plot all photography between two poles, whether these be construed as expressive/objective, mirror/ window, or pictorial/documentary.

17. For example, Janis uses Hugo's *Notre Dame de Paris* as though it were an unambivalent celebration of medieval culture. But Hugo's enthusiastic advocacy of Gothic architecture needs to be distinguished from his far more complicated view of Gothic civilization, and the novel is itself an index of his changing politics as he moved from the camp of the Ultras to his mature position as a champion of egalitarian social democracy. In *Notre Dame de Paris*, the cathedral is conceived as an emblem of a world that has become literally indecipherable, an empty and sinister bulk of stone signifying a dead culture which in the course of the novel is attacked by the people. Modernity is symbolized by the printing press, by the prophesied advent of generalized literacy and education. Janis takes no account of the fact that "Gothic," like the Romantic imagination itself, is a shifting field; it has different meanings at different historical moments. The Gothic revival in France, from the late eighteenth century on, could signify antiquarianism, Restoration politics and values, anti-classical and romantic rebellion, pastiche eclecticism (*le style troubadour* of the 1830s), nationalism and the notion of a patrimonial legacy, etc.

18. This may in part be understood as an element in the ongoing historical rehabilitation of the Second Empire. Janis wrote the photography section for the catalog of the massive exhibition "The Second Empire" at the Grand Palais in 1978.

19. Gustave Flaubert, *The Sentimental Education* (New York: Signet Books, 1972), 417.

20. The practice of making photographic transpositions of standard Beaux-Arts theory as a way to legitimize and bolster the aesthetic claims of art photography was fairly common in the Second Empire photographic circles. Disdèri—the inventor of the *carte-de-visite*—did it in *his* treatise just as Le Gray did it in his. Typically, photography historians are remarkably impressed by this practice. James Borcoman inflated Charles Nègre's single lengthy reference into an elaborate thesis involving photographic "*effet*." Similarly, if more perversely, Robert Sobieszek interpreted Disdèri's treatise as an equivalent to the Realist program for painting. See Borcoman, *Charles Nègre* (Ottawa: The National Gallery of Canada, 1976), and Sobieszek, in *One Hundred Years of Photography: Essays in Honor of Beaumont Newhall* (Albuquerque: University of New Mexico Press, 1975).

21. "Given such variables in the process of making calotype negatives, it is hardly surprising that they should be widely diverse in color, density, clarity, and transparency and not be governed by a single dominating aesthetic." Nancy Keeler, Richard Brettell, Sydney Kilgore, "The Calotype as Print Medium," in *Paper and Light*. However, despite this disclaimer, the general drift of the essays comprising *Paper and Light* is to assert the contrary. I should mention, though, that I have only been able to read galleys and have not seen Richard Brettell's introductory essay to the book.

22. It is no doubt for this reason that wall labels and captions tend to be vague. Albumen print can mean either that the negative was albumen on glass or that the printing paper was albumenized. Salt print refers to the print paper, not the negative, but almost always derives from a paper negative. However, in many instances where the negative is lost, there is no sure way of identifying the technology employed from the positive print.

23. Predictably, the ideology of aestheticism privileges "appreciation" over analysis. Here is a not unrepresentative passage (87) from *The Art of French Calotype* on a landscape photograph by Le Gray: "In one study from a unique album by Le Gray devoted to Fontainebleau, a backlighted young oak deep in the woods rises amid monstrous boulders, the famed lichen encrusted rocks of Fontainebleau, which protrude from the forest floor and sprawl at the base of the tree like so many sleeping giraffes. The tree's form anchors a scintillating tapestry of wind-blown and silhouetted leaves to the surrounding brush. Reaching out, the branches attach their weblike tracery to the sides of the frame stabilizing all the minutiae of moving surface light and shade which alternate in extraordinary complexity from bark to boulders to brush. Strange losses of delineation replace the atomized foliage of picturesque convention, the effect assisted by nature itself in a gentle breeze which 'paints' selectively, catching certain branches and leaving others stationary during the long exposure. . . . A feeling of calm and profound intimacy emerges from Le Gray's apportionment of light and shade as photography translates nature's subtle spaces and warm-to-cool coloration into a universe of palpitating chiaroscuro."

24. *Photography and Society*, by Giselle Freund, which incorporates part of the 1936 thesis, was published in an English-language version only two years ago (Boston: David R. Godine, 1980). Elizabeth Ann McCauley, a photography historian, is currently researching the economic infrastructure of Second Empire photography. It is, I believe, McCauley who has shown that Freund's notion that the *carte-de-visite* portrait was available to the masses is incorrect, and that its price put it well beyond the means of working-class people. [See Elizabeth Ann McCauley's useful and informative study *A. A. E. Disdèri and the Carte-de-visite* (New Haven: Yale University Press, 1985).]

25. Rosalind Krauss, "Photography's Discursive Spaces: Landscape/View," 315.

26. At the symposium held at the Princeton Art Museum in conjunction with the publication of *The Art of French Calotype* and the opening of the accompanying exhibition, André Jammes delivered a brief address. He began by remarking that the "idea which arises in my mind when preparing the book and the exhibition was something about freedom and the freedom of the photographers of the era of the calotype [which] was an extremely important period . . . it was practically the only moment of perfect freedom when French photographers could exert their art in freedom." Although the tone and substance might well be confused with a Heritage Foundation fund-raiser, this myth of freedom, this exalted belief in the non-contingency of cultural production, appears to be shared by most academic photography historians, with very few exceptions.

27. Phyllis Lambert's Canadian Center for Architecture in Montreal has generated its own photographic discourse along the familiar lines I am discussing here. In this instance it is architectural photography which is entirely decontextualized. See, for example, the deluxe volume assembled from the Center's photographic holdings, *Photography and Architecture*, selected and with an introduction by Richard Pare (Montreal and New York: Centre Canadien d'Architecture and Calloway Editions, 1982).

28. They are as follows: Yvan Crist, Gérard Lévy, Alain Paviot (Galerie Octant), Frédéric Proust, Collection Texbraun.

29. In an attempt to discover the reason, I phoned the acquiring editor at Princeton University Press, who was quite indignant that I would even make the inquiry, much less use the word "elision," and referred me to Eugenia Parry Janis. For attribution, Ms. Janis would say only that the decision had been made by M. Jammes.

30. *The Art of French Calotype*, 199.

31. *Ibid.*, 23.

32. *Ibid.*, 84.

33. James Borcoman, *Charles Nègre* (Ottawa: The National Gallery of Canada, 1976).

34. William M. Ivins, Jr.'s *Prints and Visual Communications* (New York: Da Capo Press, 1969) is a book that has had a profound influence on the thinking of many academic photography historians and curators. Ivin's concept of "syntax" and his implication that "exactly repeatable statements"—i.e., photographs—were the extension of the graphic media by other means have served to justify an approach to photography not dissimilar to a museum print department's approach to lithographs or mezzotints. Indeed, Brettell and his colleagues' overall framework in the *Paper and Light* text, with its elaborate discussion of papers, watermarks, and printing variables, is indistinguishable from the kinds of analyses hitherto associated with print connoisseurship. If, alternatively, we think of Roland Barthes's characterization of photography's appearance in the world as "a decisive mutation in informational economies," we will, of course, not be overly concerned with watermarks.

35. The contemporary French art photography establishment, even more recently minted than the American one, for the most part takes its cues from the States. In this regard, see my essay "The Reification of Photography in France," *Photo Communiqué* (December 1980), 14–19.

36. Here again, Jammes may be seen to have been the pioneer aesthetician. In an article entitled "La Grimace Provoquée et Nadar," published in the *Gazette des Beaux-Arts* in December 1978, Jammes examined Duchenne's 1862, two-volume *La Méchanisme de la physiologie humaine* in terms of aesthetic authorship; specifically, he discussed whether Adrien or Felix Nadar could have been the photographer, given that the photos clearly revealed "a master's hand." For this reference, I am indebted to Christopher Phillips.

37. Of dissenting voices, I am familiar only with the following: Peter Schjeldahl, "Is There Life before Photography?" *The Village Voice* (May 27, 1981); S. Varnedoe, "Of Surface Similarities, Deeper Disparities, First Photographs and the Function of Form: Photography and Painting after 1839," *Arts Magazine* (September 1981); Christopher Phillips, "The Judgement Seat of Photography"; Rosalind Krauss, "Photography's Discursive Spaces: Landscape View"; and my "Tunnel Vision."

38. In the second of the MoMA Atget books, *The Art of Old Paris* (New York: Museum of Modern Art, 1982), Hambourg argues for a late, great, poeticized style of Atget, one that emerged between 1918 and his death in 1927. This would necessarily comprise a corpus of 1,700 images (out of approximately 10,000). Not having seen anywhere near these 1,700, I would not pretend to be able to dispute this contention. However, I would venture to say that the very desire to construct the notion of a "mature style" is itself significant.

Canon Fodder

1. Michel Foucault, "What Is an Author?," in *Language, Counter-Memory, Practice*, ed. and trans. Donald Bouchard and Sherry Simon (Ithaca: Cornell University Press, 1977). See also Roland

Barthes, "The Death of the Author," in *Image, Music, Text*, ed. and trans. Stephen Heath (New York: Hill & Wang, 1977). Foucault's essay was originally published in 1969, Barthes's in 1968.

2. Berenice Abbott, *The World of Atget* (New York: Horizon, 1964), xiii.

3. "In precisely this way literature . . . by refusing to assign a 'secret,' an ultimate meaning, to the text (and to the world as text), liberates what may be called an anti-theological activity, an activity that is truly revolutionary since to refuse to fix meaning is, in the end, to refuse God and his hypostases—reason, science, law." Barthes, "The Death of the Author," 147.

4. The classic essay in American criticism is W. K. Wimsatt and Monroe Beardsley, "The Intentional Fallacy." See also their essay "The Affective Fallacy." Both texts are to be found in Wimsatt and Beardsley, *The Verbal Icon: Studies in the Meaning of Poetry* (Louisville: University Press of Kentucky, 1954). For a more recent discussion of issues of intentionality, see Stanley Cavell, *Must We Mean What We Say?* (New York: Scribner's, 1969).

5. Walter Benjamin, "A Short History of Photography," in *Classic Essays on Photography*, ed. Alan Trachtenberg (New Haven: Leete's Island Books, 1980), 208.

6. Benjamin, "The Work of Art in the Age of Mechanical Reproduction," in *Illuminations*, trans. Harry Zohn (New York: Harcourt, Brace, Jovanovich, 1969), 228. John Szarkowski undertakes a confused and confusing interpretation of Benjamin's two essays in Volume IV of *The Work of Atget*. His inability to grasp the essentials of Benjamin's argument is significant, particularly in that much of the criticism directed at Szarkowski's late modernist position on photography has been profoundly informed by the issues Benjamin raises in both essays.

7. Benjamin, "A Short History," 209.

8. *Ibid.*

9. Benjamin, "The Work of Art," 228.

10. Abbott, *The World of Atget*, viii.

11. *Ibid.*, xxx.

12. *Ibid.*, xxxii.

13. *Ibid.*, iv.

14. For an extended discussion of surrealist photographic practice, see Rosalind Krauss's two essays "The Photographic Productionof Surrealism," and "Corpus Delicti," in Jane Livingston and Rosalind Krauss, *L'Amour fou* (New York: Abbeville Press, 1985).

15. In addition to Abbott's *The World of Atget*, see Arthur D. Trottenberg, ed., *A Vision of Paris: The Photographs of Eugène Atget, the Words of Marcel Proust* (New York: Macmillan, 1963), and William Howard Adams, *Atget's Gardens* (London: Gordon Fraser, 1979).

16. In this regard it is interesting to note that while John Szarkowski now writes appreciatively of Atget's beneficial influence on such photographers as Man Ray, Ansel Adams, Walker Evans, Edward Weston, Lee Friedlander, and others, these lines of influence were never remarked upon or critically discussed before Atget's official canonization.

17. Jane Tompkins's rigorous exposition and demonstration of the mechanisms of canon formation as they operated in the establishment of Nathaniel Hawthorne's literary reputation provide the subject of her chapter "Masterpiece Theater" in her book *Sensational Designs: The Cultural Work of American Fiction* (New York: Oxford University Press, 1985). I am indebted to her clear and forceful demonstration of how canons work and to Jan Zita Grover for bringing my attention to Tompkins's book. Very useful too have been Barbara Herrnstein Smith, "Contingencies of Value," and John Guillory, "The Ideology of Canon Formation: T. S. Eliot and Cleanth Brooks," both printed in a special issue devoted to canons, *Critical Inquiry* 10 (September 1983).

18. T. S. Eliot, "Tradition and the Individual Talent," in *Selected Prose of T. S. Eliot*, ed. Frank Kermode (New York: Harcourt, Brace, Jovanovich, 1975), 109.

19. John Szarkowski and Maria Morris Hambourg, *The Work of Atget*, vols. I–IV (New York and Boston: The Museum of Modern Art and The New York Graphic Society, 1981, 1982, 1983, 1985). The citation is from vol. IV, *Modern Times*, 26.

20. Szarkowski, *ibid.*, 26.

21. Harold Bloom, *The Anxiety of Influence* (New York: Oxford University Press, 1973).

22. Maria Morris Hambourg's catalog essay on Charles Marville is a clear instance of this retrospective filter in action. See "Charles Marville's Old Paris," in *Charles Marville, Photographs of Paris 1852–1878* (New York: French Institute, 1981).

23. See, for example, *The First Century of Photography: From the Collection of André Jammes* (Chicago: The Art Institute of Chicago, 1978) and *French Primitive Photography* (Millerton: Aperture, 1968).

24. Things were far simpler in the halcyon days of Alfred Stieglitz's reign as cultural czar of the art of photography. Intentionality was, of course, a virtual prerequisite for canon consideration. But even then, when *Camera Work* made its occasional forays into the nineteenth century to attempt to forge a historical canon, there were immediate complications. I am thinking here of *Camera Work*'s approach to David Octavius Hill and Robert Adamson. A difficult critical problem was raised by the collaborative nature of their work and the fact that the bulk of it was strictly functional in nature (e.g., the photos were intended as *aides mémoires* for Hill's painting). See my essay "Back to Basics: The Return of Alfred Stieglitz," in *Afterimage* (Summer 1984), 3–6.

25. Margaret Nesbit, "Atget's *Intérieurs Parisiens*, The Point of Difference," in Margaret Nesbit and Francoise Réynaud, *Eugène Atget, 1857–1927: Intérieurs Parisiens* (Paris: Musée Carnavalet, 1982).

26. Szarkowski, *The Work of Atget*, vol. I, 18.

27. *Ibid.*

28. Rosalind E. Krauss, "Photography's Discursive Spaces," in *The Originality of the Avant-Garde and Other Modernist Myths* (Cambridge: The MIT Press, 1985), 142.

29. *Ibid.*, 147.

30. *Ibid.*, 149.

The Armed Vision Disarmed

1. *The New Vision: Forty Years of Photography at the Institute of Design* (Millerton: Aperture, 1982), 10.

2. *Ibid.*

3. Alexander Rodchenko, "Against the Synthetic Portrait, for the Snapshot" (1928), reprinted in *Russian Art of the Avant-Garde: Theory and Criticism 1902–1934*, ed. and trans. John E. Bowlt (New York: The Viking Press, 1976), 167.

4. "Contemporary Art and the Plight of Its Public," in Leo Steinberg, *Other Criteria* (New York: Oxford University Press, 1979), 5.

5. The comparison is often drawn between the critical methods of the Russian Formalists and the contemporary work of the American New Critics. Addressing this correspondence, Fredric Jameson has written: "While both the American and Russian critical movements are contemporaneous with a great modernistic literature, although both arise in part in an attempt to do theoretical

justice to that literature, the Formalists found themselves to be contemporaries of Mayakowski and Khlebnikov, revolutionaries both in art and politics, whereas the most influential literary contemporaries of the American New Critics were called T. S. Eliot and Ezra Pound. This is to say that the familiar split between avant-garde art and left-wing politics was not a universal, but merely a local, Anglo-American phenomenon." *The Prison House of Language* (Princeton: Princeton University Press, 1972), 44. The standard text in English on the Russian Formalists is Victor Erlich, *Russian Formalism* (Gravenhage: Mouton, 1955).

6. Alexander Rodchenko, "From the Easel to the Machine," reprinted in *Rodchenko and the Arts of Revolutionary Russia*, ed. David Elliott (New York: Pantheon Books, 1979), 8.

7. [For a thorough, thoughtful, and provocative discussion of the evolution from constructivism to productivism, with particular attention given to Rodchenko's problematic career, see Benjamin H.D. Buchloh's "From Faktura to Factography," in *October 30* (Fall 1984), 83–120.]

8. Osip Brik, "From Pictures to Textiles," in Bowlt, *Russian Art of the Avant-Garde*, 245.

9. Andrei B. Nakov, "Le Rétour au matériaux de la vie," in *Rodchenko* (Paris: Arc 2, Musée de l'Art Moderne de la Ville de Paris, 1977), n.p., my translation.

10. Cited in Bowlt, *Russian Art of the Avant-Garde*, 152.

11. Cited in Alexander Lavrentiev, "Alexander Rodchenko," in Elliott, *Rodchenko and the Arts of Revolutionary Russia*, 26.

12. [See Buchloh, "From Faktura to Factography," for an excellent discussion of the Worker's Club and Pressa exhibitions. At least two other monographs on Rodchenko have appeared since the writing of this essay: S. O. Kahn-Magomedev, *The Complete Rodchenko* (Cambridge: The MIT Press, 1986), and Alexander Lavrentjev, *Rodchenko Photography* (New York: Rizzoli, 1982).]

13. A valuable discussion of strategies of photographic defamiliarization may be found in Simon Watney, "Making Strange: The Shattered Mirror," in ed. Victor Burgin, *Thinking Photography* (London: Macmillan Press, 1983), 154–76.

14. The influence of Dziga Vertov on Rodchenko was immense, as indeed it was on most of the radical Soviet avant-garde. Rodchenko worked with Vertov on several projects, including the design of the titles for *The Man with a Movie Camera* and posters for Vertov's *Kino-Pravda*.

15. Both quotations from Bowlt, *Russian Art of the Avant-Garde*, 167.

16. Cited in Elliott, *Rodchenko*, 24. A selection of the letters between Rodchenko, Boris Kushner, and others, debating the implications of photographic point of view and staking out the terms of conflict between radical formalism and other positions including socialist realism, may be found in *Creative Camera International Yearbook*, ed. Colin Osman (London: Gordon Fraser, 1978). Victor Burgin examines the implications of these debates for photographic theory in his essay "Photography, Phantasy, Function," in Burgin, *Thinking Photography*, 177–216.

17. Cited in John Willett, *Art and Politics in the Weimar Period: The New Sobriety, 1917–1933* (New York: Pantheon Books, 1978), 76.

18. Cited in Herbert Molderings, "Urbanism and Technological Utopianism: Thoughts on the Photography of the Neue Sachlichkeit and the Bauhaus," in *Germany: The New Photography, 1927–1933*, Selected and Ed. by David Mellor (London: Arts Council of Great Britain, 1978), 89.

19. *Ibid.*, 92.

20. *Ibid.*, 93. However, it is important to distinguish between advertising practices developed in the Soviet Union and those in Weimar Germany. Discussing the advertising work produced by the artistic partnership of Mayakowsky and Rodchenko, Szymon Bojko has indicated, in effect, why this advertising practice may not be compared with the advertising industry of Germany or the

18. T. S. Eliot, "Tradition and the Individual Talent," in *Selected Prose of T. S. Eliot*, ed. Frank Kermode (New York: Harcourt, Brace, Jovanovich, 1975), 109.

19. John Szarkowski and Maria Morris Hambourg, *The Work of Atget*, vols. I–IV (New York and Boston: The Museum of Modern Art and The New York Graphic Society, 1981, 1982, 1983, 1985). The citation is from vol. IV, *Modern Times*, 26.

20. Szarkowski, *ibid.*, 26.

21. Harold Bloom, *The Anxiety of Influence* (New York: Oxford University Press, 1973).

22. Maria Morris Hambourg's catalog essay on Charles Marville is a clear instance of this retrospective filter in action. See "Charles Marville's Old Paris," in *Charles Marville, Photographs of Paris 1852–1878* (New York: French Institute, 1981).

23. See, for example, *The First Century of Photography: From the Collection of André Jammes* (Chicago: The Art Institute of Chicago, 1978) and *French Primitive Photography* (Millerton: Aperture, 1968).

24. Things were far simpler in the halcyon days of Alfred Stieglitz's reign as cultural czar of the art of photography. Intentionality was, of course, a virtual prerequisite for canon consideration. But even then, when *Camera Work* made its occasional forays into the nineteenth century to attempt to forge a historical canon, there were immediate complications. I am thinking here of *Camera Work*'s approach to David Octavius Hill and Robert Adamson. A difficult critical problem was raised by the collaborative nature of their work and the fact that the bulk of it was strictly functional in nature (e.g., the photos were intended as *aides mémoires* for Hill's painting). See my essay "Back to Basics: The Return of Alfred Stieglitz," in *Afterimage* (Summer 1984), 3–6.

25. Margaret Nesbit, "Atget's *Intérieurs Parisiens*, The Point of Difference," in Margaret Nesbit and Francoise Réynaud, *Eugène Atget, 1857–1927: Intérieurs Parisiens* (Paris: Musée Carnavalet, 1982).

26. Szarkowski, *The Work of Atget*, vol. I, 18.

27. *Ibid.*

28. Rosalind E. Krauss, "Photography's Discursive Spaces," in *The Originality of the Avant-Garde and Other Modernist Myths* (Cambridge: The MIT Press, 1985), 142.

29. *Ibid.*, 147.

30. *Ibid.*, 149.

The Armed Vision Disarmed

1. *The New Vision: Forty Years of Photography at the Institute of Design* (Millerton: Aperture, 1982), 10.

2. *Ibid.*

3. Alexander Rodchenko, "Against the Synthetic Portrait, for the Snapshot" (1928), reprinted in *Russian Art of the Avant-Garde: Theory and Criticism 1902–1934*, ed. and trans. John E. Bowlt (New York: The Viking Press, 1976), 167.

4. "Contemporary Art and the Plight of Its Public," in Leo Steinberg, *Other Criteria* (New York: Oxford University Press, 1979), 5.

5. The comparison is often drawn between the critical methods of the Russian Formalists and the contemporary work of the American New Critics. Addressing this correspondence, Fredric Jameson has written: "While both the American and Russian critical movements are contemporaneous with a great modernistic literature, although both arise in part in an attempt to do theoretical

justice to that literature, the Formalists found themselves to be contemporaries of Mayakowski and Khlebnikov, revolutionaries both in art and politics, whereas the most influential literary contemporaries of the American New Critics were called T. S. Eliot and Ezra Pound. This is to say that the familiar split between avant-garde art and left-wing politics was not a universal, but merely a local, Anglo-American phenomenon." *The Prison House of Language* (Princeton: Princeton University Press, 1972), 44. The standard text in English on the Russian Formalists is Victor Erlich, *Russian Formalism* (Gravenhage: Mouton, 1955).

6. Alexander Rodchenko, "From the Easel to the Machine," reprinted in *Rodchenko and the Arts of Revolutionary Russia*, ed. David Elliott (New York: Pantheon Books, 1979), 8.

7. [For a thorough, thoughtful, and provocative discussion of the evolution from constructivism to productivism, with particular attention given to Rodchenko's problematic career, see Benjamin H.D. Buchloh's "From Faktura to Factography," in *October 30* (Fall 1984), 83–120.]

8. Osip Brik, "From Pictures to Textiles," in Bowlt, *Russian Art of the Avant-Garde*, 245.

9. Andrei B. Nakov, "Le Rétour au matériaux de la vie," in *Rodchenko* (Paris: Arc 2, Musée de l'Art Moderne de la Ville de Paris, 1977), n.p., my translation.

10. Cited in Bowlt, *Russian Art of the Avant-Garde*, 152.

11. Cited in Alexander Lavrentiev, "Alexander Rodchenko," in Elliott, *Rodchenko and the Arts of Revolutionary Russia*, 26.

12. [See Buchloh, "From Faktura to Factography," for an excellent discussion of the Worker's Club and Pressa exhibitions. At least two other monographs on Rodchenko have appeared since the writing of this essay: S. O. Kahn-Magomedev, *The Complete Rodchenko* (Cambridge: The MIT Press, 1986), and Alexander Lavrentjev, *Rodchenko Photography* (New York: Rizzoli, 1982).]

13. A valuable discussion of strategies of photographic defamiliarization may be found in Simon Watney, "Making Strange: The Shattered Mirror," in ed. Victor Burgin, *Thinking Photography* (London: Macmillan Press, 1983), 154–76.

14. The influence of Dziga Vertov on Rodchenko was immense, as indeed it was on most of the radical Soviet avant-garde. Rodchenko worked with Vertov on several projects, including the design of the titles for *The Man with a Movie Camera* and posters for Vertov's *Kino-Pravda*.

15. Both quotations from Bowlt, *Russian Art of the Avant-Garde*, 167.

16. Cited in Elliott, *Rodchenko*, 24. A selection of the letters between Rodchenko, Boris Kushner, and others, debating the implications of photographic point of view and staking out the terms of conflict between radical formalism and other positions including socialist realism, may be found in *Creative Camera International Yearbook*, ed. Colin Osman (London: Gordon Fraser, 1978). Victor Burgin examines the implications of these debates for photographic theory in his essay "Photography, Phantasy, Function," in Burgin, *Thinking Photography*, 177–216.

17. Cited in John Willett, *Art and Politics in the Weimar Period: The New Sobriety, 1917–1933* (New York: Pantheon Books, 1978), 76.

18. Cited in Herbert Molderings, "Urbanism and Technological Utopianism: Thoughts on the Photography of the Neue Sachlichkeit and the Bauhaus," in *Germany: The New Photography, 1927–1933*, Selected and Ed. by David Mellor (London: Arts Council of Great Britain, 1978), 89.

19. *Ibid.*, 92.

20. *Ibid.*, 93. However, it is important to distinguish between advertising practices developed in the Soviet Union and those in Weimar Germany. Discussing the advertising work produced by the artistic partnership of Mayakowsky and Rodchenko, Szymon Bojko has indicated, in effect, why this advertising practice may not be compared with the advertising industry of Germany or the

U.S.: "The need for visual advertising appeared as a result of the coexistence on the national scene of the nationalised and private sectors. The real sense of NEP advertising was not so much commercial, since there was still a scarcity of goods, but for propaganda purposes. The aim was to stress the dominating role of the nationalised commerce and services. In this way Mayakowsky understood advertising and he wrote propaganda poems and slogans for it. . . . All Moscow was dominated by products of the partnership who signed themselves as 'advertising constructors.'" Szymon Bojko, "Productivist Life," in Elliott, *Rodchenko*, 81.

21. Carl Georg Heise, preface to *Die Welt ist Schön*, in Mellor, *Germany: The New Photography*, 9.

22. *Ibid.*, 10.

23. *Ibid.*, 14.

24. Walter Benjamin, "A Short History of Photography," *ibid.*, 72.

25. Cited in Reyner Banham, *Theory and Design in the First Machine Age* (Cambridge: The MIT Press, 1981), 313. The use of the telephone to order the paintings may, however, have been a retrospective invention, according to Lucia Moholy, Moholy's long-suffering first wife/editor/darkroom assistant: "When the panels, carried out in an enamel technique on a metal base, among them three different sizes of identical colours and composition, were finally delivered [by the enamel factory], Moholy-Nagy was satisfied, more than satisfied: he was enthusiastic. . . . His buoyancy exceeded all bounds. . . . It did not surprise me, therefore, when, overcome by emotion, he exclaimed—I distinctly remember the timbre of his voice on this occasion—'I might even have done it over the telephone!' " Lucia Moholy-Nagy, *Moholy-Nagy: Marginal Notes* (Krefeld: Scherpe Verlag, 1972), 75–76. Thanks to Christopher Phillips for this reference.

26. Karel Teige, cited in *Bauhaus 1919–1928*, eds. Herbert Bayer, Walter Gropius, and Ise Gropius (New York: The Museum of Modern Art, 1952), 91.

27. László Moholy-Nagy, "Photography Is the Manipulation of Light," reprinted in Andreas Haus, *Moholy-Nagy: Photographs and Photograms* (New York: Pantheon Books, 1980), 47.

28. Cited in *The New Vision*, 16–17.

29. Moholy-Nagy, *Painting, Photography, Film* (Cambridge: The MIT Press, 1969), 28. Originally published as *Malerei, Fotographie, Film*, vol. 8, Bauhausbüchen. For a suggestive and provocative discussion of the implications of the prevalent view of the camera as a supplement to optical vision, see Rosalind Krauss, "Jump Over the Bauhaus," *October 15* (Winter 1980), 103–10.

30. Between Moholy's departure from the Bauhaus in 1928, and his appointment as director of the New Bauhaus in Chicago, it seems probable that his politics, professional ambitions, and art practice were all variously transformed. In Amsterdam, where he initially emigrated in 1934, he worked primarily as an advertising photographer and a design consultant. Supported by Sir Herbert Read, the following year he moved to London, where he designed window displays for Simpson's of Piccadilly, and worked as a graphic designer for British Royal Airlines and London Transport. He also designed the (never used) light decorations for Alexander Korda's film *The Shape of Things to Come* and produced three photographically illustrated books.

31. Arthur Siegel, "Photography Is," *Aperture*, vol. 9, no. 2 (1961), n.p. This special issue of the magazine entitled "Five Photography Students from the Institute of Design, Illinois Institute of Technology," contained portfolios by Ken Josephson, Joseph Sterling, Charles Swedlund, Ray K. Metzker, and Joseph Jachna.

32. *Harry Callahan*, ed. and with an introd. by John Szarkowski (Millerton: Aperture in association with the Museum of Modern Art, 1976), 12.

33. *Ibid.*, 11.

34. *Ibid.*

35. Helen Gee, *Photography in the Fifties: An American Perspective* (Tucson: The Center for Creative Photography, 1980), 5.

36. Szarkowski, *Callahan*, 9.

37. For a detailed discussion of the de-Marxification of the American art-world intelligentsia, and the rapprochement of the abstract expressionist program with Cold War liberalism see Serge Guilbaut's "The New Adventures of the Avant-Garde in America," *October 15* (Winter 1980). [This essay has since been incorporated in Guilbaut's book *How New York Stole the Idea of Modern Art from Paris: Abstract Expressionism, Freedom, and the Cold War* (Chicago: University of Chicago Press, 1983).] See too the following essays relevant to the political uses of abstract expressionism and its relation to Cold War liberalism: Eva Cockcroft, "Abstract Expressionism: Weapon of the Cold War," *Artforum* no. 12 (June 1974), 39–41; Carol Duncan and Alan Wallach, "MoMA: Ordeal and Triumph on 53rd Street," *Studio International*, vol. 194, no. 1 (1978), 48–57; Max Kozloff, "American Painting during the Cold War," *Artforum*, 13 (May 1973), 43–54; Jane DeHart Matthews, "Art and Politics in Cold War America," *American Historical Review*, vol. 81, no. 41 (October 1976), 762–87; David and Cecile Shapiro, "Abstract Expressionism: The Politics of Apolitical Painting," *Prospects*, vol. 3 (1976), 175–214.

38. I am thinking here, for example, of Walker Evans's two-year association with the Farm Security Administration, Berenice Abbott's WPA-funded documentation of *Changing New York*, and Paul Strand's involvement with Frontier Films.

39. Andy Grundberg, "Photography, Chicago, Moholy, and After," *Art in America*, vol. 64, no. 5 (September–October 1976), 34.

40. *Ibid.*, 35.

41. Aaron Siskind, "Credo," in *Photographers on Photography*, ed. Nathan Lyons (New York: Prentice-Hall, 1966), 98.

42. Aaron Siskind, from "Photography as an Art Form," an unpublished lecture delivered at the Art Institute of Chicago (November 7, 1958), printed in Lyons, *Photographers on Photography*, 96.

43. Aaron Siskind, "Thoughts and Reflections," interview in *Afterimage*, vol. 1, no. 6 (March 1973), 2.

44. *Ibid.*

Playing in the Fields of the Image

1. Bruce Conner is an independent filmmaker and artist who has made films since 1958. His films are typically composed of bits and pieces of Hollywood movies, TV commercials, newsreels, etc.

2. Dara Birnbaum is a video artist whose best-known works are constructed from fragments of TV shows (e.g., *Wonder Woman, Laverne and Shirley*, etc.).

3. *New York Times*, April 11, 1982.

4. In *Photography: Current Perspectives* (Rochester: Visual Studies Workshop, 1978), 231–55. [Reprinted in Allan Sekula, *Photography Against the Grain: Essays and Works* (Halifax: The Press of the Nova Scotia College of Art and Design, 1986).]

5. See Douglas Crimp, "The Museum's Old, The Library's New Subject," *Parachute 22* (Spring 1981), 8–12; also Crimp, "The Photographic Activity of Postmodernism," *October 15* (Winter 1980), 91–102, and "On the Museum's Ruins," in *October 13* (Summer 1980), 41–57.

6. "Conventional Pictures," *The Print Collector's Newsletter*, vol. 7, no. 5 (November/ December 1981), 138–40.

7. Vickie Goldberg, ed., *Photography in Print* (New York: Touchstone Books, 1981), 3–34. [Reprinted in Sekula, *Photography Against the Grain*.]

8. See Roland Barthes's three crucial essays on photography—"The Photographic Message," "The Rhetoric of the Image," and "The Third Meaning," all printed in Barthes, *Image, Music, Text*, ed. and trans. Stephen Heath (New York: Hill and Wang, 1977).

9. See Craig Owens, "The Medusa Effect or, The Spectacular Ruse," in the exhibition catalog *We Won't Play Nature to Your Culture, Work by Barbara Kruger* (London: Institute of Contemporary Art, 1983), 5–11. [See also Hal Foster, "Subversive Signs," in Hal Foster, *Recordings: Art, Spectacle, Cultural Politics* (Port Townsend, Wash.: Bay Press, 1985), 99–118.]

10. Kate Linker, "On Richard Prince's Photographs," *Arts Magazine* (November 1982), 121–23.

11. Richard Prince, *Why I Go to the Movies Alone* (New York: Tanam Press, 1982), 22.

12. For example, see Crimp, "The Photographic Activity," and "Pictures," *October 8* (Spring 1979), 75–88; Craig Owens, "The Allegorical Impulse: Toward a Theory of Postmodernism," Parts I and II, *October 12* (Spring 1980), 67–86, and *October 13* (Summer 1980), 58–80. In Roland Barthes's last published book, *Camera Lucida*, trans. Richard Howard (New York: Hill and Wang, 1982), 62, one finds the following statement: "In front of the Winter Garden Photograph I am a bad dreamer who vainly holds out his arms toward the possession of the image. I am Golaud exclaiming 'Misery of my life!' because I will never know Mélisande's truth. (Mélisande does not conceal, but she does not speak. Such is the Photograph: it cannot say what it lets us see.)"

13. See, in this respect, Joel Snyder, "Picturing Vision," in *The Language of Images* (Chicago: University of Chicago Press, 1980), 219–58, and Marx Wartofsky, "Cameras Can't See: Representation, Photography, and Human Vision," *Afterimage*, vol. 7, no. 9 (April 1980), 8–9.

14. *Passim* Viktor Shklovsky, Walter Benjamin, Roland Barthes.

Photography after Art Photography

1. Douglas Crimp, "The Photographic Activity of Postmodernism," *October 15* (Winter 1980), 91–101. See also Rosalind Krauss, "Sculpture in the Expanded Field," *The Anti-Aesthetic: Essays in Postmodern Culture*, ed. Hal Foster (Port Townsend, Wash.: Bay Press, 1983). From a critically negative and proformalist perspective, Michael Fried provided one of the earliest accounts of this new "violation" of the aesthetic signifer in his essay "Art and Objecthood," reprinted in Gregory Battcock, ed., *Minimal Art: A Critical Anthology* (New York: Dutton, 1968), 116–47.

2. The Société Française de Photographie, for example, from its inception in 1851 (initially called La Société Héliographique) forbade any retouching on photographic submissions to its exhibitions.

3. See in this regard Bernard Edelman's major study *Ownership of the Image: Elements for a Marxist Theory of Law* (London: Routledge and Kegan Paul, 1979).

4. In 1937 an important exhibition on the history of photography was mounted at the Museum of Modern Art which resulted in the publication of Beaumont Newhall's now standard text *The History of Photography*. For an extremely illuminating and suggestive account of the significance and context of this exhibition, see Christopher Phillips's "The Judgment Seat of Photography," *October 22* (Fall 1982), 27–63.

5. See Carol Squiers's discussion "Photography: Tradition and Decline," *Aperture 91* (Summer 1983), 72–76.

6. "Photographs and Professionals III," *The Print Collector's Newsletter* (July–August 1983), 86–89.

7. Jacqueline Rose, "Sexuality in the Field of Vision," in *Difference: On Representation and Sexuality*, ed. Kate Linker (New York: The New Museum of Contemporary Art, 1984). [Reprinted in Jacqueline Rose, *Sexuality in the Field of Vision* (London: Verso, 1986).]

8. Roland Barthes, "The Death of the Author," in *Image, Music, Text*, trans. Stephen Heath (New York: Hill and Wang, 1977), 146–47.

9. *Ibid.*, 147.

Living with Contradictions

1. "Neo-geo," also referred to as "simulationism," the latest art package to blaze across the art-world firmament, is a good case in point. The artists involved (Ashley Bickerton, Peter Halley, Jeff Koons, Haim Steinbach, Meyer Vaisman—to name only the most prominent) were the subject of massive media promotion from the outset. See, for example, Paul Taylor, "The Hot Four: Get Ready for the Next Art Stars," *New York Magazine*, October 27, 1986, 50–56; Eleanor Heartney, "Simulationism: The Hot New Cool Art," *Artnews* (January 1987), 130–37; Douglas C. McGill, "The Lower East Side's New Artists, A Garment Center of Culture Makes Stars of Unknowns," *The New York Times*, June 3, 1986. The media blitz was subsequently ratified by a group exhibition at the Sonnabend Gallery and, on the museological front, by an exhibition at the Institute for Contemporary Art, Boston ("Endgame: Reference and Simulation in Recent Painting and Sculpture," September 25–November 30, 1986) with an accompanying catalog featuring essays by prominent art historians and critics such as Yves-Alain Bois, Thomas Crow, Hal Foster. For a less exalted and intellectualized view of this phenomenon, see "Mythologies: Art and the Market," an interview with Jeffrey Deitch, art adviser to Citibank, *Artscribe International* (April/May 1986), 22–26. This interview is of interest because it clearly indicates the determinations and mechanisms in the fabrication and marketing of a new art commodity.

2. See Hal Foster, "Postmodernism: A Preface," in *The Anti-Aesthetic: Essays in Postmodern Culture*, ed. Hal Foster (Port Townsend, Wash.: Bay Press, 1983), ix–xvi. The conception of postmodernism in the visual arts as a critical practice was established in the following essays: Douglas Crimp, "Pictures," in *October 8* (Spring 1979), 75–88; "On the Museum's Ruins," in Foster, "Postmodernism," 43–56; "The Photographic Activity of Postmodernism," *October 15* (Winter 1980), 91–101; "The End of Painting," *October 16* (Spring 1981), 69–86; "The Museum's Old, the Library's New Subject," *Parachute 22* (Spring 1981), 32–37. For a theorization of postmodernism as an allegorical procedure, see Craig Owens, "The Allegorical Impulse: Toward a Theory of Postmodernism," Parts I and II, *October 12* (Spring 1980), 66–86, and *October 13* (Summer 1980), 59–80; and Benjamin H. D. Buchloh, "Allegorical Procedures: Appropriation and Montage in Contemporary Art," *Artforum* (September 1982), 43–56. See further, Rosalind Krauss's important essays "Sculpture in the Expanded Field," in Foster, *The Anti-Aesthetic*, 31–42, and "The Originality of the Avant-Garde," in Krauss, *The Originality of the Avant-Garde and Other Modernist Myths*, 151–70.

3. See Robert Venturi, Denise Scott Brown, Steven Izenor, *Learning from Las Vegas* (Cambridge: The MIT Press, 1972), and Charles Jencks, *The Language of Postmodern Architecture* (New York: Rizzoli, 1977).

4. Irving Howe and Harry Levin were using the term in the late fifties.

5. See my "Winning the Game When the Rules Have Been Changed: Art Photography and Postmodernism," *Screen*, vol. 25, no. 6 (November/December 1984), 88–102, and "Photography

after Art Photography," in *Rethinking Representation*, ed. Bruce Wallis (Boston: David R. Godine, 1986), *Art after Modernism*, 75–87. Reprinted in this volume.

6. The occlusion of feminism from the postmodernist debate, remarked upon by Andreas Huyssen, among others, is significant. It is by no means incidental that many, if not most, of the central figures within oppositional postmodernism in the visual arts, film, and video have been women, and much of the work they have produced has been directly concerned with feminist issues as they intersect with the problematics of representation. See note 14.

7. On the implications and ideology of the revival of pseudoexpressionism see Benjamin H. D. Buchloh, "Figures of Authority, Ciphers of Regression," in *October 10* (Spring 1981), 39–68, and "Documenta 77: A Dictionary of Received Ideas," *October 22* (Fall 1982), 105–26; Rosalyn Deutsche, "Representing the Big City," in *German Art in the Twentieth Century*, eds. Irit Rogoff and MaryAnne Stevens (Cambridge: Cambridge University Press, forthcoming), and with Cara Gendel Ryan, "The Fine Art of Gentrification," *October 31* (Winter, 1984), 91–111; Craig Owens, "Honor, Power, and the Love of Women," in *Art in America* (January 1982), 12–15. On the construction of photography as an "auratic" art, see Crimp, "The Photographic Activity of Postmodernism" and "The Museum's Old, the Library's New Subject," and my "Winning the Game When the Rules Have Been Changed."

8. Martha Rosler, "Notes on Quotes," *Wedge 3* (1982), 72.

9. Peter Bürger, *The Theory of the Avant-Garde*, trans. Michael Shaw (Minneapolis: University of Minnesota Press, 1984).

10. The theorization of a localized "site specificity" for contestatory and oppositional practices is one of the legacies of Louis Althusser and, with a somewhat different inflection, Michel Foucault. See Michel Foucault, "The Political Function of the Intellectual," *Radical Philosophy* 12 (Summer 1977), 12–15, and "Revolutionary Action: 'Until Now,' " in *Language, Counter-Memory, Practice: Selected Essays and Interviews by Michel Foucault*, ed. Donald F. Bouchard (Ithaca, N.Y.: Cornell University Press, 1977), 218–33.

11. See Fredric Jameson, "Postmodernism, or The Cultural Logic of Late Capitalism," *New Left Review 146* (July-August 1984), 53–92. An earlier, less developed version of this essay, entitled "Post-Modernism and Consumer Society," is reprinted in Foster, *The Anti-Aesthetic*, 111–25.

12. For various critiques of Jameson's arguments, see Mike Davis, "Urban Renaissance and the Spirit of Postmodernism," *New Left Review 151* (May–June 1985), 107–18; Terry Eagleton, "Capitalism, Modernism and Postmodernism," *New Left Review 152* (July 1985), 60–73; and Douglas Crimp, "The Postmodern Museum," *Parachute 46* (Spring 1987), 61–69.

13. Douglas Crimp, "Appropriating Appropriation," in *Image Scavengers*, exhibition catalog (University of Pennsylvania, Institute of Contemporary Art, December 8, 1983–January 30, 1983), 27.

14. Craig Owens, "The Discourse of Others: Feminists and Postmodernism," in Foster, *The Anti-Aesthetic*, 57–82, is an important exception.

15. Quoted in Gerald Marzorati, "Art in the (Re)Making," *Artnews*, vol. 85, no. 5 (May 1986), 97.

16. The activities, events, and objects produced under the rubric of "A Picture Is No Substitute for Anything" collectively and individually functioned to foreground the mechanisms of cultural production, exhibition, and reception. While the working title implicitly points to—by denying—the fetish status of paintings, the practices themselves (for example, inviting an art public to the studio of Dmitri Merinoff, a recently deceased expressionist painter; the mailing [and exhibition] of gallery announcements; one-night only exhibitions in which Levine and Lawler exhibited and arranged each other's work; the production of embossed matchbooks bearing the legend "A

Picture Is No Substitute for Anything) were constituted as tactical interventions within the structures of art. Inscribing themselves in the mechanisms of publicity, display, and curatorship served to focus attention on the framing conditions of art production, which are thereby revealed to be structurally integral, rather than supplemental, to the field as a whole. See, for example, Andrea Fraser, "In and Out of Place," *Art in America* (June 1985), 122–28; Kate Linker, "Rites of Exchange," *Artforum* (November 1986), 99–100; Craig Owens, review of Levine/Lawler exhibition, *Art in America* (Summer 1982), 148; Guy Bellavance, "Dessaissiment Re-appropriation," *Parachute* (January–February 1983); Benjamin H. D. Buchloh, "Allegorical Procedures"; Louis Lawler and Sherrie Levine, "A Picture Is No Substitute for Anything," *Wedge 2* (Fall 1982), 58–67.

17. That the official museum version of modernism we inherit is in every sense partial and, more important, *founded* on these exclusions and repressions is a recurring theme in Benjamin H. D. Buchloh's essays. See also Rosalyn Deutsche, "Representing the Big City," and Douglas Crimp, "The Art of Exhibition" and "The Postmodern Museum." In the last essay, certain problems in Fredric Jameson's theorization of postmodernist culture are seen to derive from his acceptance of the official, museological, and *auteurist* version of modernism.

18. My use of the term "institutional frame" is intended in its broadest, most inclusive sense. Thus, what is at issue is not simply the physical space that the artwork inhabits, but the network of interrelated discourses (art criticism, art history), and the sphere of cultural production itself as a site of ideological reproduction within the social formation.

19. This aspect of Sherman's work was of particular importance to critics such as Douglas Crimp. For an interpretation of Sherman's photographs that stresses their feminist critique, see Judith Williamson, "Images of 'Woman,' " *Screen*, vol. 24, no. 6 (November/December 1983), 102–16.

20. "Art & Advertising: Commercial Photography by Artists," New York International Center of Photography, September 14–November 9, 1986.

21. Willis Hartshorn, gallery handout.

22. Walter Benjamin, "The Author as Producer," in *Reflections*, ed. Peter Demetz (New York: Harcourt, Brace, Jovanovich, 1978), 222.

23. "In contemporary capitalism, in the society of the simulacrum, the market is 'behind' nothing, it is *in* everything. It is thus that in a society where the commodification of art has progressed apace with the aestheticisation of the commodity, there has evolved a universal rhetoric of the aesthetic in which commerce and inspiration, profit and poetry, may rapturously entwine." Victor Burgin, "The End of Art Theory," in Burgin, *The End of Art Theory: Criticism and Postmodernity* (London: Macmillan, 1986), 174.

24. On Fred Lonidier's work and the London Docklands project, see *Cultures in Contention*, ed. Diane Neumaier and Douglas Kahn (Seattle: The Real Comet Press, 1985). On Jenny Holzer, see Bruce Ferguson, "Wordsmith: An Interview with Jenny Holzer," *Art in America* (December 1986), 108–15. On Mary Kelly, see Mary Kelly, *Post-Partum Document* (London: Routledge & Kegan Paul, 1983). On *Form Follows Finance* see Connie Hatch, "Form Follows Finance," introduction by Jim Pomeroy, *Obscura*, vol. 2, no. 5, 26–34.

25. For an excellent discussion of these issues, see Victor Burgin, *The End of Art Theory*.

A Photographer in Jerusalem

1. A more recent hypothesis has it that the generative principle was art. See Peter Galassi, *Before Photography: Painting and the Invention of Photography* (New York: The Museum of Modern Art, 1981).

2. See *The Second Empire 1852–1870: Art in France under Napoleon III* (Philadelphia: Philadelphia Museum of Art, 1978).

3. In one case, the history painter Yvon commissioned the elder Bisson to take a photograph of Napoleon III for his use in the preparation of his painting *L'Empereur au képi*. Bisson subsequently sold copy prints from his negative, Yvon brought suit, and the court decided in favor of Yvon. In Mayer & Pierson v. Betheder and Schwabbe, a suit between two competing photographic firms, "the defendants relied on the 'photography as non-art theory,' while the plaintiffs maintained the contrary view. . . . The case went through several appeals, with the final decision establishing photography as art." Both cases cited in Giselle Freund, *Photography and Society* (Boston: David Godine, 1980), 81–84.

4. The fading and discoloration of photographs were often, but not always, due to improper washing or fixing. Their frequent deterioration was considered to be a serious problem insofar as it threatened the purchase of expensive art photographs.

5. Consider, for example, a few connections. Eugène Durieu was a founder of the Société Héliographique and made academic nude photographs for Delacroix, whom he also instructed in photography. In 1848 he was named director of the Administration des Cultes, which reported to the Ministry of Public Instruction. As a member of the Cultes he was also a member of the Commission of Historic Monuments. Count Léon de Laborde, also a founding member of the Société, served variously as curator at the Louvre, director of the National Archives, and worked for the Commission of Public Monuments. He also had taken lessons in photography under Gustave Le Gray together with his two nephews, Benjamin and Edouard Delessert, who accompanied de Saulcy on his first voyage to the Middle East in 1851.

6. This first and most ambitious of photographic documentation projects engaged five photographers—Hippolyte Bayard, Henri Le Secq, Edouard-Denis Baldus, O. Mestral, and Gustave Le Gray—to photograph those sites and works of architecture designated by Viollet-le-Duc and the Commission: 120 sites throughout France were photographed. See Philippe Néagu's indispensable *La Mission Héliographique: Photographies de 1851* (Dieppe: Sitecmo, 1980).

7. Walter Benjamin, "A Short History of Photography," trans. Phil Patton, *Artforum*, vol. XV, no. 6 (February 1977), 50.

8. In exhibitions held by the Société Française and those at the Universal Exhibitions of 1855 and 1867, reproductions of works of art were shown side by side with art photographs and *essais* in photomechanical reproduction. Le Secq, the Bisson *Frères*, Charles Marville, Salzmann in the Camiros book, among many others, produced significant amounts of copy work.

9. Benjamin, 50.

10. Cited in *The Second Empire*, 254.

11. See Edward Said, *The Question of Palestine* (New York: Times Books, 1979).

12. Cited in the exhibition catalog *En Egypte au temps de Flaubert* (Paris: Kodak-Pathé, n.d.), n.p.

Who Is Speaking Thus?

1. The term "documentary" was first coined in 1926 by John Grierson, a British film producer, to describe a certain type of factual film. Writing in review of Robert Flaherty's *Moana* for a New York newspaper, Grierson characterized it as follows: "being a visual account of events in the daily life of a Polynesian youth, it has documentary value." Cited in William Stott, *Documentary Expression in Thirties America* (New York: Oxford University Press, 1973), 9. Two years later, the term appeared in France, where it was attached to the work of Eugène Atget, André Kertesz,

Charles Sheeler, and others by the critic Christian Zevros. In this usage, documentary had an aesthetic, rather than social inflection. See Maria Morris Hambourg, "Atget, Precursor of Modern Documentary Photography," in *Observations: Essays on Documentary Photography*, ed. David Featherstone (Carmel: The Friends of Photography, 1984), 18–30.

2. The ramifications of this question have been an important thematic in the work of Allen Sekula. See especially "The Body in the Archive," *October 39* (Winter 1987), 3–64.

3. The classic essays on the signifying system of photographs are Roland Barthes's "The Photographic Message" and "The Rhetoric of the Image," both printed in *Image, Music, Text*, ed. and trans. Stephen Heath (New York: Hill and Wang, 1977).

4. Martha Rosler, "In, Around and Afterthoughts (On Documentary Photography)," in *Three Works* (Halifax: The Press of the Nova Scotia College of Art and Design, 1981), 72. Rosler's essay remains the definitive analysis and demystification of the liberal/humanist assumptions underpinning traditional documentary production, characterized by her as "victim photography."

5. It is significant that the call for a photographic practice informed by the recognition of a politics of representation appeared in the work of several critics in the late 1970s. The subtitle of Allan Sekula's 1978 essay "Dismantling Modernism: Reinventing Documentary" is "Notes on the Politics of Representation." Victor Burgin's 1977 essay "Looking at Photographs" and his 1980 essay "Photography, Phantasy, Function" are fundamentally concerned with the articulation of representational politics. Martha Rosler's critique of documentary is equally concerned with this concept. Drawing on different critical methodologies and approaches (Marxism, psychoanalytic theory, semiotics, poststructuralism) these writers reached similar (and complementary) conclusions. Sekula's essay is reprinted in Sekula, *Photography Against the Grain* (Halifax: The Press of the Nova Scotia College of Art and Design, 1985), 53–76. Burgin's two essays can be found in *Thinking Photography*, ed. Victor Burgin (London: Macmillan, 1982). Rosler, "Afterthoughts."

6. The earliest articulation of the camera's role as visual encyclopedist was delivered by Dominique François Arago to the French Chamber of Deputies on the occasion of the presentation of the daguerreotype process in August 1839. This *Report* is reprinted in Alan Trachtenberg, *Classic Essays on Photography* (New Haven: Leete's Island Books, 1980), 15–26.

7. Cited in Rosalind Krauss, "A Note on Photography and the Simulachral," *October 31* (Winter 1984), 57.

8. For a book-length discussion of Dr. Charcot's photographic project and its implications, see Georges Didi-Huberman, *Invention de l'hystérie: Charcot et l'iconographie photographique de la Salpêtrière* (Paris: Editions Macula, 1982). On the photographs of Dr. Hugh Diamond, see Sander L. Gilman, ed., *The Face of Madness: Hugh W. Diamond and the Origin of Psychiatric Photography* (Secaucus: Brunner-Mazel, 1976). On expeditionary photography see my "A Photographer in Jerusalem, 1855: Auguste Salzmann and His Times" in *October 18* (Fall 1981), 91–107, reprinted in this volume. For an excellent account of the various political instrumentalities of late nineteenth-century French photography, see Donald English, *The Political Uses of Photography in the Third Republic* (Ann Arbor: UMI Press, 1986). For a discussion of the structural interrelationships between photography, imperialism, exoticism, see Mallek Alloula, *The Colonial Harem* (Minneapolis: The University of Minnesota Press, 1987).

9. Mention should be made here of various precursors, whose existence further puts in question the validity of positing a discrete documentary tradition. They are as follows: Charles Marville, who photographed sections of old Paris slated for demolition in the 1860s, this commissioned by the Prefect of the Seine, Baron Haussmann; Thomas Annan, commissioned by the Glasgow Town Council City Improvement Trust to photograph the Glasgow slums (these photographs were published as *Old Closes and Streets of Glasgow*, 1868); John Thomson, who took the photographs and was also the coauthor of *Street Life in London* (1877–78) and *Illustrations of China and Its People* (a veritable

prospectus for European investment and economic exploitation); Colonel Willoughby Hooper's photographs of the Madras famine of 1876–77. See John Tagg's important discussion of the photographic genre represented by Annan and others in "Power and Photography—Part I, A Means of Surveillance: The Photograph as Evidence in Law," *Screen Education*, no. 6 (Autumn 1980). [Reprinted in John Tagg, *The Burden of Representation: Essays on Photographies and Histories* (Amherst: The University of Massachusetts Press, 1988). See too Chapter 5, "God's Sanitary Law: Slum Clearance and Photography in Late Nineteenth Century Leeds," and Chapter 6, "The Currency of the Photograph: New Deal Reformism and Documentary Rhetoric."] An alternative construction of documentary that has emerged from the precincts of art photography finds its exemplar and avatar in Eugène Atget. In this revisionist enterprise, the category "straight" photography is collapsed into documentary. See Maria Morris Hambourg, "Atget."

10. Sally Stein, "Making Connections with the Camera: Photography and Social Mobility in the Career of Jacob Riis," in *Afterimage*, vol. 10, no. 10 (May 1983), 14.

11. This troubling aspect of documentary projects runs through Rosler's and Stein's arguments. It is, of course, the crux of the issue for politically sophisticated (as opposed to "concerned") practitioners. [See, for example, Jo Spence's discussion of the documentarian's dilemma in *Putting Myself in the Picture* (Seattle: Real Comet Press, 1988).]

12. The massive documentary project known as the F.S.A. was initiated by Rexford Guy Tugwell, Assistant Secretary of Agriculture in the Franklin Delano Roosevelt administration. In 1935 Tugwell appointed Roy Stryker, then teaching economics at Columbia University, to head the Photography Section at the Resettlement Administration—soon to be renamed the Farm Security Administration, under the aegis of the Department of Agriculture. Five photographers were initially hired by Stryker and put on the government payroll: Walker Evans, Dorothea Lange, Carl Mydans, Arthur Rothstein, and Ben Shahn. In the following year, Stryker hired John Collier, Jr., Jack Delano, Russell Lee, Gordon Parks, Marian Post Woolcott, and John Vachon. Although originally intended to generate images that would help garner support for various relief programs—principally those oriented toward the plight of the rural poor—by the end of the 1930s the project shifted emphasis in tandem with war preparations and the need to generate patriotic, upbeat images. The project officially ended in 1943. [For an extremely interesting discussion of these federal projects with respect to the women photographers involved, see Andrea Fisher, *Let Us Now Praise Famous Women* (London and New York: Pandora Press, 1987).]

13. See Stott, *Documentary Expression*. [A parallel to this approach can be seen in the ongoing production of AIDS "victim" photography, in either its journalistic or art photography versions. In both incarnations, what is typically emphasized is either the visual and spectacular signs of illness (emaciation, K.S. lesions, etc.) or the pathos and helplessness of the "afflicted." People living more or less normal lives with AIDS, as well as images denoting individual agency and collective militancy, are far less likely to be represented. The difference between self-representation (i.e., film, photography, and video work produced within the community of people with AIDS and AIDS activists) and the media representation of AIDS is particularly striking. See in this regard *October 43* (Winter 1987), entitled *AIDS: Cultural Analysis, Cultural Activism*, especially the essay by Simon Watney, "The Spectacle of AIDS," and the PWA Coalition Portfolio.]

14. *Ibid.*, 61

15. For a paradigmatic example of the tortuous arabesques of evasion, elision, and special pleading in the humanist defense of '30s documentary, see Robert Coles, "Dorothea Lange: The Politics of Photography," *Raritan*, vol. I, no. 2 (Fall 1981), 19–53.

16. Rosler, "Afterthoughts," 78.

17. *Ibid.*, 72.

18. For a lucid account of the various implications of the photographic point-of-view, see Victor Burgin's two essays cited in note 5.

19. This aspect of photographic perception was suggested to me by Rosalind Krauss.

20. Jean-Louis Baudry, "Ideological Effects of the Basic Cinematographic Apparatus," in *Apparatus*, ed. Theresa Hak Kyung Cha (New York: Tanam Press, 1980), 26. For a discussion of the way the camera was adapted to conform to this pictorial model, see Joel Snyder, "Picturing Vision," in *The Language of Images*, ed. J. Mitchell (Chicago: University of Chicago Press, 1980), 219–58.

21. At the same time that bastions of photographic orthodoxy would disqualify work such as Rosler's, Hatch's, Lonidier's, or Sekula's as documentary, the challenge posed by their critical interventions drive defenders of the faith such as A. D. Coleman into extraordinary reactions of hostility and redbaiting. Coleman, whose hero of documentary is Eugene Smith has, for example, written the following: "the overall tenor of this reinvented documentary is unaffectionate [!], arch, ironic, hostile: hostile to the past, hostile to the present. I sense here the potential for the establishment of gulags of the spirit, aesthetic Stalinism." A. D. Coleman, "Light Readings: Information, Please," in *Lens on Campus*, vol. 7, no. 1 (Feb. 1985), 9. The very terms of such attacks, with their imputation of conspiracy and consistent equation of quantitative address (i.e., use of the mass media) with political effectiveness, should alert us to what is at stake in these different allegiances to documentary forms.

Reconstructing Documentary

1. John Heartfield is here the paradigmatic figure. See Douglas Kahn, *John Heartfield* (Seattle: Real Comet Press, 1985).

2. In this context, we have only to recall the kind of mini-furor provoked, for example, by the photographer Arthur Rothstein's moving a cow skull from a patch of grass to a surface of caked dust to make a more effective visual point about the drought he was documenting. In any case, documentary is a notoriously untheorized entity. The term did not enter photographic discourse until the 1930s, and then in the version "social documentary" coined by the filmmaker John Grierson. We may conclude that before this period the term documentary photography would have been popularly considered tautological in that *all* photography not clearly differentiated as "art" or otherwise distinguished would have been understood as documentary per se. The implications of its current denotational relationship to the political or the social are explored by Martha Rosler (see following note).

3. Martha Rosler's discussion of traditional documentary practice remains the definitive critique. See "In, Around, and Afterthoughts (On Documentary Photography)," in *Three Works* (Halifax: The Press of the Nova Scotia College of Art and Design, 1981), 59–86.

4. Walter Benjamin, "A Short History of Photography," trans. Phil Patton, in *Classic Essays on Photography*, ed. Alan Trachtenberg (New Haven: Leete's Island Books, 1980), 199–216.

5. Lewis Mumford, *Technics and Civilization* (New York: Harcourt, Brace and Jovanovich, 1962), 339.

6. Siegfried Kracauer, "Photography," in Trachtenberg, 245–68.

7. Walter Benjamin, "The Author as Producer," in *Reflections*, ed. Peter Demetz (New York: Harcourt, Brace and Jovanovich, 1978), 228.

8. Benjamin, "The Author as Producer," 234.

9. There are, of course, numerous exceptions, most notably in film as well as an equally wide range of work produced under the banner of conceptualism in the 1970s. Nonetheless, what I am

stressing here is the blueprint idea, not the mutually sustaining interrelationship between theorization of practice and its implementation.

10. We might think here, for example, of the growing corpus of feminist literary theory calling for (variously) a feminine *écriture*, a writing of the body, a specifically feminine language, etc., and the relatively small amount of writing produced to conform to these theoretical demands.

11. The suggestion that this very marginality may in fact be a necessary condition of critical art practice is developed by Douglas Crimp in relation to other "outsider" artists. See "The Art of Exhibition," in *October 31* (Winter 1984), 49–82.

12. Cited by Benjamin in "The Author as Producer," 228. To which could be added Benjamin's elaboration later in the essay: "What matters, therefore, is the exemplary character of production, which is able first to induce other producers to produce, and second, to put an improved apparatus at their disposal. And this apparatus is better the more consumers it is able to turn into producers—that is, readers or spectators into collaborators" (233). This project seems to me to be crucial to Hatch's work.

13. There have, of course, been several women practitioners of this genre: Lisette Model, later, her student Diane Arbus, Helen Levitt (who, perhaps significantly, concentrated on photographing children in the street), and other women photographers who have, at least on occasion, taken pictures on the street. But for the most part, the kind of street photography I am discussing here is overwhelmingly a masculine preserve. Moreover, Garry Winogrand, whose book *Women Are Beautiful* is a particularly egregious example of misogyny recuperated through modernist readings, is far more typical of the appropriative and aggressive aspects of such photography.

14. Theodor Adorno, *Minima Moralia* (London: New Left Books, 1974), 95.

15. Theodor Adorno, "Commitment," in Ernst Bloch *et al.*, *Aesthetics and Politics*, trans. Ronald Taylor (London: New Left Books, 1979), 180.

16. Jacqueline Rose, "Kristeva: Take Two," a paper given at the Pembroke Center Conference on Feminism/Theory/Politics, March 1984. [This paper is reprinted in Jacqueline Rose, *Sexuality in the Field of Vision* (London: Verso, 1986), 141–64.]

17. Roland Barthes, "Literature and Signification," in Roland Barthes, *Critical Essays*, trans. Richard Howard (Evanston: Northwestern University Press, 1972), 263.

Reconsidering Erotic Photography

1. My discussion of erotic and pornographic photography has been greatly influenced by three feminist theorists, Beverly Brown, Elizabeth Cowie, and Annette Kuhn, the first and third of whom have explicitly addressed the issue of pornographic representation. See Elizabeth Cowie, "Woman as Sign," *M/F*, no. 1, 1978, 49–63, Beverly Brown, "A Feminist Interest in Pornography," *M/F*, nos. 5 & 6 (1981), 5–18, and Annette Kuhn, "Lawless Seeing" in Kuhn, *The Power of the Image: Essays on Representation and Sexuality* (London: Routledge & Kegan Paul, 1985), 19–47.

2. The debate between feminist anti-pornography groups such as Women Against Pornography and feminists who reject the terms and tactics of the former position has been both acrimonious and divisive. A good selection of essays representing the anti-censorship position may be found in F.A.C.T. Book Committee, *Caught Looking: Feminism, Pornography and Censorship* (New York: Caught Looking, Inc., 1986). See also Alice Echols, "The Taming of the Id: Feminist Sexual Politics, 1968–1983," in *Pleasure and Danger: Exploring Female Sexuality*, ed. by Carol S. Vance (Boston: Routledge & Kegan Paul, 1982), 50–72, and Ellen Willis, "Feminism, Moralism, and Pornography," in *Powers of Desire: The Politics of Sexuality*, eds. Ann Snitow, Christine Stansell, and Sharon Thompson (New York: Monthly Review Press, 1983), 460–67. A lucid critique of the position that

focuses on representational content may be found in Griselda Pollock, "What's Wrong with 'Images of Women,' " in *Screen Education*, vol. 24 (Autumn 1977), 25–33 [reprinted in Rozsika Parker and Griselda Pollock, *Framing Feminism: Art and the Woman's Movement 1970–1985* (London: Pandora Press, 1987)], and Elizabeth Cowie, "Women, Representation and the Image," *Screen Education*, vol. 23 (Summer 1977), 15–23.

3. Charles Baudelaire, "The Modern Public and Photography," in *Classic Essays on Photography*, ed. Alan Trachtenberg (New Haven: Leete's Island Books, 1980), 87.

4. Gerald Needham, "Manet, 'Olympia' and Pornographic Photography," in *Women as Sex Object: Studies in Erotic Art 1730–1970*, ed. by Thomas B. Hess and Linda Nochlin (New York: Newsday Books, 1972), 81–89.

5. See Uwe Scheid, *Das erotische Imago* (Dortmund: Die bibliophilen Taschenbücher, 1984).

6. Stephen Heath, *The Sexual Fix* (New York: Schocken Books, 1984), 110.

7. Beatrice Farwell, *The Cult of Images: Baudelaire and the 19th Century Media Explosion* (Santa Barbara: University of California Art Museum, 1977).

8. See Albert Boime, *The Academy and French Painting in the Nineteenth Century* (London: Phaidon Press Ltd., 1971).

9. This was first demonstrated by Aaron Scharf in his *Art and Photography* (Baltimore: Penguin, 1974). See also Jean Sagne, *Delacroix et la Photographie* (Paris: Editions Herscher, 1982).

10. Kuhn, "Lawless Seeing," 43.

11. "Réceptacle passif, féminin du visible, forme en creux où le réel vient se photographier, la vision est aussi cet organe phalloïde capable de se déplier et de s'ériger hors de la cavité et de poindre vers le visible. Le regard est l'érection de l'oeil." Jean Clair, *La Pointe à l'oeil* (Paris: Cahier du Musée National d'Art Moderne, 1983), no. 11, n.p.

12. Kuhn, "Lawless Seeing," 30–31.

13. John Berger, *Ways of Seeing* (Harmondsworth: Penguin, 1973).

14. Brown, "A Feminist Interest," 6.

15. I am indebted to Christopher Phillips for the reference to the Meilhac and Halèvy play. Some examples of the jokes, cartoons, and drawings that play on the sexual associations of photography may be found in Uwe Scheid, *Als Photographieren noch ein Abenteuer war* (Dortmund: Die bibliophilen Taschenbücher, 1985).

16. My essay "The Legs of the Countess," *October 39* (Winter 1986), 65–108, sets out these issues in greater detail. This is the first chapter of a forthcoming study of sexuality, femininity, and photography in nineteenth-century France.

17. An outline for a theoretical approach to this issue has been produced by Luce Irigaray in her essays "Women on the Market" and "Commodities Among Themselves," both reproduced in her book *This Sex Which Is Not One*, trans. by Catherine Porter (Ithaca: Cornell University Press, 1985).

Just Like a Woman

1. Cited in Jonathan Culler, *On Deconstruction* (Ithaca: Cornell University Press, 1982), 23.

2. A clear and thorough discussion of the relationship between still photography and the operations of fetishism can be found in Victor Burgin, "Photography, Phantasy, Function," in *Thinking Photography*. ed. Burgin (London: Macmillan, 1983). See also Craig Owens's very interesting

discussion in his essay "Posing," in the exhibition catalog *Difference: On Representation and Sexuality* (New York: The New Museum of Contemporary Art, 1985), 7–18, and Christian Metz, "Photography and Fetish," *October 34* (Fall 1985), 81–90.

3. Certain correspondences or similarities that one might note between surrealist photographs and Woodman's work are, most likely, fortuitous. The great majority of the former were until recently unpublished (except for those that had appeared in their original surrealist publications), unreproduced, and very little known. See in this regard, Rosalind Krauss's two essays "Photography in the Service of Surrealism" and "Corpus Delicti" in Rosalind Krauss and Jane Livingston, *L'Amourf fou* (New York: Abbeville Press, 1985). Woodman's friendship in New York with Timothy Baum, a collector of surrealist art, did however, expose her to some of this material.

4. The bibliography of articles dealing with what could be termed the problematics of the look is (significantly) both recent and extensive. Much of the critical discussion has been generated by feminist film theory. A partial listing of major essays would include the now-classic text of Laura Mulvey, "Visual Pleasure and Narrative Cinema," in *Rethinking Representation: Art after Modernism*, ed. Brian Willis (Boston: David R. Godine, 1985), 375–90; Constance Penley, " 'A Certain Refusal of Difference': Feminist Film Theory" in Wallis, *ibid.*, 361–74; Mary Ann Doane, "Film and the Masquerade—Theorizing the Female Spectator," *Screen*, vol. XXV, nos. 3–4 (Sept.–Oct. 1982), 74–88; Mary Ann Doane, "Woman's Stake: Filming the Female Body," *October 17* (Summer 1981), 23–36; Linda Williams, "When the Woman Looks," in *Re-Visions: Feminist Essays in Film Analysis*, ed. Patricia Mellencamp, Mary Ann Doane, and Linda Williams (Los Angeles: American Film Institute, 1985). For a more general discussion see Annette Kuhn, *Women's Pictures: Feminism and Cinema* (London: Routledge & Kegan Paul, 1982); E. Ann Kaplan, *Women and Film: Both Sides of the Camera* (London and New York: Methuen, 1983). The British journal *M/F* and the American *Camera Obscura* have consistently explored these issues.

5. See Mulvey, "Visual Pleasure," and Doane, "Film and the Masquerade."

6. See Mulvey, "Visual Pleasure and Narrative Cinema."

7. Jacques Lacan, "Guiding Remarks for a Congress on Feminine Sexuality," in *Feminine Sexuality: Jacques Lacan and the Ecole Freudienne*, ed. and with introductory essays by Juliet Mitchell and Jacqueline Rose, trans. by Jacqueline Rose (New York: W. W. Norton & Co., 1983), 90.

8. Sigmund Freud, "Fetishism," in *Sexuality and the Psychology of Love*, ed. and with an introduction by Philip Rieff (New York: Collier Books, 1963), 215.

9. See, for example, Susan Gubar, "The Blank Page," in *The New Feminist Criticism*, ed. Elaine Showalter (New York: Pantheon, 1985), 292–313. For a detailed discussion of a notorious text in which the woman's body is understood as wholly written see Kaja Silverman, "Histoire d'O: The Construction of a Female Subject," in *Pleasure and Danger: Exploring Female Sexuality*, ed. Carol S. Vance (Boston: Routledge & Kegan Paul, 1984), 320–49.

10. Sigmund Freud, "Medusa's Head," in Rieff, *Sexuality and the Psychology of Love*, 212.

11. Here again, the bibliography is quite substantial. Some relevant essays include: Judith Barry and Sandy Flitterman, "Textual Strategies—The Politics of Art Making," *Screen*, vol. XXI, no. 2 (Summer 1980), 35–48; Silvia Bovenschen, "Is There a Female Aesthetic?" trans. Beth Weckmueller, *New German Critique*, no. 10 (Winter 1977), 111–37; Rachel Blau DuPlessis and Members of Workshop 9, "For the Etruscans: Sexual Difference and Artistic Production—The Debate Over a Female Aesthetic," in *The Future of Difference*, eds. Hester Eisenstein and Alice Jardine (New Brunswick, NJ: Rutgers University Press, 1980), 128–56.

INDEX

Index

Compiled by Theresa Wolner and Eileen Quam

ABIGAIL SOLOMON-GODEAU is a free-lance photography critic and art historian. She has been a visiting professor at the University of California, Berkeley, and has also taught at the International Center of Photography, New York University, and Hunter College. Solomon-Godeau is completing her Ph.D. in art history at the Graduate Center of the City University of New York. She has curated several exhibitions, including "The Stolen Image and Its Uses" (1982), "The Way We Live Now: Beyond Social Documentary" (1983), and "Sexual Difference: Both Sides of the Camera" (1988). Solomon-Godeau has contributed to *The Contest of Meaning: Critical Histories of Photography*, edited by Richard Bolton, *Universal Abandon? The Politics of Postmodernism*, edited by Andrew Ross (Minnesota, 1989), *The Event Horizon*, edited by Lorne Falk and Barbara Fischer, and *Rethinking Representation: Art after Modernism*, edited by Brian Wallis. Her articles have appeared in *Afterimage, Art in America, Camera Obscura, October, The Print Collector's Newsletter, Screen*, and numerous other publications.

LINDA NOCHLIN is distinguished professor of art history at the Graduate Center of the City University of New York. She is the author of *Realism* (1971) and *Women, Art, and Power* (1988), and has contributed to *Art in America* and *October*.